Photoshop[®] Elements 11

DUMMIES®

Photoshop[®] Elements 11

DUMMIES®

by Barbara Obermeier and Ted Padova

Photoshop® Elements 11 For Dummies®

Published by John Wiley & Sons, Inc. 111 River Street Hoboken, NJ 07030-5774

www.wiley.com

Copyright © 2012 by John Wiley & Sons, Inc., Hoboken, New Jersey

Published by John Wiley & Sons, Inc., Hoboken, New Jersey

Published simultaneously in Canada

No part of this publication may be reproduced, stored in a retrieval system or transmitted in any form or by any means, electronic, mechanical, photocopying, recording, scanning or otherwise, except as permitted under Sections 107 or 108 of the 1976 United States Copyright Act, without either the prior written permission of the Publisher, or authorization through payment of the appropriate per-copy fee to the Copyright Clearance Center, 222 Rosewood Drive, Danvers, MA 01923, (978) 750-8400, fax (978) 646-8600. Requests to the Publisher for permission should be addressed to the Permissions Department, John Wiley & Sons, Inc., 111 River Street, Hoboken, NJ 07030, (201) 748-6011, fax (201) 748-6008, or online at http://www.wiley.com/go/permissions.

Trademarks: Wiley, the Wiley logo, For Dummies, the Dummies Man logo, A Reference for the Rest of Us!, The Dummies Way, Dummies Daily, The Fun and Easy Way, Dummies.com, Making Everything Easier, and related trade dress are trademarks or registered trademarks of John Wiley & Sons, Inc. and/or its affiliates in the United States and other countries, and may not be used without written permission. Photoshop is a registered trademark of Adobe Systems Incorporated. All other trademarks are the property of their respective owners. John Wiley & Sons, Inc. is not associated with any product or vendor mentioned in this book.

LIMIT OF LIABILITY/DISCLAIMER OF WARRANTY: THE PUBLISHER AND THE AUTHOR MAKE NO REPRESENTATIONS OR WARRANTIES WITH RESPECT TO THE ACCURACY OR COMPLETENESS OF THE CONTENTS OF THIS WORK AND SPECIFICALLY DISCLAIM ALL WARRANTIES, INCLUDING WITH-OUT LIMITATION WARRANTIES OF FITNESS FOR A PARTICULAR PURPOSE. NO WARRANTY MAY BE CREATED OR EXTENDED BY SALES OR PROMOTIONAL MATERIALS. THE ADVICE AND STRATEGIES CONTAINED HEREIN MAY NOT BE SUITABLE FOR EVERY SITUATION. THIS WORK IS SOLD WITH THE UNDERSTANDING THAT THE PUBLISHER IS NOT ENGAGED IN RENDERING LEGAL, ACCOUNTING, OR OTHER PROFESSIONAL SERVICES. IF PROFESSIONAL ASSISTANCE IS REQUIRED, THE SERVICES OF A COMPETENT PROFESSIONAL PERSON SHOULD BE SOUGHT. NEITHER THE PUBLISHER NOR THE AUTHOR SHALL BE LIABLE FOR DAMAGES ARISING HEREFROM. THE FACT THAT AN ORGANIZA-TION OR WEBSITE IS REFERRED TO IN THIS WORK AS A CITATION AND/OR A POTENTIAL SOURCE OF FURTHER INFORMATION DOES NOT MEAN THAT THE AUTHOR OR THE PUBLISHER ENDORSES THE INFORMATION THE ORGANIZATION OR WEBSITE MAY PROVIDE OR RECOMMENDATIONS IT MAY MAKE. FURTHER, READERS SHOULD BE AWARE THAT INTERNET WEBSITES LISTED IN THIS WORK MAY HAVE CHANGED OR DISAPPEARED BETWEEN WHEN THIS WORK WAS WRITTEN AND WHEN IT IS READ.

For general information on our other products and services, please contact our Customer Care Department within the U.S. at 877-762-2974, outside the U.S. at 317-572-3993, or fax 317-572-4002.

For technical support, please visit www.wiley.com/techsupport.

Wiley publishes in a variety of print and electronic formats and by print-on-demand. Some material included with standard print versions of this book may not be included in e-books or in print-on-demand. If this book refers to media such as a CD or DVD that is not included in the version you purchased, you may download this material at http://booksupport.wiley.com. For more information about Wiley products, visit www.wiley.com.

Library of Congress Control Number:

ISBN 978-1-118-40821-6 (pbk); ISBN 978-1-118-46201-0 (ebk); ISBN 978-1-118-49131-7 (ebk); ISBN 978-1-118-49133-1 (ebk)

Manufactured in the United States of America

10 9 8 7 6 5 4 3 2 1

About the Authors

Barbara Obermeier is the principal of Obermeier Design, a graphic design studio in Ventura, California. She is the author of *Photoshop CS6 All-in-One For Dummies* and has contributed as author or coauthor on over two dozen books on Photoshop, Photoshop Elements, Illustrator, PowerPoint, and digital photography for Wiley Publishing, Peachpit Press, and Adobe Press. She is currently a faculty member in the School of Design at Brooks Institute.

Ted Padova is the former chief executive officer and managing partner of The Image Source Digital Imaging and Photo Finishing Centers of Ventura and Thousand Oaks, California. He has been involved in digital imaging since founding a service bureau in 1990. He retired from his company in 2005 and now spends his time writing and speaking on Acrobat, PDF forms, LiveCycle Designer forms, and Adobe Design Premium Suite applications.

Ted has written more than 50 computer books and is the world's leading author on Adobe Acrobat. He has written books on Adobe Acrobat, Adobe Photoshop, Adobe Photoshop Elements, Adobe Reader, Microsoft PowerPoint, and Adobe Illustrator. Recent books published by John Wiley & Sons include Adobe Acrobat PDF Bible (versions 4, 5, 6, 7, 8, 9, and X), Acrobat and LiveCycle Designer Forms Bible, Adobe Creative Suite Bible (versions CS, CS2, CS3, CS4, and CS5), Color Correction for Digital Photographers Only, Color Management for Digital Photographers For Dummies, Microsoft PowerPoint 2007 For Dummies: Just the Steps, Creating Adobe Acrobat PDF Forms, Teach Yourself Visually Acrobat 5, and Adobe Acrobat 6.0 Complete Course. He also coauthored Adobe Illustrator Master Class — Illustrator Illuminated and wrote Adobe Reader Revealed for Peachpit/Adobe Press.

Dedication

Don Mason was a coauthor for two books with Ted. One of the books was *Color Management for Digital Photographers For Dummies*. Sadly, Don passed away this year (2012).

Don was an inspiration for both of us. He assisted a few times in reviewing images for our Photoshop Elements books, and we both considered him to be one of the best color correction experts in the industry.

Don was truly a generous individual who was always happy to offer assistance to all Photoshop Elements and Photoshop users. He was the premiere commercial photographer serving most of the graphic designers and advertising agencies in his hometown — Bakersfield, California.

Photo courtesy Teresa Harigian'Nielson

Prior to the year 1998, Don never touched a computer keyboard. His graphic artist clients were all using Adobe Photoshop and frequently asked him questions about editing photos. When asked a question, Don typically said to his clients, "It must have some kind of manual. Why don't you drop it off at my office on your way home?" Amazingly, and on several occasions, the next day Don walked his clients through steps, over the phone, to properly adjust brightness values using Adobe Photoshop. All this he did after reading a manual in one evening and never looking at a computer monitor.

In 1997 Don asked Ted about what a computer could do for him. He brought spectrometers to Ted's service center, read books, and finally late in 1997 he purchased his first computer. In less than a year, Don became the master, and we both asked Don many technical questions.

Don was a true genius and moreover a wonderful human being. He will be missed by friends and many people in our industry.

Authors' Acknowledgments

We would like to thank our excellent project editor, Rebecca Huehls, one of the very best project editors we've worked with over many years; Bob Woerner, our great and very supportive executive editor; Andy Cummings, Dummies royalty; Dennis Cohen, technical editing wizard, who made what we wrote sound better; and all the dedicated production staff at Wiley.

Barbara Obermeier: A special thanks to Ted Padova, my coauthor and friend, who always reminds me there is still a 1 in 53 million chance that we can win the lottery.

Ted Padova: As always, I'd like to thank Barbara Obermeier for her continued collaborations and lasting friendship. Also, a special thanks to Regis and Malou Pelletier; Curtis and Grace Cooper; Irene Windley; Mike Bindi; and my bridge buddies Stefan, George, and Richard for all their special modeling assistance.

Publisher's Acknowledgments

We're proud of this book; please send us your comments at http://dummies.custhelp.com. For other comments, please contact our Customer Care Department within the U.S. at 877-762-2974, outside the U.S. at 317-572-3993, or fax 317-572-4002.

Some of the people who helped bring this book to market include the following:

Acquisitions and Editorial

Sr. Project Editor: Rebecca Huehls

Executive Editor: Bob Woerner

Sr. Copy Editor: Barry Childs-Helton

Technical Editor: Dennis Cohen

Sr. Editorial Manager: Leah Michael

Editorial Assistant: Leslie Saxman

Sr. Editorial Assistant: Cherie Case

Cover Photos: Front cover images:

sunflower, @ Nikada/iStockphoto.com;

 $daisies, @\ Nicole\ S.\ Young/iStockphoto.com;$

watering can, © Mehmet Salih Guler/iStockphoto.com; background,

© kertlis/iStockphoto.com; woman,

© Liv Friis-Larsen/iStockphoto.com.

Back cover images:

left, © Eric Michaud/iStockphoto.com;

right, ${\mathbb C}$ Catharina van den Dikkenberg/

iStockphoto.com

Composition Services

Project Coordinator: Katie Crocker

Layout and Graphics: Carl Byers,

Carrie A. Cesavice, Joyce Haughey

Proofreaders: Evelyn Wellborn **Indexer:** Potomac Indexing, LLC

Cartoons: Rich Tennant (www.the5thwave.com)

Publishing and Editorial for Technology Dummies

Richard Swadley, Vice President and Executive Group Publisher

Andy Cummings, Vice President and Publisher

Mary Bednarek, Executive Acquisitions Director

Mary C. Corder, Editorial Director

Publishing for Consumer Dummies

Kathleen Nebenhaus, Vice President and Executive Publisher

Composition Services

Debbie Stailey, Director of Composition Services

Contents at a Glance

Introduction	1
Part 1: Organizing and Editing Images	7
Chapter 2: Getting to Know the Editing Work Areas	
Chapter 3: Getting Ready to Edit Chapter 4: Working with Resolutions, Color Modes, and File Formats	59
Part 11: Managing Media	97
Chapter 5: Tagging Photos and Creating Albums Chapter 6: Viewing and Finding Your Images	99
Part 111: Selecting and Correcting Photos	141
Chapter 8: Working with Layons	143
Chapter 8: Working with Layers Chapter 9: Simple Image Makeovers	
Chapter 10: Correcting Contrast, Color, and Clarity	
Part IV: Exploring Your Inner Artist	
Chapter 11: Playing with Filters, Effects, Styles, and More	257
Chapter 12: Drawing and Painting	293
Chapter 13: Working with Type	
Part V: Printing, Creating, and Sharing	337
Chapter 14: Getting It on Paper	
Chapter 15: Sharing Your Work	
Chapter 16: Making Creations	
Part VI: The Part of Tens	385
Chapter 17: Ten Tips for Composing Better Photos	387
Chapter 18: Ten More Project Ideas	393
Index	399

Table of Contents

Introdu	uction	1
	About This Book	
	Conventions Used in This Book	2
	How This Book Is Organized	2
	Part I: Organizing and Editing Images	ປ
	Part II: Managing Media	J
	Part III: Selecting and Correcting Photos	7 1
	Part IV: Exploring Your Inner Artist	¬
	Part V: Printing, Creating, and Sharing	5
	Part VI: The Part of Tens	5
	Icons Used in This Book	5
	Where to Go from Here	6
. 1		
Part 1:	Organizing and Editing Images	7
Cha	apter 1: Getting Your Images	.9
	Organizing Photos and Media on a Hard Drive	10
	Launching Photoshop Elements	
	Adding Images to the Organizer	13
	Adding files from folders and removable media	13
	Downloading images from your camera	
	with the Elements Downloader	14
	Importing additional photos from folders	16
	Understanding the Media Browser	17
	Viewing images in the Media Browser	18
	Adding people in the Media Browser	18
	Hainer a Conservation	20
	Using a Scanner	40
	Using a Scanner Understanding image requirements	20
	Understanding image requirements Using scanner plug-ins on Windows	20 21
	Understanding image requirements Using scanner plug-ins on Windows Scanning on the Macintosh	20 21 23
	Understanding image requirements Using scanner plug-ins on Windows Scanning on the Macintosh Scanning many photos at a time	20 21 23 23
	Understanding image requirements Using scanner plug-ins on Windows Scanning on the Macintosh	20 21 23 23 25

Cha	pter 2: Getting to Know the Editing Work Areas	29
	Launching the Photo Editor	
	Examining the Photo Editor	32
	Examining the image window	35
	Moving through the menu bar	38
	Uncovering the contextual menus	40
	Using the Tools panel	40
	Selecting from the Tool Options	43
	Playing with panels	43
	Using the Photo Bin	46
	Creating images from scratch	47
	Using the Quick Mode	49
	Using Guided Mode	51
	Retracing Your Steps	54
	Using the Undo History panel	55
	Reverting to the last save	56
	Getting a Helping Hand	56
Cha	pter 3: Getting Ready to Edit	59
Ona	Controlling the Editing Environment	
	Launching and navigating preferences	60
	Checking out all the preferences panes	62
	Controlling the Organizer Environment	63
	Navigating Organizer preferences	63
	Setting preferences in all the panes	64
	Customizing Presets	65
	Getting Familiar with Color	66
	Getting Color Right	68
	Color the easy way	68
	Calibrating your monitor	68
	Choosing a color workspace	69
	Understanding how profiles work	70
Cha	ntor A. Working with Populations	
Cna	pter 4: Working with Resolutions,	71
Cold	or Modes, and File Formats	
	Grappling with the Ubiquitous Pixels	72
	Understanding resolution	73
	Understanding image dimensions	
	The Art of Resampling	76
	Changing image size and resolution	76
	Understanding the results of resampling	
	Choosing a Resolution for Print or Unscreen	ot

Go Ahead — Make My Mode!	
Converting to Bitmap mode	8
Converting to Grayscale mode	8
Converting to Indexed Color mode	8
Saving Files with Purpose	8
Using the Save/Save As dialog box	8
Saving files for the web	8
Understanding file formats	8
File formats at a glance	9
Audio and video formats supported in Elements	9: 9:
Part 11: Managing Media	
Chapter 5: Tagging Photos and Creating Albums	99
Touring the Organizer Window	100
Organizing Groups of Images with Keyword Tags	10:
Creating and viewing a keyword tag	103
Adding icons to keyword tags	105
Working with custom keyword tags	105
Working with default keyword tags	106
Working with keyword tag sub-categories	107
Creating Albums	108
Rating images	108
Adding rated files to an album	110
Editing an album	112
Exploring album benefits	113
Creating a Smart Album	113
Chapter 6: Viewing and Finding Your Images	
Cataloging Files	117
Using the Catalog Manager	118
Working with catalogs	119
Backing up your catalog	119
Backing up photos and files (Windows)	121
Backing up photos on a second hard drive	121
The Many Faces of the Organizer	122
Using the View menu	122
Viewing photos in a slideshow (Full Screen view)	122
Comparing the Organizer on Windows and the Macintosh	128
Placing Pictures on Maps	128
Working with Events	120

Auto Color Correction	206
Auto Sharpen	207
Auto Red Eye Fix	207
Editing in Quick Mode	208
Fixing Small Imperfections with Tools	212
Cloning with the Clone Stamp tool	212
Retouching with the Healing Brush	214
Zeroing in with the Spot Healing Brush	216
Lightening and darkening with Dodge and Burn tools	217
Smudging away rough spots	219
Softening with the Blur tool	220
Focusing with the Sharpen tool	221
Sponging color on and off	222
Replacing one color with another	223
Chapter 10: Correcting Contrast, Color, and Clarity	
Chapter 10. Corrotating Constant, Correct Worldow	226
Editing Your Photos Using a Logical Workflow	226
Adjusting Lighting	226
Fixing lighting with Shadows/Highlights	228
Using Brightness/Contrast Pinpointing proper contrast with Levels	228
Adjusting Color	231
Removing color casts automatically	231
Adjusting with Hue/Saturation	232
Eliminating color with Remove Color	234
Switching colors with Replace Color	235
Correcting with Color Curves	236
Adjusting skin tones	238
Defringing layers	239
Correcting with Color Variations	240
Adjusting color temperature with photo filters	242
Mapping your colors	243
Adjusting Clarity	244
Removing noise, artifacts, dust, and scratches	244
Blurring when you need to	245
Sharpening for better focus	248
Working Intelligently with the Smart Brush Tools	251
Part IV: Exploring Your Inner Artist	255
Chapter 11: Playing with Filters, Effects, Styles, and More	
Having Fun with Filters	
Applying filters	258
Corrective or destructive filters	259
One-step or multistep filters	259
Fading a filter	259
rading a inter	

	Selectively applying a filter	260
	Working in the Filter Gallery	261
	Distorting with the Liquify filter	262
	Correcting Camera Distortion	265
	Exploring New Filters	267
	Creating a comic	267
	Getting graphic	268
	Using the Pen & Ink filter	260
	Dressing Up with Photo and Text Effects	271
	Adding Shadows, Glows, and More	272
	Applying layer styles	272
	Working with layer styles	274
	Mixing It Up with Blend Modes	275
	General blend modes	275
	Darken blend modes	276
	Lighten blend modes	
	Lighting blend modes	278
	Inverter blend modes	278
	HSL blend modes	
	Using Photomerge	
	Photomerge Panorama	281
	Photomerge Group Shot	284
	Photomerge Scene Cleaner	286
	Photomerge Exposure	$\frac{200}{287}$
	Photomerge Style Match	290
Cha	pter 12: Drawing and Painting	293
	Choosing Color	
	Working with the Color Picker	293 204
	Dipping into the Color Swatches panel	294 205
	Sampling with the Eyedropper tool	293 207
	Getting Artsy with the Pencil and Brush Tools	291 200
	Drawing with the Pencil tool	290 200
	Painting with the Brush tool	290 200
	Creating your own brush	ono ouo
	Using the Impressionist Brush	30Z
	Filling and Outlining Selections	2013 2014
	Fill 'er up	204
	Outlining with the Stroke command	304 205
	Splashing On Color with the Paint Bucket Tool	30 <i>c</i> 909
	Working with Multicolored Gradients	207
	Applying a preset gradient	307 307
	Customizing gradients	300 201
	- accomments bradiento	107

Working with Patterns	311
Applying a preset pattern	311
Creating a new pattern	312
Creating Shapes of All Sorts	313
Drawing a shape	313
Drawing multiple shapes	315
Specifying Geometry options	315
Editing shapes	317
Chapter 13: Working with Type	
Understanding Type Basics	
Tools	320
Modes	320
Formats	321
Creating Point Type	321
Creating Paragraph Type	323
Creating Path Type	324
Using the Text On Selection tool	324
Using the Text On Shape tool	325
Using the Text On Custom Path tool	326
Specifying Type Options	327
Editing Text	329
Simplifying Type	330
Masking with Type	331
Stylizing and Warping Type	333
Adjusting type opacity	334
Applying filters to your type	334
Painting your type with color and gradients	335
Warping your type	335
Part V: Printing, Creating, and Sharing	337
Chapter 14: Getting It on Paper	
Getting Pictures Ready for Printing	340 240
Working with Color Printer Profiles	540 110
Printing a photo with the printer managing color	341 247
Printing a photo with Elements managing color) 34 1 عد
Getting Familiar with the Print Dialog Box	351
Using Page Setup	ალი მომ
Using More Options	
Exploring Other Print Options	334

Chapter 15: Sharing Your Work	
Getting Familiar with the Elements Sharing Options	357
Planning ahead	
Understanding Adobe Revel	360
Understanding some common setup attributes	
Creating an Online Photo Album	362
Understanding export options	362
Exporting to Photoshop Showcase	362
Using Photoshop Showcase	
Viewing Photoshop Showcase galleries	
E-Mailing Photos	
Working with Adobe Premiere Elements	369
Sharing Your Photos on Social Networks	
Sharing photos on Flickr and Facebook	
Using other online services	371
Chapter 16: Making Creations	
Getting a Grip on Creations	373
Grasping Creation-Assembly Basics	374
Creating a Slide Show (Windows Only)	
Creating a Slide Show project (Windows)	
Exporting to slides and video	
Making Additional Creations	
Part VI: The Part of Tens	385
Chapter 17: Ten Tips for Composing Better Photos	
Find a Focal Point	
Use the Rule of Thirds	
Cut the Clutter	
Frame Your Shot	389
Employ Contrast	
Use Leading Lines	
Experiment with Viewpoints	
Use Light	
Give Direction	
Consider Direction of Movement	392

Chapter 18: Ten More Project Ideas	
Screen Savers	
Flyers, Ads, and Online Auctions	395
Clothes, Hats, and More	396
Posters	396
Household and Business Inventories	
Project Documentation	
School Reports and Projects	397
Blogs	397
Wait — There's More	397
Index	399

Introduction

hotoshop Elements is now in its eleventh version. The product has matured as a tool for both professional and amateur photographers who want to edit, improve, manage, manipulate, and organize photos and other media. Considering the power and impressive features of the program, Elements remains one of the best values for your money among computer software applications.

We live in a photo world. With more than 200 million Apple iOS devices, millions of smart phones, various tablets, netbooks, laptops, and computers, users are managing and editing photos routinely every hour and every day of the year. In order to manage and edit your photos, you need a program like Adobe Photoshop Elements.

Why should you buy Photoshop Elements (and, ultimately, this book)? The range of people who can benefit from using Elements is wide and includes a vast audience. From beginning image editors to intermediate users to more advanced amateurs and professionals, Elements has something for everyone. Hopefully this book can help guide you through the changes in Elements 11 and explain how to take charge of many of the editing features.

What's so nice about this latest release is that the Adobe Development Team made many tasks much easier. Elements 11 has a brand new and simpler interface. Sharing your photos has been greatly simplified by using the free Photoshop Showcase online service and more parity exists between Windows and the Macintosh.

To set your frame of mind to thinking in Photoshop Elements terms, don't think of the program as a scaled-down version of Adobe Photoshop; those days are gone. Consider the following:

- ✓ If you're a digital photographer, Elements has the tools for you to open, edit, and massage your pictures into professional images.
- ✓ If you worry about color management, Elements can handle the task for you, as we explain in Chapters 4 and 14, where we talk about color profiling and printing. For the professional, Photoshop Elements has almost everything you need to create final images for color printing and commercial printing.
- ✓ If you're interested in displaying photos on online services or handheld devices, you're in the right spot. We cover everything from uploading Facebook images to connecting to an iPhone or iPad. Look over Chapters 1 and 15 to find out more.

- ✓ **If you're a beginner or an intermediate user**, you'll find that some of the Photoshop Elements quick-fix operations are a breeze to use for enhancing your images, as we explain in Chapters 9 and 10.
- ✓ If you like to print homemade greeting cards and photo albums whether you're a beginner, an intermediate user, or a professional user Elements provides you with easy-to-follow steps to package your creations, as we discuss in Chapters 15 and 16. In addition, the wonderful sharing services are your gateway to keeping family, friends, and clients connected to your photos, as we explain in Chapter 15.

About This Book

This book is an effort to provide as much of a comprehensive view of a wildly feature-rich program as we can. Additionally, this book is written for a cross-platform audience. If you're a Macintosh user, you'll find all you need to work in Elements 11 for the Macintosh, including support for placing photos on maps and more consistency with Windows features.

Elements is overflowing with features, and we try to offer you as much as possible within a limited amount of space. We begged for more pages, but alas, our publisher wants to get this book in your hands in full color and with an attractive price tag. Therefore, even though we may skip over a few little things, all you need to know about using Photoshop Elements for designing images for print, sharing, the web, versatile packaging, e-mailing, and more is covered in the pages ahead. If you still crave more, take a look at our *Adobe Photoshop Elements 11 All-in-One For Dummies* (John Wiley & Sons, Inc.), where you can find more comprehensive coverage of Photoshop Elements 11.

As we said, Photoshop Elements has something for just about everyone. Hence, we know that our audience is large and that not everyone will use every tool, command, or method described in this book. Therefore, we added a lot of cross-references in the text, in case you want to jump around. You can go to just about any chapter and start reading; and, if some concept needs more explanation, we point you in the right direction for getting some background when it's necessary.

Conventions Used in This Book

Throughout this book, we point you to menus where commands are accessed frequently. A couple of things to remember are the references for where to go

when we walk you through steps in a procedure. For accessing a menu command, you may see a sentence like this one:

Choose File

Get Photos

From Files and Folders.

When you see commands like this one, we're asking you to click the File menu to open the drop-down menu, click the menu command labeled Get Photos, and then choose the command From Files and Folders from the submenu that appears.

Another convention we use refers to context menus. A *context menu* jumps up at your cursor position and shows you a menu similar to the menu you select at the top of the Elements workspace. To open a context menu, right-click the mouse (Control-click on the Macintosh if you don't have a two-button mouse).

A third item relates to using keystrokes on your keyboard. When we mention that some keys need to be pressed on your keyboard, the text looks like this:

Press Alt+Shift+Ctrl+S (Option+Shift+\(\mathbb{H}\)+S on the Macintosh).

In this case, you hold down the Alt key on Windows or the Option key on the Macintosh, the Shift key, and the Control key on Windows or the \Re key on the Macintosh, and then press the S key. Then, release all the keys at the same time.

How This Book Is Organized

This book is divided into logical parts where related features are nested together in chapters within six different parts of the book.

Part 1: Organizing and Editing Images

There are two major components in Photoshop Elements. The Organizer is where you manage all your media — not just photos, but also video, music, PDFs, and projects you create in Elements. The other component is the Photo Editor where you edit photos in a vast number of ways.

We begin Part I with importing photos and performing some tasks in the Organizer. We then introduce you to the Photo Editor in Chapter 2. After all, once you have photos in the Organizer, one of the next things you'll want to

do is edit your photos. We continue in Chapters 3 and 4 with the Photo Editor and talk about essential file attributes you need to know for editing, printing, and sharing your files.

Part 11: Managing Media

In Part II we return to the Organizer and talk about the many ways you can search and find media in the Media Browser. We explore the Find menu and talk about metadata and adding captions and notes to your media. We also cover viewing files in the Organizer in many ways, such as after sorting media and viewing media in slideshows. We conclude this part by talking about albums that help you further organize your media, including both regular albums and Smart Albums.

Part 111: Selecting and Correcting Photos

Part III relates to creating and manipulating selections. There's a lot to making selections in photos, but after you figure it out (by reading Chapter 7), you can cut out a figure in a picture and drop it into another picture, drop different backgrounds into pictures, or isolate an area that needs some brightness and contrast adjustment. In Chapter 8, we talk about layers and how to create and manage them in Elements. In many other chapters, we refer you to Chapter 8 because you need to work with layers for many other tasks you do in Elements.

In Chapter 9, we talk about fixing image flaws and problems. That picture you took with your digital camera may be underexposed or overexposed, or it may need some work to remove dust and scratches. Maybe it needs a little sharpening, or another imperfection requires editing. All the know-how and how-tos are in this chapter.

In Chapter 10, we cover how to correct color problems, brightness, and contrast. We show you ways to quickly fix photos, as well as some methods for custom image corrections.

Part IV: Exploring Your Inner Artist

This part is designed to bring out the artist in you. Considering the easy application of Elements filter effects, you can turn a photo image into a drawing or apply a huge number of different effects to change the look of your image. Find out all about them in Chapter 11.

In Chapter 12, we talk about drawing and painting so that you can let your artistic expression run wild. We follow up in Chapter 13 by talking about

adding text to photos so that you can create your own layouts, posters, cards, and more.

Part V: Printing, Creating, and Sharing

You may find yourself printing fewer photos than ever with all the online opportunities and the display devices available to you. However, when it comes time to print a photo, we provide you information on how to produce good color on your desktop color printer in Chapter 14.

If screen viewing is of interest to you, we cover a number of different options for viewing your pictures onscreen and sharing photos in Chapter 15. For web-hosted images, animated images, photo viewing on your TV, and sending files to social networks, this chapter shows you the many ways you can view your Elements images onscreen.

We wrap up this part with Chapter 16, in which we describe how to make creations for both printing to your desktop printers and sharing photos.

Part VI: The Part of Tens

The last part of the book contains the Part of Tens chapters. We offer ten tips for composing better images and give you ten more project ideas to try with Elements.

Icons Used in This Book

This icon informs you that the item discussed is a new feature in Photoshop Elements 11.

Pay particular attention when you see the Warning icon. This icon indicates possible side-effects or damage to your image that you might encounter when performing certain operations in Elements.

This icon is a heads-up for something you may want to commit to memory. Usually, it tells you about a shortcut for a repetitive task, where remembering a procedure can save you time.

A Tip tells you about an alternative method for a procedure, by giving you a shortcut, a workaround, or some other type of helpful information related to working on tasks in the section being discussed.

Elements is a computer program, after all. No matter how hard we try to simplify our explanation of features, we can't entirely avoid the technical information. If we think that a topic is on the technical side, we use this icon to alert you that we're moving into a complex subject. You won't see many of these icons in the book because we try our best to give you the details in nontechnical terms.

Where to Go from Here

As we say earlier in this Introduction, the first part of this book serves as a foundation for all the other chapters. Try to spend a little time reading through the four chapters in Part I. After you know how to acquire photos and organize them, feel free to jump around and pay special attention to the cross-referenced chapters, in case you get stuck on a concept. When you need a little extra help, refer to Chapter 1, where we talk about using the online help documents available in Elements.

If you have questions, comments, suggestions, or complaints, go to http://support.wiley.com. Occasionally, we have updates to our technology books. If this book does have technical updates, they will be posted at dummies.com/go/photoshopelements11fdupdates.

We hope you have much success and enjoyment in using Adobe Photoshop Elements 11, and it's our sincere wish that the pages ahead provide you with an informative and helpful view of the program.

Part I Organizing and Editing Images

In this part . . .

he first thing you want to do after opening the Photoshop Elements program is to access your photos from a digital camera, hard drive, iPad, iPod, iPhone, or scanner. In this part, we talk about how to access your pictures and get them into Elements for editing. After you load up images in the Organizer, you're ready to make some edits on your picture, so Chapter 2 introduces you to the Photo Editor. In Chapters 3 and 4, we talk about essential image attributes you need to understand throughout the editing process.

Getting Your Images

In This Chapter

- Organizing your photos on your computer
- Launching Photoshop Elements
- Importing photos into the Organizer
- Scanning photos and artwork
- Working with online services
- Acquiring photos from cell phones

Before you begin anything in Photoshop Elements, your first job is to handle organizing photos on your hard drive. We begin by looking at some options for organizing images before you first launch the program.

You can't do much in Photoshop Elements until you bring in some pictures to work on. Therefore we begin by discussing importing images into the Elements Organizer. You have many different ways to import a picture into Elements, where you can play with it, experiment on it, and edit it. If you have a digital camera, you're in the right place; we walk you through an easy method for importing images from cameras and card readers into the Organizer.

If you have a digital scanner, you're in the right place, too, because we also talk about scanning photos. If you have CDs, sources of files on the Internet, some massive collection of images written to a DVD, or even a picture or two that you took with your cell phone, you're still in the right place!

This chapter covers all you need to know about bringing images into Elements from all kinds of sources, and explains how to move around the workspaces to get your files into Elements.

Organizing Photos and Media on a Hard Drive

Several years ago, when we wrote the first edition of *Photoshop Elements For Dummies*, photos for the average user took up less space on hard drives and fewer images needed organizing. Over the past decade, photos and media have become the primary data source on the average consumer's computer. We grab a ton of images with our digital cameras and smart phones, import videos from cameras and phones, and now we're capturing both photos and other media with tablets. With Facebook claiming almost one billion users, you can easily understand how important photos are to computer users.

For many people, a single internal hard drive doesn't offer enough space to store our cherished memories, whether in the form of pictures, videos, or sound and music files. We need more storage space and we need to organize our files, first on hard drives, and then later in Photoshop Elements.

Fortunately, the price of large-capacity drives is well within the reach of most people who own a computer, digital camera, and smart phone. One of the best things you can do to accommodate your photography collection is to invest in a 1 to 3TB USB drive and attach it to your computer. Use the drive only for your photos, videos, and other media, and don't bother copying other data files to it. You can always disconnect a USB drive and use another drive for other kinds of data files.

Even if you store photos on your computer's internal hard drive, organizing the photos in folders will help you manage them efficiently before you get into the Elements Organizer. Regardless of whether you follow our advice for storing your photos on a separate drive, you should look at organizing files in folders first before you start working with Elements. How you label your folders is a personal choice. You may want to name the folders by years and use subfolders for organizing photos by events, locations, photo content, and so on. In Figure 1-1, you can see just one example of how you might organize your photos on a hard drive. After you organize your photos

Figure 1-1: Organize photos and media in folders and subfolders on your hard drive.

into folders, you can use the command to import files from folders, as we explain later, in the section "Adding files from folders and removable media."

As you learn in this chapter, your initial hard drive arrangement of folders and subfolders for your photos and media will make the enormous task of organizing content much easier in Photoshop Elements.

Launching Photoshop Elements

Photoshop Elements has two separate components: the Organizer and the Photo Editor mode. The Organizer is where you manage photos, and the Photo Editor mode is where you correct photos for brightness and color, add effects, repair images, and so on.

By default, the Adobe Photoshop Elements 11 icon appears on your desktop after installation; you can click the icon to launch the Photoshop Elements Welcome screen. In the Welcome screen, you can choose to visit the Organizer or the Photo Editor mode.

Note that you have two buttons on the Welcome screen. The first is labeled *Organizer*. The other button is labeled Photo Editor. Click the Organize button to open the Photoshop Elements Organizer. The Organizer is your central Photoshop Elements media file cabinet where all your imported images, videos, sound files, and PDF documents are displayed in the current catalog file. We talk more about catalog files in Chapter 2. The Photo Editor button is used to open Photo Edit mode. We talk more about this mode elsewhere, beginning in Chapter 4.

Look over the Welcome Screen and browse the information provided. Here you find links to information and help in using Photoshop Elements.

Both the Organizer and the Photo Editor are workspaces. In this chapter, you take a look at the Organizer. (In Chapter 2, you look at the Photo Editor that you enter when clicking the Photo Editor button.) You open a workspace from the Welcome screen. For the purposes of this chapter, click Organize to open the Photoshop Elements Organizer, shown in Figure 1-2.

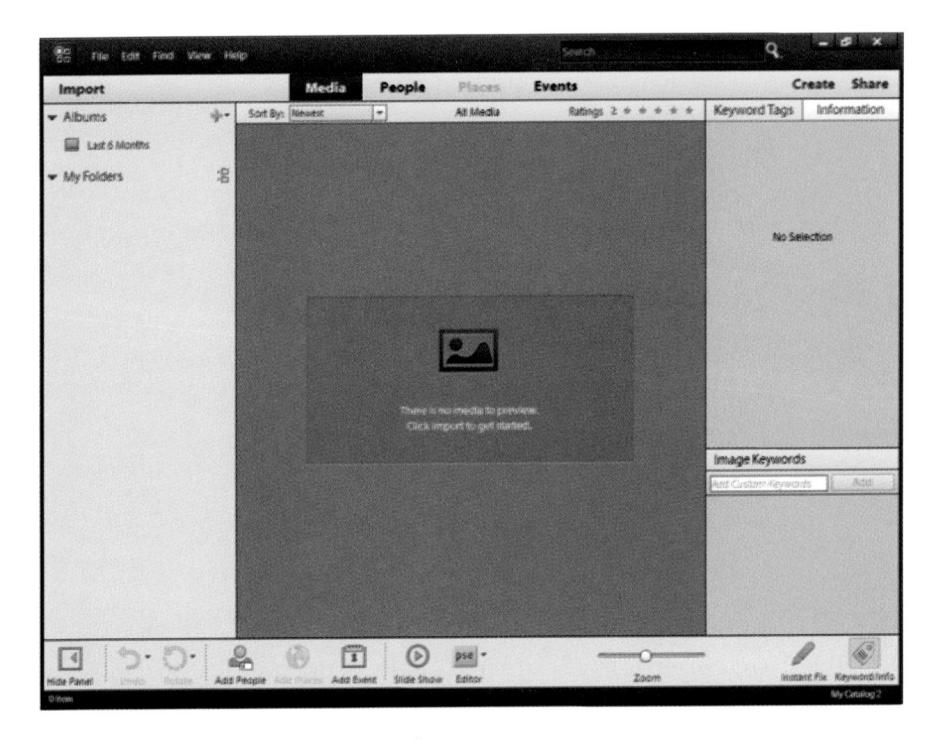

Figure 1-2: The new Organizer User Interface.

- ✓ If you're new to Photoshop Elements, you see an empty Media Browser this is the central panel in the Organizer window. If you are a new user, then you should be looking at a window containing no image thumbnails. You find out how to add images to the Organizer in the next section.
- ✓ **If you're upgrading from a previous version of Photoshop Elements,** you are prompted to convert a previous catalog. (We talk about catalogs in Chapter 6.)

If you already use a previous version of Elements, you know how to import images, so just skim this section to find out what's new.

For those who have worked with Photoshop Elements prior to Elements 11, you'll immediately see a completely new User Interface when you launch either the Organizer or the Photo Editor. Don't be alarmed. Most of the tasks and features you're used to are still available in Elements 11. However, accessing tools, panels, and menus have been scrambled a bit. We address the changes routinely throughout this book.

For those new to Photoshop Elements, you don't have to be concerned about the changes in workspaces. We address the features available in both the Organizer and the Photo Editor in forthcoming chapters.

Adding Images to the Organizer

To edit photos in Photoshop Elements, you need to download your images from your camera to your computer's hard drive and then import photos you want to edit into the Photoshop Elements Organizer.

You have several options for downloading photos from your camera and other sources to your computer:

- Using AutoPlay Wizards for Windows and Assistants on the Mac
- Importing photos directly from iPhoto if you use a Mac
- Using the Photoshop Elements Downloader

The built-in downloaders from your operating system attempt to make your life easier, but in reality, it may be more difficult to struggle with a downloader application and later organize files in folders (as we recommend earlier in this chapter).

Perhaps the easiest method for transferring photos from a camera or card reader is to cancel out of the operating system's downloader application or any camera-specific applications and just stay with the tools that Photoshop Elements provides you.

This section introduces you to the tools available for adding images to the Organizer. If you've already organized images on your hard drive or other media into folders, the Get Files from Folders command (explained in the first section) can help. If images are still on your camera, the Elements Downloader enables you to download images from your camera into the folder where you want to keep the images, using whatever folder organization system you've created; the Elements Downloader also imports the images into the Organizer at the same time.

Adding files from folders and removable media

Most people have photos on their computer's hard drive, as well as on removable media, such as CDs or maybe even a USB flash drive. Adding images from your hard drive is easy. If you have a source such as a USB flash drive or a CD, you copy files from the source to the drive where you store photos or you can copy files into the Organizer directly from the removable media.

The following steps explain how to import images from your hard drive into the Organizer Media Browser:

1. Choose File⇔Get Photos and Videos⇔From Files and Folders.

Or press Ctrl+Shift+G ($\mathcal{H}+Shift+G$ on the Macintosh). The Get Photos and Videos from Files and Folders dialog box opens as shown in Figure 1-3.

2. Browse your hard drive for the photos you want to add.

You can elect to import individual images, a single folder of photos, or a folder and all its subfolders.

3. Select files or a folder and click Get Media.

When you add files to the Organizer, the image thumbnails are links to the files stored on your drive. They are not the complete image data.

Figure 1-3: Choose File □ Get Photos and Videos □ From Files and Folders to import photos into the Organizer.

Your catalog in Elements grows as you add more images, but the growth is miniscule compared to the photo file sizes.

To copy files from CDs, DVDs, or a USB flash drive you can open the external device and drag photos to your hard drive. You can also use the Get Photos and Videos&From Files and Folders command and import photos directly from the external device. By default, the Get Photos and Videos from Files and Folders dialog box copies your media to your hard drive when you click the Get Media button. You can uncheck Copy Files on Import so that only thumbnail images will appear in the Media Browser. In order to edit a photo, you have to reconnect the CD or DVD to your computer. If you elect to copy the images, the photos are available for editing each time you start a new Elements session.

Downloading images from your camera with the Elements Downloader

Import photos from your camera to the Organizer as follows:

1. Insert a media card from a camera or attach a camera to your computer via a USB port.

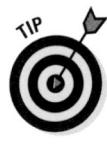

We recommend using a media card instead of attaching your camera, in case the battery is low on your camera. (If the battery runs out, the import stops). If you have a media card for your camera, take it out and insert it into a card reader that you attach to your computer via a USB port.

- 2. If you see an Autoplay Wizard on Windows or a dialog box for importing photos into iPhoto on the Macintosh, cancel out of the dialog box and let Elements control your import.
- 3. In Elements, open the Organize workspace, and choose File⇔Get Photos and Videos from Camera or Card Reader, or press Ctrl+G (\mathcal{H}+G on the Macintosh).

The Photoshop Elements Organizer – Photo Downloader opens, as shown in Figure 1-4.

Figure 1-4: Choose File⇔Get Photos and Videos⇔From Camera or Card Reader, and the Elements Organizer — Photo Downloader opens.

- 4. In the Photo Downloader, open the drop-down menu at the top of the dialog box and choose your media card.
- 5. Click the Browse button and locate the folder on your drive to which you want to copy the photos.

If you don't click the Browse button and select a folder all files copied to your hard drive are copied to the User Pictures folder. This is the default for Photoshop Elements. If you use an external hard drive to store your photos, you'll want to copy photos to the external drive. When you select a folder, select the one that fits the overall folder organizational structure for your images, so your image files stay organized.

We recommend leaving the rest of the settings at the defaults. Don't rename the photos here. You can take care of file renaming in the Organizer later. Don't delete the photos from your card just in case you delete some photos in the Organizer and want to retrieve them. After you're certain everything in Elements is to your liking, you can later delete photos using your camera.

There's an Advanced dialog box for the Downloader that you access by clicking the Advanced Dialog button. In the Advanced settings, you can make choices for things like correcting for red-eye, creating photo stacks, and editing photo data that we call metadata (we explain this in Chapter 6). Because you can handle all these tasks in Elements, just leave the Advanced settings at their defaults.

6. Import photos by clicking the Get Media button in the Photo Downloader dialog box.

Importing additional photos from folders

Suppose you have your folders organized and photos copied to various folders. You take some more pictures of family members and want to add these photos to a folder you already have labeled as Family. To add pictures to a folder on your hard drive, follow these steps.

 Copy photos from a CD, Media card, or external media drive to your hard drive.

In this example, we want to copy photos to a folder we have labeled Family.

- 2. In the Organizer choose Get Photos and Videos

 From Files and Folders.
- 3. Select the folder on your hard drive where you copied the new photos.

In this case, we select the folder labeled Family.

- 4. Click Get Media.
- Click OK in the Getting Media dialog box.

Photoshop Elements is smart enough to only import new images into the Organizer. Any images you previously imported from a given folder are listed in the Getting Media dialog box and you are informed that the old images will not be imported, as shown in Figure 1-5.

Figure 1-5: Only new photos added to a folder are imported in the Organizer.
Understanding the Media Browser

When you add photos to the Organizer, the photos and any additional media appear as thumbnails in the central portion of the Organizer window. This area is called the Media Browser.

If you use the Elements Photo Downloader, you may see several folders in the Import panel where the new photos are found on your hard drive. As you can see in Figure 1-6, Elements doesn't provide you with a very good photo management system when you're using the Photo Downloader. You may take 50 photos in one session and find that when the photos are imported from a media card, they may be copied to a dozen different folders.

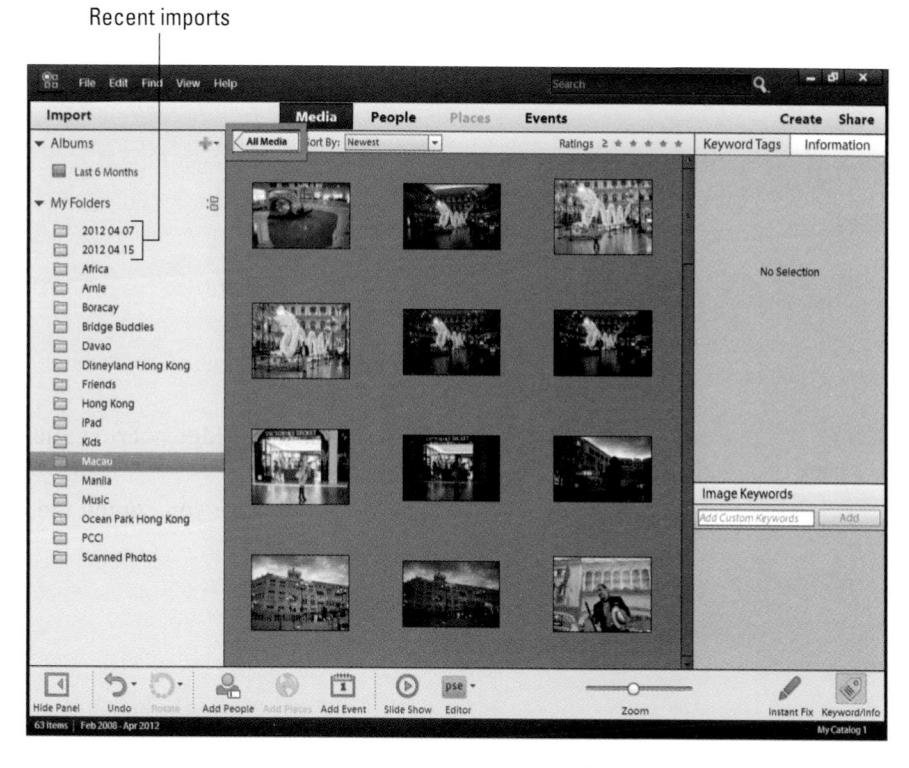

Figure 1-6: After importing files, you need to click the All Media button in order to see all photos in your catalog.

As we recommended earlier in this chapter in the section "Copying files to folders," our preference is to copy files to a hard drive, create the folder organization you want, place the photos in respective folders, then use the Get Photos and Videosc From Files and Folders command. This organization

will make it much easier to locate photos than trying to find your images in a series of folders with date labels.

In this section, you learn basic tips for viewing images in the Media Browser and find out how to use the Elements face-recognition feature to tag people in your photos. Before the photos are scrambled around your catalog, you can also delete photos, assign ratings to them, add tags to the photos, or perform other organizational tasks that we discuss in Chapter 3.

Viewing images in the Media Browser

After files are imported into the Organizer, you see just those photos you imported in the Media Browser. To see all the photos in your catalog, click the Back button at the top of the Media Browser.

For those who are familiar with Photoshop Elements prior to version 11, you'll notice that there is no Display menu where you can choose various display options. Prior to Elements 11 you had a menu command to display your pictures in a folder list.

In this version of Elements, folders appear by default in the left Import panel. You can collapse the panel to provide more viewing area in the Media Browser by clicking the Hide Panel button in the lower left corner of the Organizer workspace.

Adding people in the Media Browser

For many of us, the pictures we enjoy the most are those photos of family and friends. We take photos of landscapes and wonderful places, but quite often we ask someone to stand in front of the Coliseum, Louvre, Grand Canyon, or other notable landmark.

It's people at home or remarkable places that we enjoy viewing and sharing with others. And, Photoshop Elements makes it easy for us to identify, sort, and view pictures with people in our catalogs.

You know that you can add folders of pictures to the Organizer to help manage photos. Once you add new pictures to the Organizer, you can select a folder in the Import panel and label all the people in the photos. Elements makes it easy to label people's faces:

1. Add photos from a folder on your hard drive.

Copy photos to a folder and choose File

Get Photos and Videos

From Files and Folders.

2. Select the folder in the Import panel and click Add People at the bottom of the Organizer window.

3. If you have several photos in a folder, Elements prompts you in a dialog box to confirm your action. Click OK.

The People Recognition – Label People window opens as shown in Figure 1-7. You see the text *Who is This?* below each photo.

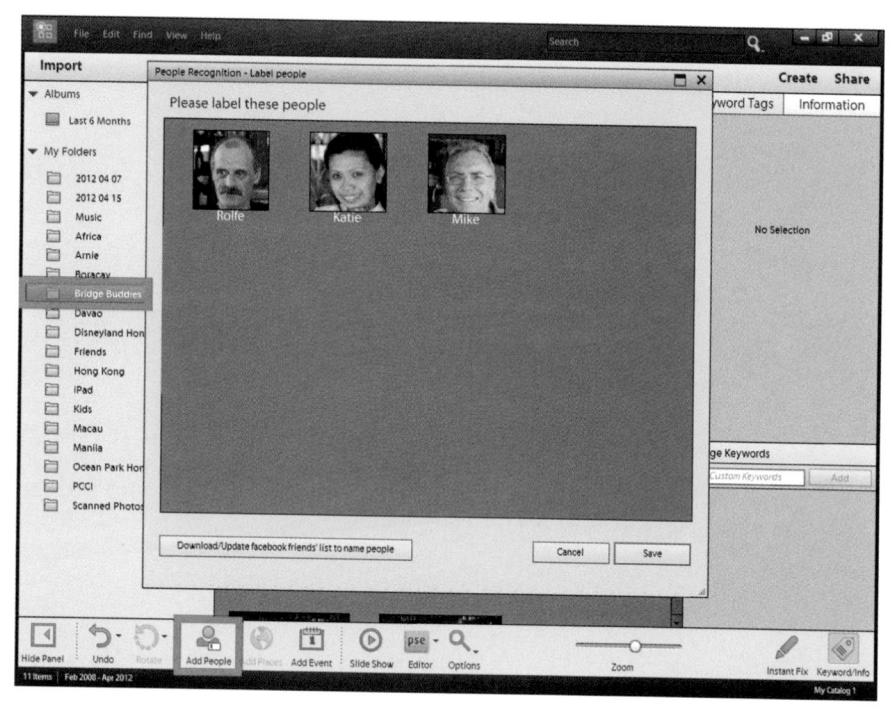

Figure 1-7: Select a folder and click Add People.

4. Click the Who Is This? text and type the name of the individual as shown in Figure 1-8.

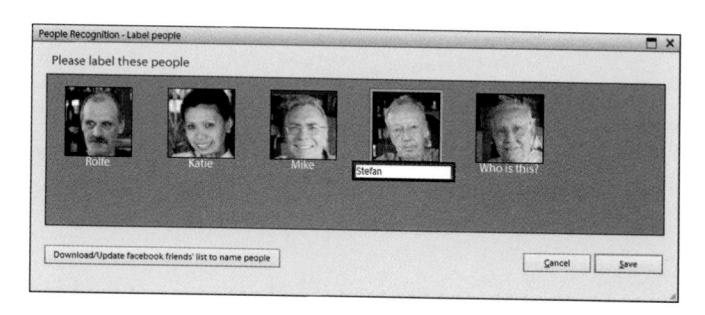

Figure 1-8: Type the name of the individual below each photo.

That's it! Elements provides you with easy methods for labeling people in your photos. Once the photos are labeled you can easily search, sort, and locate photos with specific people. You can even download your Facebook friends' list to the Organizer to help simplify labeling people.

What happens if all people aren't recognized by Elements? Elements is very good at recognizing people but it's not perfect. Profile shots are particularly difficult for Elements to determine that the object in the photo is a person. To add people tags when you are not prompted to do so:

1. Click the Missing People button.

Elements adds a new rectangle that you can move and resize.

- 2. Move the rectangle to a person that hasn't been tagged and click the Who Is This? text box.
- 3. Type the person's name and click the check mark adjacent to the text box to confirm your action.

Using a Scanner

Scanners connect through the same ports as cameras and card readers. (The exception is a SCSI, or *Small Computer Systems Interface* device; SCSI is another type of connection port, almost nonexistent today.) Most scanners today use either USB or FireWire. Low-end scanners sold now are typically USB devices.

Even the lowest-end scanners provide 16-bit scans that help you get a little more data in the shadows and highlights. As with a digital camera, a scanner's price is normally in proportion with its quality.

Understanding image requirements

All scanning software provides you with options for determining resolution and color mode before you start a new scan.

- ✓ Resolution: An image's resolution determines how many pixels it contains. Indeed, resolution is measured in ppi, or pixels per inch.
 - Images displayed on the web use low resolutions, because monitors don't need lots of pixels to display images clearly. Also, images download faster the lower their resolutions are, and fast download times are ideal for the web. A good-looking print requires a higher resolution, because printers and paper require more pixels than monitors do in order to render an image clearly.
- ✓ Color mode: RGB, Grayscale, or Bitmap (line art).

You should decide what output you intend to use and scan originals at target resolutions designed to accommodate a given output. Some considerations include the following:

- Scan the artwork or photo at the size and resolution for the final output. If you have a 3-x-5 photo that needs to be 1.5 × 2.5 inches on a web page, scan the original with a 50-percent reduction in size at 72 ppi (the desired resolution for images on the web). (See Chapter 4 for information about resizing images.)
- Size images with the scanner software. If you have a 4-x-6 photo that needs to be output for prepress and commercial printing at 8×12 inches, scan the photo at 4×6 inches at 600 ppi (a resolution that's large enough to increase the image size to 200 percent and still have a 300 dpi image, which is the desired resolution for a print).
- Scan properly for line art. *Line art* is 1-bit black and white only and should be used for scanning not only black and white artwork but also text. When you print line art on a laser printer or prepare files for commercial printing, the line art resolution should match the device resolution. For example, printing to a 600 dpi (dots per inch) laser printer requires 600 ppi for a 1-bit line-art image.
- Scan grayscale images in color. In some cases, it doesn't matter, but with some images and scanners, you can get better results by scanning in RGB (red, green, and blue) color and converting to grayscale by using the Hue/Saturation dialog box or the Convert to Black and White dialog box, as we explain in Chapter 4.
- Scan in high bit depths. If your scanner is capable of scanning in 16- or 32-bit, by all means, scan at the higher bit depths to capture the most data. See Chapter 4 for more information about working with higher-bit images.

Using scanner plug-ins on Windows

Generally, when you install your scanner software, a standalone application and a plug-in are installed to control the scanning process. *Plug-ins* are designed to work inside other software programs, such as Photoshop Elements. When you're using the plug-in, you can stay right in Elements to do all your scanning. Here's how it works:

- 1. After installing a new scanner and the accompanying software, launch Elements and then open the Organizer by clicking Organize on the Welcome screen.
- 2. From the Organizer, open the Preferences dialog box by pressing Ctrl+K.
- 3. Click Scanner in the left column and adjust the Scanner preferences, as we describe in Chapter 5.

When the Preferences dialog box displays your scanner, you know that the connection is properly set up and you're ready to scan. Here's how to complete your scan:

1. To open the scanner software from within Elements, choose File Get Photos⇔From Scanner.

You must be in the Organizer window on Windows to access the File⇔Get Photos⇔From Scanner menu command.

2. In the Get Photos from Scanner dialog box that appears (as shown in Figure 1-9), make your choices and click OK.

Here you can choose your scanner in the Scanner drop-down menu, a location on your hard drive for saving the scanned images, a quality setting, and an option to automatically correct red-eye.

Elements may churn a bit,

ion to automatically correct Figure 1-9: Make choices in the Get Photos from Scanner dialog box and click OK.

Get Photos from Scanner

Save As: | jpeg =

Save Files in:

Scanner: CanoScanLiDE 90 ▼

C:\Users\TedPadoja\...dobe\Scanned Photos

Quality: 6 (Medium)

QK

Cancel

but eventually your scanner software window appears atop the Organizer window, as you can see in Figure 1-10. The window is the scanner software provided by your scanner manufacturer. (Your window will look different from Figure 1-10 unless vou use the same scanner we use.)

Scantilear | Complete Mode | Mode |

3. Preview the scan.

Regardless of which software you use, you should have

Figure 1-10: When you scan from within Elements, your scanner software window loads on top of the Elements workspace.

similar options for creating a preview; selecting resolution, color mode, and image size; scaling; and other options. If you click the Preview button, you see a preview before scanning the photo(s).

- 4. Adjust the options according to your output requirements and the recommendations made by your scanner manufacturer.
- 5. When everything is ready to go, click the Scan button.

The final image drops into an Elements image window.

Scanning on the Macintosh

Photoshop Elements doesn't support scanning on the Macintosh as it does for Windows. On the Mac, you have a few different options:

- Scanner software. You can use your scanner software and open the resultant scan in the Elements Photo Editor.
- Image Capture. With Image Capture, you can complete a scan and open the file directly in Elements. Image Capture provides options for saving scans as JPEG, TIFF, PNG, or PDF. Quite often you'll find best results when saving as PNG.

Scanning many photos at a time

If you have several photos to scan, you can lay them out on the scanner platen and perform a single scan to acquire all images in one pass. Arrange the photos to scan on the glass and set up all the options in the scanner window for your intended output. When you scan multiple images, they form a single scan, as you can see in Figure 1-11.

After you scan multiple images, Elements makes it easy for you to separate each image into its own image window, where you can save the images as separate files. In Photo Editor mode, choose Image Divide Scanned Photos to make Elements magically open each image in a separate window while your original scan remains intact. The images are neatly tucked away in the Photo Bin, where you can select them for editing, as shown in

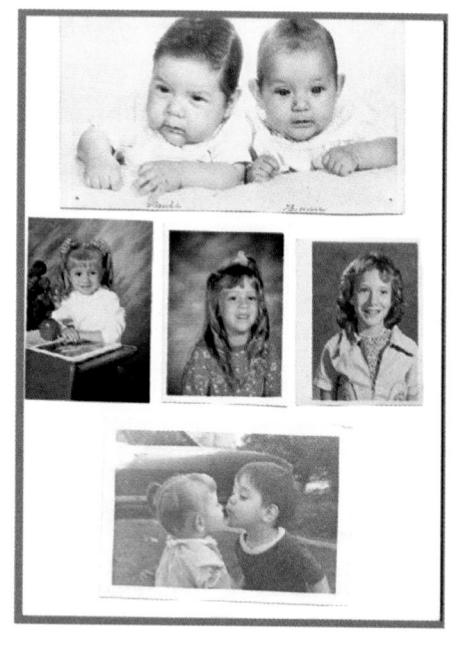

Figure 1-11: You can scan multiple images with one pass.

Figure 1-12. (For more information on using the Photo Editor and working with the Photo Bin, see Chapter 2).

When scanning multiple images and using the Divide Scanned Photos command, be sure to keep your photos on the scanner bed aligned vertically, horizontally, and parallel to each other as best you can. Doing so enables Elements to do a better job of dividing and straightening your photos.

Figure 1-12: After you choose Image ⇒ Divide Scanned Photos, the scan is split.

If you close one of the images that were divided, Elements prompts you to save the image. Only the scan was saved when you started the process. You still need to save the divided scans.

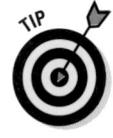

After dividing the images, choose File Close All. Elements closes all files that have been saved and individually prompts you to save all unsaved images.

Grabbing Photos from iPhoto (Macintosh Only)

If you insert a media device and your photos are automatically loaded up in iPhoto on the Mac, you can easily import the iPhoto images into the Organizer. Unique to the Macintosh is the File Get Photos and Videos From iPhoto command. A dialog box opens where you can choose to import photos as iPhoto Events or convert imported photos to albums. You can convert Events or just simply import photos from your iPhoto library. All photos contained within iPhoto are imported into the Organizer unless you import photos as an Event (for more information on Events, see Chapter 6).

Phoning In Your Images

You can acquire images from cell phones, iPhone, iPods, iPads, and a variety of different handheld devices. As a matter of fact, you can do quite a bit with uploading, downloading, and preparing photos for handheld devices.

If you want to add images from a cell phone to the Organizer or open images in one of the editing modes, you need to copy files to your hard drive via a USB or Bluetooth connection or download an e-mail attachment of the photos if your phone is capable of using e-mail. Follow these steps after copying files to your hard drive:

- 1. Choose File ⇔Get Photos and Video ⇔From Files and Folders, or press Ctrl+G (ℋ+G on the Macintosh).
- 2. Locate the folder into which you copied the files and add them to your Organizer.

Or, you can open them in one of the editing modes.

With an iPhone, iPod touch, or iPad, you can use the Photo Downloader to transfer media.

3. Hook up the device with a USB cable.

The Photo Downloader automatically opens. In this particular case, you would use the Photoshop Elements Photo Downloader.

- 4. Click the Browse button to select a destination, as shown in Figure 1-13.
- 5. Click the Get Media button to download the photos to your computer.

For iPhone, iPod touch, and iPad, you can also hook up your device via a USB cable and choose File Get Photos and Videos From Camera or Card Reader. Elements recognizes the device, and the Photo Downloader opens where you have options for importing all photos or selected images.

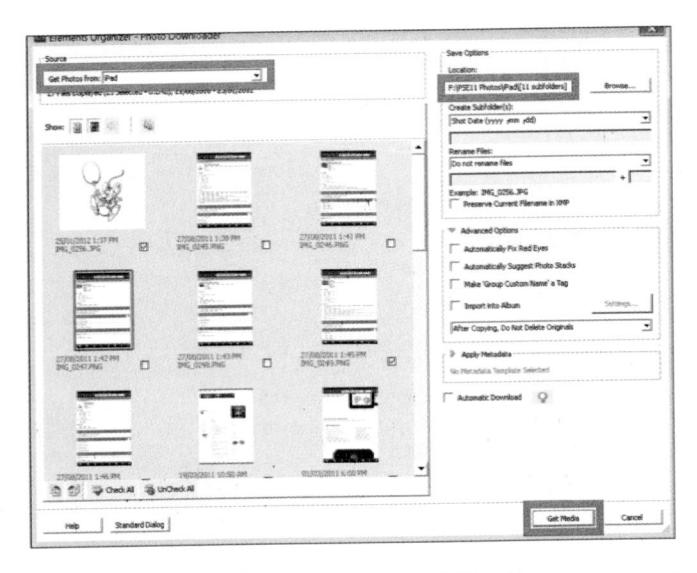

Figure 1-13: Hook up an iPhone or iPad via a USB cable to your computer and choose Filer Get Photos and Videos From Camera or Card Reader.

To upload Elements creations and edited photos to your iPhone, iPad, or iPod touch, use Apple's iTunes.

- 1. In iTunes, choose File⇔Add Files to Library.
- 2. Select the images and videos from a folder on your hard drive that you want to upload to the device.

When uploading photos to an iPhone or iPad, use only the formats these devices support, such as JPEG, TIFF, GIF, and PNG.

- 3. Hook up the iPhone or iPad or connect wirelessly and click the Photos and/or Videos tab at the top of the iTunes window.
- 4. Select the check boxes adjacent to each item you want to upload and then click the Sync button.

Your files are uploaded to your device while the Sync is in progress.

You can bypass iTunes with the iPad using the Camera Connection Kit, provided by Apple for \$29.95. The kit only supports SD cards, but you can attach many different types of card readers to the USB port on the Camera Connection Kit and use other media cards. Copy files from the Organizer to the media card and use it as you would use an external media source to share photos back and forth between your computer and the iPad.

Getting to Know the Editing Work Areas

In This Chapter

- Using the Expert Editing Mode
- Working in the Quick mode
- Working in the Guided mode
- Using the Undo History panel
- Accessing Help documents

hotoshop Elements has two different workspaces: the Organizer, which we introduce in Chapter 1, and the Photo Editor. You manage and arrange your photos in the Organizer, and you edit photos in the Photo Editor.

In this chapter, we hope to provide you with a basic understanding of the Photo Editor so that you can begin to edit your pictures. There's much more to the Organizer than Chapter 1 covers, and there's much more to the Photo Editor than we can hope to cover here in Chapter 2. In Chapters 3 through 6, you find much more detail about both the Organizer and the Photo Editor.

In this chapter, you first find out how to navigate back and forth between the Organizer and the Photo Editor and how to access the Photo Editor's three editing modes: Expert, Quick, and Guided. After a tour of each mode, you find out how to undo edits so that you can start over easily and discover where to find sources of Help within Elements.

If you've used an earlier version of Elements, you'll notice that the way you launch the Photo Editor from within the Organizer and the way you access the editing modes is different. The nomenclature has also changed a bit. In earlier versions of Elements, we referred to the Photo Editor as Full Photo Edit mode. In version 11, we simply refer to the editing workspace as the Photo Editor and recognize the fact that the Photo Editor has three different modes. It may sound complicated now, but follow along and we'll help simplify understanding the entire editing process in Photoshop Elements 11.

Launching the Photo Editor

After you have pictures in the Organizer, you may want to edit the pictures by cropping a photo, editing the brightness, adding text, merging two or more photos, or applying an interesting filter to a photo. All these tasks are performed in the Photo Editor. Hence, you leave the Organizer and open the Photo Editor or you can launch the Photo Editor from your desktop and completely bypass the Organizer.

When you open the Welcome Screen you can click the Photo Edit button to open the Photo Editor. However, most often you'll want to open the Photo Editor from within the Organizer. Why? Because in the Organizer you see thumbnail images of your photos (as shown in Figure 2-1). You may have several very similar photos and want to make a choice for which photo you want to edit. Therefore you're most likely to look over the photos in the Organizer, select the one you want to edit, and open the selected photo in the Photo Editor.

Here's how you move into the Photo Editor:

- ✓ From the initial Welcome screen. Click Photo Edit and open a photo. Opening a photo from the Photo Editor is handled by choosing Filer. Open and selecting the photo you wish to open from files and folders on your hard drive. Your Elements window then appears in the Photo Editor mode, as shown in Figure 2-2.
- From the Organizer. As we have suggested, this is the method you use the most. Click a photo (or several photos) and then click Photo Editor at the bottom of the Organizer window. The selected file(s) open in the Photo Editor.

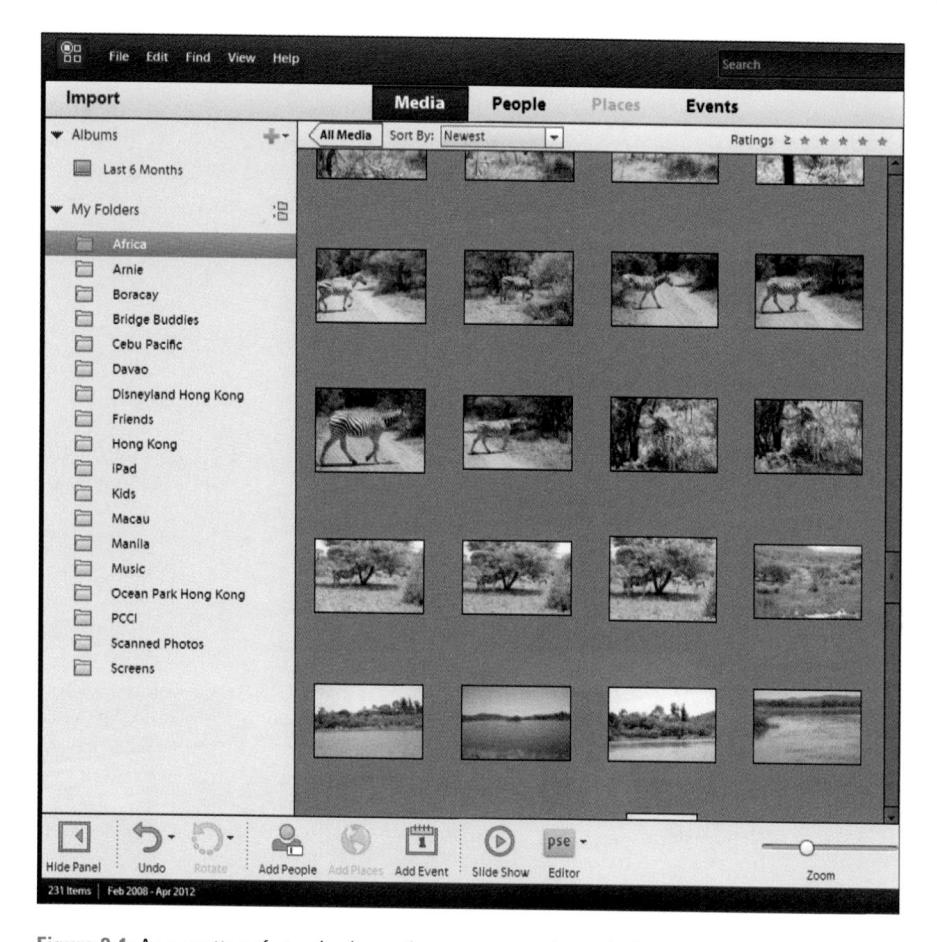

Figure 2-1: As a matter of standard practice, you open photos in the Photo Editor from thumbnails shown in the Organizer.

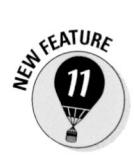

When you jump to the Photo Editor, you immediately notice a very different appearance than you have seen in all earlier versions of Photoshop Elements. The various editing modes are accessed by the three tabs at the top of the Photo Editor workspace. Here you find Quick, Guided, and Expert. Most of the work you do in the Photo Editor takes place in the Expert mode, which opens by default when you click a thumbnail in the Organizer and then click the Photo Editor button.

Examining the Photo Editor

Before you begin editing photos, you'll find it helpful to look over the Photo Editor and learn how to move around the workspace. When the Photo Editor is in Expert mode, you find the following (see to Figure 2-2).

- **A. Menu bar.** Most of the menu commands you find in Elements 11 are the same as those you found in earlier versions of Elements.
- **B. Photo Editor modes.** There are three different Photo Editor modes. The default is the Expert mode that you see in Figure 2-2 and is automatically opened when you click the Photo Editor button in the Organizer or open the Photo Editor from the Welcome Screen.
- **C. Panel Bin.** In Figure 2-2 you see the Layers panel. You change panels by clicking on the icons at the bottom of the Panel Bin (see item P). *Creations* (items you make) are also contained in the Panel Bin when you click the Create button (see item E).

Figure 2-2: The default Photo Editor workspace with several files open in the Photo Editor.

- **D. Open menu.** When you select several thumbnails in the Organizer and click the Photo Editor button, all the files you selected are opened in the Photo Editor. In Figure 2-2 you can see four files tabbed at the top of the image window. You have several ways to place one of the open files in the foreground in the image window:
 - Click a tab at the top of the image window to move the image to the foreground (see item F).
 - Click a photo in the Photo Bin (see item M).
 - Open the Window menu and choose a photo.
 - Click Open and from the drop-down menu click the image you want to move to the foreground.
- E. Create. When you click the Create button you leave the current editing mode. For example when in the Expert mode, click the Create button and all the options that were available in the Photo Editor disappear and are replaced by items listed in the Create panel. To return to the Photo Editor, click Expert (or one of the other two modes) and you leave the Create panel and return to the Photo Editor. At first, this will be confusing, so be sure to remember that once you're in the Create panel, you need to click an editing mode to continue editing your photos. (For more information on using the Create panel see Chapter 16).
- **F. Photo tabs.** Multiple photos opened in the Photo Editor appear in different tabs at the top of the window by default. We call this a docked postion, where the photos are docked in the image window. You can click a tab and drag it down to *undock* the photo. Doing so makes the photo appear as a *floating window*. You might wish to float windows when copying and pasting image data between two or more photos.
- **G. Tools panel.** Here you find the Photo Editor toolbox, where you click a tool and apply an edit to the photo. See "Using the Tools panel" later in this chapter.
- **H. Photo Bin/Tool Options.** In Figure 2-2 you see the Photo Bin opened (see item M for more on the Photo Bin). Click the Tool Options button, and a set of Tool Options replace the Photo Bin. You can also open the Tool Options by clicking a tool in the Tools panel.
 - Tool Options provide you more editing features for a tool that you select in the Tools panel. For example, click the Brush tool and you see tool options for the Brush tool (as shown in Figure 2-3). Each tool in the Tools panel supports various tool options. To return to the Photo Bin, click Photo Bin or click the Expert tab at the top of the image window.
- **I. Undo/Redo.** Click the respective tool for Undo or Redo. You can also use the keyboard shortcuts Ctrl+Z (#+Z on the Mac) for Undo and Ctrl+Y (#+Y) for Redo.

Figure 2-3: Tool Options provide more editing features for tools selected in the Tools panel.

- **J. Rotate.** Click the arrow to open a pop-up menu and choose the Clockwise or Counterclockwise tool to rotate the photo in view in the image window.
- K. Layout. When you have multiple photos open in the Photo Editor, you can make choices in the Layout pop-up menu for how the photos are displayed in the image window (such as rows, columns, as a grid, and so on). To return to the tabbed view, click Default in the Layout pop-up menu.
- **L. Organizer.** Click the Organizer button to return to the Organizer. Elements makes it very easy for you to toggle back and forth between the Organizer and the Photo Editor by clicking the respective buttons at the bottom of the windows.
- M. Photo Bin. The Photo Bin displays thumbnail images of the photos you have open in the Photo Editor. Double-click a thumbnail to bring the photo to the foreground in the image window.
- N. Image window. In this window, you view a photo you want to edit. Likewise, you can view multiple photos you want to edit.
- **O. Photo Bin Options menu.** Click this icon to open a pop-up menu of tasks, such as making creations from photos selected in the Photo Bin and printing selected photos.
- P. Panel Bin icons. Click an icon at the bottom of the Panel Bin to display a different panel. Your choices are the Layers panel, the Effects panel, the Graphics panel, and the Favorites panel. These panels are docked in the Panels Bin and cannot be removed.
- Q. Panels Options menu. To open additional panels, click the right-pointing arrow and you open a pop-up menu of choices. The panels you open from the Panel Options menu open as floating windows and cannot be docked in the Panel Bin.

The description of the Photo Editor workspace is brief in this chapter. Most of the options you have for using tools, panels, and menu commands are discussed in later chapters. For now, try to get a feel for what the Photo

Editor provides for you and how to move among many of the different Photo Editor features.

Examining the image window

Not surprisingly, the image window's tools and features are most useful when an image is open in the window. To open an image in the image window (as shown in Figure 2-2), follow these steps:

1. Choose File⇔Open.

You can always click one or more photos in the Organizer and click the Photo Editor button to open the selected photos in the Photo Editor.

2. Move around your hard drive by using methods you know to open folders and then select a picture.

If you haven't yet downloaded digital camera images or acquired scanned photos and want an image to experiment with, you can use a sample image. Both your operating system and Photoshop Elements typically provide sample images:

- On your operating system, sample images are typically found in your Pictures folder that's one of the default folders in both Windows and Mac OS X installations.
- Elements installs some nice sample images with the application installation. Look in the appropriate folder — Photoshop Elements 11\Support Files\Tutorials (Windows) or /Applications/Adobe Photoshop Elements 11/Support Files/Tutorials (Macintosh) — to find some photos to play with.

3. After selecting a picture, click Open.

The photo opens in a new image window in Elements.

You can open as many image windows in Elements as your computer memory can handle. When each new file is opened, a thumbnail image is added to the Photo Bin at the bottom of the screen. (Refer to Figure 2-2.)

> Notice that in Figure 2-2, filenames appear as tabs above the image window. Additionally, photo thumbnails appear in the Photo Bin. To bring a photo forward, click the filename in a tab or double-click a thumbnail in the Photo Bin. To close a photo, click the X adjacent to the filename or use the File ⇔ Close menu command.

Here's a quick look at important items in the image window, as shown in Figure 2-4:

Figure 2-4: The image window displays an open file within the Elements workspace.

- ✓ Filename. Appears above the image window for each file open in the Photo Editor.
- ✓ Close button. Click the X to the right of the filename to close the file. (On the Macintosh, click the red far-left button.)
- ✓ **Scroll bars.** Become active when you zoom in on an image. You can click the scroll arrows, move the scroll bar, or grab the Hand tool in the Tools panel and drag within the window to move the image.

For Macintosh users, if you don't see scroll bars on your Finder windows, open the System Preferences by clicking the System Preferences icon in the Dock. In General Preferences, click Always in the Show scroll bars section.

Magnification box. Shows you at a glance how much you've zoomed in or out.

Information box. Shows you a readout for a particular tidbit of information. You can choose what information you want to see in this area by selecting one of the options from the pop-up menu, which we discuss in more detail later in this section.

When you're working on an image in Elements, you always want to know the physical image size, the image resolution, and the color mode. (These terms are explained in more detail in Chapter 4.) Regardless of which menu option you select from the status bar, you can quickly glimpse these essential stats by clicking the

Figure 2-5: Click the readout on the status bar to see file information.

Information box (not the right-pointing arrow but the box itself), which displays a pop-up menu like the one shown in Figure 2-5.

✓ **Size box.** Enables you to resize the window. If you move the cursor to the box, a diagonal line with two opposing arrows appears. When the cursor changes, drag in or out to size the window smaller or larger, respectively.

You can also resize the window by dragging any corner in or out $(\mbox{Windows}). \label{eq:windows}$

Now that you're familiar with the overall image window, we want to introduce you to the Information box's pop-up menu, which enables you to choose the type of information you want to view in the Information box. Click the right-pointing arrow to open the menu, as shown in Figure 2-6.

Here's the lowdown on the options you find on the pop-up menu:

Figure 2-6: From the pop-up menu on the status bar, choose commands that provide information about your file.

- **Document Sizes.** Shows you the saved file size. For information on file sizes and resolutions, see Chapter 4.
- ✓ Document Profile. Shows you the color profile used with the file. Understanding color profiles is important when printing files. Look to Chapters 5 and 14 for more information on using color profiles.
- **Document Dimensions.** When selected, this option shows you the physical size in your default unit of measure, such as inches.
- ✓ **Scratch Sizes.** Displays the amount of memory on your hard drive that's consumed by all documents open in Elements. For example, 20M/200M

indicates that the open documents consume 20 megabytes and that a total of 200 megabytes are available for Elements to edit your images. When you add more content to a file, such as new layers, the first figure grows while the second figure remains static.

✓ Efficiency. Indicates how many operations you're performing in RAM, as opposed to using your scratch disk (space on your hard drive). When the number is 100 percent, you're working in RAM. When the number drops below 100 percent, you're using the scratch disk.

If you continually work below 100 percent, it's a good indication that you need to buy more RAM to increase your efficiency.

- ✓ **Timing.** Indicates the time it took to complete the last operation.
- Current Tool. Shows the name of the tool selected from the Tools panel.

Why is this information important? Suppose you have a great photo you want to add to your Facebook account and you examine the photo to find the physical size of 8×10 inches at 300 pixels per inch (ppi). You also find that the saved file size is over 20MB. At a quick glance, you know you want to resize the photo to perhaps 4×6 inches at 72 ppi (doing so will drop the file size from over 20MB to around 365K). Changing the resolution dramatically reduces the file size. We cover file sizes and changing the physical dimensions of your photos in Chapter 4. For now, realize that the pop-up menu shows you information that can be helpful when preparing files for print and display.

Don't worry about trying to understand all these terms. The important thing to know is that you can visit the pop-up menu and change the items at will during your editing sessions.

Moving through the menu bar

Like just about every other program you launch, Elements supports dropdown menus. The menus are logically constructed and identified to provide commands for working with your pictures (including many commands that you don't find supported in tools and on panels). A quick glimpse at the menu names gives you a hint of what might be contained in a given menu list.

Here are the 10 different menus (11 on a Macintosh):

- Photoshop Elements (Macintosh only). On the Macintosh, you find the Photoshop Elements menu preceding the File menu. This menu provides you the Quit command used to exit Elements, and it provides access to 1Photo Edit and Preferences, as we explain in Chapter 5.
- File. Just as you might suspect, the File menu contains commands for working with your picture as a file. You find commands on the menu

- for saving, opening, processing, importing, exporting, and printing. We cover saving files in Chapter 6 and printing or exporting for other output in Part V.
- ✓ Edit. The old-fashioned Copy, Cut, and Paste commands are located on this menu. Additionally, you have important application settings commands on the menu, including Preferences (Windows), which we cover in more detail in Chapter 3.
- Image. You use the Image menu most often when you want to effect changes to the entire image, such as changing a color mode or cropping, rotating, and resizing the image. For details about sizing and color modes, check out Chapter 6. For more about cropping and rotating images, flip to Chapter 9.
- Enhance. Just the name of this menu should tell you what commands to expect here. This is where you go to change the appearance of an image, such as changing its brightness and contrast, adjusting its color and lighting, and doing other smart fix-up work to improve its appearance. On the Enhance⇔Adjust Color submenu, you find a number of commands that offer you a variety of color adjustments. Look to Chapter 10 for some detail on correcting color. In Chapters 9 and 10, you can find out how to use correction tools so that your images look their best.
- Layer. As we describe in great detail in Chapter 8 (a whole chapter just about layers), most kinds of editing you do in Elements are best handled by using layers. Elements neatly tucks away most of the relevant commands associated with working in layers right in this menu.
- Select. Selections are equally as important as layers. Whereas the Image menu contains commands that are applied to the entire image, you can edit isolated areas of an image by using the commands on the Select menu. To isolate an area, you need to create a selection, as we explain in Chapter 7. This menu contains commands to help you with many essential tasks related to working with selections.
- Filter. The Filter menu is where you find professional photographic darkroom techniques, or you can completely leave the world of photography and explore the world of a fine artist. With tons of different filter commands, you can create some extraordinary effects. Find out all about filters in Chapter 11.
- ✓ View. Zooming in and out of images, turning on a grid, exposing horizontal and vertical rulers, adding annotations, and checking out the print sizes of your pictures are handled on the View menu. Chapter 5 unearths secrets of the Zoom tool, rulers, and more.
- Window. Elements supports a number of different panels, as we explain in the section "Playing with panels," later in this chapter. Elements has so many panels that keeping them all open at one time is impractical. Thanks to the Window menu, you can easily view and hide panels,

- reopen the Welcome window, tile and cascade open windows, and bring inactive windows to the foreground.
- ✓ Help. We hope that you get all the help you need right here in this book; but just in case we miss something (or your neighbor has borrowed it, fine book that it is), you have interactive help right at your mouse-tip on the Help menu. The menu also offers links to the Adobe website for more information and a little assistance, courtesy of the tutorials accessible from this menu. (Find a little more detail about accessing help in the section "Getting a Helping Hand," later in this chapter.)

Uncovering the contextual menus

Contextual menus are common to many programs, and Photoshop Elements is no exception. They're those little menus that appear when you right-click (Control-click on a Macintosh with a one-button mouse), offering commands and tools related to whatever area or tool you right-clicked.

The contextual menus are your solution when you are in doubt about where to find a command on a menu. You just right-click an item, and a pop-up menu opens. Before you become familiar with Photoshop Elements (in both the Organizer and in the Photo Editor), you might struggle to find a menu command. Instead, always try to first open a contextual menu and look for the command you want on that menu.

Because contextual menus provide commands respective to the tool you're using or the object or location you're clicking, the menu commands change according to the tool or feature you're using and where you click at the moment you open a contextual menu. For example, in Figure 2-7, you can see the contextual menu that appears after we create a selection marquee and right-click that marquee in the image window. Notice that the commands are all related to selections.

Deselect
Select Inverse
Feather...
Refine Edge...

Layer via Copy
Layer via Cut
New Layer...

Free Transform
Transform Selection

Fill Selection...
Stroke (Outline) Selection...

Figure 2-7: A contextual menu for selections.

In Figure 2-7, notice the Transform Selection command. Photoshop Elements enables you to modify selections using this command, as we explain in Chapter 7.

Using the Tools panel

Elements provides a good number of panels for different purposes. The one that you'll use most is the Tools panel. In panel hierarchy terms, you typically

first click a tool on the Tools panel and then use another panel for additional tool options or use the Tool Options (which we describe in the section "Selecting from the Tool Options," later in the chapter) for fine-tuning your tool instruments. More often than not, clicking a tool on the Tools panel is your first step in editing operations.

Where did all the tools go? When you first open the Photo Editor and look over the Tools panel, you might think that Elements 11 reduced the number of tools you had available in earlier versions of the program.

You have the same tools available in Elements 11 as you had in Elements 10. However, rather than clutter the Tools panel with pop-up toolbars, Elements 11 provides you with additional tools in the Tool Options. For example, you may click the Marquee Rectangle tool and wonder what happened to the Elliptical Marquee tool. It's now in the Tool Options, directly below the image window.

In Figure 2-8, notice the Quick Selection tool is the current tool in the Tools panel. When you look down at the Tool Options, you see the Quick Selection tool; to the right is the Selection Brush tool; and below is the Magic Wand tool.

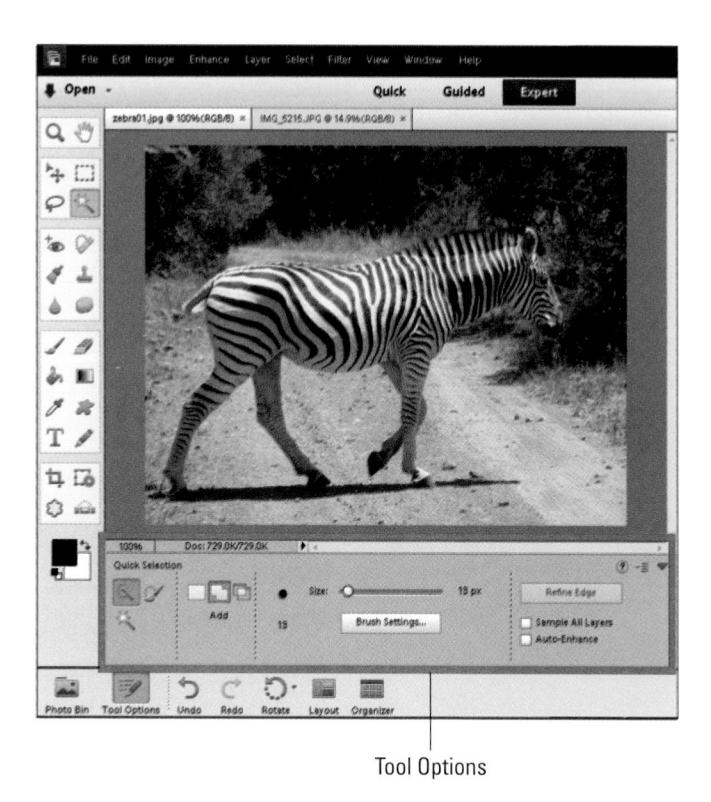

Figure 2-8: Additional tools within a tool group are available in the Tool Options.

Keep in mind that if you don't find a tool in the Tools panel, look in the Tool Options for additional tools within a tool group.

You can easily access tools in Elements by pressing shortcut keys on your keyboard. For a quick glance at the Tools panel, look over Figure 2-9.

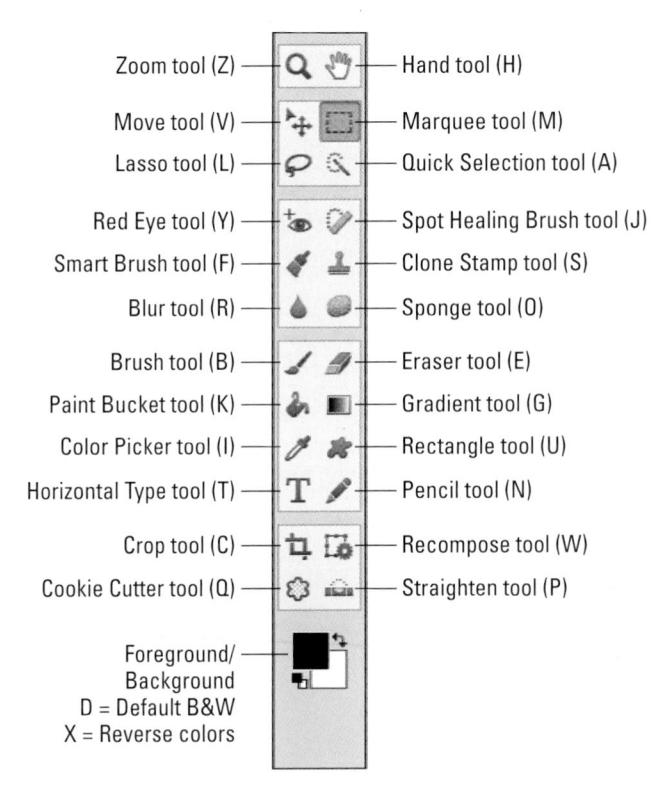

Figure 2-9: The Tools panel with keystroke equivalents to access a tool from the keyboard.

The following tips can help you find your way around the Tools panel with keyboard shortcuts:

✓ To select tools within a tool group by using keystrokes, hold down the Shift key and press the respective key to access the tool. For example, press the Shift+L key combination to select the next tool — the Magnetic Lasso tool. Hold the Shift key down and repeatedly press the shortcut key to step through all tools in a given group.

- Whether you have to press the Shift key to select tools is controlled by a preference setting. To change the default setting so that you don't have to press Shift, choose Edit⇔Preferences⇔General or press Ctrl+K. (Choose Photoshop Elements 11⇔Preferences⇔General or press ℋ+K on the Macintosh.) Then, in the General Preferences, uncheck Use Shift Key for Tool Switch.
- The shortcuts work for you at all times, except when you're typing text with the cursor active inside a text block. Be certain to click the Tools panel to select a tool when you finish editing text.

The tools are varied, and you may find that you don't use all the tools in the Tools panel in your workflow. Rather than describe the tool functions here, we address the tools in the rest of this book as they pertain to the respective Elements tasks.

Selecting from the Tool Options

When you click a tool on the Tools panel, the Tool Options offer you choices specific to the selected tool. Shown earlier in Figure 2-8 you can see options for the Quick Selection tool. In addition to providing you choices for selecting tools within a tool group, you can adjust settings for a selected tool.

In Figure 2-8, you see choices for adjusting the brush size, a button to change the Brush Settings, and choices for adding and subtracting from selections or creating a new selection.

You'll find many of these fine-tuning adjustments in the Tool Options for most of the tools you select in the Tools panel.

Playing with panels

In addition to the Tool Options, covered in the preceding section, Elements provides you with a bunch of panels that contain settings and options for tools and feature such as layers, effects, and more. In the Photo Editor, you open these panels in the Panel Bin:

Layers. The Layers panel displays all the layers you have added to a photo. We talk much more about layers in Chapter 8. For now, try to understand how the different panels are designed. In the Layers panel you find various tools at the top of the panel and an icon with a number of horizontal lines in the top-right coner (as shown in Figure 2-10).

When you click the icon, a pop-up menu appears. In Figure 2-11 you see menu items supporting the tasks you perform in the Layers panel.

- Panel Bin, click the fx button to open the Effects panel. The Effects panel contains menus and tabs for applying a number of different effects to your pictures. You simply double-click the effect you want when you edit the photo. Applying effects are covered in Chapter 16.
- Graphics. Graphics contains several menus where you can choose among a huge assortment of graphic illustrations that can also be applied to your photos. For more information on using the Graphics panel, see Chapter 16.
- Favorites. The Favorites panel also contains a number of graphic images. You can also select items from the Effects and the Graphics panel and add them to the Favorites panel. We talk more about using the Favorites panel in Chapter 11.
- Additional panels. Click the right-pointing arrow at the bottom of the Panel Bin and a pop-up menu opens where you can choose additional panels. The Layers, Effects, Graphics, and Favorites panels are docked in the Panel Bin and cannot be removed. The panels you open from the pop-up menu shown in Figure 2-12 open as floating panels.
 - Actions. Earlier versions of Elements supported Actions; however, you selected Actions from options in the Guided Edit mode. In Elements 11, Actions have graduated to their own panel. Actions are like macros that enable you to automate a series of edits to your pictures. In Figure 2-13, you can see the actions that are supported when you open the Text Effects presets. As with other panels, a pop-up menu is supported where you can Load, Replace, Reset, and Clear actions.

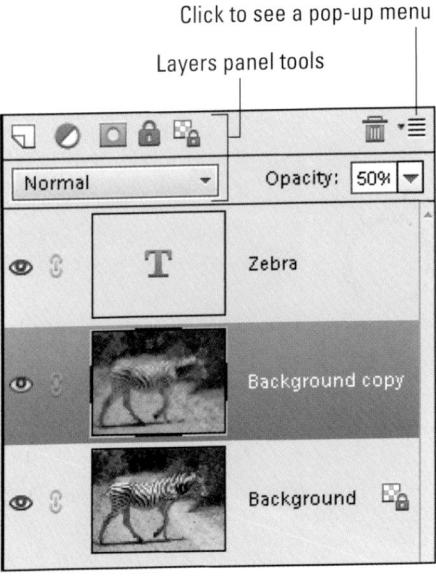

Figure 2-10: The Layers panel contains tools, a menu icon, and a pop-up menu.

Figure 2-11: Click the horizontal lines icon to open a menu.

Elements 11 still doesn't support recording your own series of editing steps and capturing the steps as an Action. However, most of the Actions that are created in Adobe Photoshop can be loaded in Elements.

You can find a number of free dowloadable Actions on the Internet. Just search for Photoshop Actions and explore the many downloads available to you. You can also find YouTube videos explaining how to load actions.

Figure 2-12: Click the rightpointing arrow to display a menu where you can open additional panels.

- Adjustments. The Adjustments panel works only when you have an Adjustment layer. For details about using the Adjustments panel and Adjustment layers, see Chapter 8.
- **Artwork.** Click Artwork and the Graphics panel opens.
- Color Swatches. This panel displays color swatches you might use for coloring and painting that we cover in Chapter 12.
- **Histogram.** Open this panel to display a histogram of the photo in the foreground. We talk more about histograms in Chapters 9 and 10.
- **History.** Choose this item to display the Undo History panel. See the section "Retracing Your Steps" later in this chapter for more on using the Undo History panel.

Figure 2-13: Actions shown for Text Effects.

- **Info.** The Info panel provides readouts for different color values and physical dimensions of your photos.
- Navigator. The Navigator panel helps you zoom in and move around on a photo in the image window.
- ✓ Create. Another panel that exists in the Photo Editor is the Create panel. Click Create at the top right of the Panel Bin to open the Create panel. This panel also exists in the Organizer. The Organizer also supports

another panel called the Share panel. In short, the Create panel in both the Photo Editor and the Organizer is used for making a number of different creations such as calendars, photo books, greeting cards, photo collages, and more. We talk more about making different creations in Chapter 16, and we cover using the Organizer's Share panel in Chapter 15.

When you open the additional panels as floating windows, the panels are docked in a common floating window. You can drag a panel out of the docked position and view it as a separate panel or move it to the docked panels.

When you open a panel in either the Organizer or the Photo Editor, you find other options available from tools, drop-down menus, and from a menu you open by clicking the horizontal lines icon.

Using the Photo Bin

The Photo Bin displays thumbnail views of all your open images. You can immediately see a small image of all the pictures you have open at one time, as shown earlier in Figure 2-2. You can also see thumbnail views of all the different views you create for a single picture. Find out all the details in the following sections.

If you want to rearrange the thumbnails in the Photo Bin, click and drag horizontally to reorganize the order of the thumbnails.

Creating different views of an image

What? Different views of the same picture, you say? Yes, indeed. You might create a new view when you want to zoom in on an area for some precise editing and then want to switch back to a wider view. Here's how you do it:

1. Double-click a thumbnail image in the Photo Bin.

You must have a photo open in the Photo Editor. The photo you doubleclick in the Photo Bin appears in the image window as the active document.

2. Choose View⇔New Window for <filename>.

Note that *<filename>* is the name of the file in the image window.

3. Zoom to the new view.

A new view appears for the active document, and you see another thumbnail image added to the Photo Bin.

To zoom quickly, click the Zoom tool in the Tools panel and then click a few times on the picture in the image window to zoom in to the photo.

4. Toggle views of the same image using the thumbnails in the Photo Bin.

Double-click the original thumbnail to see the opening view; double-click the other thumbnail to see the zoomed view.

Viewing filenames

By default, photos open and are displayed in the Photo Bin without the associated filenames. If you want the name of each file shown in the Photo Bin, open a contextual menu on a photo in the Photo Bin and choose Show Filenames.

Using Panel Bin Actions

A nice feature in Elements is the Panel Bin Actions menu, where you find tasks that you can perform on photos open in the Photo Editor. Click the Photo Bin Options menu to display the menu commands shown in Figure 2-14.

Figure 2-14: Open the Bin Actions pop-up menu to display various actions you can perform on pictures open in the Photo Bin.

The Panel Bin Actions available in the menu include:

- ✓ Create. Select the photos in the Photo Bin that you want to use and click the Create button to open the Create panel where you can make one of the creations listed in the panel.
- ✓ Print Bin Files. Select the files in the Photo Bin that you want to print and choose Print Bin Files. The selected files open in the Print dialog box where you can make photo prints of the selected images.
- Save Bin As an Album. You can do many wonderful things with Photo Albums, and we cover it all in Chapter 14.

Creating images from scratch

You may want to start from scratch by creating a new document in Elements. New, blank pages have a number of uses. You can mix and merge images in a new document, as we explain in Chapter 8; create a canvas where you can draw and paint, as we explain in Chapter 12; or use the New dialog box to find out a file's size, dimensions, and resolution.

Follow these steps to create a new document while working in any editing mode:

1. Open Elements and select an editing mode.

From the Welcome screen, clicking Photo Editor does the trick.

2. Choose File⇔New⇔Blank File in any workspace or press Ctrl+N (ૠ+N on the Macintosh).

Either way, the New dialog box opens, as shown in Figure 2-15.

3. Select the attributes for the new file.

When you select these attributes, among the things you need to consider is the output you want to use for the image: a screen or paper. Files created for the web or for screen views

Figure 2-15: When you create a new, blank file, the New dialog box opens.

are measured in pixels and you don't need to specify a resolution. For print, the measure is other than pixels and you need to specify resolution. We explain how all this works for the relevant settings in the following bulleted list.

You have several options from which to choose:

- Name. Type a name for your file.
- Preset. From the drop-down menu (Windows) pop-up menu (Macintosh), you can select from a number of different sizes.
- Size. You can select a preset size from a long drop-down menu.
 This is optional because you can change the file attributes in the other text boxes and drop-down menus.
- Dimensions (Width/Height). Values in the Width and Height text boxes are independent; either box can be edited without affecting the other. Adjacent to the values in the Width and Height text boxes, you find drop-down menus that offer many different options for units of measure, such as the default units of pixels followed by inches, centimeters (cm), millimeters (mm), points, picas, and columns.
- Resolution. Resolution here is similar to editing the resolution value in the Image Size dialog box when the Resample check box is selected. Resolution is a critical concept when working with photo images; we cover working with image resolution in much more detail in Chapter 4.
- Color Mode. Your choices are Bitmap, Grayscale, and RGB Color. (See Chapter 4 for more information about color modes.)

- Background Contents. You have three choices: White, Background Color, and Transparent. The selection you make results in the color of the blank image. If you choose Background Color, the current background color assigned on the Tools panel is applied to the background. See Chapter 12 for information on changing background color. If you choose Transparent, the image is created as a layer, and the layer name changes to Layer 0, as we explain in Chapter 8.
- Image Size. This value (displayed in the lower-right corner of the dialog box) dynamically changes when you change the Width, Height, and Resolution values. The Image Size value tells you how much file space is required to save the uncompressed file.

4. Click OK after setting the file attributes to create the new document.

Sometimes you may want to copy a selection to the Clipboard and convert the Clipboard information to an image. Be sure you have copied some image data to the Clipboard. In Elements, choose File⊅New⊅Image From Clipboard. The data on the Clipboard appears in a new document window.

In addition to creating new, blank files, the New dialog box can be a helpful source of information for all your work in Elements. Suppose that you want to know how many images you can copy to a USB storage device with 2,656MB of free space, or how large your digital camera files will print with a 150-ppi resolution. All you have to do is press Ctrl+N (\Re +N on the Macintosh) to open the New dialog box, plug in the values, and read the Image Size number or examine the file dimensions. If your files will be converted to grayscale, choose Grayscale from the Color Mode drop-down menu and check the Image Size number to see how much your file size is reduced. Because the Image Size number is *dynamic*, it updates with each change you make to the file attributes.

Using the Quick Mode

When you're in the Photo Editor, the default mode is the Expert, which enables you to apply any kind of edits to a picture, improve the picture's appearance, and use the tools and features that Elements offers you. Expert mode is the richest editor in Elements, in terms of accessing all features. Because Elements has so many different kinds of editing opportunities, the program offers you other workspace views, tailored to the kinds of tasks people typically want to perform.

Quick mode is designed to provide you with just those tools that you need to prepare a picture for its intended destination, whether it's printing, onscreen viewing, or one of the other organizing items. Use this mode to make your pictures look good. You don't find tools for adding text, painting with brushes, or applying gradients in Quick mode. Rather, what you find is a completely different set of panels for enhancing the overall look of your image, such as balancing contrast and brightness, lighting, and sharpening. This mode is like having a digital darkroom on your desktop, where you take care of perfecting an image like you would in analog photography darkrooms.

To enter Quick mode while you're in the Expert mode, click the Quick tab, and the view changes, as shown in Figure 2-16.

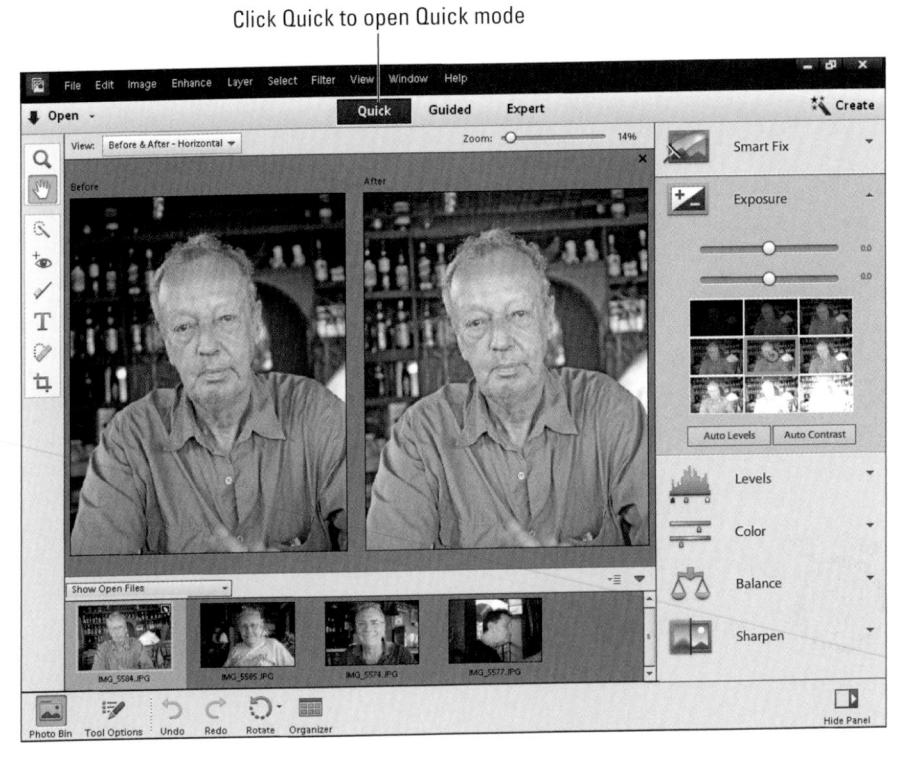

Figure 2-16: Click the Quick tab to open the Quick mode.

There are several differences between Expert and Quick mode:

- Completely different sets of panels are docked in the Panels Bin. All the panels in Quick mode are related to adjusting brightness controls, and they're designed to improve the overall appearance of your pictures. In addition, all the Windows menu commands for accessing panels are grayed out. While you work in Quick mode, Elements insists on limiting your use of panels to just the ones docked in the Panels Bin.
- ✓ The Tools panel shrinks. Quick Photo Edit mode offers only these tools on the Tools panel:
 - Zoom
 - Hand
 - · Quick Selection
 - Red Eye Removal
 - Whiten Teeth
 - Horizontal Type
 - Spot Healing Brush
 - Crop

None of the other Elements tools are accessible while you work in this mode.

Multiple viewing options are available. Notice in Figure 2-16 that you see two views of the same image. The Before view on the left displays the unedited image. The After view shows you the results of changes you make with panel options and menu commands. You select different viewing modes from menu choices on the View drop-down/pop-up menu below the image window.

If you want to return to Expert mode, simply click the Expert tab and the edited version appears in the Photo Editor, where you can use all the Photo Editor tools.

Using Guided Mode

Guided mode is a marvelous editing feature in Elements. It's the third and final editing mode we discuss in this chapter. You access Guided mode by clicking the Guided tab.

Guided mode, as the name implies, is a guided process for performing various editing tasks. When you open the Guided panel, you find a list of items for producing various edits, as shown in Figure 2-17. Not all editing tasks are contained in the Guided panel, but what you have available is an impressive list of many tasks you'll perform often.

As you peruse the panel, notice that some of the basic photo-editing items you have available are similar to what you find in Quick mode, such as Brightness and Contrast, Lighten and Darken, and other brightness control adjustments. As you scroll down the panel to reveal items such as Photo Effects, Photo Play, and Photomerge, you find some interesting, fun edits you can make with photos.

Using Guided mode

The process is the same for all the items you use in the Guided panel. You open a file in the Photo Editor and click Guided.

Once in Guided mode, you click one of the items listed under a category head. For example, suppose you want to create a pop-art style image. You click Pop Art in the Photo Play category and the panel changes to offer you a step-by-step set of procedures to create the artwork.

Figure 2-17: Click the Guided tab to open the Guided Photo Edit panel.

To create a Pop Art style image similar to Figure 2-18, do the following:

- 1. With an image open in the Photo Editor, click Guided and then click Pop Art in the Guided Photo Edit panel.
- 2. Click Convert Image Mode.
- 3. Click Duplicate Image.
- 4. Click Done.

This example is quite simple since you have only a few steps to follow. However, even the more complicated items in Guided mode offer you step-by-step instructions you can easily follow to create a final result.

Figure 2-18: Follow steps in the Guided Photo Edit panel to produce a final image.

Exploring the Guided options

The best way to learn what results you can achieve is to open photos and apply various edits using the Guided panel. Some of the more complicated items, such as creating Out of Bounds effects, offer you a link to online video tutorials to help you further simplify the process.

Some items, such as Photomerge and Photo Stack, require using multiple images. Load up the Photo Bin with photos and apply the effects to multiple images.

You have effects that can help improve images that might otherwise be uninteresting photos. Experiment with the Lomo effect (which is similar to cross-processing film), Old Fashioned Photo effect, Saturated Slide Film effect, and Soft Focus effect.

For portraiture, you'll find the Perfect Portrait item in the Advanced Edits group to be an easy way to improve portrait-type images, as you see in Figure 2-19.

Figure 2-19: The Perfect Portrait effect is a set of easy steps to help you improve portraits.

The best way to learn more about Guided mode is to open images, apply effects, and have a lot of fun!

Retracing Your Steps

Ever since the Apple Macintosh brought a window-like interface to the masses, the Undo command has been one of the most frequently used menu commands in every program developed. You make a change to your document, and if you don't like it, you simply choose Edit⇔Undo or press the keyboard shortcut Ctrl+Z (ૠ+Z on the Macintosh).

In Elements, your options to undo your work provide you much more than reverting to the last view, as we explain in the following sections.

Using the Undo History panel

Elements takes the Undo command to new levels by offering you a panel on which all (well, almost all) your changes in an editing session are recorded and available for undoing at any step in an editing sequence.

Each edit you make is recorded on the Undo History panel. To open the panel, choose Window Undo History. Make changes to your document, and each step is recorded on the panel, as you see in Figure 2-20.

If Elements slows down and you're moving along at a snail's pace, choose Edit Clear Undo History or choose Clear Undo History from the panel's Options menu. Elements flushes all the recorded history and frees up some precious memory, which often enables you to work faster. Just be sure you're okay with losing all the history in the Undo History panel thus far. You can also use Edit Clear Clipboard or Edit Clear All to eliminate Clipboard data from memory.

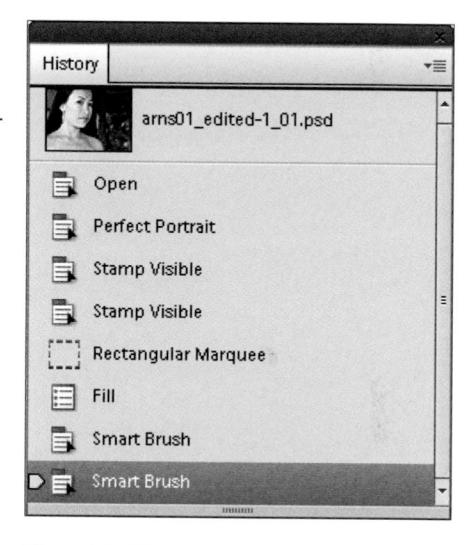

Figure 2-20: The Undo History panel.

We said *almost all* steps are recorded because the number of steps the History panel can record is controlled by a preference setting that tops out at 1,000 steps. If you choose Edit Preferences (Windows) or Adobe Photoshop Elements Preferences (Macintosh) and look at the Performance preferences, as we explain in more depth in Chapter 3, the number of *history states* (times you can go back in history and undo) defaults to 50. You can change the number to the maximum of 1,000, if you like. But realize that the more history states you record, the more memory Elements requires.

When you want to undo multiple edits, open the Undo History panel and click any item listed on the panel. Elements takes you to that last edit while scrubbing all edits that follow the selected item. If you want to bring back the edits, just click again on any step appearing grayed out on the panel to redo up to that level.

All your steps are listed on the Undo History panel as long as you remain in Elements and don't close the file. When the file is closed, all history information is lost.

Reverting to the last save

While you make edits on photos in Elements, always save your work regularly. Each time you save in an editing session, the Undo History panel preserves the list of edits you made before the save and up to the maximum number of history states defined in the General preferences.

If you save, then perform more edits, and then want to return to the last saved version of your document, Elements provides you with a quick, efficient way to do so. If you choose Edit Revert, Elements eliminates your new edits and takes you back to the last time you saved your file.

When you choose Revert, *Revert* appears in the Undo History panel. You can eliminate the Revert command from the Undo History panel by right-clicking (Windows) or Ctrl-clicking (Macintosh with one-button mouse) Revert on the Undo History panel and choosing Delete from the context menu that appears. This command returns you to the edits made after the last save.

Getting a Helping Hand

You can reach for this book whenever you want some details about accomplishing a task while working in Elements. However, for those little annoying moments, and just in case some coffee stains blot out a few pages in this book, you may want to look for an alternative feature description from another source.

Rather than accumulate a library of Elements books, all you need to do is look within Elements to find valuable help information quickly and easily. If you're stuck on understanding a feature, ample help documents are only a mouse-click away and can help you overcome some frustrating moments.

Your first stop in exploring the helpful information Elements provides is on the Help menu. On this menu, you can find several menu commands that offer information:

✓ Photoshop Elements Help. Choose Help

¬Photoshop Elements Help or press the F1 key (Windows) or the Help key (Macintosh with extended keyboard) to open the Elements Help file. You can type a search topic

- and press Enter to display a list of items that provide helpful information about the searched words.
- ✓ Key Concepts. While you read this book, if we use a term that you don't completely understand, choose Help

 Key Concepts. A web page opens in your default web browser and provides many web pages with definitions of terms and concepts.
- Support. This menu command launches your default web browser and takes you to the Adobe website, where you can find information about Elements, problems reported by users, and some workaround methods for getting a job done. You can find additional web-assisted help information by clicking Photoshop Elements Online and Online Learning Resources. The vast collection of web pages on Adobe's website offers you assistance, tips and techniques, and solutions to many problems that come with editing images. Be sure to spend some time browsing these web pages.
- ✓ **Video Tutorials.** Choose Help⇔Video Tutorials to open a web page where videos for common tasks are hosted on Adobe's website.
- **Forum.** Choose Help⇔Forum to explore user comments and questions with answers to many common problems.

Tool tips can be another helpful resource. While you move your cursor around tools and panels, pause a moment before clicking the mouse. A slight delay in your actions produces a tool tip. Elements provides this sort of dynamic help when you pause the cursor before moving to another location.

Getting Ready to Edit

In This Chapter

- Specifying editing preferences
- Specifying organizing preferences
- Working with presets
- ▶ Understanding color in Photoshop Elements
- Setting up your color management system

ou quickly learn that when working in Photoshop Elements you constantly toggle back and forth between the Organizer and the Photo Editor. This chapter explains how to take charge of Elements and customize your work environment by adjusting preference settings in both the Organizer and the Photo Editor and setting up a color management system. When you're new to Elements or image editing in general, you might not know just how you want to set up certain features right away. However, you can always refer to this chapter later, after you become familiar with Elements and have a sense for how you'd like to change the default setup for the way you use

Although not as exciting as firing up Elements and working on your precious pictures, customizing Elements for your personal work habits and properly setting up color management are critical to everything else you do in the program.

Controlling the Editing Environment

Opening Elements for the first time is like moving into a new office. Before you begin work, you need to organize the office. At minimum, you need to set up the desk and computer before you can do anything. In Elements terms, the office organization consists of specifying preference settings. *Preferences* are settings that provide a means to customize your work in Elements and to fine-tune the program according to your personal work habits.

What we offer in the following sections is a brief description of the available preference options. When you need details about one preference option or another, look at the help documents we discuss in Chapter 2. If you use the help documents as a reference, you won't need to memorize the vast number of settings Elements provides.

Elements has two Preferences dialog boxes: one in the Photo Editor workspace and another in the Organizer workspace. This section covers the Preferences dialog box that you open when in the Photo Editor; the dialog box is common to both Windows and the Macintosh.

Launching and navigating preferences

The Photo Editor's Preferences dialog box organizes all the options into nine panes. By default, when you open the Preferences dialog box, you see the General pane.

To open the Preferences dialog box, choose Edit⇔Preferences⇔General. (Or choose Photoshop Elements⇔Preferences⇔General on the Macintosh.) Alternatively, press Ctrl+K (策+K on the Macintosh). Using either method opens the Preferences dialog box to the General pane, as shown in Figure 3-1.

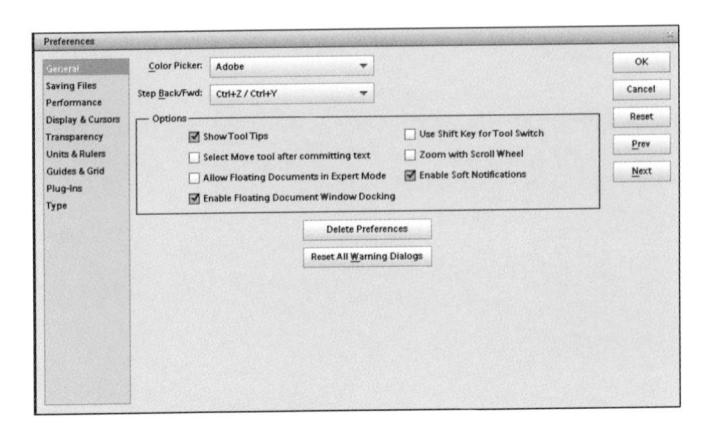

Figure 3-1: The General pane in the Preferences dialog box.

What's a scratch disk?

Assume that you have 100 megabytes (MB) of free RAM (your internal computer memory) and you want to work on a picture that consumes 200MB of hard drive space. Elements needs to load all 200MB of the file into RAM. Therefore an auxiliary source of RAM is needed in order for you to work on the image; Elements uses your hard drive. When a hard drive is used as an extension of RAM, this source is a *scratch disk*.

If you have more than one hard drive connected to your computer, you can instruct Elements to

use all hard drives, and you can select the order of the hard drives that Elements uses for your extension of RAM. All disks and media sources appear in a list as 1, 2, 3, 4, and so on.

Warning: Don't use USB 1.1 external hard drives or other drives that have connections slower than USB 2.0 or FireWire. Using slower drives slows Elements' performance.

In Figure 3-1, you see items on both the left and right sides of the dialog box that are common to all preferences panes. Here's a quick introduction to what these items are and how they work:

- ✓ Panes list. Elements lists all the different panes along the left side of the Preferences dialog box. Click an item in the list to make the respective pane open on the right side of the dialog box. (In earlier versions of Elements, you selected panes from a drop-down menu.)
- ✓ OK. Click OK to accept any changes made in any pane and dismiss the Preferences dialog box.
- Cancel. Click Cancel to return to the same settings as when you opened a pane and to dismiss the dialog box.
- **Reset.** Clicking the Reset button returns the dialog box to the same settings as when you opened the dialog box.
- **Prev.** Switch to the previous pane.
- Wext. Switch to the next pane. You can also press Ctrl+(1 through 9 keys) to jump to another pane, or press \%+(1 through 9 keys) on the Macintosh.

Checking out all the preferences panes

The settings in the Preferences dialog box are organized into different panes that reflect key categories of preferences. The following list briefly describes the types of settings you can adjust in each preferences pane:

- General preferences, as the name implies, apply to overall general settings you adjust for your editing environment.
- Saving Files preferences relate to options available for saving files. You can add extensions to filenames, save a file with layers or flatten layers when you're saving a file (as we explain in Chapter 8), save files with image previews that appear when you're viewing files as icons on your desktop (Windows), and save with some compatibility options. On the Macintosh the Finder generates thumbnails automatically without the need for specifying thumbnails in a Save diaog box.
- ✓ Performance preferences is the pane where you find history states (explained in Chapter 6) and memory settings, such as scratch disk settings. (See the sidebar "What's a scratch disk?" in this chapter for more on scratch disks.)
- ✓ Display & Cursors preferences offer options for how certain tool cursors are displayed and how you view the Crop tool when you're cropping images. Chapter 9 explains how cropping works.
- ✓ Transparency preferences require an understanding of how Elements represents transparency. Imagine painting a portrait on a piece of clear acetate. The area you paint is opaque, and the area surrounding the portrait is transparent. To display transparency in Elements, you need some method to represent transparent areas. (Chapter 7 has more details.) Open the Transparency preferences and make choices for how transparency is displayed in your 2-D Elements environment.
- Units & Rulers preferences let you specify settings for ruler units, column guides, and document preset resolutions.
- ✓ **Grid preferences (Windows) or Guides & Grid (Macintosh)** offers options for gridline color, divisions, and subdivisions. A *grid* shows you nonprinting horizontal and vertical lines. You use a grid to align objects, type, and other elements. You can snap items to the gridlines to make aligning objects much easier. You can drag guides (sometimes called guidelines) from the ruler and position them between gridlines.
- ✓ Plug-Ins preferences include options for selecting an additional Plug-Ins folder for storing third-party utilities to work with Elements. Keeping plug-ins in a seaparate folder can be advantageous when you need to upgrade plug-ins, reinstall, or delete.
- ✓ Type preferences provide options for setting text attributes. You have options for using different quote marks, showing Asian characters, showing font names in English, and previewing font sizes.

Controlling the Organizer Environment

A whole different set of Preferences appears when you open the Organizer and choose Edit Preferences or press Ctrl+K (Adobe Elements 11 Organizer Preferences or \mathbb{H}+K on the Macintosh). Initially, you may be confused because the dialog box that opens when you work in the Organizer is also named Preferences. However, a quick glance at the dialog box shows you a different set of choices. In the following sections, you can find a brief introduction to the Organizer preferences that Elements has to offer.

When you open the Photo Editor mode and press Ctrl+K (\mathbb{H}+K on the Macintosh) to open the Preferences dialog box, pressing Ctrl (\mathbb{H})+K opens the Organizer Preferences. After you make a preference adjustment in the Organizer Preferences and click OK — or you click Cancel or press the Esc key to dismiss the dialog box — you're returned to the Photo Editor's Preferences dialog box.

Navigating Organizer preferences

After opening the Organizer, press Ctrl(\mathbb{H})+K to open the Organizer Preferences dialog box. Alternatively, you can choose Edit⇔Preferences (Adobe Elements 11 Organizer⇔Preferences on the Macintosh) or press Ctrl+K (\mathbb{H}+K on the Macintosh) in the Organizer window to open the Organizer Preferences dialog box, shown in Figure 3-2.

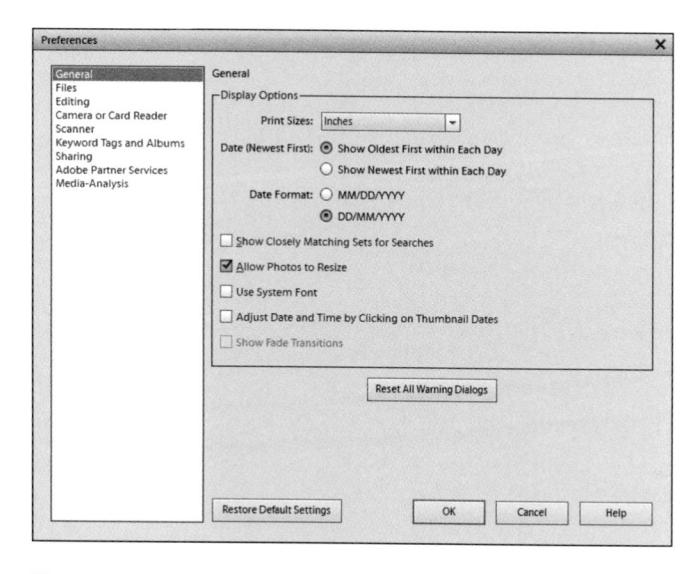

Figure 3-2: Choose Edit€ Preferences and select a submenu item to open the Organizer Preferences dialog box.

The Organizer Preferences dialog box allows you to toggle through a number of panes in the same way the Photo Editor Preferences dialog box does. Click the names in the list on the left side of the dialog box to open the respective panes on the right. At the bottom of the dialog box, you find items that are common to all panes in the Preferences dialog box. These include

- ✓ Restore Default Settings. Click Restore Default Settings to change all panes to their original defaults.
- ✓ OK. Click OK to accept new changes.
- Cancel. If you click Cancel in any pane, any changes you made aren't registered.
- ✓ Help. Click Help to open the Help window and find information about Organize & Share preferences.

Setting preferences in all the panes

Here's a quick overview of what you'll find in the Organizer Preferences dialog box:

- ✓ General. These items affect a miscellaneous group of settings that are applied to files for print, date views, searches, font handling, and transitions.
- Files. Here you find options for managing file data, connecting to missing files, setting prompts to back up your data, saving catalogs, choosing file and folder locations for saved files, rotating images, burning CDs and DVDs (Windows only), and handling preview sizes.
- ► Editing. You can enable another application that provides some editing features not found in Elements to edit an image based on its file type. One good example for adding another editor is when you're editing video clips. If you have Adobe Premiere Elements, you can add Premiere Elements as another editor. If you don't have Premiere Elements installed, you can use another editor, such as Windows Movie Maker (Windows) or iMovie (Macintosh).
- Camera or Card Reader. Here you can specify how Elements acquires images from digital cameras and media storage cards. Your computer may have a built-in card reader into which you can insert a media card, such as SD cards, CompactFlash or Smart Media, or a USB card reader that supports a media card. In other cases, you may have a cable that connects from your camera to a USB port on your computer. Use these preferences with media cards, camera connections, and download options.
- Scanner (Windows only). If you scan images with a scanner connected to your computer, the Scanner preferences hold all the options you may want to set.
- ✓ Keyword Tags and Albums. These preferences help you find and sort your images, as we explain in much more detail in Chapters 5 and 6. Tag preferences offer options for sorting tags and icon views for tags.

- Sharing. The options on this pane relate to sharing files via e-mail. Options are available for setting an e-mail client and adding captions to e-mailed files.
- Adobe Partner Services. These preferences offer choices for handling program updates and online service orders. You can choose to check for program updates automatically or manually; choose options for printing and sharing images; and specify how you want to update creations, accounts, and more.
- Media-Analysis. Media-Analysis performs automatic analysis of media in a catalog — such as analyzing photos with people in the images. You can turn off Media-Analysis in this pane.

Customizing Presets

Part of the fun of image editing is choosing brush tips, swatch colors, gradient colors, and patterns to create the look you want. To get you started, Elements provides you with a number of preset libraries that you can load and use when you want. For example, you can load a Brushes library to acquire different brush tips that you can use with the Brush tool and the Eraser tool. But you're likely to want to customize the preset libraries at least a little bit, too.

You can change libraries individually in respective panels where the items are used. For example, you can change color swatch libraries on the Color Swatches panel or choose brush-tip libraries in the Tool Options. Another way you can change libraries is to use the Preset Manager dialog box, shown in Figure 3-3.

Figure 3-3: The Preset Manager dialog box provides a central area where you can change libraries.

We cover using the presets in Chapter 12, which is where you can find out how to use the many presets that Elements provides. The important thing to note here is that you can change the presets according to your editing needs.

To open the Preset Manager dialog box, choose Edit⇔Preset Manager. The available options include

- ✓ Learn More About: The Preset Manager: Click the blue Preset Manager hyperlinked text to open the Help document and find out more about managing presets.
- ✓ Preset Type: Open the drop-down menu to choose from Brushes, Swatches, Gradients, and Patterns.
- ✓ **Append:** Click the Append button to append a library to the existing library open in the Preset Manager.
- ✓ **Add:** Click this button to open another library. Elements allows you to choose from several libraries for each preset type.
- ✓ More: The More drop-down menu lists different viewing options. You can view the library items as text lists or as thumbnail views.
- ✓ Done: Any changes you make in the Preset Manager are recorded and saved when you click Done.
- Save Set: You can save any changes you make in the Preset Manager as a new library. If you make a change, use this option so that you don't disturb the original presets.
- ✓ Rename: Each item in a library has a unique name. If you want to rename an item, click the thumbnail in the Preview pane, click Rename, and then type a new name in the dialog box that appears.
- ✓ Delete: Click an item in the Preview window and click Delete to remove the item from the library.

Getting Familiar with Color

We could spend a whole lot of time and many pages in this book delving into the complex world of color theory and definitions. You wouldn't likely read it, and we're not so inclined to reduce this book from a real page-turner to something that's likely to sedate you. Rather, in the following sections, we offer some fundamental principles to make your work in Elements easier when you're editing color images.

Your first level of understanding color is to understand what RGB is and how it works. *RGB* stands for *red*, *green*, and *blue*. These are the primary colors in the computer world. Forget about what you know about primary colors in an analog world; computers see primary colors as RGB. RGB color

is divided into *color channels*. Although you can't see the individual channels in Elements, you still need to understand just a little about color channels.

When you see a color *pixel* (a tiny square), the color is represented as different levels of gray in each channel. This may sound confusing at first, but stay with us for just a minute. When you have a color channel, such as the red channel, and you let all light pass through the channel, you end up with a bright red. If you screen that light a little with a gray filter, you let less light pass through, thereby diluting the red color. This is how channels work. Individually, they all use different levels of gray that permit up to 256 levels of light to pass through them. When you change the intensity of light in the different channels, you ultimately change the color.

Each channel can have up to 256 levels of gray that mask out light. The total number of possibilities for creating color in an RGB model is achieved by multiplying the values for each channel ($256 \times 256 \times 256$). The result is more than 16.7 million; that's the total number of colors a computer monitor can display in RGB color.

This is all well and good as far as theory goes, but what does that mean in

practical terms? Actually, you see some of this information in Elements' tools and dialog boxes. As an experiment, open a file in Elements and choose Enhance Adjust Lighting Levels; the dialog box shown in Figure 3-4 opens.

Notice that the Channel drop-down menu shows you Red, Green, and Blue as individual channels, as well as a composite RGB selection. Furthermore, the Output Levels area shows you values ranging from 0 on the left to 255 on the right. Considering that 0 is a number, you have a total of 256 different levels of gray.

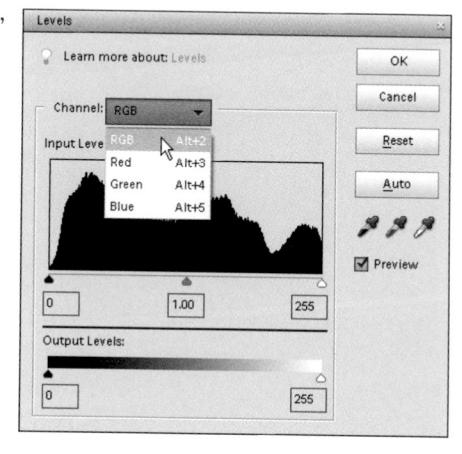

Figure 3-4: Choose Enhance → Adjust Lighting → Levels to open the Levels dialog box.

What's important is that you know that your work in color is related to RGB images that comprise three different channels. There are 256 levels of gray that can let through or hold back light and change brightness values and color. See Chapters 9 and 10 for more on using tools, such as levels, to adjust color in this way.

Getting Color Right

In Elements, when it comes to color, the challenge isn't understanding color theory or definitions, but rather matching the RGB color you see on your computer monitor as closely as possible to your output. *Output* can be a printout from a color printer or a screen view on a web page.

We say match "as closely as possible" because you can't expect to achieve an exact match. You have far too many printer and monitor variables to deal with. However, if you properly manage color, you can get a very close match.

To match color between your monitor and your output, you need to first calibrate your monitor and then choose a color workspace profile. In the following sections, you can find all the details.

Color the easy way

This section is complex and requires some serious study to follow the descriptions in the upcoming sections. If you're interested in sharing photos only onscreen (that is, on web pages, Flickr, Facebook, Twitter, and so on) and you plan to leave the printing to others, you don't need to bother with color correction and going through a maze of steps to get the color perfected.

The only consideration you need to make is your overall monitor brightness. If your monitor displays images darker or lighter than other computers viewing your images, then you need to follow the upcoming sections and understand how to adjust your overall monitor brightness.

If, on the other hand, you adjust brightness and contrast to get a snappy, good-looking photo, upload it to Facebook, and the rest of the world sees a reasonable representation of the photo, then skip all the technical stuff following this section. Your monitor is fine, and you're ready to go.

Calibrating your monitor

Your monitor needs to be calibrated to adjust the gamma and brightness; correct any color tints or colorcasts; and generally get your monitor to display, as precisely as possible, accurate colors on your output. You can choose among a few tools to adjust monitor brightness. These tools range from a low-cost hardware device that sells for less than \$100 to expensive calibration equipment of \$3,000 or more — or you can skip the hardware and use tools provided by Mac OS X or Windows.

Gamma is the brightness of midlevel tones in an image. In technical terms, it's a parameter that describes the shape of the transfer function for one or more stages in an imaging pipeline.

We skip the costly high-end devices and software utilities that don't do you any good and suggest that you make, at the very least, one valuable purchase for creating a monitor profile: a hardware profiling system. On the low end, some affordable devices go a long way toward helping you adjust your monitor brightness and color balance, with prices ranging from \$60 to \$100. The best way to find a device that works for you is to search the Internet for hardware descriptions, dealers, and costs. You'll find items such as the ColorVision Spyder2express and Pantone huey Pro, to name just a few.

On LCD/LED monitors, you need to adjust the hardware controls to bring your monitor into a match for overall brightness with your photo prints. Be certain to run many test prints and match your prints against your monitor view to make the two as similar as possible.

You have a lot to focus on when calibrating monitors and getting the color right on your monitor and your output. We talk more about color output in Chapter 14. For a good resource for color correction and printing using Photoshop Elements, we recommend that you look at *Color Management for Digital Photographers For Dummies*, by Ted Padova and Don Mason.

Choosing a color workspace

After you adjust your monitor color by using a hardware profiling system, your next step is to choose your color workspace. In Elements, you have a choice between two workspace colors: either sRGB or Adobe RGB (1998). You access your color workspace settings by choosing Edit Color Settings. The Color Settings dialog box opens, as shown in Figure 3-5.

The options you have in the Color Settings dialog box include

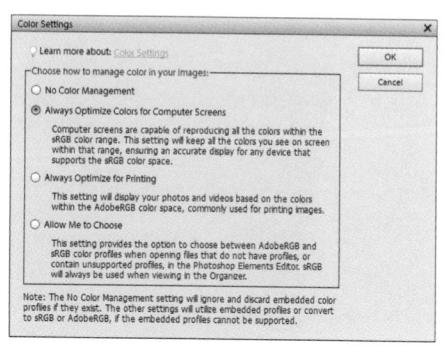

Figure 3-5: The Color Settings dialog box.

No Color Management: This choice turns off all color management. Don't choose this option for any work you do in Elements. When using No

- Color Management, you need to work with files that have color profiles embedded in the photos. Most likely you won't use these types of photos. For information related to using the No Color Management option, see Chapter 14.
- Always Optimize Colors for Computer Screens: Selecting this radio button sets your workspace to sRGB. sRGB color is used quite often for viewing images on your monitor. But this workspace often results in the best choice for color printing, too. Many color printers can output all the colors you can see in the sRGB workspace. In addition, many photo services, such as the Kodak EasyShare services we talk about in Chapter 16, prefer this workspace color.
- Always Optimize for Printing: Selecting this option sets your color work-space to Adobe RGB (1998). The color in this workspace has more available colors than you can see on your monitor. If you choose this workspace, be certain that your printer is capable of using all the colors in this color space.
- Allow Me to Choose: When you choose this option, Elements prompts you for a profile assignment when you open images that contain no profile. This setting is handy if you work back and forth between screen and print images.

Understanding how profiles work

You probably created a monitor color profile when you calibrated your monitor. You probably also selected a color profile when you opened the Color Settings dialog box and selected your workspace color. When you start your computer, your monitor color profile kicks in and adjusts your overall monitor brightness and corrects for any colorcasts. When you open a photo in Elements, color is automatically converted from your monitor color space to your workspace color.

At print time, you use another color profile to output your photos to your desktop color printer. Color is then converted from your workspace color to your printer's color space. In Chapter 14, we show you how to use color profiles for printing. For now, just realize that each of these color profiles, and using each one properly, determines whether you can get good color output.

Working with Resolutions, Color Modes, and File Formats

In This Chapter

- Understanding and changing resolution
- Resampling images
- ▶ Understanding color modes
- Working with file formats

hen you open a picture in Photoshop Elements, you're looking at a huge mass of pixels. These *pixels* are tiny, colored squares, and the number of pixels in a picture determines the picture's *resolution*.

This relationship between pixels and resolution is important for you to understand in all your Elements work. You'll find the concepts covered in this chapter especially helpful when creating selections (as we explain in Chapter 7), printing files (Chapter 14), and sharing files (Chapter 15).

You also need to understand *color modes*, which are also represented as collections of pixels. Color modes are important when you're using tools and printing and sharing files. Basically, you want to choose a color mode for your image that is best suited for print or onscreen and the type of image you have (a photo with lots of colors versus a line drawing with only a few colors, for example).

Like resolution and color modes, the file format in which you save an image often depends on your desired output — print or screen — so this chapter concludes with an introduction to choosing a file format. After you read through this chapter, you'll understand the basics of working with resolution, color modes, and file formats that are essential to great results in your

final images. We talk about changing resolution by resizing images, converting color modes, and saving the results in different file formats.

Grappling with the Ubiquitous Pixels

Files you open in Elements are composed of millions of tiny, square pixels. Each pixel has one, and only one, color value. The arrangement of the pixels of different shades and colors creates an illusion to your eyes when you're viewing an image onscreen. For example, you may have black and white pixels arranged in an order that creates the impression that you're looking at something gray — not at tiny black and white squares.

Just about everything you do in Elements has to do with changing pixels:

- Surrounding pixels with selection tools to select what appear to be objects in your image
- Making pixels darker or lighter to change contrast and brightness.
- Changing shades and tints of pixels for color correction
- Performing a variety of other editing tasks

An image made of pixels is called a *raster image*. If you open a file in Elements that isn't made of pixels, Elements *rasterizes* the data. In other words, Elements converts other data to pixels if the document wasn't originally composed of pixels.

Images not made of pixels are typically *vector images*. You can also have vector content in an Elements file. Text added with the Type tool, for example, is a vector object. When you save an Elements file with the Text layer intact or save it as a Photoshop PDF file, the vector data is retained. We talk more about vector data in Chapter 13. For this chapter, you just need to focus on raster data.

To use most of the tools and commands in Elements, you must be working on a raster image file. If your data isn't rasterized, many tools and commands are unavailable.

The pixels in an image determine an image's resolution and dimensions, as we explain in the following sections.

Understanding resolution

The number of pixels in an image file determines the image's resolution, which is measured in pixels per inch. For example:

- ✓ If you have 300 pixels in 1 inch, your image resolution is 300 ppi.
- ✓ If you have 72 pixels across a 1-inch horizontal line, your image resolution is 72 pixels per inch (ppi).

Image resolution is critical to properly outputting files in the following instances:

- ✓ Printing images: The optimal resolution for print is 300 ppi. If the image resolution is too low, the image prints poorly. If the resolution is too high, you waste time processing all the data that needs to be sent to your printer.
- Showing images onscreen: The best resolution for onscreen images is 72 ppi. Onscreen resolution is lower than print to match typical screen resolutions (also called *display resolution*). Just as images have resolution inherent in their files, your computer monitor displays everything you see on it in a fixed resolution. Computer monitors display images at 72 ppi (or 85 or 96 ppi or higher). That's all you get. What's important to know is that you can always best view photos on your computer monitor at a 72-ppi image size in a 100-percent view.

Newer devices like smart phones and tablets have screens with higher resolutions. You can find device display resolutions from 150 ppi to over 300 ppi on a variety of devices. When you design for different displays, it's important to know the device display-resolution capabilities before you start working in Elements.

To see how image resolution and screen resolution combine and impact what you see onscreen, take a look at Figure 4-1. You see an image reduced to 50 percent and then at different zoom sizes. When the size changes, the monitor displays your image at different resolutions. For example, if you view a photo with a resolution of 72 ppi and reduce the size to 50 percent view on your monitor, the resolution on the monitor appears as though the photo is at 144 ppi. When the size is 100 percent, the image resolution is the same as the monitor resolution. Table 4-1 provides a closer look at these differences in resolution.

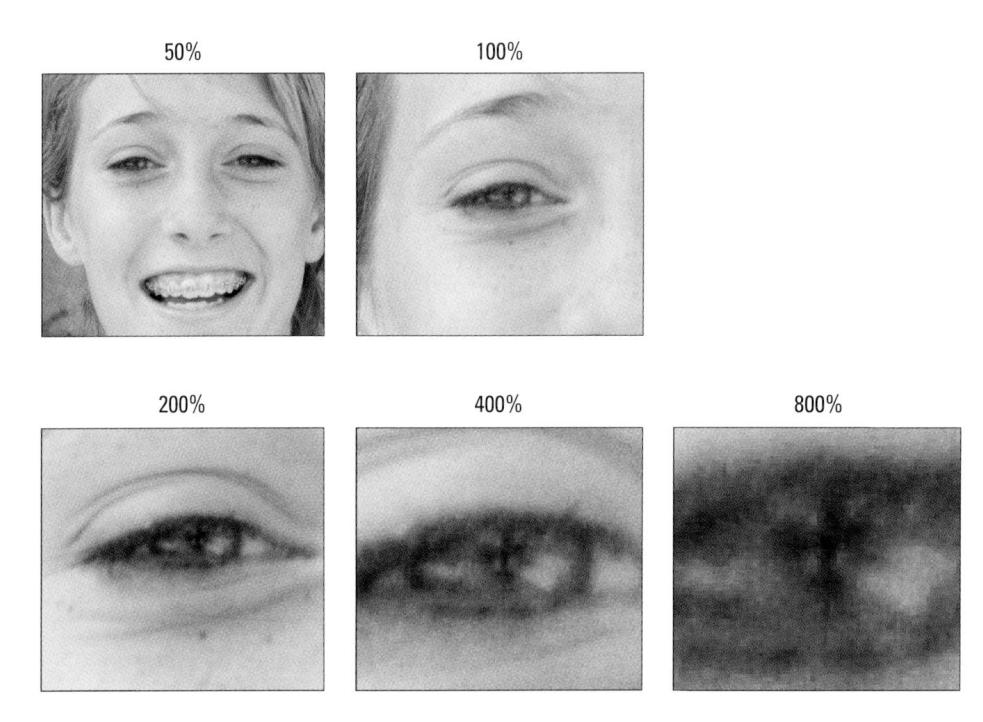

Figure 4-1: The same image is viewed at different zoom levels.

Table 4-1	How Image and Display Resolutions Affect What You See Onscreen			
lmage Resolution	Display Resolution	Zoom Level	How Image Appears Onscreen	
72 ppi	72 ppi	100%	Image appears onscreen at its actual resolution, so the onscreen display is the same as what you would see if you printed the image. The print will not be crisp, however, because the resolution is too low for print. A low resolution looks fine on a monitor, but not on paper.	
72 ppi	72 ppi	50%	Image appears smaller onscreen, as though it has a higher image resolution (144 ppi, or twice the resolution that it actually has).	

lmage Resolution	Display Resolution	Zoom Level	How Image Appears Onscreen	
though it has a lowe (36 ppi or half of its a The display needs to		Image appears larger onscreen, as though it has a lower image resolution (36 ppi or half of its actual resolution). The display needs to simulate "spreading out" the pixels to make the image appear bigger.		
300 ppi	72 ppi	100%	Image appears larger onscreen than it will in print, because the monitor can display only 72 ppi.	
300 ppi	72 ppi	50%	Image appears smaller onscreen but will print larger than the monitor view.	
300 ppi	72ppi	200%	Image appears larger onscreen but will print smaller than the monitor view.	

This relationship between the image resolution and viewing the image at different zoom levels is an important concept to grasp. If you grab an image off the web and zoom in on it, you may see a view like the 800-percent view shown in Figure 4-1. If you acquire a digital camera image, you may need to zoom out to a 16-percent view to fit the entire image in the image window.

The reason that these displays vary so much is because of image resolution. That image you grabbed off a web page might be a 2-inch-square image at 72 ppi, and that digital camera image might be a 10-x-15-inch image at 240 ppi. To fill the entire window with the web image, you need to zoom in on the file. When you zoom in, the image appears as though tit is reduced in resolution.

When you zoom into or out of an image, you change the resolution as it appears on your monitor. *No resolution changes are made to the file.* The image resolution remains the same until you use one of the Elements tools to reduce or increase the image resolution.

Understanding image dimensions

Image dimensions involve the physical size of your file. If the size is $4\,x\,5$ inches, for example, the file can be any number of different resolution values. After the file is open in Elements, you can change the dimensions of the image, the resolution, or both.

When you change only the dimensions of an image (not the number of pixels it contains), an inverse relationship exists between the physical size of your image and the resolution. When image size is increased, resolution decreases. Conversely, when you raise resolution, you reduce image size.

The Art of Resampling

In some cases, images are too large, and you need to reduce their resolution and physical size. In other cases, you might need a higher resolution to output your images at larger sizes. This method of sizing — changing the size, as well as the number of pixels — is called *resampling* an image. Specifically, reducing resolution is *downsampling*, and raising resolution is *upsampling*.

Use caution when you resample images; when you resample, you either toss away pixels or manufacture new pixels. We discuss the resampling details in the section "Understanding the results of resampling," later in this chapter.

Changing image size and resolution

You can change an image's size and resolution in a couple different ways. One method is cropping images. You can use the Crop tool with or without resampling images. For more information on using the Crop tool, see Chapter 9. Another method is using the Image Size dialog box, which you use in many of your editing sessions in Elements.

To resample an image with the Image Size dialog box, follow these steps:

1. Choose Image⇔Resize⇔ Image Size.

Alternatively, you can use the keyboard shortcut Ctrl+Alt+I (\mathbb{H}+Option+I on the Macintosh). The Image Size dialog box opens, as shown in Figure 4-2.

The Pixel Dimensions area in the Image Size dialog box shows the file size (in this example, 12.1M). This number is the amount of space the image takes up on your hard drive. The width and height values are fixed unless you click the Resample Image check box at the bottom of the dialog box.

2. In the Document Size area, you can redefine dimensions and resolution. The options are

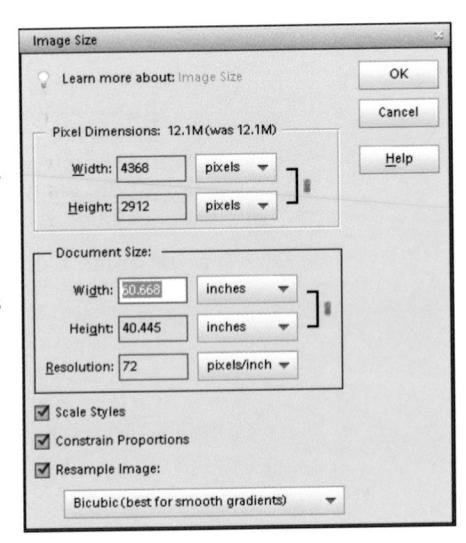

Figure 4-2: Choose Imager\$Resizer\$ Image Size to open the Image Size dialog box.

- *Width:* Type a value in the text box to resize the image's width and then press Tab to move out of the field to implement the change. From the drop-down menu to the right of the text box, you can choose a unit of measure: percent, inches, centimeters, millimeters, points, picas, or columns.
- *Height*: The Height options are the same as the Width options with the exception of no column setting.
 - If you keep the sizing proportional, you typically edit either the Width or Height text box, but not both. When you alter either width or height, the resolution changes inversely.
- Resolution: Type a value in the text box to change resolution, and press the Tab key to change the value. When resolution is edited, the Width and Height values are changed inversely (if the Constrain Proportions check box is selected).
- 3. If you're okay with resampling your image to get the desired size, select the Resample Image check box.

With this check box selected, you can change dimensions and pixels at the same time, which results in either reducing or increasing the number of pixels. When the check box is deselected, the values for dimensions are linked; changing one value automatically changes the other values.

Before you resample your image, however, be sure to check out the following section, "Understanding the results of resampling."

4. If you select the Resample Image check box, you can choose a resampling method, as well as other resample options.

In the drop-down menu, you find different choices for resampling. See Table 4-2 for details. When you select the Resample Image check box, the two check boxes above it become active. Here's what they do:

- Scale Styles. Elements has a Styles panel from which you can add a variety of different style effects to images. (See Chapter 11 for details.) When you apply a style, such as a frame border, the border appears at a defined width. When you select the Scale Styles check box and then resize the image, the Styles effect is also resized. Leaving the check box deselected keeps the style at the same size while the image is resized.
- Constrain Proportions. By default, this check box is selected, and you want to keep it that way unless you want to intentionally distort an image.
- When you're done selecting your options, click OK to resize your image.

Table 4-2	Resampling Methods				
Method	What It Does	Best Uses			
Nearest Neighbor	This method is fastest, and the results produce a smaller file size.	This method is best used when you have large areas of the same color.			
Bilinear	This method produces a medium-quality image.	You might use this option with grayscale images and line art.			
Bicubic	This method is the default and provides a good-quality image.	Unless you find better results by using any of the other methods, leave the default at Bicubic.			
Bicubic Smoother	This method improves on the Bicubic method, but you notice a little softening of the edges.	If sharpness isn't critical and you find Bicubic isn't quite doing the job, try this method. It tends to work best if you have to upsample an image.			
Bicubic Sharper	This method produces good- quality images and sharpens the results.	Downsample high-resolution image that need to be output to screen resolutions and web pages.			

Understanding the results of resampling

As a general rule, reducing resolution is okay, but increasing resolution isn't. If you need a higher-resolution image and you can go back to the original source (such as rescanning the image or reshooting a picture), try (if you can) to create a new file that has the resolution you want, instead of resampling in Elements. In some cases, upsampled images can be severely degraded. Regardless of whether you upsample or downsample an image, always save a copy of the photo under a new filename.

If you take a picture with a digital camera and want to add the picture to a web page, the image needs to be sampled at 72 ppi. In most cases, you visit the Image Size dialog box, select the Resample Image check box, add a width or height value, and type **72** in the Resolution text box. What you end up with is an image that looks great on your web page. In Figure 4-3, you can see an image that was downsampled in Elements from over 14 inches horizontal width.

If you start with an image that was originally sampled for a web page and you want to print a large poster, you can forget about using Elements or any other image editor. Upsampling low-resolution images often turns them to mush, as you can see in Figure 4-4.

Figure 4-3: Downsampling images most often produces satisfactory results.

You might wonder whether upsampling can be used for any purpose. In some cases, yes, you can upsample with some satisfactory results. You can achieve better results with higher resolutions of 300 ppi and more if the resample size isn't extraordinary. If all else fails, try applying a filter to a grainy, upsampled image to mask the problem. Chapter 11 has the details on filters.

Figure 4-4: Upsampling low-resolution images often produces severely degraded results.

Choosing a Resolution for Print or Onscreen

The importance of resolution in your Elements work is paramount to printing files. Good ol' 72-ppi images can be forgiving, and you can get many of your large files scrunched down to 72 ppi for websites and slide shows. With output to printing devices, it's another matter. There are many different printing output devices, and their resolution requirements vary.

For your own desktop printer, plan to print a variety of test images at different resolutions and on different papers. You can quickly determine the best file attributes by running tests. When you send files to service centers, ask the technicians what file attributes work best with their equipment.

For a starting point, look over the recommended resolutions for various output devices listed in Table 4-3.

Table 4-3 Resolutions	Resolutions and Printing		
Output Device	Optimum	Acceptable Resolution	
Desktop laser printers	300 ppi	200 ppi	
Desktop color inkjet printers	300 ppi	180 ppi	
Large-format inkjet printers	150 ppi	120 ppi	
Professional photo lab printers	300 ppi	200 ppi	
Desktop laser printers (black and white)	170 ppi	100 ppi	
Magazine quality — offset press	300 ppi	225 ppi	
Screen images (web, slide shows, video)	72 ppi	72 ppi	
Tablet devices and smart phones	150+ ppi	150 ppi	

Go Ahead — Make My Mode!

Regardless of what output you prepare your files for, you need to consider color mode and file format. In Chapter 3, we talk about RGB (red, green, and blue) color mode. This color mode is what you use to prepare color files for printing on your desktop color printer or to prepare files for photo service centers.

You can also use color modes other than RGB. If you start with an RGB color image, menu options in Elements enable you to convert to a different color mode. Photoshop Elements uses an *algorithm* (a mathematical formula) to convert pixels from one mode to another. In some cases, the conversion

that's made via a menu command produces good results, and in other cases, a method other than a menu command works better.

In the following sections, we introduce the modes that are available in Elements, discuss when changing an image's color mode can be useful, and explain how to convert from RGB to the mode of your choice: bitmap, gray-scale, or indexed color.

Another mode you may have heard of is CMYK. Although CMYK mode isn't available in Photoshop Elements, you should be aware of what it is and the purposes of CMYK images. CMYK, commonly referred to as *process color*, contains percentages of cyan, magenta, yellow, and black colors. This mode is used for commercial printing. If you design a magazine cover in Elements and send the file to a print shop, the file is ultimately converted to CMYK. Also note that most desktop printers use different ink sets within the CMYK color space.

Converting to Bitmap mode

Bitmap mode is most commonly used in printing line art, such as black-and-white logos, illustrations, or black-and-white effects that you create from your RGB images. Also, you can scan your analog signature as a bitmap image and import it into other programs, such as the Microsoft Office applications. If you're creative, you can combine bitmap images with RGB color to produce many interesting effects.

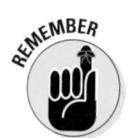

One important thing to keep in mind is that when you combine images into single documents you need to convert bitmap files to grayscale or color if you want to merge the images with an RGB image. If you convert to grayscale, Elements takes care of converting grayscale to RGB mode.

As an example of an effect resulting from combining grayscale and color images, look over Figure 4-5. The original RGB image was converted to a bitmap and then saved as a different file. The bitmap was converted to grayscale and dropped on top of the RGB image. After adjusting the opacity, the result is a grainy effect with desaturated color.

You can acquire Bitmap mode images directly in Elements when you scan images that are black and white. Illustrated art, logos, your signature, or a copy of a fax might be the kinds of files you scan directly in Bitmap mode. Additionally, you can convert your images to Bitmap mode.

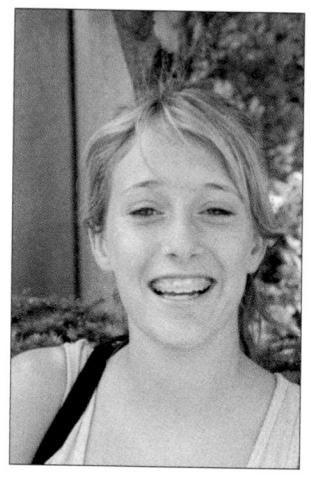

Figure 4-5: You can create some interesting effects by combining the same image from a bitmap file and an RGB file.

Converting RGB color to bitmap is a two-step process. You need to first convert to grayscale and then convert from grayscale to bitmap. If you select the Bitmap menu command while in RGB color, Elements prompts you to convert to grayscale first.

To convert from RGB mode to Bitmap mode, do the following:

- 1. In the Photo Editor workspace, open an image that you want to convert to Bitmap mode in either Expert or Quick mode.
- 2. Choose Image➪Mode➪Bitmap.

If you start in RGB mode, Elements prompts you to convert to grayscale.

3. At the prompt, if you see it, click OK.

The Bitmap dialog box opens and provides options for selecting the output resolution and a conversion method.

4. Select a resolution.

By default, the Bitmap dialog box, shown in Figure 4-6, displays the current resolution. You can edit the text box and resample the image or accept the default. See the section "The Art of Resampling," earlier in this chapter, for more on changing image resolutions.

5. From the Use drop-down menu, select a method for converting an RGB image to a bitmap image.

Your options are as follows:

- 50% Threshold
- Pattern Dither
- Diffusion Dither

Figure 4-6: Type a resolution for your output and select the conversion method from the Use drop-down menu.

Figure 4-7 shows the effect each method creates.

6. Click OK to convert your image to Bitmap mode.

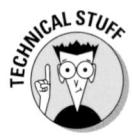

The Elements Bitmap mode isn't the same as the Windows .bmp file format. In Elements, Bitmap mode is a color mode. A Windows .bmp file can be an RGB color mode image, a Grayscale color mode image, or a Bitmap color mode image.

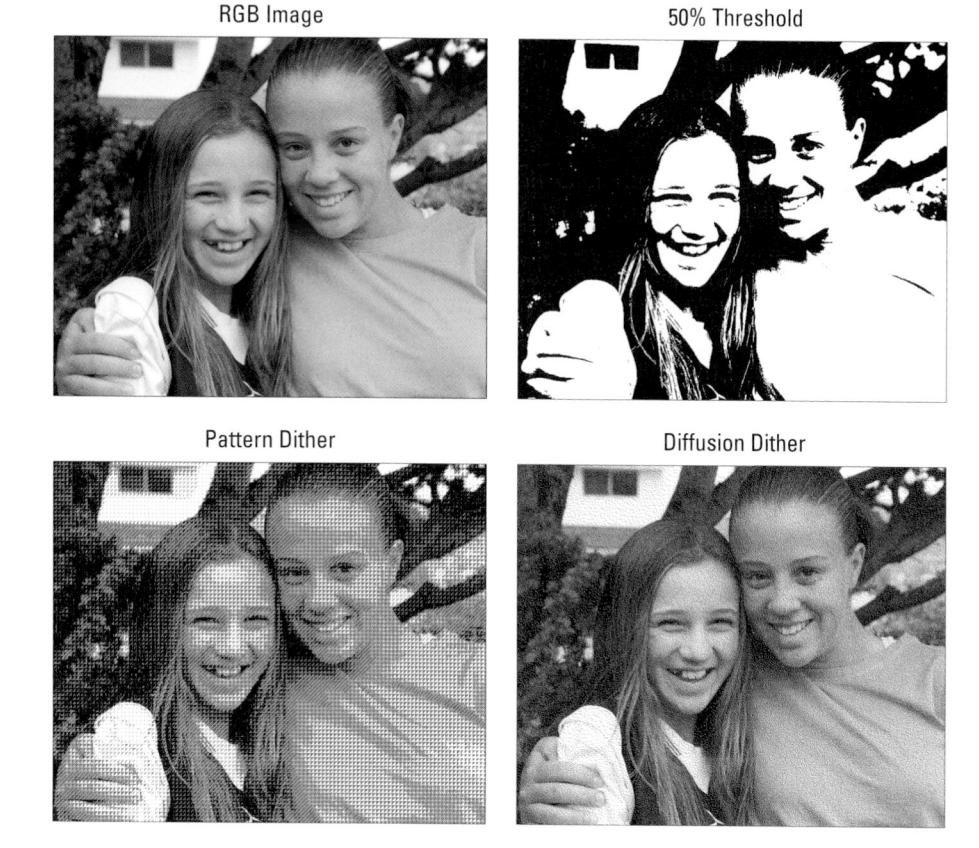

Figure 4-7: An original RGB image converted to bitmap by using 50% Threshold, Pattern Dither, and Diffusion Dither.

Converting to Grayscale mode

Grayscale images have black and white pixels and any one of an additional 254 levels of gray. By converting an RGB image to grayscale, you can make it look like a black-and-white photo.

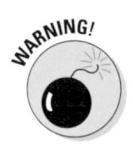

You can convert an image to grayscale in one of three ways, but remember that one of these methods isn't as good as the others. We recommend that you avoid converting to grayscale by choosing Image Mode Grayscale. When Elements performs this conversion, it removes all the color from the pixels, so you lose some precious data during the conversion and can't regain the color after conversion. If you were to convert an image to grayscale, save the file, and delete the original from your hard drive or memory

card, the color image would be lost forever. You could save a secondary file, but this method can add a little confusion and require some more space on your hard drive.

The following two sections explain better ways to create a grayscale image.

Desaturating a layer

You don't *have* to give up your color data, though. As an alternative to using the menu command for converting images to grayscale, follow these steps:

- 1. Open an RGB image in Elements.
- 2. Duplicate a layer.

The default Panels Bin contains the Layers panel. In this panel, you find a pop-up menu when you click the icon in the upper-right corner. From the menu commands, choose Duplicate Layer. (For more information on working with layers, see Chapter 8.). In this example we duplicated the layer, adjusted the duplicate layer, and duplicated again to create a third layer.

You can also duplicate a layer by dragging the layer name to the New Layer icon at the bottom of the Layers panel.

3. Choose Enhance Adjust Color Adjust Hue/Saturation to open the Hue/Saturation dialog box, shown in Figure 4-8.

Alternatively, you can press Ctrl+U (策+U on the Macintosh).

Drag the Saturation slider to the far left to desaturate the image on the selected layer, and click OK.

All color disappears, but the brightness values of all the pixels remain unaffected. (For more information on using the Hue/Saturation dialog box and the other Adjust Color commands, see Chapter 10.)

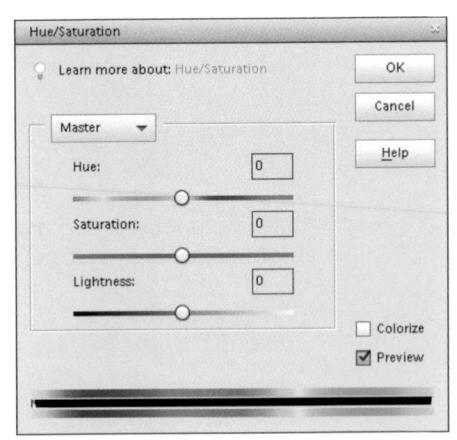

Figure 4-8: Open the Hue/Saturation dialog box and move the Saturation slider to the far left to eliminate color.

5. Turn off the color layer by clicking the eye icon in the Layers panel.

In the Layers panel, you see three layers, as shown in Figure 4-9. You don't need to turn off the color layer to print the file in grayscale, but turning it off can help you remember which layer you used the last time you printed or exported the file.

Following the preceding steps provides you with a file that contains both RGB and grayscale information. If you want to print the color layer, you can turn off the grayscale layer. If you need to exchange files with graphic designers, you can send the layered file, and then the design pro-

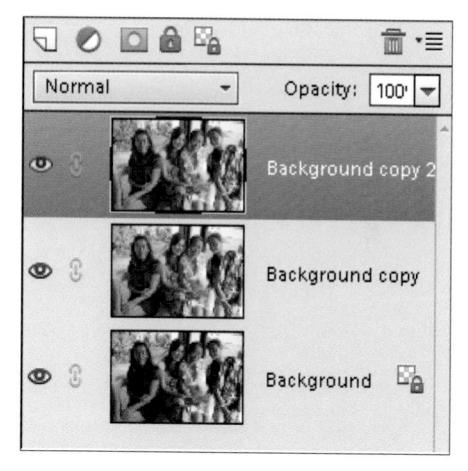

Figure 4-9: The Layers panel shows the grayscale and color layers. You can turn layers on or off by clicking the eye icon.

fessional can use both the color image and the grayscale image.

The other advantage of converting RGB color to grayscale by using the Hue/Saturation dialog box is that you don't disturb any changes in the brightness values of the pixels. Moving the Saturation slider to desaturate the image affects only the color. The luminance and lightness values remain the same.

Choosing the Convert to Black and White command

A menu command was introduced in Photoshop Elements 5 for converting color images to grayscale. Here's how it works:

1. Choose Enhance Convert to Black and White in either Expert or Quick mode.

You see the Convert to Black and White dialog box, as shown in Figure 4-10. This dialog box contains many controls for adjusting brightness and contrast in images that you convert to grayscale.

6

2. (Optional) Select from some preset options in the Select a Style list.

As you make adjustments, keep your eye on the dynamic preview in the After thumbnail area.

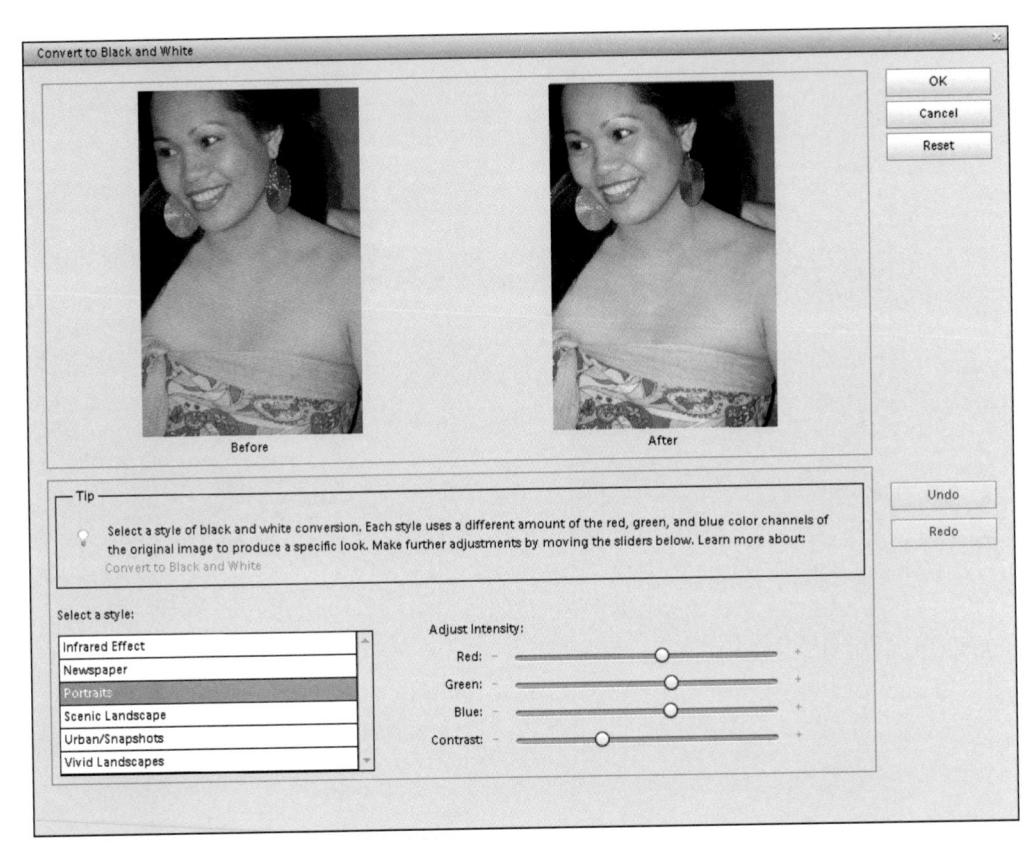

Figure 4-10: The Convert to Black and White dialog box.

- 3. (Optional) Move the sliders in the Adjustment Intensity area.
- 4. Click OK when you're done.

If you want to keep your original RGB image in the same file as the gray-scale version, duplicate the background by choosing Duplicate Layer from the Layers panel's More menu. Click the background and choose Enhance©Convert to Black and White. The conversion is applied only to the background, leaving the copied layer in your original color mode.

Converting to Indexed Color mode

Indexed Color is a mode you use occasionally with web graphics, such as saving in GIF or PNG-8 format. When saving indexed color images, sometimes you can create smaller file sizes than RGB that are ideal for using in website designs (because the smaller the file size, the faster a page downloads to the visitor's browser).

RGB images in 24-bit color (8 bits per channel) are capable of rendering a palette of 16.7 million colors, as we explain in Chapter 3. An indexed color image is an 8-bit image with only a single channel. The total number of colors you get with indexed color can be no more than 256. When you convert RGB images to indexed color, you can choose to *dither* the color, which displays the image with an effect much like what you see with bitmapped images. (See the section "Converting to Bitmap Mode" earlier in this chapter for more on diffusion dithering.) This dithering effect makes the file appear as though it has more than 256 colors, and the transition between colors appears smoother than if no dithering was applied.

On occasion, indexed color images have an advantage over RGB images when hosting the images on web servers: The fewer colors in a file, the smaller the file size. When you prepare images for web hosting, you can choose to use indexed color or RGB color. Whether you choose one over the other really depends on how well the image appears on your monitor. If you have some photos that you want to show on web pages, you should use RGB images and save them in a format appropriate for web hosting, as we explain in the section "Saving files for the web," later in this chapter.

If you have files composed of artwork, such as logos, illustrations, and drawings, you may find that the appearance of index colors is no different from the same images in RGB mode. If that's the case, you can keep the indexed color image and use it for your web pages.

To convert RGB images to indexed color, choose Image♥Mode♥Indexed Color; the Indexed Color dialog box opens. A number of different options are available to you, and fortunately, you can preview the results while you make choices. Get in and poke around, and you can see the options applied in the image window.

Saving Files with Purpose

Photoshop Elements files can be saved in a variety of different formats. Some format types require you to convert a color mode before the format can be used. Therefore a relationship exists between file formats and saving files. Additionally, bit depths in images also relate to the kinds of file formats you can use when saving files.

Before you go too far in Elements, become familiar with file formats and the conversions that you need to make in order to save in one format or another. If you do nothing to an image in terms of converting modes or changing bit depth, you can save a file after editing in the same format in which the file was opened. In many circumstances, you open an image and prepare it for some form of output, which requires more thought about the kind of file format you use when saving the file.

Using the Save/Save As dialog box

In most any program, the Save (or Save As) dialog box is a familiar place where you make choices about the file to be saved. With Save As, you can save a duplicate copy of your image, or save a modified copy and retain the original file.

To use the Save (or Save As) dialog box, choose File

Save for files to be saved the first time, or choose File

Save As for any file, and a dialog box then opens.

As a matter of good practice when you open an image, choose File Save As for your first step in editing a photo. Save with a new file name to make a copy then proceed to edit the photo. If you don't like your editing results, you can return to the original unedited photo and make another copy for editing.

The standard navigational tools you find in any Save dialog box appear in the Elements Save/Save As dialog box. Here are some standard options you find in the Elements Save/Save As dialog box:

- ✓ Filename. This item is common to all Save (Windows) or Save As (Macintosh) dialog boxes. Type a name for your file in the text box.
- Format. From the drop-down menu (pop-up menu on a Macintosh), you select file formats. We explain the formats supported by Elements in the section "Understanding file formats," later in this chapter.

A few options make the Photoshop Elements Save/Save As dialog box different from other Save dialog boxes that you might be accustomed to using. The Save Options area in the Save As dialog box provides these choices:

- ✓ **Include in the Elements Organizer.** If you want the file added to the Organizer, select this check box. (For more information about using the Organizer, see Chapter 1.)
- ✓ Save in Version Set with Original. You can edit images and save a version of your image, but only in Quick mode. When you save the file from Quick mode, this check box is enabled. Select the box to save a version of the original, which appears in the Organizer.
- Layers. If your file has layers, clicking this check box preserves the layers.
- ✓ **As a copy.** Use this option to save a copy without overwriting the original file.
- ✓ Color. Select the box for ICC (International Color Consortium) Profile. Depending on which profile you're using, the option appears for sRGB or Adobe RGB (1998). When the check box is selected, the profile is embedded in the image. See Chapter 3 for more information on profiles.
- Thumbnail (Windows only). If you save a file with a thumbnail, you can see a miniature representation of your image when viewing it in folders or on the desktop. If you select Ask When Saving in the Saving Files preferences, the check box can be enabled or disabled. If you select an option for Never Save or Always Save in the Preferences dialog box, this box is enabled or disabled (grayed out) for you. You need to return to the Preferences dialog box if you want to change the option.
- Use Lower Case Extension (Windows only). File extensions give you a clue to which file format was used when a file was saved. Elements automatically adds the extension to the filename for you. Your choices are to use uppercase or lowercase letters for the extension name. Select the check box for Use Lower Case Extension for lowercase or deselect the check box if you want to use uppercase characters in the filename.

Saving files for the web

When you want to prepare photos for web browsers and for onscreen viewing such as interactive PDF files, you can optimize the images for the web by choosing the File⇔Save For Web command. After you open a file in the Photo Editor in Expert mode and choose the command, the Save For Web dialog box opens, as shown in Figure 4-11. In this dialog box, you see your original image on the top — and the result of making changes for file format and quality settings on the bottom.

The standard rule with web graphics is to find the smallest file size for an acceptable image appearance. In the Save For Web dialog box, you have many choices for reducing file size. Notice in Figure 4-11 that you see the original image with the file size reported below the image on the top. After choosing JPEG for the file type, you can see that the image size is reduced from the original 410K to 10.84K.

From the drop-down menu, you can make choices for the file type from JPEG to GIF, PNG-8, or PNG-24. You can also use the Quality item that appears to the right of the drop-down menu to adjust the final quality of the saved file.

For photographs we refer to as continuous tone images, JPEG or PNG-24 are most often your best choices. If you experiment and view the result of making changes in the drop-down menu for other file types, be certain to zoom in on the image by clicking the Zoom tool in the Tools panel on the left, or simply use the keyboard shortcuts Ctrl+plus key to zoom in and Ctrl+minus key to zoom out (\Re +plus key and \Re +minus key on the Macintosh). In the lower-left corner of the dialog box, you can choose zoom levels from the pop-up menu or just type a value in the field box. For the most accurate viewing, set the zoom size to 100 percent. If there is any loss of image quality, it is easily discernable when viewing at a 100 percent view.

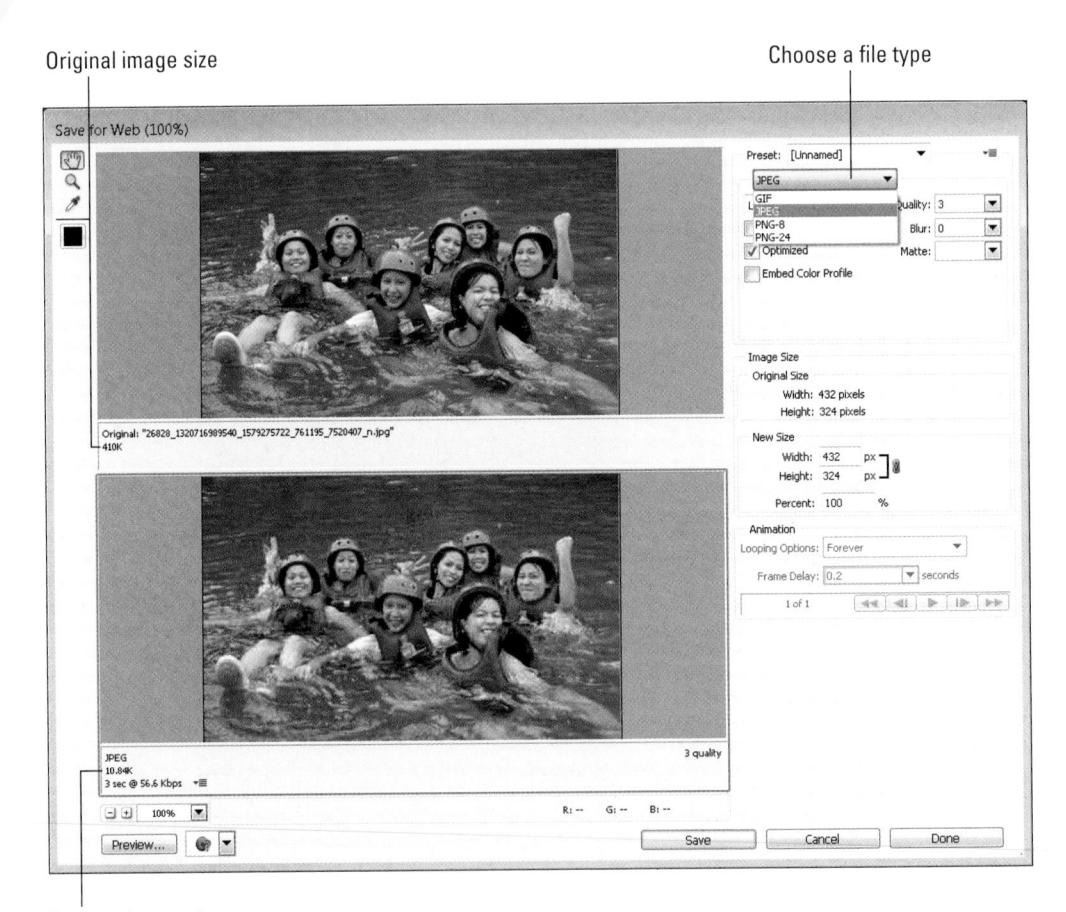

Reduce image size

Figure 4-11: In the Photo Editor with a file open, choose File Save For Web to open the Save For Web dialog box.

If you have an image with just a few colors such as a logo, try the GIF or PNG formats. If you need transparency in an image, then you need to use either GIF or PNG-24. Quite often you'll find PNG-24 results in the best-looking image.

Working in the Save For Web dialog box is a matter of making choices and viewing the results. Toggle the different file type choices and make adjustments for quality. If you see image degradation, change to a different quality setting or file format. Always look at the file-size item reported below the image on the right and try to find the lowest file size that produces a good-looking image.

Understanding file formats

When you save files in Elements, you need to pick a file format in the Format drop-down/pop-up menu found in both the Save and Save As dialog boxes.

When you choose from the different format options, keep the following information in mind:

- ✓ File formats are especially important when you exchange files with other users. Each format has a purpose, and other programs can accept or reject files depending on the format you choose.
- Whether you can select one format or another when you save a file depends on the color mode, the bit depth, and whether layers are present. If a format isn't present in the Format drop-down/pop-up menu when you attempt to save a file, return to one of the edit modes and perform some kind of edit, such as changing a color mode or flattening layers, in order to save the file in your chosen format.

Elements provides you a long list of file formats, many of which are outdated. What is important is to know the essentials and what you're likely to use in your editing sessions. Although many different file formats are available, you'll want to use only a few. Figure 4-12 shows the open Format drop-down menu you see in the Save or Save As dialog box.

Figure 4-12: The drop-down menu of file formats that Elements supports.

In the following sections, we explain the most common formats you will typically use.

Photoshop (*.PSD, *.PDD)

This format is the native file format for both Photoshop and Photoshop Elements. The format supports saving all color modes and bit depths, and you can preserve layers. Use this format when you want to save in a native format or exchange files with Photoshop users. Also use it for saving files that you need to return to for more editing. When you save layers, any text you add to layers can be edited when you return to the file. (See Chapter 13 for more information on adding text to an image.)

BMP (*.BMP, *.RLE, *.D]B)

The term *bitmap* can be a little confusing. You have both a file format type that's bitmap and a color mode that's bitmap. Don't confuse the two. The bitmap *format* supports saving in all color modes and in all bit depths. The Bitmap *color mode*, which we cover in the section "Converting to Bitmap mode," earlier in this chapter, is 1-bit black-and-white only.

Use the bitmap format when you want to add images to system resources, such as wallpaper for your desktop. Bitmap is also used with many different programs. If you can't import images in other program documents, try to save them as BMP files.

CompuServe GIF (*.GIF)

Barb was a college coed, and Ted had a mustache and wore a green leisure suit when CompuServe was the host for our e-mail accounts. We exchanged files and mail on 300-baud modems. Later, in 1977, CompuServe developed GIF (Graphics Interchange Format) to exchange files between mainframe computers and the ever-growing number of users working on Osborne, Kaypro, Apple, and Radio Shack TRS-80 computers.

If you choose to use the GIF format, don't save the file using the File

Save or File

Save As command. Instead, choose File

Save For Web, as we explain earlier in the section "Saving files for the web."

Photo Project Format (*. PSE)

Use this option when you create a project in Elements and want to save the file as a project. See Chapter 16 for more on creating projects.

IPEG (*.IPG, *.JPEG, *.JPE)

JPEG (Joint Photographic Experts Group) is perhaps the most common file format now in use. JPEG files are used with e-mail attachments and by many photo labs for printing files, and they can be viewed in JPEG viewers and directly in web browsers. Just about every program capable of importing images supports the JPEG format. Creative professionals wouldn't dream of using the JPEG format in design layouts, but everyone else uses the format for all kinds of documents.

You need to exercise some caution when you're using the JPEG format. JPEG files are compressed to reduce file size, so you can scrunch an image of several megabytes into a few hundred kilobytes. When you save a file with JPEG compression, however, you experience data loss. You might not see this on your monitor, or it might not appear noticeably on photo prints if you're using low compression while preserving higher quality. However, when you save with maximum compression, more pixels are tossed away, and you definitely notice image degradation.

When you save, open, and resave an image in JPEG format, each new save degrades the image more. If you need to submit JPEG images to photo labs for printing your pictures, keep saving in the Photoshop PSD file format until you're ready to save the final image. Save in JPEG format when you want to save the final file for printing, and use a low compression with high quality.

When you select JPEG for the format and click Save, the JPEG Options dialog box opens, as shown in Figure 4-13. You choose the amount of compression

by typing a value in the Quality text box or by moving the slider below the Quality text box. The acceptable range is from 0 to 12-0 is the lowest quality and results in the highest compression, and 12 is the highest quality that results in the lowest amount of compression.

Notice that you also have choices in the Format Options area of the JPEG Options dialog box. The Progressive option creates a progressive JPEG file commonly used with web browsers. This file type shows progressive quality while the file downloads from a website. The image first appears in a low-quality view and shows higher-resolution views until the image

Figure 4-13: When saving in JPEG format, choose the amount of compression you want to apply to the saved image.

appears at full resolution when it's completely downloaded in your browser window.

Photoshop PDF (*.PDF, *.PDP)

Adobe PDF (Portable Document Format) is designed to maintain document integrity and exchange files between computers. PDF is one of the most popular formats and can be viewed in the free Adobe Reader program available for installation on your Elements CD installer or by downloading it from the Adobe website.

PDF is all over the place in Elements. When you jump into Organize mode and create slide presentations, cards, and calendars, for example, you can export your documents as PDF files. When you save in Photoshop PDF format, you can preserve layers and text. Text is recognizable in Adobe Reader (or other Acrobat viewers) — and can be searched by using the Reader's Find and Search tools.

PDF files can be printed, hosted on websites, and exchanged with users of Windows, Macintosh, Unix, and Linux. All in all, this format is well suited for all the files you create in Elements that contain text, layers, and transparency, and for when you want to exchange files with users who don't have Elements or Photoshop.

Pixar (*.PXR)

This format is used for exchanging files with Pixar workstations. In all likelihood, you may never use this format.

PNG (*.PNG)

PNG (Portable Network Graphics) is another format used with web pages. PNG supports all color modes, 24-bit images, and transparency. One disadvantage

of using PNG is that color profiles can't be embedded in the images, like they can with JPEG. An advantage, however, is that PNG uses lossless compression, resulting in images without degradation.

PNG is also an option in the Save For Web dialog box we describe in the section "Saving files for the web." Use the File Save For Web command to export your photos as PNG.

TIFF (*.TIF, *.TIFF)

TIFF (Tagged Image File Format) is the most common format used by graphic designers. TIFF is generally used for importing images in professional layout programs, such as Adobe InDesign and QuarkXPress, and when commercial photo labs and print shops use equipment that supports downloading TIFF files directly to their devices. (*Note:* Direct downloads are used in lieu of opening a Print dialog box.)

Inasmuch as creative professionals have used TIFF for so long, a better choice for designers using a program such as Adobe InDesign is saving in the native Photoshop PSD file format. This requires a creative professional to save only one file in native format without bothering to save both native and TIFF formats.

TIFF, along with Photoshop PSD and Photoshop PDF, supports saving layered files and works in all color modes. When you save in TIFF format, you can also compress files in several different compression schemes, and compression with TIFF files doesn't lose data unless you choose a JPEG compression.

When you select TIFF for the format and click Save in the Save/Save As dialog box, the TIFF Options dialog box opens, as shown in Figure 4-14.

In the Image Compression area, you have these choices:

NONE. Selecting this option results in no compression. You use this option when sending files to creative professionals for creating layouts in programs such as Adobe InDesign. (None of the three compression schemes listed next aft)

Figure 4-14: Choose TIFF from the Format dropdown menu and click Save to open the TIFF Options dialog box.

mended for printing files to commercial printing devices.)

- ∠ LZW. This lossless compression scheme results in much lower file sizes without destroying data.
- ✓ ZIP. ZIP is also a lossless compression scheme. You can favor ZIP compression over LZW when you have large areas of the same color in an image.
- JPEG. JPEG is lossy and results in the smallest file sizes. Use JPEG here the same as when you apply JPEG compression with files saved in the JPEG format.

Leave the remaining items in the dialog box at defaults and click OK to save the image.

File formats at a glance

Although we've been working with Photoshop (which saves in the same formats listed in this section) since 1989, we have never used all the formats available in Photoshop Elements. At most, you'll use maybe three or four of these formats.

You don't need to remember all the formats and what they do. Just pick the ones you use in your workflow, mark Table 4-4 for reference, and check it from time to time until you have a complete understanding of how files need to be prepared in order to save them in your desired formats. If you happen to receive a file from another user in one of the formats you don't use, come back to the description in this chapter when you need details about what the format is used for.

Table 4-4 Fi	File Format Attributes Supported by Photoshop Elements				
Format	Color Modes Supported	Embed Profiles* Supported	Bit Depth Supported**	Layers Supported	
Photoshop PSD, PDD	Bitmap, RGB, Index, Grayscale	Yes	1, 8, 24, H	Yes	
ВМР	Bitmap, RGB, Index, Grayscale	No	1, 8, 24, H	No	
CompuServe GIF***	Bitmap, RGB, Index, Grayscale	No	1, 8	No	
JPEG	RGB, Grayscale	Yes	8, 24	No	

(continued)

Format	Color Modes Supported	Embed Profiles*	Bit Depth Supported**	Layers Supported
		Supported		
Photoshop PDF	Bitmap, RGB, Index, Grayscale	Yes	1, 8, 24, H	Yes
Pixar	Bitmap, RGB, Index, Grayscale	No	1, 8, 24, H	No
PNG	Bitmap, RGB, Index, Grayscale	No	1, 8, 24, H	No
TIFF	Bitmap, RGB, Index, Grayscale	Yes	8, 24, H	Yes

^{*} Embedding profiles is limited to embedding either sRGB IEC61966-2.1 or AdobeRGB (1998).

Audio and video formats supported in Elements

In addition to the image formats listed in Table 4-4, Elements supports audio and video files. The support is limited to adding and viewing audio and video files in the Organizer and printing the first frame in a video file. Other kinds of edits made to audio and video files require special software for audio and video editing.

Audio files can be imported in slide shows, as we explain in Chapter 15. The acceptable file formats for audio files are MP3, WAV, QuickTime, and WMA. If you have audio files in another format, you need to convert the file format. For these kinds of conversions, you can search the Internet for a shareware audio-conversion program.

Video files can also be imported in slide shows, as we discuss in Chapter 15. Elements supports the WMV (Windows) and Apple QuickTime (Macintosh) video formats. As with audio files, if videos are saved in other formats (too numerous to mention), you need to convert the video format to a format acceptable to Elements. For video-conversion utilities, you can also find shareware and freeware programs to do the job. Search the Internet for a video converter.

^{**} The letter H in Column 4 represents higher-bit modes, such as 16- and 32-bit images, which you might acquire from scanners and digital cameras. See Chapter 5 for more information on higher-bit images.

^{***} CompuServe GIF doesn't support saving layers, although it supports saving layers as frames. You use the frames when creating an animated GIF file to be used for web pages.

Part II Managing Media

"I've got the red-eye reduction, I'm just seeing if there's a button that'11 fix your hair."

In this part . . .

n this second part of the book, we elaborate more on using the Organizer. Managing files and keeping your media well organized helps you quickly locate media you want to use for editing, sharing, and making creations.

In this part, we talk about finding your media using a vast array of search and find techniques. We also cover a number of viewing options you have in the Organizer and how to create albums to further help you organize your media.

Tagging Photos and Creating Albums

In This Chapter

- Creating and organizing keyword tags
- Working with albums

If you read this book in a linear fashion, you know we first introduced the Organizer where we talked about adding photos to the Media Browser, then we moved on and discussed editing photos in the Photo Editor. In this chapter we jump back to the Organizer and cover many features you have for managing and organizing your photos. You need some photo management skills so you can easily find photos you want to edit in the Photo Editor, add photos to a new creation, or share the photos with friends and family.

Downloading a bunch of media cards filled with photos and leaving them in folders distributed all over your hard drive is like having a messy office with papers stacked haphazardly all over your desk. Trying to find a file, even with all the great search capabilities we cover in Chapter 6, can take you as much time as sorting through piles of papers. What you need is a good file-management system.

In this chapter, we talk about tagging photos, organizing and annotating files, creating versions and stacks, creating photo albums, and performing other tasks to help you quickly sort through large collections of photos to easily find images you want to use in your editing sessions. Be certain to take some time to understand the organizational methods that Elements offers, keep your files organized when you copy them to your hard drive, and back up files to CDs or DVDs. The time you invest in organizing your pictures helps you quickly locate files when you need them.

Although the Organizer wasn't always available to Mac users, now Macintosh users can take full advantage of all the Organizer tools and methods in Photoshop Elements 9 and above. This chapter, of course, focuses on how the tools work in Photoshop Elements 11.

Touring the Organizer Window

In Chapter 1, we talk about some of the tasks you can perform using the Elements Organizer, but we don't give you an overall view of the Organizer and the various panels associated with it. Therefore, we begin this chapter about more Organizer tasks by first offering a glimpse at the Organizer workspace.

Figure 5-1 shows you an Organizer view. The various items in the Organizer include the following:

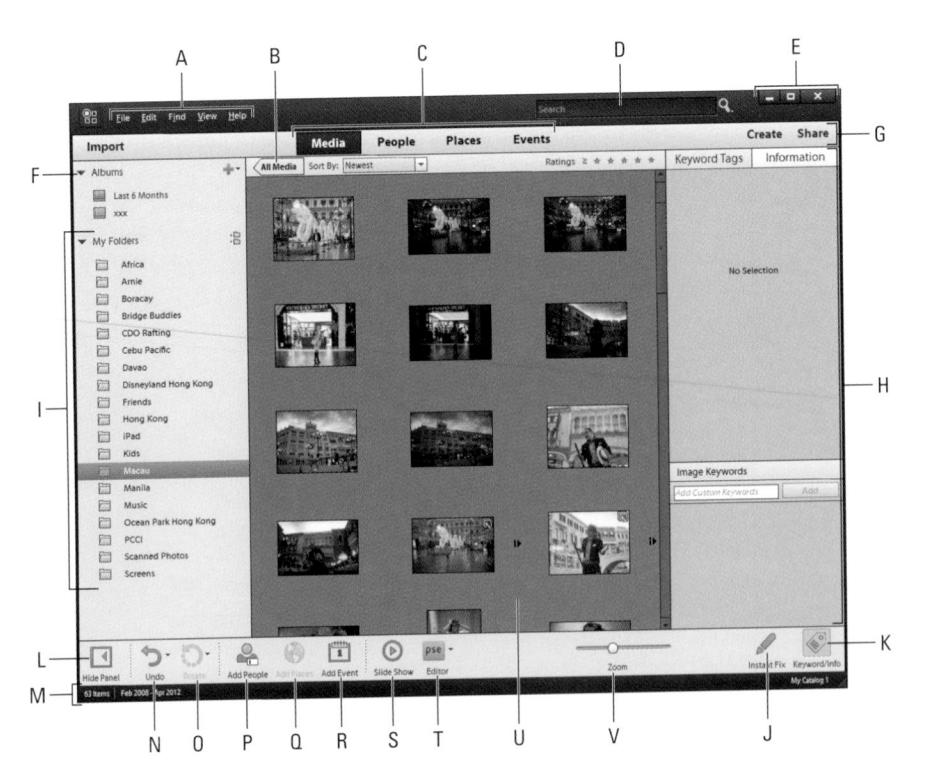

Figure 5-1: The Organizer workspace.

- **A. Menu Bar.** The Organizer menus appear in the top-left section of the menu bar. On Windows, the menus belong to the application. On the Macintosh, the menu bar is part of the operating system's menus.
- B. All Media/Sort By. When you click a folder as you see in item I, the thumbnail images shown in the Media Browser (item U) display only those photos within the selected folder. In Figure 5-1 you see the Macau folder selected. Click the All Media button and you leave the selected folder and see all photos from all folders in the Media Browser. Adjacent to the All Media button is a drop-down menu where you can sort the thumbnails in the Media Browser according to Newest, Oldest, and Batches of photos that you imported.
- **C. Media/People/Places/Events.** At the top of the Organizer window you find four tabs.
 - **Media.** The first tab is Media. Click the Media tab to display thumbnails of photos either in a folder or in the entire catalog. (See Chapter 1 for more on catalogs).
 - **People.** Click this tab to display photos where you have tagged the faces as we discuss in Chapter 1.
 - Places. Click this tab and a Google map appears in the Panel Bin. Geospatial mapping was available in Elements 9 with Yahoo! but disappeared in Elements 10. Now in Elements 11 you can tag photos according to map coordinates, using Google maps. You use the Add Places button (item Q) to tag an image with a place on the map. See Chapter 6 for more on adding places.
 - Events. Click this tab to display photos that have been tagged as Events. To tag a photo with an event, use the Add Event button (item R). See Chapter 6 for more on Events.

We talk more about tagging photos later in this chapter in the section "Organizing Groups of Images with Keyword Tags."

- **D. Search.** Any photos you have tagged with keywords can be searched. Type the search criteria such as the name of a person you have tagged with the People tag in the text box, and then press Enter/Return or click the magnifying-glass icon.
- **E. Features buttons.** In Windows you find buttons for Maximize, Minimize, and Close in the top-right corner of the Organizer. On the Macintosh, these buttons appear in the top-left corner.
- **F. Albums.** When you create albums (as we explain in the section "Creating Albums" later in this chapter), your albums appear at the top of the left panel.

- **G. Create/Share.** The Create and Share panels open when you choose an item from the drop-down menu. Click either Create or Share and select a menu item. The workspace then changes and displays options for making a creation or sharing files. For more information on making creations, see Chapter 16. For more information on sharing photos, see Chapter 15.
- H. Panel Bin. Within the Panel Bin you find various panels that are docked in the Panel Bin. By default you see Keyword Tags, Information, and Image Keywords. The section "Organizing Groups of Images with Keyword Tags" (later in this chapter) has details about using the panels.
- **I. My Folders.** If you read Chapter 1, this panel should be familiar to you. You import photos in the Organizer and the photos are organized by folders.
- J. Instant Fix. Click this button, and you see the same panel open in the Organizer that opens in when you select Quick mode in the Photo Editor. We explain Quick mode in Chapter 2. The nice thing about having the Quick mode options in the Organizer is that you don't need to open files in the Photo Editor to apply some edits to your photos.
- K. Keyword/Info. Click this button while the Keyword Tags panel is open, and the Panel Bin is dismissed. Click again and you display the Panel Bin.
- **L. Hide Panel.** Click this button, and you hide the left panel. If you click this button and the Keyword/Info button (item K) you can hide both panels. Doing so provides you a maximum viewing area for the photo thumbnails.
- M. Status Bar. The bottom of the Organizer window provides you information. From left to right, you see the number of items in your catalog, the date you created the catalog, and on the far right you see the name of your catalog.
- N. Undo/Redo. Click the tiny arrow and a pop-up menu displays Undo and Redo. Choose an item to undo or redo your last action.
- **O. Rotate.** Click the arrow and you can choose to rotate a photo clockwise or counterclockwise. To use either tool, you must first select a thumbnail in the Media Browser.
- P. Add People. In Chapter 1 we talk about adding people when you import photos in the Media Browser. Elements does a nice job of recognizing people but it has a hard time with profile shots, tilted heads, and photos where people are not easily recognized.
 - Double-click a photo to zoom into it and click the Add People button. A new rectangle appears in the photo that you can move to position and add a name.

- **Q. Add Places.** When you click Add Places, a window opens atop the Organizer window. A film strip appears at the top of the window displaying files currently shown in the Media Browser. Below the filmstrip is a large map where you can assign map locations to the photos you select in the filmstrip.
- **R.** Add Event. Add Event is yet another item that helps you organize your photos. You can add tags for people, places, and then events to help narrow down a large collection of photos. Each of these items can be sorted by clicking the respective tab at the top of the Organizer window.
- **S. Slide Show.** Slide Show provides you an onscreen view of all the photos you have open in the Media Browser. You can sort photos according to tags, click Slide Show, and sit back and watch the photos scroll on your computer monitor.
- T. Editor. Click to return to the Photo Editor.
- U. Media Browser. Shows thumbnail displays of your images.
- V. Zoom. Adjust the slider to see thumbnails larger or smaller.

This overall description of the Organizer can be helpful when you perform tasks related to the Organizer. Earmark this page and use it as a reference to quickly identify items contained in the Organizer window.

Organizing Groups of Images with Keyword Tags

Elements provides you with a great opportunity for organizing files, in the form of keyword tags. After you acquire your images in the Organizer, as we discuss in Chapter 1, you can sort them out and add keyword tags according to the dates when you took the pictures, the subject matter, or some other categorical arrangement.

In the Organizer window, the Keyword Tags panel helps you sort your pictures and keep them well organized. You use the Keyword Tags panel to identify individual images by using a limitless number of options for categorizing your pictures. On this panel, you can create keyword tags and collection groups to neatly organize files.

In the following sections, you can find out how to create and manage keyword tags.

Creating and viewing a keyword tag

To create a new keyword tag and add photos to the tag, follow these steps:

1. Open photos in the Organizer.

See Chapter 1 for more on opening images in the Organizer.

2. To create a new keyword tag, click the plus (+) icon in the Keyword Tags panel to open a drop-down menu, and then choose New Keyword Tag. Alternatively, you can press Ctrl+N (第+N on the Macintosh) to create a new keyword tag.

The Create Keyword Tag dialog box opens, as shown in Figure 5-2.

3. Specify a category.

Click the Category drop-down menu and choose one of the preset categories listed in the menu. (See the next section for instructions on customizing these categories.)

4. Type a name for the tag in the Name text box and add a note to describe the keyword tag.

You might use the location where you took the photos, the subject matter, or other descriptive information for the note.

Click OK in the Create Keyword Tag dialog box.

You return to the Organizer window.

In the Organizer window, select the photos to which you want to add keyword tags.

Click a photo and Shift-click another photo to select photos in a group. Click a photo and Ctrl-click (#-click on the Macintosh) different photos scattered around the Organizer window to select nonsequential photos.

7. To add a new keyword tag to a photo (or selection of photos), click one of the selected photos in the Organizer window and as the Plus symbol in the Keyword Tags panel shown in Figure 5-3.

Alternatively, you can drag a tag to the selected photos.

When you release the mouse button, the photos are added to the new keyword tag.

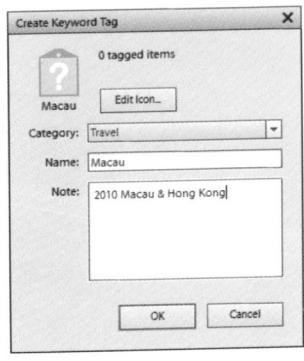

Figure 5-2: The Create Keyword Tag dialog box.

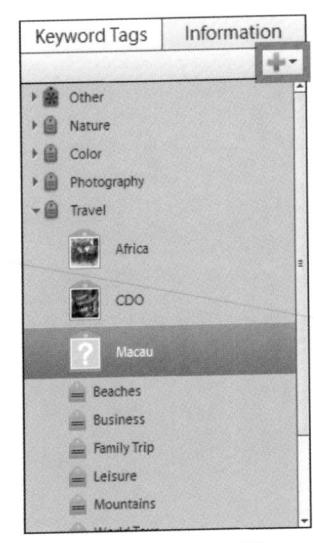

Figure 5-3: The Keyword Tags panel after adding a keyword tag.

8. Repeat Steps 2 through 5 to create keyword tags for all the images you want to organize.

Adding icons to keyword tags

Notice, in Figure 5-3, that the new tag in the Keyword Tags panel appears empty without an icon. The other tags in the panel have a mini image inside the tag icon. If you want to add an image to the tag icon, you can handle it in a few ways. Perhaps the most reliable is to edit the tag as follows:

- 1. Open a contextual menu on a tag in the Keyword Tags panel and choose Edit.
- 2. When the Edit Keyword Tag dialog box opens, click Edit Icon.

At this point the Edit Keyword Tag Icon dialog box opens. The dialog displays the total number of images that are tagged with the current tag, a button to Import an image for the icon, and left and right arrows to permit you to scroll through all the images and choose one for an icon as shown in Figure 5-4.

- 3. Select an image for the tag icon.
- 4. (Optional) Crop the image by moving handles on the rectangle displayed in the Edit Keyword Tag Icon dialog box.
- 5. Click OK when you finish editing the icon.

The icon is displayed in the Keyword Tags panel.

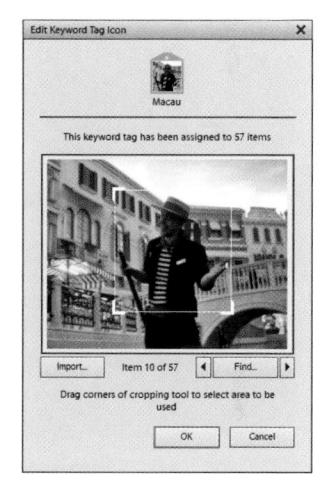

Figure 5-4: The Edit Keyword Tag Icon dialog enables you to add or change a tag icon.

Working with custom keyword tags

We refer to Custom Keyword Tags as those tags you create in the Keyword Tags panel. Elements offers you a number of tags that you can use to tag your photos, and these tags we refer to as the default tags. In this section we look at creating and editing custom tags.

You can manage keyword tags by using menu commands from the Keyword Tags panel drop-down menu (click the down arrow adjacent to the Plus icon) and other commands from a contextual menu that you open by right-clicking a keyword tag on the Keyword Tags panel.

In the Keyword Tags panel drop-down menu, you can access these commands:

- ✓ New Keyword Tag. Create a new keyword tag, as we describe in the steps in the preceding section.
- ✓ New Sub-Category. A subcategory is like a nested bookmark. Create a subcategory by selecting New Sub-Category from the New menu; a dialog box opens, prompting you to type a name for the new subcategory. As

- an example of how you would use keyword tags and subcategories, you might have a keyword tag named Uncle Joe's Wedding. Then, you might create subcategories for Bride Dressing Room, Ceremony, Family Photos, Reception, and so on.
- ✓ New Category. Choose New Category to open a dialog box that prompts you to type a name for the new category. By default, you can find predefined category names for People, Places, Events, and Other. If you want to add your own custom categories, use this menu command.
- ✓ **Edit.** Click Edit and the Edit Keyword Tag dialog box opens. This dialog appears exactly the same as the Create Keyword Tag dialog box shown earlier in Figure 5-2.
- Import Keyword Tags From File. If you export a keyword tag, the file is written as XML (eXtensible Markup Language). When you choose From File, you can import an XML version of a keyword tags file.
- Save Keyword Tags to a File. You can save keyword tags to a file that you can retrieve with the Import Keyword Tags from File command. This option is handy when you open a different catalog file and want to import the same collection names created in one catalog file to another catalog file. (See Chapter 1 for more information.)
- Collapse All Keyword Tags. Keyword tags appear like bookmark lists that can be collapsed and expanded. An expanded list shows you all the subcategory keyword tags. Choose Collapse All Keyword Tags to collapse the list.
- Expand All Keyword Tags. This command expands a collapsed list.

When you create a new keyword tag, you see a large icon in the Keyword Tags panel. The default tags appear with small icons. You can access the items that appear below default tags by clicking the right-pointing arrow to expand the list.

Keyword tags are saved automatically with the catalog you work with. By default, Elements creates a catalog and automatically saves your work to it. If you happen to create another catalog, as we explain in the next section, your keyword tags disappear. Be aware of which catalog is open when you create keyword tags in order to return to them.

Working with default keyword tags

When you create a custom tag, you can modify its appearance. With the default tags that Elements provides, you can make some changes to the tags' appearances, but in limited ways. For example, you cannot add a custom image for the tag icon. You can also modify the names for the preset tags and you can add some custom subcategories.

To edit a preset category tag, follow these steps:

1. On one of the predefined categories, open a context menu and choose Edit.

The Edit Category dialog box opens as shown in Figure 5-5.

- 2. Click the Change Color button to change the color of the tag icon.
- 3. To choose an icon for the preset category, move the scroll bar horizontally and click the icon you want to use.

You are limited to the images Elements provides you for displaying icons on the predefined categories.

4. Click OK when you're done.

Figure 5-5: The Edit Category dialog enables you to make some changes to the tag icon.

Working with keyword tag sub-categories

A Category tag is at the top of the tag hierarchy. Below a category or sub-category, you can add additional sub-categories. For example, you may want to create a Holiday category tag and below it you may want to add several different holidays such as Valentine's Day, Groundhog Day, Independence Day, and so on. The Category tag you create is limited to the same conditions you have with the default Category tags. You cannot use custom icons, and you are restricted to using the icons provided by Elements as shown in Figure 5-6. Here's how to add a new category and sub-category:

- 1. From the Keyword Tags panel drop-down menu (Plus icon) choose New Category.
- 2. Provide a name and choose a color and icon for the appearance in the Create Category dialog box.
- 3. After creating a new category, choose New Sub-Category from the Keyword Tags panel drop-down menu.
- 4. In the Create Sub-category dialog box, provide a Sub-Category name.
- 5. Click OK and continue until you create all the subcategories you want.

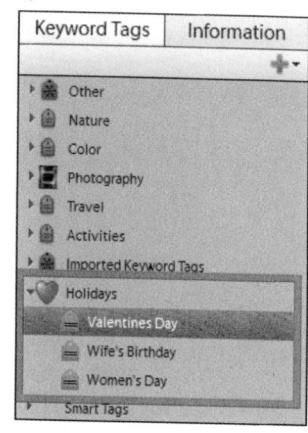

Figure 5-6: A new Category Tag with three Sub-Category tags.

Notice that you do not have options for creating custom icons nor do you have choices for adding icons provided by Elements. All the Sub-Category icons are predefined for you, as shown in Figure 5-6, where a new category and three subcategories appear on the Keyword Tags panel.

Creating Albums

With keyword tags, you can organize files into categories and subcategories, which help keep your files neatly organized within a catalog. Elements offers additional organizing control in the Albums panel. You might want to organize an album for sharing photos with others on Photoshop Showcase (see Chapter 15 for more on Photoshop Showcase), assemble an album and rate each photo with a range of one to five stars, create a slideshow, or just use the Albums panel to further segregate images within different categories.

Think of a catalog as a parent item, and think of keyword tags albums as its children. Within keyword tags, you can use the sort options (discussed in Chapter 6) to sort files according to date. If you still have a number of files in an Organizer window that are hard to manage, you can create tags that form subcategories within the keyword tags. Additionally, you can create an album out of a number of photos within a given keyword tag. For example, say you have a huge number of photos taken on a European vacation, and all these photos are in your catalog. You can create keyword tags for photos according to the country visited. You then might rate the photos according to the best pictures you took on your trip. The highest-rated images could then be assembled in an album and viewed as a slideshow.

Rating images

You can rate photos in the Organizer by tagging images with one to five stars. You might have some photos that are exceptional, which you want to give five-star ratings, whereas poor photos with lighting and focus problems might be rated with one star.

Although rating photos according to stars is not new in Photoshop Elements, the location in the Organizer is newly labeled. In earlier versions of Elements, you accessed star ratings via the Properties panel. As you look at the Elements 11 interface, you see Information nested in the Panel Bin. Think of this panel as the former Properties panel.

Rating photos is handled in the Information panel. To assign a star rating to a photo, select a photo in the Media Browser and click a star in the Information panel as shown in Figure 5-7. One star is the lowest rating and five stars is the highest rating.

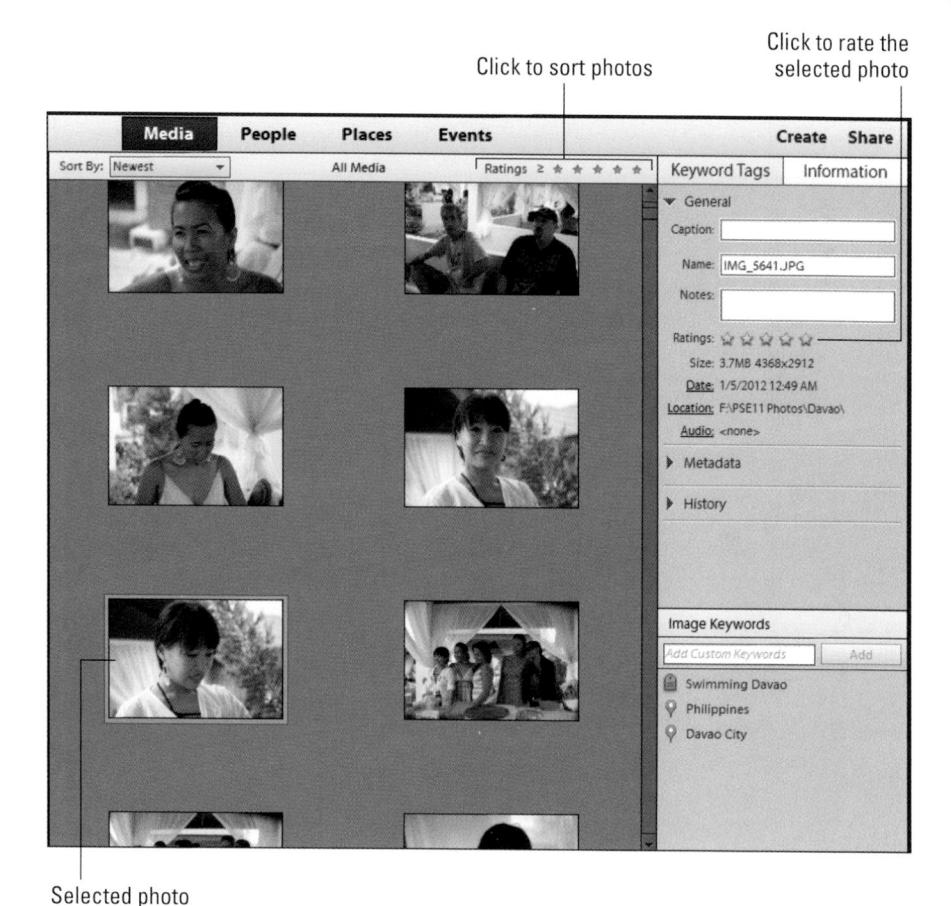

Figure 5-7: Rating photos with stars in the Information panel.

After you rate photos with star ratings you can sort photos according to a rating. For example, after you have photos rated with stars, click a star that appears in the Ratings at the top of the Media Browser (see Figure 5-7). If you click the third star, all photos rated with 3, 4, and 5 stars appear in the Media Browser. If you click the fifth star, only those photos rated with five stars appear in the Media Browser.

Be certain to click the star value in the Information panel when rating a photo with a star rating. If you click a star in the Ratings at the top of the Media Browser, Elements thinks you want to sort photos in the Media Browser according to star rating.

Adding rated files to an album

You might want to rate images with star ratings and then add all your images to an album. Within the album, you can still choose to view your pictures according to star ratings.

Creating an album

In the section "Organizing Groups of Images with Keyword Tags," earlier in this chapter, we discuss how creating keyword tags and assigning tags to photos helps you organize a collection of photos and how subcategories help you break down a collection into additional categories. With albums and star ratings, you can further break down a collection into groups that you might want to mark for printing, sharing, or onscreen slideshows.

To create an album, follow these steps:

- Sort photos in the Media Browser to determine what photos you want to include in a new album.
- 2. Click the plus (+) icon next to Albums at the top of the left panel, as shown in Figure 5-8. From the drop-down menu, click New Album.

In our example, we clicked the third star to sort photos ranked with 3 or more stars.

Notice in Figure 5-8 you see the Albums menu on the left side of the Organizer window. When you create a new album, the remaining work you perform on an album such as naming the album, categorizing the album, adding content to an album, and sharing an album is all handled in the Panel Bin on the right side of the Organizer window. The location of the menu is different from earlier versions of Elements where the menu and the album options were all contained in the Panel Bin.

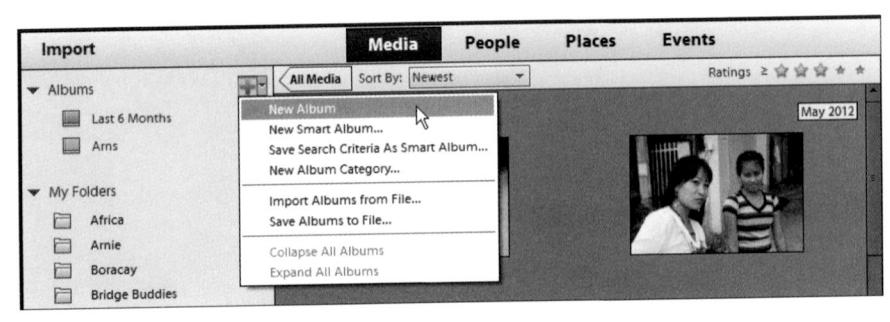

Figure 5-8: Click the plus (+) icon to open the drop-down menu and then choose New Album.

3. Name the new album.

In the Panel Bin, you see the Add New Album panel. Type a name for the album in the Album Name text box, as shown in Figure 5-9.

If you didn't sort files in Step 1, you can do so now or simply pick and choose which photos to add to the new album from photos appearing in your catalog.

4. Drag photos from the Media Browser to the Content tab in the Add New Album panel, as shown in Figure 5-9.

If photos are sorted and you want to include all photos in the Media Browser, press Ctrl+A/ૠ+A to Select All or choose Edit

Select All. Once the files are selected, drag them to the Content pane in the Add New Album panel (see Figure 5-9).

If you don't have files sorted, click one or more photos and drag them to the Content pane. Repeat dragging photos until you have all photos you want to include in your new album.

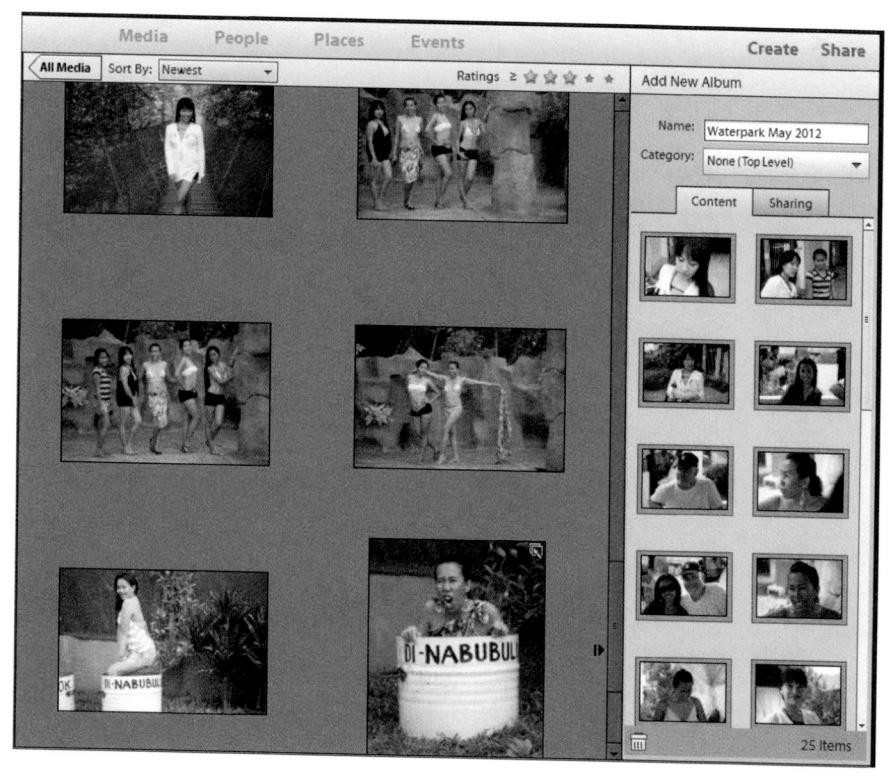

Figure 5-9: Drag photos to the items window in the Album Content panel.

5. Click Done at the bottom of the panel.

Your new album now appears listed in the Albums category on the Import panel.

That's it! Your new album is created, and the photos you dragged to the album are added to it. You can display all the photos within a given album in the Media Browser by clicking the album name in the Albums panel.

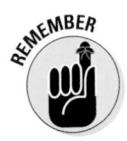

Creating multiple albums uses only a fraction of the memory that would be required if you wanted to duplicate photos for multiple purposes, such as printing, web hosting, sharing, and so on.

Using albums for temporary work

As you explore various features in Photoshop Elements, you may want to explore some of the creation and sharing items in the Create and Share panels. As you peruse the options, first create an album and add photos to it. Then proceed to explore the many features Elements offers you.

When you finish your exploration, right-click (or Ctrl-click on a Macintosh with a one-button mouse) to open a context menu and choose Delete <*album name*>. You can add an album for temporary work, and then delete the album when you no longer need it.

Editing an album

After creating an album you may want to change the album name, add more photos to an album, delete some photos from an album, change the album category, or some other kind of edit.

Your first step in performing any kind of edit to an album is to look at the left side of the Organizer window. In the Import panel you see a list of albums under the Albums category. To edit an album, open a context menu on an album name and choose Edit. After clicking Edit, the album appears in the Panel Bin on the right side of the Organizer window much like you see in Figure 5-9.

Other commands are available in the context menu you open from an album name in the Import panel. You can rename an album, delete an album, explore some export options, share an album, and add more media to your album.

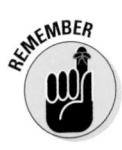

If you want to use the context menu commands, you must close the Add New Album panel in the Panel Bin. While this panel is open, you cannot open a context menu on an album name. Click either Done or Cancel to close the Add New Album panel in the Panel Bin.

Exploring album benefits

An album is a starting point for many exciting things you can do with a collection of photos. Here are examples of what you can do:

- Create albums and then share your albums with friends and family.
- Host albums online for others to view your photos.
- Write albums to CDs and DVDs (Windows only) that can be viewed on your television sets or show them off on an Apple TV or other device for television viewing.
- Save the albums as complete packages on your hard drive.
- Add templates to albums for professional touches.
- ✓ View albums as slideshows.

In short, albums help you assemble a collection of photos that can be viewed on many devices and shared with others.

In this chapter we want to introduce you to the wonderful world of albums and offer you methods for creating them. In Chapter 15, we talk about the many sharing opportunities you have with Elements and how to share your albums with others. Chapter 16 discusses how starting with an album benefits you in making a variety of wonderful creations.

Creating a Smart Album

What's the difference between an album and a Smart Album? Quite simply an album specifically contains images you choose to add to your album. Any additional images with similar tags, ratings, and other search criteria are not included in the album. A Smart Album starts when you define the image criteria you want to include; then as you tag or add new files with the same criteria, Elements automatically adds the photos to your Smart Album.

An example of a Smart Album might be some photos where you add a People tag. You create a Smart Album with the name of the individual you want to add to your album. As you tag additional photos with the same name, Elements automatically adds the new tagged photos to your Smart Album.

Look over the following steps to create a Smart Album:

 Open the New menu on the Albums panel and choose New Smart Album.

The New Smart Album dialog box opens, as shown in Figure 5-10.

To begin with in our example, we created a new Smart Album and added the People tag (as you see in Figure 5-10). We included the person named Arnie for this album. Several photos were tagged with Arnie's name.

If we want to add additional criteria such as some of the better photos of Arnie, we might add those photos of her that were tagged with 4 or more stars, also shown in Figure 5-10.

4. After making the criteria selections, click OK.

The Smart Album is added to the Import panel.

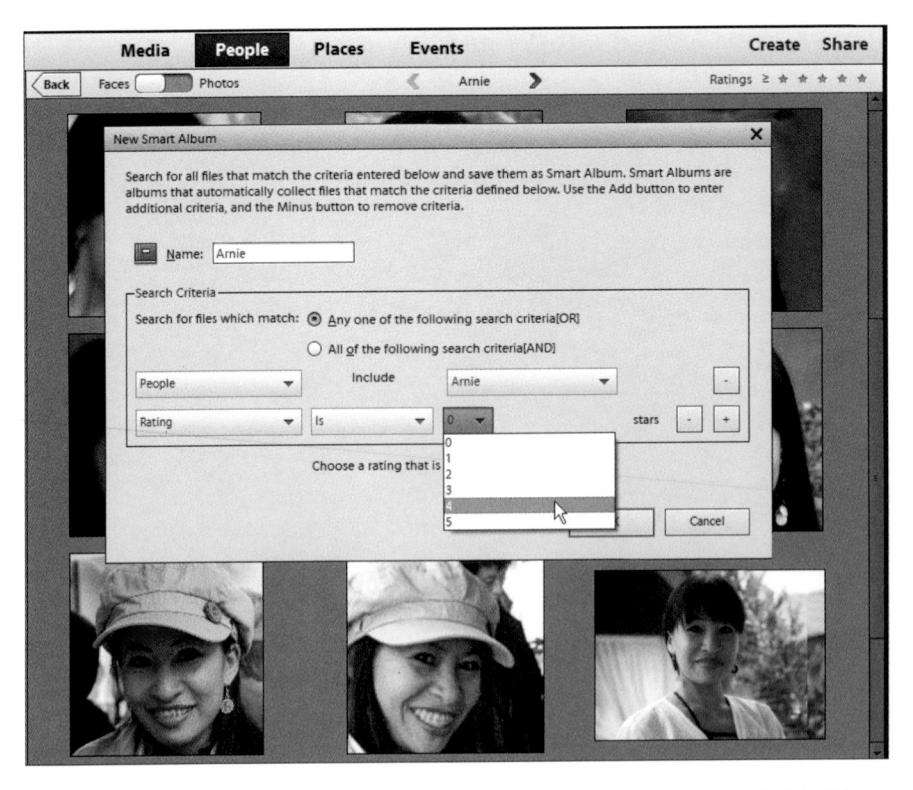

Figure 5-10: Type a name for your new Smart Album, add the search criteria, and click OK to add the album to the Albums panel.

Here's where the magic begins. As we search through our catalog and find photos of Arnie that have not been tagged with a people tag, we tag the photos. As each photo is tagged with Arnie's name, the photos are added to the Smart Album automatically. If we import new photos and tag some of the photos that show Arnie, those new photos are also added to our Smart Album.

There are many more sorting opportunities you have available in Elements. We explain some of them in Chapter 6. However, not all the available search criteria can be explained in this book. The best way to learn more about adding criteria when you are creating Smart Albums or narrowing down your searches is to poke around, experiment, and try out many of the options you have in the drop-down menu (under Filename) in the New Smart Album dialog box.

Viewing and Finding Your Images

In This Chapter

- Working with catalogs
- Viewing photos in the Organizer
- Mapping photos
- Creating Events
- Sorting photos
- Showing and hiding files

hapter 1 offers a brief glimpse of the Organizer and looks at a few different views; we continue our exploration of the Organizer in Chapter 5 with how to tag photos and create photo albums. In this chapter, we show you more Organizer features, look at sorting through volumes of photos in a catalog, and explain how to find files in many different ways.

Photo organization begins with adding images to a catalog. By default, the Organizer creates a new catalog for you. As your catalog grows with the addition of more files, you'll want to discover ways to search and use a given set of images for a project.

In this chapter, we begin by talking about catalogs and then look at how to view and organize your pictures in the Organizer and the Media Browser, and show how the many options help speed up your work in Photoshop Elements.

Cataloging Files

When you open files in the Organizer, all your files are saved automatically to a catalog. The files themselves aren't really saved to the catalog; rather, links from the catalog to the individual files are saved. *Links* are like pointers that

tell the catalog where to look for a file. When you add and delete files within the Organizer, the catalog is continually updated.

Your default catalog is titled *My Catalog* by the Organizer. As you add photos in the Organizer, your default catalog grows and may eventually store thousands of photos. At some point, you may want to create an additional catalog or many different catalogs to store photos. You may want to use one catalog for your family's and friends' photos and another for business or recreational activities. You may want to create separate catalogs for special purposes such as business, family, social networking, or other kinds of logical divisions.

Using the Catalog Manager

Catalogs are created, deleted, and managed in the Catalog Manager. To access the Catalog Manager, choose File⇔Catalog. The Catalog Manager opens, as shown in Figure 6-1.

To keep your photos organized and your catalog files small, you can start a completely new catalog before you import photos. Follow these steps:

- 1. Choose File Catalog and click the New button in the Catalog Manager dialog box, shown in Figure 6-1.
- 2. When the New Catalog dialog box opens, type a name for the new catalog in the File Name text box and then click Save.
- 3. (Optional) If you want to add the free music files that installed with Elements, select the Import Free Music into All New Catalogs check box.

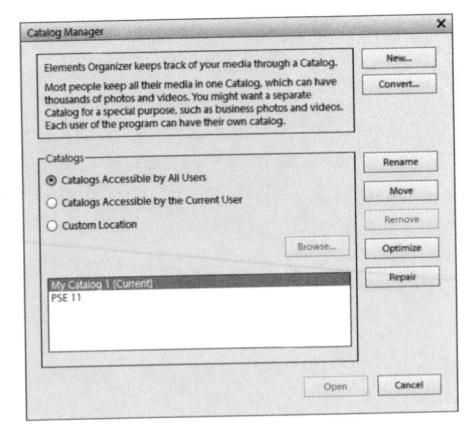

Figure 6-1: Choose File➪Catalog to open the Catalog Manager dialog box.

check box. The Organizer ships with free music files that you can use in a variety of projects. See Chapter 16 for more on making Creations.

4. Back in the Organizer window, choose File⇔Get Photos and Videos⇔From Files and Folders to add files to the new catalog.

When the Get Photos from Files and Folders dialog box opens, a list of media files appears in the dialog box when the Import Free Music into All New Catalogs check box is selected.

5. Navigate your hard drive and select the photos you want to add. After you identify all the files, click Open.

The selected music files and photos are added to your new collection of media contained in the catalog.

Working with catalogs

After you create different catalogs for your images, the following tips for working with catalogs will come in handy:

- Splitting a big catalog into smaller catalogs. Unfortunately, Elements doesn't provide you with a command to split large catalogs into smaller ones. It's best to understand first how you want to organize your photos before creating your first catalog. However, if you've created a large catalog and want to split it into two or more separate catalogs, you can manually add new photos to a new catalog and delete photos from the older catalog.
- ✓ **Switching to a different catalog.** When you need to open a different catalog file, choose File⇔Catalog and select the name of the catalog you want to open. Click Open at the bottom of the dialog box to open the selected catalog. The Organizer window changes to reflect files contained in that catalog.
- Fixing a corrupted catalog. Notice the Repair button in Figure 6-1. If you can't see thumbnail previews of images or open them in one of the editing modes, your catalog file might be corrupted. Click the Repair button to try to fix the problem.
- Improving catalog performance. When catalogs get sluggish, you might need to optimize a catalog to gain better performance. You should regularly optimize your catalog (by clicking the Optimize button in the Catalog Manager) to keep your catalog operating at optimum performance.

Backing up your catalog

Computer users often learn the hard way about the importance of backing up a hard drive and the precious data they spent time creating and editing. We can save you that aggravation right now, before you spend any more time editing your photos in Elements.

We authors are so paranoid when we're writing a book that we back up our chapters on multiple drives, CDs, and DVDs when we finish them. The standard rule is that if you spend sufficient time working on a project and it gets to the point that redoing your work would be a major aggravation, then it's time to back up files.

When organizing your files, adding keyword tags, creating albums, and creating stacks and version sets, you want to back up the catalog file in case it becomes corrupted. Fortunately, backing up catalogs is available to both Windows and Macintosh users; however, backing up to a CD or DVD from within Elements is only available on Windows.

Here's how you can use Elements to create a backup of your catalog:

1. Choose File⇔Backup Catalog to CD, DVD or Hard Drive (Windows) or File⇔Backup Catalog to Hard Drive (Macintosh) to open the Backup Catalog Wizard.

This wizard has three panes that Elements walks you through to painlessly create a backup of your files.

2. Select the source to back up.

The first pane in the Backup Catalog to CD, DVD or Hard Drive wizard offers two options, which you can see in Figure 6-2:

- Full Backup: Click this radio button to perform your first backup or write files to a new media source.
- Incremental Backup: Click this radio button if you've already performed at least one backup and you want to update the backed-up files.

3. Click Next and select Backup Catalog to CD, DVD, or Hard Drive a target location for your backed-up files.

Active drives, including CD/ DVD drives (on Windows) attached to your computer, appear in the Select **Destination Drive** list. Select a drive. and Elements automatically assesses the write speed and identifies a previous backup file if one was created. The total

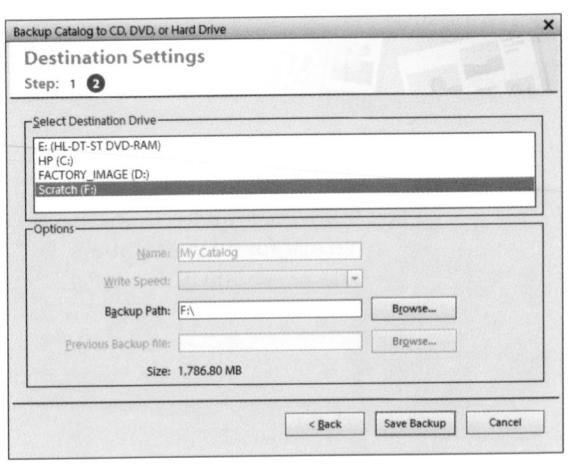

Figure 6-2: The wizard provides options for selecting the destination media for the backup.

size of the files to copy is reported in the wizard. This information is helpful so that you know whether more than one CD or DVD is needed to complete the backup (on Windows) or a backup drive has enough space to complete the backup.

 If you intend to copy files to your hard drive or to another hard drive attached to your computer, click the Browse button and identify the path.

If you use a media source, such as a CD or DVD (Windows only), Elements prompts you to insert a disc and readies the media for writing.

5. Click Done, and the backup commences.

Be certain to not interrupt the backup. It might take some time, so just let Elements work away until you're notified that the backup is complete.

Backing up photos and files (Windows)

With files stored all over your hard drive, manually copying files to a second hard drive, CD, or DVD would take quite a bit of time. Fortunately, Elements makes finding files to back up a breeze.

Choose File⇔Backup Catalog to CD, DVD, or Hard Drive and then, in the dialog box that opens, click the Full Backup radio button and click Next. Select a hard drive or a CD/DVD drive, type a name for the backup folder, and click OK. Elements goes about copying all files shown in the Organizer window to your backup source.

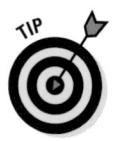

Macintosh users don't have an option for backing up photos from the Organizer to CDs or DVDs. On the Mac, you can create a burn folder in the Finder, select all photos in the Organizer window, and drag the selected files to the burn folder. Click Burn and the files are copied to a CD or DVD.

Backing up photos on a second hard drive

If you follow our advice from Chapter 1 and decide to use a large hard external drive just for all your photos, you need to purchase a second external drive for the backup. If your photos are precious and you want to protect them against a drive failure, it's well worth the expense of a second drive.

To back up content on a second drive, follow these steps:

- 1. Attach both external drives via USB ports.
- 2. Choose File⇔Backup Catalog to CD, DVD, or Hard Drive (Windows) or File⇔Backup Catalog to Hard Drive (Macintosh).
- 3. Click Next and select the target drive for the backup in the wizard.
- 4. Click Save Backup to begin the backup.

You can perform this operation before retiring at night and just let the computer do its work while you take this book to bed with you.

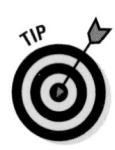

The Many Faces of the Organizer

The Organizer provides you several different viewing options. In Chapter 1, you learn about viewing files in the Media Browser and look at viewing recent imports and all files. You can also view files according to a timeline, a slide-show, view certain media types, and view places and events.

Using the View menu

In the View menu you have choices for sorting files that are displayed in the Media Browser. Some of the menu choices you have include

- ✓ Media Types. Choose View

 Media Types and look over the submenu. You can eliminate video, audio, and PDF by selecting the respective items if you want to view just photos in the Media Browser. Likewise you can eliminate photos and explore the other choices by checking/unchecking the submenu items.
- ✓ Hidden Files. If files are hidden, you can view all files by choosing View⇔ Hidden Files, and then choose (in the submenu) to view All Files, view Hidden Files, or (if files are in view) to hide Files.
- ✓ Details. By default, file details such as file creation dates and star ratings are hidden. You can show file details by choosing View

 Details or press Ctrl+D/#+D.
- File Names. By default, the filenames of the photos appearing in the Media Browser are hidden. You can show filenames by choosing View

 File Names.
- ✓ **Timeline.** Choose View Timeline and a horizontal bar opens at the top of the Organizer window. A slider appears on the bar that you can drag left and right to select a time when your photos were taken. In Figure 6-3, you can see the timeline, details, and filenames.

Viewing photos in a slideshow (Full Screen view)

Are you ready for some exciting viewing in Photoshop Elements? To take an alternative view of your Organizer files, you can see your pictures in a self-running slideshow (in Full Screen view), complete with transition effects and background music. Full Screen view takes you to a slideshow view. For the purposes of clarity, think of Full Screen view and viewing a slideshow as the same thing. Full-screen viewing temporarily hides the Elements tools and menus, and gives you the most viewing area on your monitor to see your pictures.

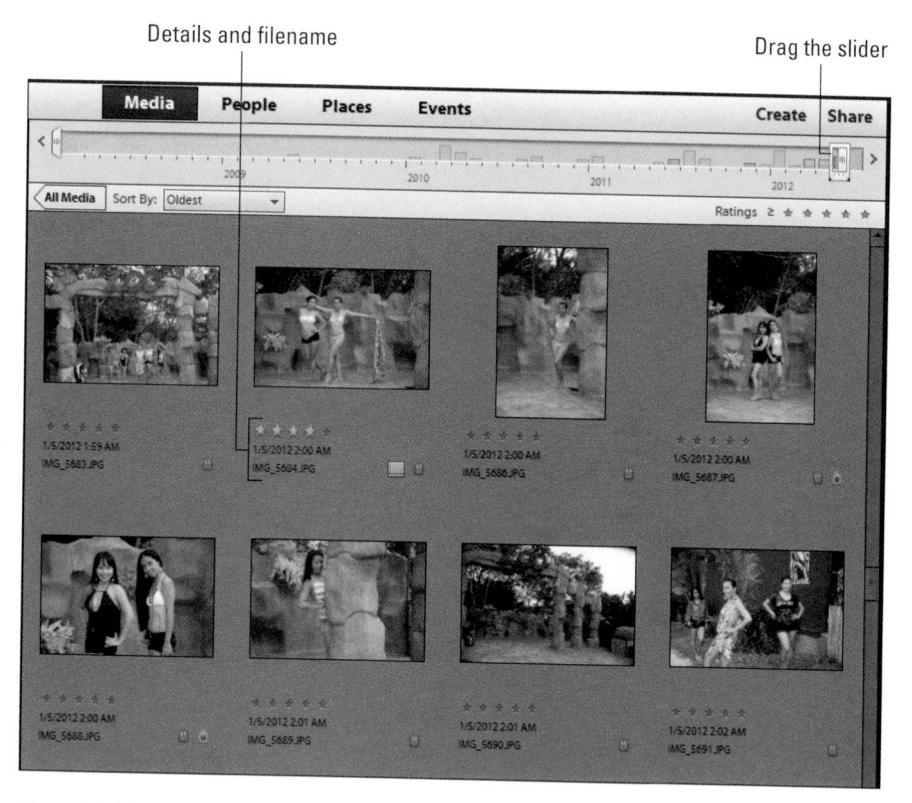

Figure 6-3: The Media Browser displaying a timeline, file details, and filenames.

Viewing files in slideshow mode can be helpful for quickly previewing the files you want to edit for all kinds of output, as well as for previewing photos that you might use for an exported slideshow, which we explain in Chapter 15.

Creating slideshows and outputting to a movie file is supported only on Windows. However, viewing slideshows in Elements is supported for both Windows and Macintosh users. Also both Windows and Mac users can create PDF slideshows as we explain in Chapter 16. The only limitation Macintosh users have is that they cannot export slideshows as movie files unless they have Premiere Elements installed.

Taking a quick view of the slideshow

To set up your slideshow and/or enter Full Screen view, follow these steps:

- 1. Open the Organizer.
- 2. Select images that you want to see in a slideshow or use all the images in the Organizer for your slideshow.

If no images are selected when you enter Full Screen view, all photos in the Organizer window are shown in Full Screen view.

3. Click the Slideshow button at the bottom of the Organizer window, or press the F11 key (#+F11 on the Macintosh).

After choosing the menu command, you jump right into the Full Screen view with some panels and tools displayed, as shown in Figure 6-4.

4. View the slides.

The slideshow swipes photos at an interval you can specify in the Settings. By default the photos change every 4 seconds. You can watch the slideshow or you can click the arrow keys at the bottom of the screen to move forward and back through the slides.

5. Exit the Full Screen view. Press the Esc key on your keyboard to return to the Organizer window.

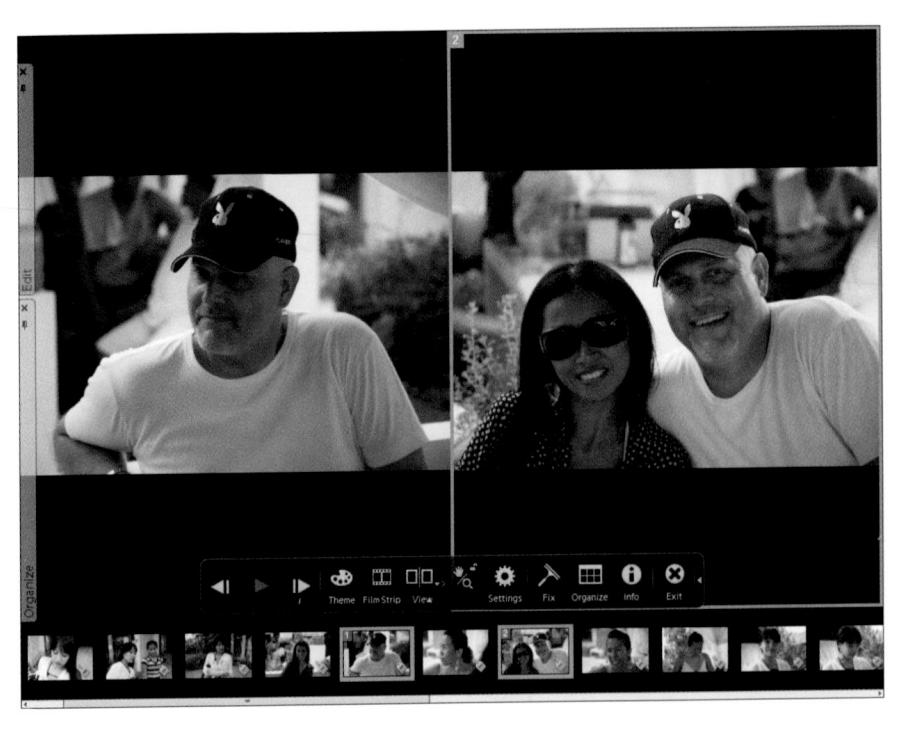

Figure 6-4: Elements takes you right to Full Screen view after you click Slideshow or press the F11 key (光+F11 on the Macintosh).
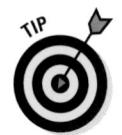

You can also open Full Screen view by choosing View Full Screen or press F11 (ૠ+F11 on the Macintosh). Opening the Full Screen view is the same as clicking the Slideshow button in the Organizer.

Working with the Edit and Organize tools

Full Screen and Slideshow views provide you with several editing tools. When you open selected photos from the Organizer in Full Screen or Slideshow view, you find two panels on the left side of the screen:

- The Edit panel provides Edit tools for editing photos, such as sharpening images and removing red-eye.
- ✓ The Organize panel permits you to add keyword tags for easily organizing photos. (See Chapter 5 for more on adding keyword tags to photos.)

The Edit tools

To open the Edit panel click the vertical tab on the left side of the Full Screen window or click the Fix button on the Slideshow toolbar. The Edit panel opens as shown in Figure 6-5.

Notice that as you move the mouse cursor over the tools, tooltips display the tool name. You can easily locate tools in the Edit panel and make image adjustments without leaving the Full Screen/Slideshow view.

Elements provides you many different editing options using the basic edit tools, and we cover each of the tools in Chapter 9.

The Organize tools

The other panel on the left side of the Full Screen/Slideshow window is the Organize panel.

Click Organize on the left side of the window to open the panel or click the Organize button on the Slideshow toolbar.

Figure 6-5: The Edit panel enables you to make image adjustments without leaving Full Screen view.

As you can see in Figure 6-6, this panel offers you choices for adding images to existing albums from the current images in the Full Screen/Slideshow view and you can tag photos with keyword tags. For more information on creating albums and keyword tags, see Chapter 5.

Using the Slideshow toolbar

The toolbar shown in Figure 6-4 offers the following options for slide viewing (from left to right):

- Previous Media. Click the left arrow to open the previous photo or other media.
- Play/Pause. Click to play or pause a slideshow.
- Next Media. Click the right arrow to advance to the next photo or other media.
- in earlier versions of Elements. When you enter Full Screen view, the Themes tool is selected, and when you click it, the Select Transition dialog box opens, as shown in Figure 6-7. Four different transition effects are displayed in the dialog box. You can preview a transition effect by placing the cursor over one of the images. When you find an effect you like, click the image and click OK to change the transition.

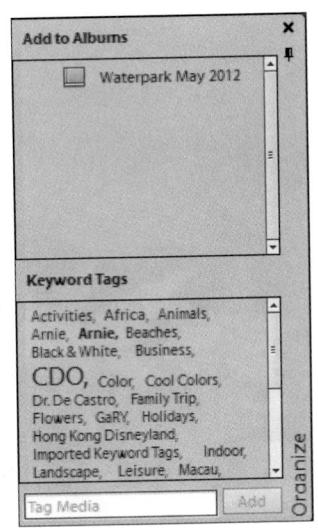

Figure 6-6: The Organize panel enables you to create albums and keyword tags.

- ✓ Filmstrip. Click this tool to show or hide the filmstrip that appears on the bottom of the Full Screen view.
- ✓ View. The View tool displays a popup menu when you click the tool. From the popup menu you have two choices: View media side by side, horizontally or vertically. Choosing either option splits the screen where two media items are shown. When

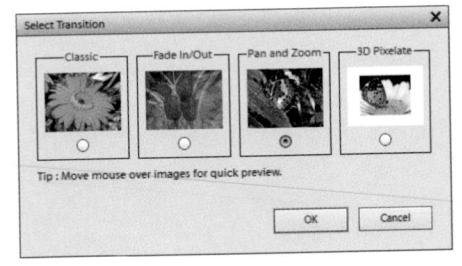

Figure 6-7: If you click the Theme tool, the Select Transition dialog box opens.

- one of these options is chosen you can return to the default for a view of a single item on screen by selecting the single monitor icon.
- Sync Panning and Zooming. This tool is only active when you view media side by side vertically or horizontally. Click the tool and both media items sync when panning and zooming.
- ✓ Settings. Click to open the Full Screen View Options dialog box, shown in Figure 6-8. Notice that you can choose a music file to play background music while viewing a slideshow, set the page durations, and display items such as captions.

- Fix. Click this tool to open the Edit panel.
- Organize. Click this tool to open the Organize panel.
- ✓ **Info.** Click this tool to open the Properties panel. This panel contains the same information and editing options as the Information panel we discuss in Chapter 1.

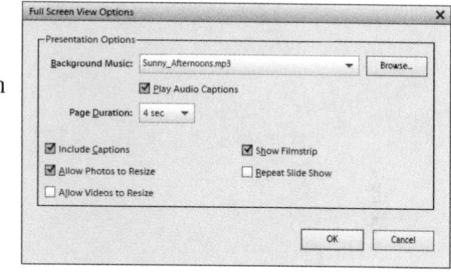

Figure 6-8: Click Settings and the Full Screen View Options dialog box opens.

- Screen view and return to the Organizer window. You can also press Esc to exit Full Screen view.
- Show All Controls (right arrow). Click the tiny right-pointing arrow on the right side of the toolbar, and the toolbar expands to reveal additional tools or collapse the panel and hides the Fix, Organize, and Info tools.

The main thing to keep in mind is that the Full Screen view is a temporary viewing option you have in Elements. It's not permanent. You use the view for a quick display method on your computer when you want to show off some photos to family and friends. Windows users have more permanent options for saving files as slideshows that they can share with other users, as we explain in Chapter 15.

Exploring more options in context menus

Notice that when you are in Full Screen view you lose the top-level menus. If you're wondering how you can add the slide images to an album or create a slideshow movie file (Windows only), you need a menu command. Because the menus are hidden, you must open a context menu in the Full Screen view.

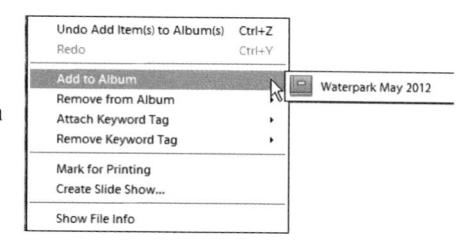

Figure 6-9: Open a context menu when in Full Screen view to access menu commands.

In a context menu you find options not available in the panels or the slideshow tools. Figure 6-9 shows a context menu opened in Full Screen view. You have menu commands for adding images to an existing album, Create Slide Show (Windows only), Mark for Printing, and several commands for working with keyword tags.

When in doubt, always look for commands and features by opening a context menu.

Comparing the Organizer on Windows and the Macintosh

As we said at the beginning of this chapter, the Macintosh version of Elements 9 introduced the Organizer. You have many great opportunities on the Macintosh for an assortment of tasks that were not available in earlier versions of Elements.

Unfortunately, not all the options available to Windows users are available to Macintosh users in the Organizer. The following list gives you a quick glance at the Organizer features the Windows version of Elements supports but that the Macintosh version does not and points you to more information about each feature:

- Burn data to CD/DVD. See "Backing up photos and files" section, this chapter.
- Create flipbooks. See Chapter 15.
- Create slideshows. See Chapter 15.
- ✓ HTML-based photo mail. See Chapter 15 and the Photoshop Elements Help document for information that goes into more depth than the chapter.
- **✓ Watched folders.** See Photoshop Elements Help document.

The reason you find differences between the features that are available on Windows and the Macintosh is because of significant technical issues related to the platform differences. There are some native supported OS features on Windows that are integrated with Elements.

Placing Pictures on Maps

You may take vacations to interesting places and want to sort photos according to the location where the photos were shot.

In earlier versions of Elements on Windows only you had support for placing photos on Yahoo! Maps. In Elements 10, the geospatial mapping features were omitted. Now, in Elements 11, we find placing photos on Google Maps supported on both Macintosh and Windows.

To see how easy placing photos on maps is, do the following:

1. Select a folder of photos in the Media Browser in the Organizer.

If you followed some of our recommendations in Chapter 1 for sorting photos in folders on your hard drive, you should have photos taken from various places sorted in individual folders. If not, you can simply view photos in the Media Browser in any sort order or view All Media.

2. Click the Add Places icon at the bottom of the Media Browser.

The Organizer window changes to the Add Places window as shown in Figure 6-10.

3. Search for a location.

Type the name of a location on the Google map that you want to assign photos. The Google map offers some suggestions in a drop-down menu below the location you type in the text box. Select the area on the map you want for assigning photos.

4. Select photos to assign to locations.

At the top, you can click individual photos and press Ctrl or \mathbb{H} and click to add more photos to a selection. If you want to add all photos to a given location, open the drop-down menu in the top-right corner and choose Select All (see Figure 6-10).

5. Click the Assign Location button.

The selected photos are now assigned to the specified location.

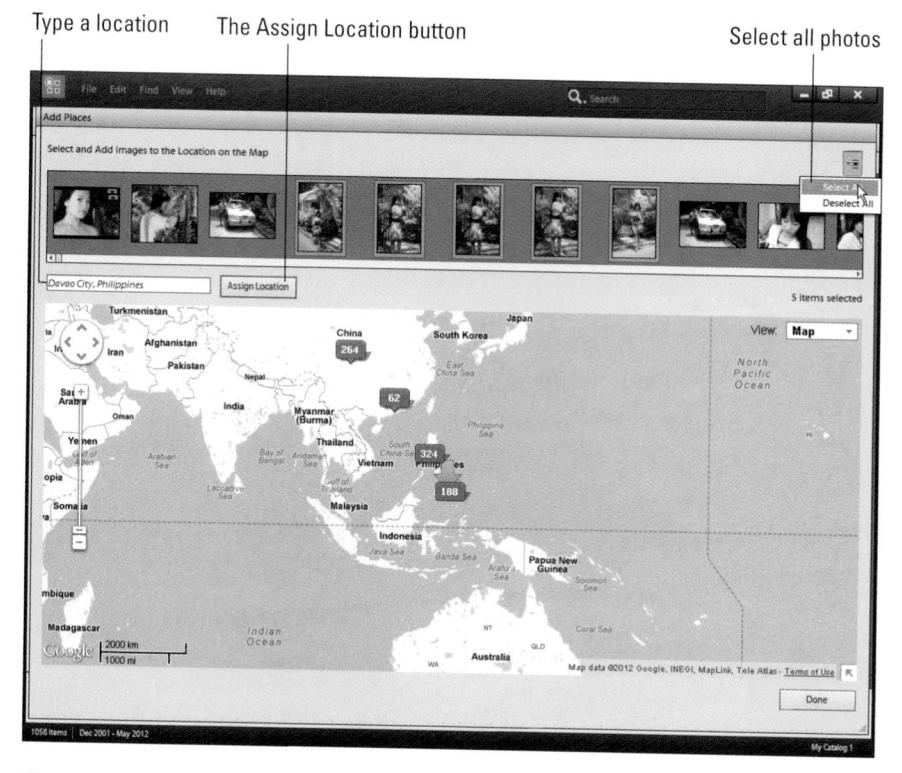

Figure 6-10: Click the Add Places icon at the bottom of the Media Browser to open the Add Places window.

Your first step is to assign photos to a location. Later, if you want to sort photos according to location, choose Find⇔Using Advanced Search. The Organizer window changes to the view you see later in this chapter in Figure 6-12. Notice the column for Places. All photos assigned to places are listed in this column. You can easily check the boxes to find photos assigned to a given place or check multiple boxes to find photos from several places.

Working with Events

You may have photos taken at special occasions or during holidays. You can add more to your Organizer management by assigning photos to different Events.

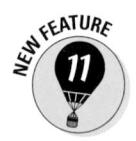

An Event can be any function of your choosing. To create an Event and assign photos to the Event, do the following:

1. Select Photos in the Media Browser in the Organizer.

You can select photos in folders, select from an All Media view, or use any sort order you choose.

2. Click the Add Event icon at the bottom of the Media Browser.

The Panel Bin changes to reveal options for naming an Event and assigning photos to the new Event.

- 3. Type a name for the event in the Event text field, as shown in Figure 6-11.
- 4. Choose dates for the event by clicking the calendar icons in the Panel Bin.
- 5. Type a description in the Description text box.
- 6. Add photos to the event.

Select all photos or individual photos and drag them to the Panel Bin, as shown in Figure 6-11.

7. Click Done.

The photos are now assigned to an event. To view events, click the Events tab at the top of the Organizer window. You see collections of photos if you added several Events with the first photo in the Event appearing on top. To view all photos, double-click the Event thumbnail you want to view.

Figure 6-11: Type an Event name, choose the start and end dates, type a description, and drag photos to the Panel Bin to assign photos to a new Event.

Using Search Options

With all the Photoshop Elements modes and workspaces, you need a consistent starting place to handle all your editing tasks. Think of the Organizer as Grand Central Station, from which you can take the Long Island Railroad to any destination you desire. In Elements terms, rather than head out to Port Washington, you travel to an editing mode. Rather than go to the Hamptons, you journey through all the creation areas. In short, the Organizer is the central depot on the Photoshop Elements map.

In addition to being a tool to navigate to other workspaces, the Organizer is a management tool you can use to organize, sort, search, and describe photos with identity information. In terms of sorting and organizing files, Elements provides many different options, and we cover them all in the following sections.

The Organizer's Find menu is devoted entirely to searching photos. From the Find menu, you can locate photos in collections, catalogs, and the Organizer window according to a variety of different search criteria.

To use the commands on the Find menu, you need to have photos loaded in the Media Browser, or create collections or catalogs. The categories in the following sections can be searched in the Organizer.

As you review various choices for finding photos, keep in mind that you don't necessarily need to use all the search options Elements provides. Look over the commands in the Find menu and familiarize yourself with a couple of options that suit your needs for finding files.

Using Advanced Search Options

Open the Find menu and the first menu command you see is Using Advanced Search. Choose this command and a row of items appear at the top of the screen displaying columns for Keywords, People, Places, and Events. If you tagged photos with keyword tags, added People Recognition, identified photos for Places and/or added Events, you find several check boxes that you can select as shown in Figure 6-12.

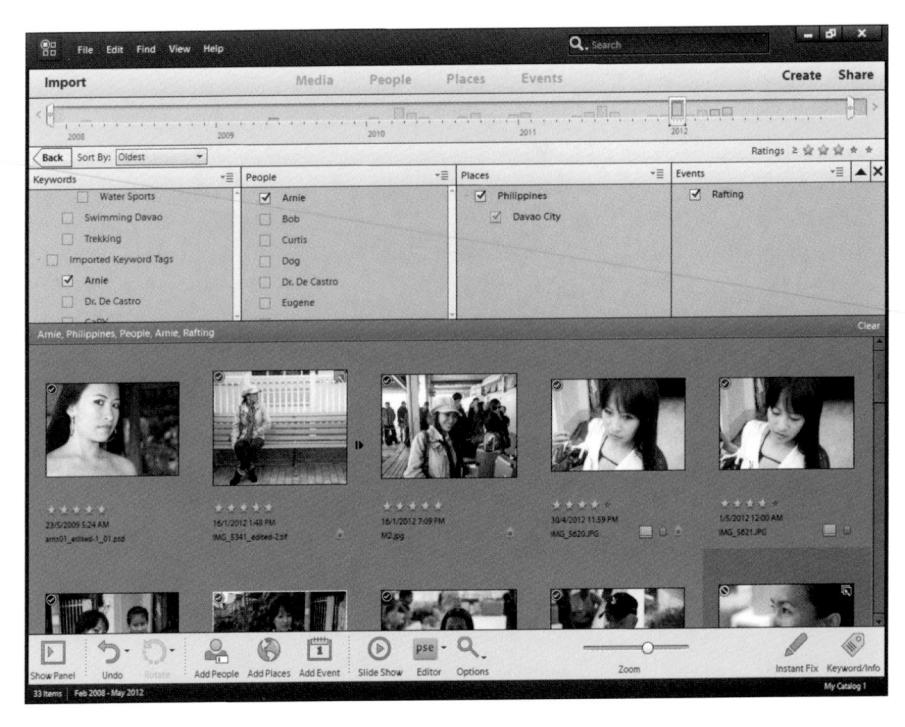

Figure 6-12: Open the Advanced Search Options and check the items you want to use in your search.

As you check boxes displayed in the Advanced Search Options, all media meeting the criteria are displayed in the Media Browser.

To provide more viewing area in the Media Browser, click the Hide Panel button in the lower left corner of the Organizer window. In Figure 6-12, you see the panel collapsed, and the Media Browser extends to the full horizontal width of the screen.

Searching by date

When you have a number of different files in a catalog from photos shot on different dates, you can narrow your search to find photos, and all other types of files supported by Elements, through a date search.

In the Organizer, the date is taken from the camera metadata; however, if a date isn't available from the camera data, the date is taken from the file creation date. The creation date isn't likely to be the date you shot the photo.

To search files by date in the Organizer, follow these steps:

1. Verify you have media added in the Organizer.

At this point we assume you have media added to a catalog. If you haven't added photos to your catalog yet, see Chapter 1 for details.

2. Select a date range by choosing Find⇔Set Date Range.

The Set Date Range dialog box opens, as shown in Figure 6-13.

3. Specify the dates.

In the Start Date area, type a year in the Year text box. Select the month and day from the Month and Day drop-down menus. Repeat the same selections for the end date.

Figure 6-13: Open the Set Date Range dialog box and specify the start and end dates.

4. Click OK.

The thumbnails shown in the Organizer window include only files created within the specified date range.

Searching for untagged items

You can tag files with a number of different criteria, as we explain in Chapter 5. When tags are added to images, you can sort files according to tag labels. We also cover sorting by tag labels in Chapter 5. For now, take a look at the Find menu and notice the Untagged Items command. If you haven't added tags to some items and want to show only the untagged files so that you can begin to

add tags, choose Find⇔Untagged Items or press Ctrl+Shift+Q on Windows or ૠ+Shift+O on the Macintosh.

Elements displays all files without tags in the Media Browser. This option is helpful when you want to locate files that meet criteria for different keyword tags. You can select photos and tag them with keyword tags that meet the criteria for tags you have created.

Searching captions and notes

Captions and notes are added in the Information panel. When captions or notes are added to files, you can search for the caption name, contents of a note, or both. To search caption names and notes, follow these steps:

1. Make sure you have media added to a catalog.

If you're adding files stored on your hard drive, choose File⇔ Get Photos and Videos⇔From Files and Folders.

2. Add captions and/or notes.

If you don't have any files tagged with captions or notes you need to add them in the Information panel. Open the Information panel and type captions and notes in the respective text boxes.

3. Choose Find⇔By Caption or Note.

The Find by Caption or Note dialog box opens, as shown in Figure 6-14.

4. In the Find Items with Caption or Note text box, type the words you want to locate and choose to match all or part of the word or words you typed.

Options in the dialog box are

Figure 6-14: In the Find by Caption or Note dialog box, specify search criteria.

- Match Only the Beginning of Words in Captions and
 - *Notes:* Click this radio button when you know that your caption or note begins with words you type in the text box.
- Match Any Part of Any Word in Captions and Notes: Click this radio button if you're not sure whether the text typed in the box is used at the beginning of a caption or note, or whether it's contained within the caption name or note text.

5. Click OK.

The Results appear in the Organizer window.

Searching by history

Searching *history* is searching for chronologically ordered information about operations performed on your media such as printing, e-mailing, sharing, and so on. Elements keeps track of what you do with your photos when you perform a number of different tasks. You can search for files based on their file history by choosing Find By History. Select the options you want on the By History submenu, and Elements reports files found on date searches that meet your history criteria.

Searching metadata

Metadata includes information about your images that's supplied by digital cameras, as well as custom data you add to a file. *Metadata* contains descriptions of the image, such as your camera name, the camera settings you used to take a picture, copyright information, and much more.

Metadata also includes some of the information you add in Elements such as keyword tags, albums, People tags, and so on. You can combine various metadata items such as keyword tags, camera make and model, *f*-stop, ISO setting, and so on in your search. This might be particularly helpful when you have photos taken during an event by several family members and friends. In this example, you might want to isolate only those photos taken with a particular camera model.

To search metadata, follow these steps:

1. Choose Find⇔By Details (Metadata) in the Organizer.

The Find by Details (Metadata) dialog box, shown in Figure 6-15, opens.

2. Choose to search for one of your criteria or all your criteria by selecting a radio button.

> The first two radio buttons in the dialog box offer choices for Boolean OR and Boolean AND. In other words, do you

Search Criteria					
Search for files whi	ch match:	O Any one of the	following search criteria[OR]		
			ring search criteria[AND]		
People	-	Include	Arnie	-	
Albums	•	Include	Waterpark May 2012	-	
Camera Make	·	Contains	Canon		
Camera Model	Ŧ	Contains	▼ 5D		
	The model	name or number of	the camera used to take the	nhata	
		Smart Album	are corners used to take the	photo	

Figure 6-15: Choose Find → By Details (Metadata) in the Organizer to open the dialog box in which metadata are specified.

want to search for an *either or item* or search for one item *and* another. The results can be quite different depending on the criteria you identify in the menus below the radio buttons.

3. Choose an item from the first menu (we used People in Figure 6-15) and then choose to include or exclude the item. How you fill in the third column depends on your selections in the first two columns.

Items are listed as menus in horizontal rows. The third column can be a menu or a text box, as you see in Figure 6-15.

4. (Optional) To add criteria (in our example, we use four items for our search), click the Plus (+) symbol.

Another row is added to the dialog box, and you select your choices as explained in Step 3.

5. After identifying your search criteria, click Search.

The media matching the criteria is shown in the Media Browser.

Searching similarities

We discussed tagging people in Chapter 1. Once you have people tagged, you can easily click the People tab at the top of the Organizer window and locate all people you have tagged.

Elements also provides you with the ability to search photos for visual similarities. You may have group shots, architecture, animal life, and so on, and want to search for photos where objects in the photos are visually similar.

To search for photos with visual similarities choose Find⇔By Visual Searches. From the submenu you can choose Visually similar photos and videos, Objects within photos, and Duplicate photos.

Searching duplicates

You may have a number of photos that are duplicates or the photos appear very close to duplicate images. You might want to locate duplicates or near duplicate images and delete some from your catalog or stack the photos (see "Stacking 'em up" later in this chapter). Searching for duplicates is a two-step process:

- 1. First, choose Find⇔By Visual Searches⇔Visually Similar Photos and Videos.
- 2. Then return to the Find⇔By Visual Searches menu and choose Duplicate Photos.

Photos that are visually similar appear in horizontal rows. In Figure 6-16 you can see one of the rows as it appeared after we performed a search. Notice the Stack button on the right side of the figure. Click Stack and the photos are stacked.

Figure 6-16: Elements search features can help you find duplicate photos.

If you want to delete photos, click a photo and click the Remove from Catalog button at the bottom of the window.

Searching objects

You may have objects in photos such as buildings, automobiles, trees, groups of people, and so on that you want to stack or delete. To search for objects:

- 1. Choose Find⇔By Visual Searches⇔Visually Similar Photos and Videos.
- 2. Search again and choose Objects within photos from the By Visual Searches submenu.

A rectangle appears for selecting a photo that contains the object you want to search.

- 3. Move the rectangle and resize it so it surrounds the object you're looking for, as shown in Figure 6-17.
- 4. Click Search Object and Elements displays its search results.

Figure 6-17: Mark the object you want to search and click Search Object.

Grouping Files That Get in the Way

Elements offers a few ways to organize images that are getting in the way. You can hide files, stack files, or create versions, as we explain the following sections.

Marking files as hidden

With a simple menu command, you can mark selected files in the Organizer as *hidden*. Select files you want to hide, and, from either the Edit menu or a contextual menu, choose Visibility Mark as Hidden. To see the files you mark for hiding, return to the same Visibility menu and choose Show Hidden. Essentially, you remove the check mark for Show Hidden, which results in the files being hidden. To easily toggle between showing and hiding files marked for hiding, choose View Hidden Files. Selecting this menu command toggles between showing and hiding the files you marked for hiding.

Stacking 'em up

Think of a *stack* of images as like a stack of cards that is face-up: You see only the front card, and all the other cards are hidden behind that card. Stacks work the same way. You hide different images behind a foreground image. At any time, you can sort the images or display all images in the stack in the Organizer window.

To create a stack, follow these steps:

1. In the Organizer, select several photos.

You can select any number of photos. However, you can't stack audio or movie files.

Choose Edit Stack Stack Selected Photos.

Elements stacks your photos. The first image you select remains in view in the Media Browser. In the upper-right area, an icon that looks like a stack of cards appears on the image thumbnail when you've stacked some images. Double-click the photo to open the stack in the Media Browser, and you find the same icon in the top-right corner, as shown in Figure 6-18.

Figure 6-18: Viewing a stack in the Media Browser.

In Figure 6-16, you see an arrow icon to the right of a stack. Click the arrow and the stack expands. A left-pointing arrow appears on the right of the last image in a stack. Click this arrow and the photos are stacked.

After you stack a group of images, you can use the Stack submenu commands to manage the photos. Click a stack to select it and then choose Edit Stack. The available submenu commands are as follows:

- Automatically Suggest Photo Stacks
- Stack Selected Photos
- Unstack Photos
- Expand Photos in Stack
- Collapse Photos in Stack
- Flatten Stack

(When you flatten a stack, all photos except for the top photo are deleted from the catalog but not from your hard drive.)

- Remove Photo from Stack
- Set as Top Photo

If you want to view all stacks in the Media Browser in expanded form, choose View Expand All Stacks. Using this command doesn't require you to individually select stacks in the Media Browser before expanding them.

Creating versions

Versions are similar to stacks, but you create versions from only one file. You can edit an image and save both the edited version and the original as a version set. Also, you can make additional edits in either editing mode and save to a version set. To create a version set, follow these steps:

- 1. Select an image by clicking it in the Media Browser.
- 2. Apply an edit.

For example, right in the Organizer, you can correct some brightness problems in your image. Click Instant Fix to open the Instant Fix panel and click one of the tools in the panel. See Chapter 9 for more details on using the Instant Fix tools.

3. View the items in the version set by clicking the image in the Media Browser and choosing Edit → Version Set → Expand Items in Version Set.

Elements automatically creates a version set for you when you apply the Auto Smart Fix to the file. The Media Browser shows two thumbnail images — one representing the original image and the other representing the edited version. In Figure 6-19 you can see a photo expanded from a Version Set.

Figure 6-19: Viewing a stack in the Media Browser.

- 4. To open the original image in the Photo Editor, select the image in the Media Browser and then select Photo Editor.
- 5. Edit the image in Expert mode.

You can choose from many different menu commands to edit the image. For example, change the color mode to Indexed Color by choosing Imageç Modeç Indexed Color, as we explain in Chapter 4.

- 6. Save a version by choosing File⇔Save As.
- 7. In the Save Options area of the Save As dialog box, select the Include in the Organizer and Save in Version Set with Original check boxes.

Chapter 4 also explains the options for saving files.

8. Click Save.

The edits made in the Photo Editor are saved as another version in your version set.

After you create a version set, you find additional submenu commands that you can use to manage the version set. Choose Edit Version Set, or open a contextual menu on a version set and then choose Version Set.

Part III Selecting and Correcting Photos

"I've got some new image editing software, so I took the liberty of erasing some of the smudges that kept showing up around the clouds. No need to thank me."

In this part . . .

he wide array of editing features in Elements permit you to change, optimize, perfect, and combine images into composite designs. In this part, you discover how to select image content and then alter that content for a variety of purposes, such as correcting the color, changing the appearance, and extracting the content so that you can introduce it in other photos. Because photos are composed of many thousands of tiny pixels, you need to develop some skill in selecting just the pixels you want to use for any given editing task.

In addition to describing how to create image selections, this part covers photo correction for image contrast and brightness, color correction, and color conversions from one color mode to another. Rarely do you encounter digital images that don't require some kind of correction. In the chapters ahead, you find out how to quickly master some powerful correction techniques.

Making and Modifying Selections

不了上方

In This Chapter

- ▶ Creating selections with the Lasso tools, Magic Wand, and more
- Resizing smartly with the Recompose tool
- ▶ Using the Cookie Cutter tool
- ▶ Rubbing away pixels with the Eraser tools
- Working with the Magic Extractor command
- Saving and loading your selections

f all you want to do is use your photos in all their unedited glory, feel free to skip this chapter and move on to other topics. But if you want to occasionally pluck an element out of its environment and stick it in another, or apply an adjustment to just a portion of your image, this chapter's for you.

Finding out how to make accurate selections is one of those skills that's well worth the time you invest. In this chapter, we cover all the various selection tools and techniques. We also give you tips on which tools are better for which kinds of selections. But remember that you usually have several ways to achieve the same result. Which road you choose is ultimately up to you.

Defining Selections

Before you dig in and get serious about selecting, let us clarify for the record what we mean by defining a selection.

When you *define* a selection, you specify which part of an image you want to work with. Everything within a selection is considered selected. Everything outside the selection is unselected. After you have a selection,

you can then adjust only that portion, and the unselected portion remains unchanged. Or you can copy the selected area into another image altogether. Want to transport yourself out of your background and onto a white, sandy beach? Select yourself out of that backyard BBQ photo, get a stock photo of the tropical paradise of your choice, and drag and drop yourself onto your tropics photo with the Move tool. It's that easy.

When you make a selection, a dotted outline — variously called a *selection border*, an *outline*, or a *marquee* — appears around the selected area. Elements, the sophisticated imaging program that it is, also allows you to partially select pixels, which allows for soft-edged selections. You create soft-edged selections by feathering the selection or by using a mask. Don't worry: We cover these techniques in the section "Applying Marquee options," later in this chapter.

For all the selection techniques described in this chapter, be sure that your image is in Expert mode in the Photo Editor and not in Quick or Guided modes or in the Organizer.

Creating Rectangular and Elliptical Selections

If you can drag a mouse, you can master the Rectangular and Elliptical Marquee tools. These are the easiest selection tools to use, so if your desired element is rectangular or elliptical, by all means, grab one of these tools.

The Rectangular Marquee tool, as its moniker states, is designed to define rectangular (including square) selections. This tool is great to use if you want to home in on the pertinent portion of your photo and eliminate unnecessary background.

Here's how to make a selection with this tool:

1. Select the Rectangular Marquee tool from the Tools panel.

It looks like a dotted square. You can also press M to access the tool. If it isn't visible, press again.

2. Drag from one corner of the area you want to select to the opposite corner.

While you drag, the selection border appears. The marquee follows the movement of your mouse cursor.

3. Release your mouse button.

You now have a completed rectangular selection, as shown in Figure 7-1.

The Elliptical Marquee tool is designed for elliptical (including circular) selections. This tool is perfect for selecting balloons, clocks, and other rotund elements.

Here's how to use the Elliptical Marquee:

1. Select the Elliptical Marquee tool from the Marquee flyout menu on the Tools panel.

It looks like a dotted ellipse. You can also press M to access this tool, if it's visible. If it isn't, press again.

Position the crosshair near the area you want to select and then drag around your desired element.

With this tool, you drag from a given point on the ellipse. While you drag, the selection border appears.

Figure 7-1: Use the Rectangular Marquee tool to create rectangular selections.

3. When you're satisfied with your selection, release the mouse button.

Your elliptical selection is created, as shown in Figure 7-2. If your selection isn't quite centered around your element, simply move the selection border by dragging inside the border.

You can move a selection while you're making it with either of the Marquee tools by holding down the space bar while you're dragging.

Perfecting squares and circles with Shift and Alt or Option

Sometimes you need to create a perfectly square or circular selection. To do so, simply press the Shift key after you begin dragging. After you make your selection, release the mouse button first and then release the Shift key. You can also set the aspect ratio to 1:1 in the Tool Options.

When you're making an elliptical selection, making the selection from the center outward is often easier. To draw from the center, first click the mouse

button where you want to position the center, press Alt (Option on the Macintosh), and then drag. When you make your selection, release the mouse button first and then release the Alt (Option on the Macintosh) key.

If you want to draw from the center outward and create a perfect circle or square, press the Shift key, as well. After you make your selection, release the mouse button and then release the Shift+Alt (Shift+Option on the Macintosh) keys.

Applying Marquee options

The Marquee tools offer additional options when you need to make precise selections at specific measurements. You also find options for making your selections soft around the edges.

The only thing to remember is that you must select the options in the Tool Options, shown in Figure 7-3, before you make your selection with the Marquee tools. Options can't be applied after the selection has already been made. The exception is that you can feather a selection after the fact by choosing Select. Feather.

©istockphoto.com/sjlocke Image #14312433
Figure 7-2: The Elliptical
Marquee tool is perfect for
selecting round objects.

Here are the various Marquee options available to you:

Feather. Feathering creates soft edges around your selection. The amount of

Figure 7-3: Apply Marquee settings in the Tool Options.

softness depends on the value, from 0 to 250 pixels, that you enter by adjusting the slider. The higher the value, the softer the edges, as shown in Figure 7-4. Very small amounts of feathering can be used to create subtle transitions between selected elements in a collage or for blending an element into an existing background. Larger amounts are often used when you're combining multiple layers so that one image gradually fades into another. If you want a selected element to have just a soft edge without the background, simply choose Select. Inverse and delete the background. See more on inversing selections in the "Modifying Your Selections" section, later in this chapter. For more on layers, see Chapter 8.

©istockphoto.com/cobalt Image #1275827

Figure 7-4: Feathering creates soft-edged selections.

Don't forget that those soft edges represent partially selected pixels.

- ✓ **Antialiasing.** Antialiasing barely softens the edge of an elliptical or irregularly shaped selection so that the jagged edges aren't quite so obvious. An antialiased edge is always only 1 pixel wide. We recommend leaving this option chosen for your selections. It can help to create natural transitions between multiple selections when you're creating collages.
- Aspect. The Aspect drop-down menu contains three settings:
 - Normal. The default setting, which allows you to freely drag a selection of any size.
 - Fixed Ratio. Lets you specify a fixed ratio of width to height. For example, if you enter 3 for width and 1 for height, you get a selection that's three times as wide as it is high, no matter what the size.
 - *Fixed Size*. Lets you specify desired values for the width and height. This setting can be useful when you need to make several selections that must be the same size.
- Width (W) and Height (H). When you select Fixed Ratio or Fixed Size from the Aspect drop-down menu, you must also enter your desired values in the Width and Height text boxes. To swap the Width and Height values, click the double-headed arrow button between the two measurements.

The default unit of measurement in the Width and Height text boxes is pixels (px), but that doesn't mean that you're stuck with it. You can enter any unit of measurement that Elements recognizes — pixels, inches (in), centimeters (cm), millimeters (mm), points (pt), picas (pica), or percentages (%). Type your value and then type the word or abbreviation of your unit of measurement.

Making Freeform Selections with the Lasso Tools

You can't select everything with a rectangle or an ellipse. Life is just way too freeform for that. Most animate, and many inanimate, objects have undulations of varying sorts. Luckily, Elements anticipated the need to capture these shapes and provided the Lasso tools.

The Lasso tools enable you to make any freehand selection you can think of. Elements generously provides three types of lasso tools:

✓ Lasso

✓ Polygonal

Magnetic

Although all three tools are designed to make freeform selections, they differ slightly in their methodology, as we explain in the sections that follow.

To use these tools, all that's really required is a steady hand. You'll find that the more you use the Lasso tools, the better you become at your tracing technique. Don't worry if your initial lasso selection isn't super-accurate. You can always go back and make corrections by adding and deleting from your selection. To find out how, see the section "Modifying Your Selections," later in this chapter.

If you find that you really love the Lasso tools, you may want to invest in a digital drawing tablet and stylus. This device makes tracing (and also drawing and painting) on the computer more comfortable. It better mimics pen and paper, and many users swear that they'll never go back to a mouse after trying it out. This is especially handy for laptop users. Accurately drawing on a trackpad can make you downright cranky.

Selecting with the Lasso tool

Using the Lasso tool is the digital version of tracing an outline around an object on a piece of paper. It's that easy. And you have only three choices in the Tool Options — Feather, Antialias, and Refine Edge. To find out more about Feather and Antialias, see the section "Applying Marquee options,"

earlier in this chapter. For the scoop on Refine Edge, see the section "Wielding the Wand to select," later in this chapter.

Here's how to make a selection with the Lasso tool:

1. Select the Lasso tool from the Tools panel.

It's the tool that looks like a rope. You can also just press the L key. If the Lasso tool isn't visible, press L to cycle through the various Lasso flavors.

2. Position the cursor anywhere along the edge of the object you want to select.

The leading point of the cursor is the protruding end of the rope, as shown in Figure 7-5. Don't be afraid to zoom in to your object, using the Zoom tool — or, more conveniently, pressing Control++ (Cmd++on the Mac) — if you need to see the edge more distinctly. In this figure, we started at the top of the tulip.

3. Hold down the mouse button and trace around your desired object.

Try to include only what you want to select. While you trace around your object, an outline follows the mouse cursor.

Try not to release the mouse button until you return to your starting point. When you release the mouse button, Elements assumes that you're done and closes the selection from wherever you released the mouse

©istockphoto.com/jtyler Image #2723146

Lasso cursor

Figure 7-5: The Lasso tool makes freeform selections

button to your starting point; if you release the button too early, then Elements creates a straight line across your image.

4. Continue tracing around the object and return to your starting point; release the mouse button to close the selection.

You see a selection border that matches your lasso line. Look for a small circle that appears next to your lasso cursor when you return to your starting point. This icon indicates that you're closing the selection at the proper spot.

Getting straight with the Polygonal Lasso tool

The Polygonal Lasso tool has a specific mission in life: to select any element whose sides are straight. Think pyramids, stairways, skyscrapers, barns — you get the idea. It also works a tad differently from the Lasso tool. You don't drag around the element with the Polygonal Lasso. Instead, you click and release the mouse button at the corners of the element you're selecting. The Polygonal Lasso tool acts like a stretchy rubber band.

Follow these steps to select with the Polygonal Lasso tool:

1. Select the Polygonal Lasso tool from the Tools panel.

You can also press the L key to cycle through the various Lasso tools.

2. Click and release at any point to start the Polygonal Lasso selection line.

We usually start at a corner.

3. Move (don't drag) the mouse and click at the next corner of the object. Continue clicking and moving to each corner of your element.

Notice how the line stretches out from each point you click.

4. Return to your starting point and click to close the selection.

Be on the lookout for a small circle that appears next to your lasso cursor when you return to your starting point. This circle is an indication that you're indeed closing the selection at the right spot.

Note that you can also double-click at any point, and Elements closes the selection from that point to the starting point.

©istockhoto.com/fotostorm Image #17970388

Figure 7-6: After you close the polygonal lasso line, Elements creates a selection border.

After you close the polygonal lasso line, a selection border appears, as shown in Figure 7-6.

Snapping with the Magnetic Lasso tool

The third member of the Lasso team is the Magnetic Lasso. We aren't huge fans of this Lasso tool, which can sometimes be hard to work with. However, we'll show you how it works so that you can decide whether to use it. The Magnetic Lasso tool works by defining the areas of the most contrast in an image and then snapping to the edge between those areas, as though the edge has a magnetic pull.

You have the most success using the Magnetic Lasso tool on an image that has a well-defined foreground object and high contrast between that element and the background — for example, a dark mountain range against a light sky.

The Magnetic Lasso tool also has some unique settings, which you can adjust in the Tool Options before you start selecting:

- **Width.** Determines how close to the edge (between 1 and 256 pixels) you have to move your mouse before the Magnetic Lasso tool snaps to that edge. Use a lower value if the edge has a lot of detail or if the contrast in the image is low. Use a higher value for high-contrast images or smoother edges.
- Contrast. Specifies the percentage of contrast (from 1 percent to 100 percent) that's required before the Magnetic Lasso snaps to an edge. Use a higher percentage if your image has good contrast between your desired element and the background.
- Frequency. Specifies how many fastening points (from 1 to 100) to place on the selection line. The higher the value, the greater the number of points. As a general rule, if the element you want to select has a smooth edge, keep the value low. If the edge has a lot of detail, try a higher value.
- ✓ Tablet Pressure (pen icon). If you're the proud owner of a pressuresensitive drawing tablet, select this option to make an increase in stylus pressure cause the edge width to decrease.

Follow these steps to use the Magnetic Lasso tool:

1. Select the Magnetic Lasso tool from the Tools panel.

You can also press the L key to cycle through the various Lasso tools. The Magnetic Lasso tool looks like a straight-sided lasso with a little magnet on it.

2. Click the edge of the object that you want to select to place the first fastening point.

Fastening points anchor the selection line, as shown in Figure 7-7. You can start anywhere; just be sure to click the edge between the element you want and the background you don't want.

3. Continue to move your cursor around the object, without clicking.

While the selection line gets pinned down with fastening points, only the

©istockphoto.com/swilmor Image #3160253

Figure 7-7: The Magnetic Lasso tool snaps to the edge of your element and places fastening points to anchor the selection.

newest portion of the selection line remains active.

If the Magnetic Lasso tool starts veering off the desired edge of your object, back up your mouse and click to force down a fastening point. Conversely, if the Magnetic Lasso tool adds a fastening point where you don't want one, press your Backspace (Delete on the Macintosh) key to delete it. Note that successive presses of the Backspace or Delete key continue to remove the fastening points.

If the Magnetic Lasso isn't cooperating, you can temporarily switch to the other Lasso tools. To select the Lasso tool, hold down Alt (Option on the Macintosh) and then click the mouse button and drag. To select the Polygonal Lasso tool, hold down Alt (Option on the Macintosh) and click.

4. Return to your starting point and click the mouse button to close the selection.

You see a small circle next to your cursor, indicating that you're at the right spot to close the selection. You can also double-click, whereby Elements closes the selection from where you double-clicked to your starting point. The selection border appears when the selection is closed.

Working Wizardry with the Magic Wand

The Magic Wand tool is one of the oldest tools in the world of digital imaging. This beloved tool has been around since Photoshop was in its infancy and Elements was not yet a twinkle in Adobe's eye. It's extremely easy to use, but a little harder to predict what selection results it will present.

Here's how it works: You click inside the image, and the Magic Wand tool makes a selection. This selection is based on the color of the pixel you clicked. If other pixels are similar in color to your target pixel, Elements includes them in the selection. What's sometimes hard to predict, however, is how to determine *how* similar the color has to be to get the Magic Wand tool to select it. Fortunately, that's where the Tolerance setting comes in. In the sections that follow, we first introduce you to this setting and then explain how to put the Magic Wand to work.

Talking about Tolerance

The Tolerance setting determines the range of color that the Magic Wand tool selects. It's based on brightness levels that range from 0 to 255:

- \blacksquare Setting the Tolerance to 0 selects one color only.
- Setting the Tolerance to 255 selects all colors, or the whole image.

The default setting is 32, so whenever you click a pixel, Elements analyzes the value of that base color and then selects all pixels whose brightness levels are between 16 levels lighter and 16 levels darker.

What if an image contains a few shades of the same color? It's not a huge problem. You can make multiple clicks of the Magic Wand to pick up additional pixels that you want to include in the selection. You can find out how in the section "Modifying Your Selections," later in this chapter. Or you can try a higher Tolerance setting. Conversely, if your wand selects too much, you can also lower your Tolerance setting.

So, you can see by our talk on tolerance that the Magic Wand tool works best when you have high-contrast images or images with a limited number of colors. For example, the optimum image for the Wand would be a solid black object on a white background. Skip the wand if the image has a ton of colors and no real definitive contrast between your desired element and the background.

Wielding the Wand to select

To use the Magic Wand tool to adjust Tolerance settings, follow these steps:

1. Select the Magic Wand tool from the Tools panel.

It looks like a wand with a starburst on the end. You can also just press A to cycle through the Magic Wand, Quick Selection, and Selection Brush tools.

2. Click anywhere on your desired element, using the default Tolerance setting of 32.

Remember that the pixel you click determines the base color.

If the pixel gods are with you and you selected everything you want on the first click, you're done. If your selection needs further tweaking, like the top image shown in Figure 7-8, continue to Step 3.

3. Specify a new Tolerance setting on the Options bar.

If the Magic Wand selects more than you want, lower the Tolerance setting. If the wand didn't select enough, increase the value. While you're poking around in the Tool Options, here are a couple more options to get familiar with:

• Sample All Layers. If you have multiple layers and enable this option, the Magic Wand selects pixels from all visible layers. Without this option, the tool selects pixels from the active layer only. For more on layers, see Chapter 8.

Tolerance 32

Tolerance 90

©istockphoto.com/bholland Image #5314427

Figure 7-8: The Magic Wand selects pixels based on a specified Tolerance setting.

- Contiguous. Forces the Magic Wand to select only pixels that are adjacent to each other.
 Without this option, the tool selects all pixels within the range of tolerance, whether or not they're adjacent to each other.
- Antialiasing. Softens the edge of the selection by one row of pixels. See the section "Applying Marquee options," earlier in this chapter, for details.
- Refine Edge. Click the Refine Edge button. In the Refine Edge dialog box, clean up your selection by moving the Smooth slider to reduce the amount of jagginess in your edges. Feather works like the feather option discussed in the "Applying Marquee options" section, earlier in the chapter. Move the Shift Edge slider to the left or right to decrease or increase the selected area, respectively. For even more details, see the section "Refining the edges of a selection," later in this chapter. We explain yet another way to refine edges (which you don't find in the Tool Options) in "Applying the Grow and Similar commands" also later in this chapter.

4. Click your desired element again.

Unfortunately, the Magic Wand tool isn't magical enough to modify your first selection automatically. Instead, it deselects the current selection and makes a new selection based on your new Tolerance setting. If it still isn't right, you can adjust the Tolerance setting again. Try, try again.

Modifying Your Selections

It's time for a seventh-inning stretch in this chapter on selection tools. In this section, you can find out how to refine that Marquee, Lasso, or Magic Wand selection to perfection. Although these tools do an okay job of capturing the bulk of your selection, if you take the time to add or subtract a bit from your selection border, you can ensure that you get only what you really want.

You're not limited to the manual methods described in the following sections, or even to keyboard shortcuts. You can also use the four selection option buttons on the left side of the Tool Options to create a new selection (the default), add to a selection, subtract from a selection, or intersect one selection with another. Just choose your desired selection tool, click the selection option button you want, and drag (or click if you're using the Magic Wand or Polygonal Lasso tool). The Add to Selection and Subtract from Selection buttons are also available when you're using the Selection Brush, explained later in this chapter. When you're adding to a selection, a small plus sign (+) appears next to your cursor. When you're subtracting from a selection, a small minus sign (-) appears. When you're intersecting two selections, a small multiplication sign (×) appears.

Adding to a selection

If your selection doesn't quite contain all the elements you want to capture, you need to add those portions to your current selection border. To add to a current Marquee selection, simply press the Shift key and drag around the area you want to include. If you're using the Polygonal Lasso, click around the area. And, if you're wielding the Magic Wand, just press the Shift key and click the area you want.

You don't have to use the same tool to add to your selection that you used to create the original selection. Feel free to use whatever selection tool you think can get the job done. For example, it's very common to start off with the Magic Wand and fine-tune with the Lasso tool.

Subtracting from a selection

Got too much? To subtract from a current selection, press the Alt (Option on the Macintosh) key and drag the marquee around the pixels you want to subtract. With the Alt (Option on the Macintosh) key, use the same method for the Magic Wand and Polygonal Lasso as you do for adding to a selection.

Intersecting two selections

Get your fingers in shape. To intersect your existing selection with a second selection, press Shift+Alt (Shift+Option on the Macintosh) and drag with the Lasso tool. Or, if you're using the Magic Wand or Polygonal Lasso, press those keys and click rather than drag.

Avoiding key collisions

If you read the beginning of this chapter, you found out that by pressing the Shift key, you get a perfectly square or circular selection. We tell you in the section "Adding to a selection," earlier in this chapter, that if you want to add to a selection, you press the Shift key. What if you want to create a perfect square while adding to the selection? Or, what if you want to delete part of a selection while also drawing from the center outward? Both require the use of the Alt (Option on the Macintosh) key. How in the heck does Elements know what you want? Here are a few tips to avoid keyboard collisions — grab your desired Marquee tool:

- ✓ To add a square or circular selection, press Shift and drag. While you drag, keep the mouse button pressed, release the Shift key for just a second, and then press it again. Your added selection area suddenly snaps into a square or circle. You must then release the mouse button first and then release the Shift key.
- ✓ To delete from an existing selection while drawing from the center outward, press Alt (Option on the Macintosh) and drag. While you drag, keep the mouse button pressed, release the Alt (Option on the Macintosh) key for just a second, and then press it down again. You're now drawing from the center outward. Again, release the mouse button first and then release the Alt (Option on the Macintosh) key.

Remember you can also use the selection option buttons in the Tool Options.

Painting with the Selection Brush

If you like the organic feel of painting on a canvas, you'll appreciate the Selection Brush. Using two different modes, you can either paint over areas

of an image that you want to select or paint over areas you don't want to select. This great tool also lets you make a basic, rudimentary selection with another tool, such as the Lasso, and then fine-tune the selection by brushing additional pixels into or out of the selection.

Here's the step-by-step process of selecting with the Selection Brush:

1. Select the Selection Brush from the Tools panel.

Or simply press the A key to cycle through the Selection Brush, Quick Selection, and Magic Wand tools.

This tool works in either Expert or Quick mode.

2. Specify your Selection Brush options in the Tool Options.

Here's the rundown on each option:

- Brush Presets Picker. Choose a brush from the presets drop-down menu. To load additional brushes, click the downward-pointing arrow to the left of Default Brushes and choose the preset library of your choice. You can select the Load Brushes command from the panel menu (top right down-pointing arrow).
- *Mode.* Choose between Selection and Mask. Choose Selection if you want to paint over what you *want* to select. Choose Mask if you want to paint over what you *don't* want. If you choose Mask mode, you must choose some additional overlay options. An *overlay* is a layer of color (that shows onscreen only) that hovers over your image, indicating protected or unselected areas. You must also choose an overlay opacity between 1 and 100 percent (which we describe in the Tip at the end of these steps). You can change the overlay color from the default red to another color. This option can be helpful if your image contains a lot of red.
- $^{\bullet}$ $Brush\,Size.$ Specify a brush size, from 1 to 2,500 pixels. Enter the value or drag the slider.
- Hardness. Set the hardness of the brush tip, from 1 to 100 percent.

3. If your mode is set to Selection, paint over the areas you want to select.

You see a selection border. Each stroke adds to the selection. (The Add to Selection button in the Tool Options is automatically selected.) If you inadvertently add something you don't want, simply press the Alt (Option on the Macintosh) key and paint over the undesired area. You can also select the Subtract from Selection button in the Tool Options. After you finish painting what you want, your selection is ready to go.

4. If your mode is set to Mask, paint over the areas that you don't want to select.

When you're done painting your mask, choose Selection from the Selection/Mask drop-down menu, or simply choose another tool from the Tool Options, in order to convert your mask into a selection border. Remember that your selection is what you *don't* want.

While you paint, you see the color of your overlay. Each stroke adds more to the overlay area, as shown in Figure 7-9. In the example, the sky is masked (with a red overlay) to replace it with a different sky. When working in Mask mode, you're essentially covering up, or *masking*, the areas you want to protect from manipulation. That manipulation can be selecting, adjusting color, or performing any other Elements command. Again, if you want to remove parts of the masked area, press Alt (Option on the Macintosh) and paint.

©istockphoto.com/Hanis Image#2054524

Figure 7-9: The Selection Brush allows you to make a selection (right) by creating a mask (left).

If you painted your selection in Mask mode, your selection border is around what you don't want. To switch to what you do want, choose Select Inverse.

Which mode should you choose? Well, it's up to you. But one advantage to working in Mask mode is that you can partially select areas. By painting with soft brushes, you create soft-edged selections. These soft edges result in partially selected pixels. If you set the overlay opacity to a lower percentage, your pixels are even less opaque, or "less selected." If this partially selected business sounds vaguely familiar, it's because this is also what happens when you feather selections, as we discuss in the section "Applying Marquee options," earlier in this chapter.

Painting with the Quick Selection Tool

Think of the Quick Selection tool as a combination Brush, Magic Wand, and Lasso tool. Good news — it lives up to its "quick" moniker. Better news — it's also easy to use. The best news? It gives pretty decent results, so give it a whirl.

Here's how to make short work of selecting with this tool:

1. Select the Quick Selection tool from the Tools panel.

The tool looks like a wand with a marquee around the end. It shares the same Tools panel cell with the Selection Brush tool and the Magic Wand tool. You can also press the A key to cycle through the Quick Selection, Selection Brush, and Magic Wand tools.

This tool works in either Expert or Quick mode.

2. Specify the options in the Tool Options.

Here's a description of the options:

- *New Selection*. The default option enables you to create a new selection. There are also options to add to and subtract from your selection.
- \bullet Size. Choose your desired brush size. Specify the diameter, from 1 to 2,500 pixels.
- *Brush Settings*. With these settings you can specify hardness, spacing, angle, and roundness. For details on these settings, see Chapter 12.
- Sample All Layers. If your image has layers and you want to make a
 selection from all the layers, select this option. If you leave it deselected, you will select only from the current layer.
- *Auto-Enhance*. Select this option to have Elements automatically refine your selection by implementing an algorithm.

3. Drag, or paint, the desired areas of your image.

Your selection grows as you drag, as shown in Figure 7-10. If you stop dragging and click in another portion of your image, your selection includes that clicked area.

4. Add to or delete from your selection, as desired:

- To add to your selection, press the Shift key while dragging across your desired image areas.
- To delete from your selection, press the Alt (Option on the Macintosh) key while dragging across your unwanted image areas.

You can also select the Add to Selection and Subtract from Selection options in the Tool Options.

5. If you need to finetune your selection, click the Refine Edge option in the Tool Options and then change the settings, as desired.

The settings are explained in detail in the "Refining the edges of a selection" section, later in this chapter.

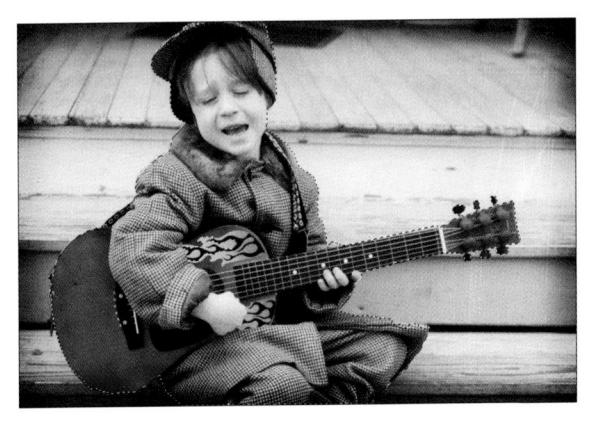

©istockphoto.com/ParkerDeen Image #6013582

Figure 7-10: Paint a selection with the Quick Selection tool.

Note that if your object is fairly detailed, you may even need to break out the Lasso or another selection tool to make some final cleanups. Eventually, you should arrive at a selection you're happy with.

Resizing Smartly with the Recompose Tool

The Recompose tool is like an über-intelligent crop-and-transform tool. You can move elements closer together or even change the orientation of a land-scape shot from horizontal to vertical without sacrificing your most vital content.

Here's how this great tool works:

1. In the Photo Editor, in Expert mode, select the Recompose tool from the Tools panel.

You can also press the W key.

2. Using the Brushes and Erasers in the Tool Options, mark the areas you want to protect and eliminate.

Although this step isn't mandatory, it will help to give you better results.
Here's a description of these tools:

- *Mark for Protection Brush*. Brush over the areas of the image you want to protect or retain. (Strokes will be green.) You don't have to be super precise; just give Elements an inkling of what you want to keep (or remove, in the case of the next brush), as shown in Figure 7-11.
- Mark for Removal Brush. Brush over those areas you want to remove first. (Strokes will be red.) Make sure to choose the area you don't mind eliminating at all.
- Erase Highlight Marked for Protection. Use this tool to

©istockphoto.com/dageldog Image #2808734

Figure 7-11: Mark areas that you want to retain or remove.

erase any area you erroneously marked to retain.

• Erase Highlights Marked for Removal. Use this tool to erase any area you erroneously marked to remove.

3. Specify the other options in the Tool Options.

Here's a description of those options:

- Size. Drag the slider to make the brush diameter smaller or larger.
- *Threshold.* Set a recomposition threshold to help minimize distortion. Start with a higher percentage, and then adjust as needed.
- Presets. Use a preset ratio or size to which to recompose your image. Or leave on the default of No Restriction.
- Width and Height. Enter width and height scale percentages if desired.
- Highlight Skin tones. Select this option and brush over skin areas to prevent skin tones from being distorted when scaled.

4. Grab an image handle and resize your image.

As you drag, the red areas are removed first, and the green areas remain intact. After all the red areas have been removed, Elements begins to "carve" out areas you didn't mark to protect.

5. After you've recomposed your image as desired, click the Commit (green) check-mark icon in the image window to accept the composition.

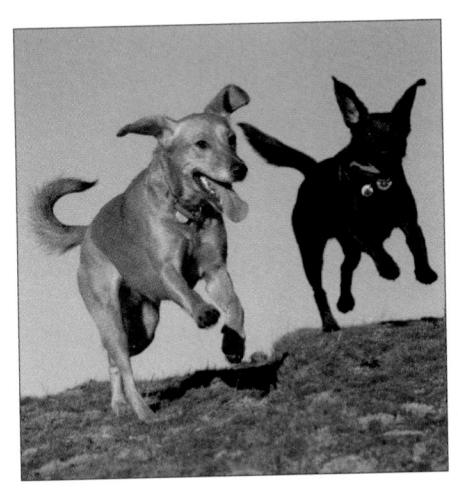

©istockphoto.com/dageldog Image #2808734

Retouch any areas as needed with Figure 7-12: A recomposed image. the Clone Stamp or Healing tools. For our example, shown in Figure 7-12, we cloned a few seams on the grass which we repaired.

Working with the Cookie Cutter Tool

The Cookie Cutter tool is a cute name for a pretty powerful tool. You can think of it as a Custom Shape tool for images. But, whereas the Custom Shape tool creates a mask and just hides everything outside the shape, the Cookie Cutter cuts away everything outside the shape. The preset libraries offer you a large variety of interesting shapes, from talk bubbles to Swiss cheese. (We're not being funny here — check out the food library.)

Here's the lowdown on using the Cookie Cutter:

1. Choose the Cookie Cutter tool from the Tools panel.

There's no missing it; it looks like a flower. You can also press the Q key.

2. Specify your options in the Tool Options.

Here's the list:

- Shape. Choose a shape from the Custom Shape picker preset library. To load other libraries, click the shapes pop-up menu and choose one from the submenu.
- · Geometry Options. These options let you draw your shape with certain parameters:

- Unconstrained. Enables you to draw freely.
- Defined Proportions. Enables you to keep the height and width proportional.
- *Defined Size*. Crops the image to the original, fixed size of the shape you choose. You can't make it bigger or smaller.
- Fixed Size. Allows you to enter your desired width and height.
- From Center. Allows you to draw the shape from the center outward.
- *Feather.* This option creates a soft-edged selection. See the section "Applying Marquee options," earlier in this chapter, for more details.
- Crop. Click this option to crop the image into the shape. The shape will fill the image window.
- Drag your mouse on the image to create your desired shape, size the shape by dragging one of the handles of the bounding box, and position the shape by placing the mouse cursor inside the box and dragging.

You can also perform other types of transformations, such as rotating and skewing. These functions can be performed by dragging the box manually, or by entering values in the Tool Options. For more on transformations, see Chapter 9.

4. Click the Commit button on the image or press Enter to finish the cutout.

See Figure 7-13 to see the image cut into a leaf shape. If you want to bail out of the bounding box and not cut out, you can always click the Cancel button on the image or press Esc.

©istockphoto.com/buzbuzzer Image #2272088

Figure 7-13: Crop your photo into interesting shapes with the Cookie Cutter.

Eliminating with the Eraser Tools

The Eraser tools let you erase areas of your image. Elements has three Eraser tools: the regular Eraser, the Magic Eraser, and the Background Eraser. The Eraser tools look like those pink erasers you used in grade school, so you

can't miss them. If you can't locate them, you can always press ${\bf E}$ to cycle through the three tools.

When you erase pixels, those pixels are history — they're gone. So, before using the Eraser tools, you should probably have a backup of your image stored somewhere. Think of it as a cheap insurance policy in case things go awry.

The Eraser tool

The Eraser tool enables you to erase areas on your image to either your background color or, if you're working on a layer, a transparent background, as shown in Figure 7-14. For more on layers, check out Chapter 8.

To use this tool, simply select it and drag through the desired area on your image, and you're done. Because it isn't the most accurate tool on the planet, remember to

©istockphoto.com/samdiesel Image #6164396

Figure 7-14: Erase either to your background color (left) or to transparency (right).

zoom way in and use smaller brush tips to do some accurate erasing.

You have several Eraser options to specify in the Tool Options:

- ▶ Brush Presets Picker. Click the drop-down menu to access the Brush presets. Choose the brush of your choice. Again, additional brush libraries are available on the Brush menu (click the down-pointing arrow in the top-right).
- ✓ Size. Slide the Size slider and choose a brush size between 1 and 2,500 pixels.
- Opacity. Specify a percentage of transparency for your erased areas. The lower the Opacity setting, the less it erases. Opacity isn't available in Block mode.
- ✓ Type. Select from Brush, Pencil, and Block. When you select Block, you're stuck with one size (a 16-x-16-pixel tip) and can't select other preset brushes.

The Background Eraser tool

The Background Eraser tool, which is savvier than the Eraser tool, erases the background from an image while being mindful of leaving the foreground untouched. The Background Eraser tool erases to transparency on a layer. If you use this tool on an image with only a background, Elements converts the background into a layer.

The key to using the Background Eraser is to carefully keep the hot spot, the crosshair at the center of the brush, on the background pixels while you drag. The hot spot samples the color of the pixels and deletes that color whenever it falls inside the brush circumference. But if you accidentally touch a foreground pixel with the hot spot, it's erased as well. And the tool isn't even sorry about it! This tool works better with images that have good contrast in color between the background and foreground objects, as shown in Figure 7-15. If your image has very detailed or wispy edges (such as hair or fur), you're better off using the Magic Extractor command, which we describe in the section "Using the Magic Extractor Command," later in this chapter. Or if you are up for a little more challenge, layer masking can also provide good results. Layer masks are described in Chapter 8.

©istockphoto.com/Darkcloud Image #7909523

Figure 7-15: The Background Eraser erases similarly colored pixels sampled by the hot spot of your brush cursor.

Here's the rundown on the Background Eraser options:

- Brush Settings. Click the Brush Settings button to bring up the settings to customize the Size, Hardness, Spacing, Roundness, and Angle of your brush tip. The Size and Tolerance settings at the bottom are for pressure-sensitive drawing tablets.
- Limits. Discontiguous erases all similarly colored pixels wherever they appear in the image. Contiguous erases all similarly colored pixels that are adjacent to those under the hot spot.

✓ Tolerance. The percentage determines how similar the colors have to be to the color under the hot spot before Elements erases them. A higher value picks up more colors, whereas a lower value picks up fewer colors. See the section "Talking about Tolerance," earlier in this chapter, for more details.

The Magic Eraser tool

You can think of the Magic Eraser tool as a combination Eraser and Magic Wand tool. It selects *and* erases similarly colored pixels simultaneously. Unless you're working on a layer with the transparency locked (see Chapter 8 for more on locking), the pixels are erased to transparency. If you're working on an image with just a background, Elements converts the background into a layer.

Although the Magic Eraser shares most of the same options with the other erasers, it also offers unique options:

- ✓ Sample All Layers. Samples colors using data from all visible layers but erases pixels on the active layer only.
- Contiguous. Selects and erases all similarly colored pixels that are adjacent to those under the hot spot.
- Antialiasing. Creates a slightly soft edge around the transparent area.

Using the Magic Extractor Command

The last selection tool in the Elements repertoire is the Magic Extractor command. This command enables you to make selections based on your identification of the foreground and background portions of your image. The way this tool works is that you specify your foreground and background by simply clicking these areas with a Brush tool and "marking" them. Click the magic OK button, and your object or objects are neatly and painlessly extracted.

Although it isn't mandatory, you can make a rough selection first before selecting the Magic Extractor command. This technique obviously restricts what's extracted and can result in a more accurate selection.

Follow these steps to magically extract your element:

1. Choose Image⇔Magic Extractor.

The huge Magic Extractor dialog box appears.

2. Grab the Foreground Brush tool and click or drag to mark your foreground areas — or the areas you want to select.

The default color of the Foreground Brush is red.

Like with the Selection Brush, the more accurate the data you provide to the command's algorithm, the more accurate your extraction. Be sure to use the Zoom and Hand tools to help magnify and move around your image, as needed. For more on these tools, see Chapter 2.

You can also change the size of your brush tip (from 1 to 100 pixels) in the Tool Options area on the right side of the dialog box. If necessary, change your foreground and background colors by clicking the swatch and choosing a new color from the Color Picker.

3. Select the Background Brush tool and then click or drag to mark the background area or the portions you don't want to select, as shown in Figure 7-16.

The default color of the Background Brush is blue.

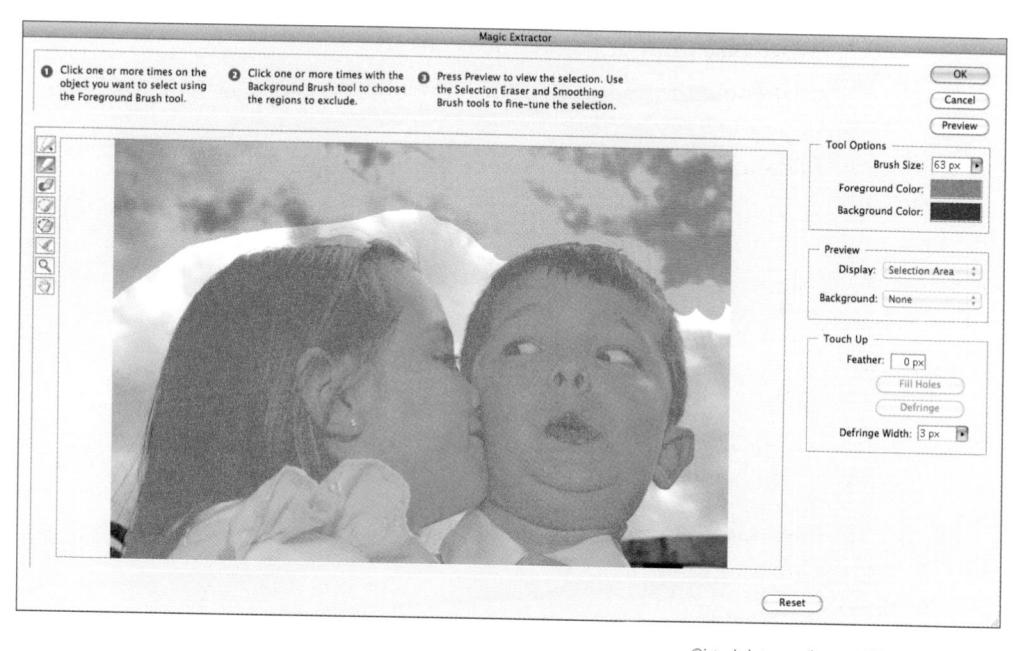

©istockphoto.com/ImagesbyTrista Image #1638352

Figure 7-16: The Magic Extractor allows you to identify foreground and background areas.

4. Click Preview to view your extraction.

Elements churns for a few seconds before presenting you with a look at your extraction. You can change the preview by choosing either Selection Area or Original Photo from the Display pop-up menu.

If you want to see your selection against a different background, choose one, such as black matte for a black background, from the Background pop-up menu.

5. If you aren't happy with the preview of your selection, you can refine the selection:

- To erase any markings, select the Point Eraser tool and click or drag over the offending areas.
- To add areas to the selection, click or drag over your desired areas with the Add to Selection tool.
- To delete areas from the selection, drag with the Remove from Selection tool.
- To smooth the edges of your foreground selection, drag over the edges with the Smoothing Brush tool.
- To soften the edges of your selection, enter a value in the Feather box. Remember: The higher the value, the softer the edge.
- To fill a hole, click the aptly named Fill Holes button.
- To remove the halo of pixels between the foreground and background areas, click Defringe. Enter a value in the Defringe Width box.

If things start to get messy, you can always start over by clicking Reset at the bottom of the dialog box.

6. When you're pleased with the results, click OK to finish the selection process and close the Magic Extractor dialog box.

> The newly extracted image appears, as shown in Figure 7-17.

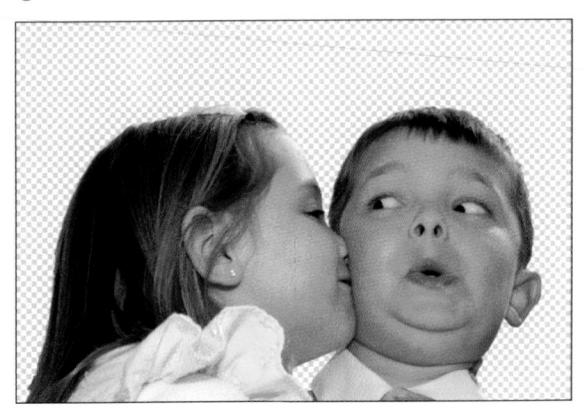

©istockphoto.com/ImagesbyTrista Image #1638352

Figure 7-17: A cute couple selected with the Magic Extractor.

Using the Select Menu

In the following sections, we breeze through the Select menu. Along with the methods we describe in the "Modifying Your Selections" section, earlier in this chapter, you can use this menu to further modify selections by expanding, contracting, smoothing, softening, inversing, growing, and grabbing similarly colored pixels. If that doesn't satisfy your selection needs, nothing will.

Selecting all or nothing

The Select All and Deselect commands are no-brainers. To select everything in your image, choose Select All or press Ctrl+A (%+A on the Macintosh). To deselect everything, choose Select Deselect or press Ctrl+D (%+D on the Macintosh). Remember that you usually don't have to Select All. If you don't have a selection border in your image, Elements assumes that the whole image is fair game for any manipulation.

Reselecting a selection

If you sacrifice that second cup of coffee to steady your hand and take the time to carefully lasso around your desired object, you don't want to lose your selection before you have a chance to perform your next move. But all it takes is an inadvertent click of your mouse while you have an active selection border to obliterate your selection. Fortunately, Elements anticipated such a circumstance and offers a solution: If you choose Select Reselect, Elements retrieves your last selection.

One caveat: The Reselect command works only for the last selection you made, so don't plan to reselect a selection you made last Tuesday or even just five minutes ago, if you selected something else after that selection. If you want to reuse a selection for the long term, save it as we explain in the section "Saving and loading selections," later in this chapter.

Inversing a selection

You know the old song lyric: "If you can't be with the one you love, love the one you're with." Well, making selections in Elements is kind of like that. Sometimes it's just easier to select what you don't want rather than what you do want. For example, if you're trying to select your beloved in his or her senior photo, it's probably easier to just click the studio backdrop with the Magic Wand and then inverse the selection by choosing Selectchree.

Feathering a selection

In the "Applying Marquee options" section earlier in this chapter, we describe how to feather a selection when using the Lasso and Marquee tools by entering a value in the Feather box in the Tool Options. Remember that this method of feathering requires that you set the Feather value *before* you create your selection. What we didn't tell you is that there's a way to apply a feather *after* you make a selection.

Choose Select \circlearrowleft Feather and enter your desired amount from 0.2 to 250 pixels. Your selection is subsequently softened around the edges.

This method is actually a better way to go. Make your selection and fine-tune it by using the methods we describe earlier in this chapter. Then, apply your feather. The problem with applying the feather before you make a selection happens when you want to modify your initial selection. When you make a selection with a feather, the marquee outline of the selection adjusts to take into account the amount of the feathering. So, the resulting marquee outline doesn't resemble your precise mouse movement, making it harder to modify that selection.

Refining the edges of a selection

The Refine Edge option enables you to fine-tune the edges of your selection. It doesn't matter how you got the selection, just that you have one. You can find the command in the Tool Options of the Magic Wand, Lasso, and Quick Selection tools. And, of course, you can find it in the Select menu. The Refine Edge options have been increased and enhanced. They are actually the exact same options you'll find in Photoshop CS6. Here's the scoop on each setting for this option, as shown in Figure 7-18:

- ✓ View Mode. Choose a mode from the pop-up menu to preview your selection. For example, Marching Ants shows the selection border. Overlay lets you preview your selection with the edges hidden and a semi-opaque layer of color in your unselected area. On Black and On White show the selection against a black or white background. Hover your cursor over each mode to get a tooltip. Show Original shows the image without a selection preview. Show Radius displays the image with the selection border.
- ✓ Smart Radius. Select this option to have Elements automatically adjust the radius for hard and soft edges near your selection border. If your border is uniformly hard or soft, you may not want to select this option. This enables you to have more control over the radius setting.

- Radius. Specify the size of the selection border you will refine. Increase the radius to improve the edge of areas with soft transitions or a lot of detail. Move the slider while looking at your selection to find a good setting.
- Smooth. Reduces jaggedness along your selection edges.
- Feather. Moves the slider to create an increasingly softer, more blurred edge.
- Contrast. Removes artifacts while tightening soft edges by increasing the contrast. Try using the Smart Radius option first before playing with Contrast.
- ✓ Shift Edge. Decreases or increases your selected area.
 Slightly decreasing your selection border can help to defringe (eliminate undesirable background pixels) your selection edges.
- Decontaminate Colors. Replaces background fringe with the colors of your selected element. Note that because decontamination changes the colors of some of the pixels, you will have to output to, or create, another layer or document to preserve your current layer. To see the decontamination in action, choose Reveal Layer for your View mode. Chapter 8 explains how to work with layers.
- Amount. Changes the level of decontamination.
- Output To. Choose whether you want to output your refined, decontaminated selection to a selection on your current layer, layer mask, layer, layer with layer mask, new document, or new document with layer mask.
- ✓ Refine Radius tools. Select a tool on the left and brush around your border to adjust the area you are refining. To understand exactly what area is being included or excluded, change your View mode to Marching Ants. Use the right and left brackets to decrease and increase the brush size.
- Zoom tool. Allows you to zoom in to your image to see the effects of your settings.
- Hand tool. Enables you to pan around your image window to see the effects of your settings.

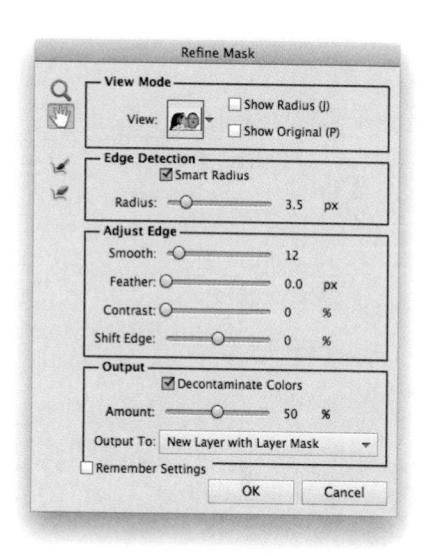

Using the Modify commands

Although the commands on the Modify submenu definitely won't win any popularity contests, they may occasionally come in handy. Here's the scoop on each command:

- ✓ Border. Selects the area, from 1 to 200 pixels, around the edge of the selection border. By choosing Edit

 Fill Selection, you can fill the border with color.
- ✓ **Smooth.** Rounds off any jagged, ragged edges. Enter a value from 1 to 100 pixels, and Elements looks at each selected pixel and then includes or deselects the pixels in your selection based on your chosen value. Start with a low number, like 1, 2, or 3 pixels. Otherwise, it may make your selection less accurate.
- ✓ Expand. Enables you to increase the size of your selection by a given number of pixels, from 1 to 100. This command is especially useful if you just barely missed getting the edge of an elliptical selection and need it to be a little larger.
- ✓ Contract. Decreases your selection border by 1 to 100 pixels. When you're compositing multiple images, you often benefit by slightly contracting your selection if you plan to apply a feather. That way, you avoid picking up a fringe of background pixels around your selection.

Applying the Grow and Similar commands

The Grow and Similar commands are often used in tandem with the Magic Wand tool. If you made an initial selection with the Magic Wand but didn't quite get everything you want, try choosing Selecten Grow. The Grow command increases the size of the selection by including adjacent pixels that fall within the range of tolerance. The Similar command is like Grow except that the pixels don't have to be adjacent to be selected. The command searches throughout the image and picks up pixels within the tolerance range.

These commands don't have their own tolerance options. They use whatever Tolerance value is displayed on the Tool Options when the Magic Wand tool is selected. You can adjust that Tolerance setting to include more or fewer colors.

Saving and loading selections

At times, you toil so long over a complex selection that you really want to save it for future use. Saving it is not only possible but highly recommended. It's also a piece a cake. Here's how:

- 1. After you perfect your selection, choose Select⇔Save Selection.
- 2. In the Save Selection dialog box, leave the Selection option set to New Selection and enter a name for your selection, as shown in Figure 7-19.

The operation is automatically set to New Selection.

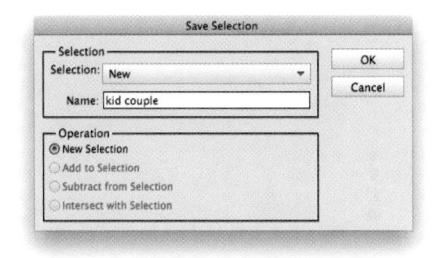

Figure 7-19: Save your selection for later use to save time and effort.

- 3. Click OK.
- 4. When you want to access the selection again, choose Select Doad Selection and choose a selection from the Selection drop-down menu.

Working with Layers

In This Chapter

- Getting to know layers and the Layers panel
- Working with the Layer and Select menus
- Using different layer types
- Creating new layers
- Moving and transforming layers
- Adding layer masks
- Merging and flattening layers

sing Elements without ever using layers would be like typing a book on an old IBM Selectric typewriter: Sure, you could do it, but it wouldn't be fun. An even bigger issue would occur when it came time to edit that book and make changes. Correction tape, Wite-Out, and erasers would make that task downright tedious, not to mention messy. The benefit of using layers is that you have tremendous flexibility. You can quickly make as many edits as you want for as long as you want, as long as you keep your composite image in layers. Layers make working in Elements a lot more productive. Don't give a darn about productivity? Well, let's just say that layers also make it a breeze for you to bring out your more artsy side.

waii

This chapter explains the tools and techniques you need to start working with layers. After you give layers a try, you'll wonder how you ever lived without them.

Getting to Know Layers

Think of layers as sheets of acetate or clear transparency film. You have drawings or photographs on individual sheets. What you place on each sheet doesn't affect any of the other sheets. Any area on the sheet that doesn't have an image on it is transparent. You can stack these sheets on top of the others to create a combined image, or *composite* (or *collage*, if you prefer). You can reshuffle the order of the sheets, add new sheets, and delete old sheets.

In Elements, *layers* are essentially digital versions of these clear acetate sheets. You can place elements, such as images, text, or shapes, on separate layers and create a composite, as shown in Figure 8-1. You can hide, add, delete, or rearrange layers. Because layers are digital, of course, they have added functionality. You can adjust how opaque or transparent the element on a layer is. You can also add special effects and change how the colors interact between layers.

To work with layers, you must be in the Photo Editor in Expert mode.

When you create a new file with background contents of white or a background color, scan an image into Elements, or open a file from a CD or your digital camera, you basically have a file with just a background. There are no layers yet.

©istockphoto.com/ Kubrak78 Image #12642467, naomiwoods Image #9128343, 4x6, Image #20236672, goldhafen Image #1512452

Figure 8-1: Layers enable you to easily create composite images.

An image contains at most one background, and you can't do much to it besides paint on it and make basic adjustments. You can't move the background or change its transparency or blend mode. How do you get around all these limitations? Convert your background into a layer by following these easy steps:

1. Choose Window ⇒ Layers to display the Layers panel.

The Layers panel is explained in detail in the next section.

2. Double-click Background on the Layers panel.

Or, choose Layer⇔New⇔Layer From Background.

3. Name the layer or leave it at the default name of Layer 0.

You can also adjust the blend mode and opacity of the layer in the New Layer dialog box. Or you can do it via the Layers panel commands later.

4. Click OK.

Elements converts your background into a layer, known also as an *image* layer.

When you create a new image with transparent background contents, the image doesn't contain a background but instead is created with a single layer.

Anatomy of the Layers panel

Elements keeps layers controlled with a panel named, not surprisingly, the *Layers panel*. To display the Layers panel, shown in Figure 8-2, choose Window-Layers in the Photo Editor in Expert mode.

The order of the layers on the Layers panel represents the order in the image. We refer to this concept in the computer graphics world as the *stacking order*. The top layer on the panel is the top layer in your image, and so on. Depending on what you're doing, you can work on a single layer or on multiple layers at one time. Here are some tips for working with the Layers panel:

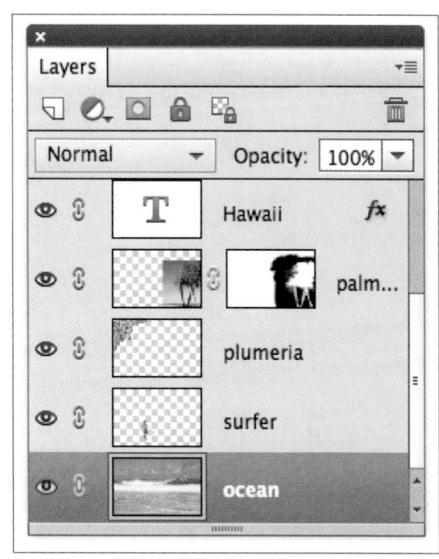

Figure 8-2: The Layers panel controls layers in your image.

- ✓ To select a layer, click a layer name or its thumbnail. Elements highlights the active layer on the panel.
- ✓ To select multiple contiguous layers, click your first layer and then Shift-click your last layer.
- ✓ To select multiple noncontiguous layers, Ctrl-click (ૠ-click on the Macintosh) your desired layers.
- Viewing and hiding layers. To hide a layer, click the eye icon for that layer so that the eye disappears. To redisplay the layer, click the blank space in the eye column. You can also hide all the layers except one by selecting your desired layer and Alt-clicking (Option-clicking on the Macintosh) the eye icon for that layer. Redisplay all layers by Alt-clicking (Option-clicking on the Macintosh) the eye icon again. Hiding all the layers except the one you want to edit can be helpful in allowing you to focus without the distraction of all the other imagery.

Only layers that are visible are printed. This can be useful if you want to have several versions of an image (each on a separate layer) for a project within the same file.

- ✓ To select the actual element (the nontransparent pixels) on the layer, Ctrl-click (ℋ-click on the Macintosh) the layer's thumbnail (not the name) on the panel.
- ✓ To create a new blank layer, click the Create A New Layer icon at the top of the panel.
- ✓ **To add a layer mask**, click the Add Layer Mask icon at the top of the panel. A layer mask enables you to selectively show and hide elements or adjustments on your layer, as well as creatively blend layers together. For more details, see "Adding Layer Masks," later in this chapter.
- ✓ **To create an adjustment layer,** click the Create A New Fill Or Adjustment Layer icon at the top of the panel. *Adjustment layers* are special layers that modify contrast and color in your image. You can also add *fill layers* layers containing color, gradients, or patterns by using this command. We give you more details on adjustment and fill layers in the section "Working with Different Layer Types," later in this chapter.
- ✓ To duplicate an existing layer, drag the layer to the Create A New Layer icon at the top of the panel.
- Rearranging layers. To move a layer to another position in the stacking order, drag the layer up or down on the Layers panel. While you drag, you see a fist icon. Release the mouse button when a highlighted line appears where you want to insert the layer.

If your image has a background, it always remains the bottommost layer. If you need to move the background, convert it to a layer by double-clicking the name on the Layers panel. Enter a name for the layer and click OK.

- When you create a new layer, Elements provides default layer names (Layer 1, Layer 2, and so on). If you want to rename a layer, double-click the layer name on the Layers panel and enter the name directly on the Layers panel.
- Adjusting the interaction between colors on layers, and adjusting the transparency of layers. You can use

©istockphoto/meltonmedia Image #1779174, tomh1000 Image #1281272

Figure 8-3: We created this effect by using blend modes and opacity options.

the blend modes and the opacity options at the top of the panel to mix the colors between layers and adjust the transparency of the layers, as shown in Figure 8-3.

- Linking layers. Sometimes you want your layers to stay grouped as a unit to make your editing tasks easier. If so, link your layers by selecting the layers on the panel and then clicking the Link Layers icon at the top of the panel. A link icon appears to the right of the layer name. To remove the link, click the Link Layers icon again.
- To lock layers, select your desired layer or layers and then click one of the two lock icons at the top of the panel. The *checkerboard square icon* locks all transparent areas of your layers. This lock prevents you from painting or editing any transparent areas on the layers. The *lock icon* locks your entire layer and prevents it from being changed in any way, including moving or transforming the elements on the layer. You can, however, still make selections on the layer. To unlock the layer, simply click the icon again to toggle off the lock.

By default, the background is locked and can't be unlocked until you convert it into a layer by choosing Layer⇔New⇔Layer from Background.

To delete a layer, drag it to the trash icon.

Using the Layer and Select menus

As with many features in Elements, you usually have more than one way to do something. This is especially true when it comes to working with layers. Besides the commands on the Layers panel, you have two layer menus — the Layer menu and the Select menu — both of which you can find on the main menu bar at the top of the application window (top of the screen on the Macintosh).

The Layers menu

Much of what you can do with the Layers panel icons you can also do by using the Layer menu on the menu bar and the Layers panel menu connected to the Layers panel. (Access the Layers panel menu by clicking the horizontally lined button in the upper-right corner of the Layers panel.) Commands, such as New, Duplicate, Delete, and Rename, are omnipresent throughout. But you find commands that are exclusive to the Layers panel, the main Layer menu, and the Layers menu, respectively. So, if you can't find what you're looking for in one area, just go to another. Some commands require more explanation and are described in the sections that follow. However, here's a quick description of most of the commands:

- ✓ Delete Linked Layers and Delete Hidden Layers. These commands delete only those layers that have been linked or hidden from display on the Layers panel.
- ✓ Layer Style. These commands manage the styles, or special effects, you apply to your layers.
- ✓ Arrange. This enables you to shuffle your layer stacking order with options such as Bring to Front and Send to Back. Reverse switches the order of your layers if you have two or more layers selected.
- ✓ Create Clipping Mask. In a clipping mask, the bottommost layer (base layer) acts as a mask for the layers above it. The layers above "clip" to the opaque areas of the base layer and don't show over the transparent areas of the base layer. Clipping masks work well when you want to fill a shape or type with different image layers.
- ✓ Type. The commands in the Type submenu control the display of type layers. For more on type, see Chapter 13.
- Rename Layer. This enables you to give a layer a new name. You can also simply double-click the name on the Layers panel.
- ✓ Simplify Layer. This converts a type layer, shape layer, or fill layer into a regular image layer. Briefly, a *shape layer* contains a vector object, and a *fill layer* contains a solid color, a gradient, or a pattern.
- Merge and Flatten. The various merge and flatten commands combine multiple layers into a single layer or, in the case of flattening, combine all your layers into a single background.
- Panel Options. You can select display options and choose to use a layer mask on your adjustment layers. Leave this option selected.

The Select menu

Although the Select menu's main duties are to assist you in making and refining your selections, it offers a few handy layer commands. Here's a quick introduction to each command:

- ✓ Select All Layers. Want to quickly get everything in your file? Choose Select

 All Layers.
- ✓ Select Layers of Similar Type. This command is helpful if you have different types of layers in your document, such as regular layers, type layers, shape layers, and adjustment layers, and you want to select just one type. Select one of your layers and then choose Select⇔Similar Layers. For details on different types of layers, see the following section.
- ✓ Deselect All Layers. If you want to ensure that nothing is selected in your document, simply choose Select Deselect Layers.

Working with Different Layer Types

Layer life exists beyond just converting an existing background into a layer, which we describe in the section "Getting to Know Layers," earlier in this chapter. In fact, Elements offers five kinds of layers. You'll probably spend most of your time creating image layers, but just so that you're familiar with all types, the following sections describe each one.

Image layers

The *image layer*, usually just referred to as a *layer*, is the type of layer we're referring to when we give the analogy of acetate sheets in the section "Getting to Know Layers," earlier in this chapter. You can create blank layers and add images to them, or you can create layers from images themselves. You can have as many image layers as your computer's memory allows. Just keep in mind that the more layers you have, the larger your file size and the slower your computer speed.

Each layer in an image can be edited without affecting the other layers. You can move, paint, size, or apply a filter, for example, without disturbing a single pixel on any other layer or on the background, for that matter. And, when an element is on a layer, you no longer have to make a selection to select it — just drag the element with the Move tool. (See Chapter 7 for information on selections.)

Adjustment layers

An *adjustment layer* is a special kind of layer used for modifying color and contrast; Figure 8-4 shows an example. The advantage of using adjustment layers for your corrections, rather than applying them directly on the image layer, is that you can apply the corrections without permanently affecting the pixels. This means that adjustment layers are totally nondestructive. And, because the correction is on a layer, you can edit, or even delete, the

adjustment at any time. Adjustment layers apply the correction only to all the layers below them, without affecting any of the layers above them.

Another unique feature of adjustment layers is that when you create one, you also create a layer mask on that layer at the same time. If you are unfamiliar with layer masks, take a peek at the section "Adding Layer Masks," later in this chapter. The layer mask allows you to selectively and even partially apply the adjustment to the layers below it by applying shades of gray — from white to black — on the mask. For example, by default, the mask is completely white (refer to Figure 8-4). This allows the adjustment to be fully applied to the layers. If you paint on a layer mask with black, the areas under those black areas don't

Figure 8-4: Adjustment layers correct color and contrast in your image.

show the adjustment. If you paint with a shade of gray, those areas partially show the adjustment. Note that if you have an active selection border in your image before you add an adjustment layer, the adjustment is applied only to that area within the selection border.

Elements has eight kinds of adjustment layers, and you can use as many as you want. These are the same adjustments that you find on the Enhance Adjust Lighting, Enhance Adjust Color, and Filter Adjustments submenus. For specifics on each adjustment, see Chapters 9 and 10. Here's how to create an adjustment layer:

Open an image that needs a little contrast or color adjustment.

Note that you don't need to convert your background into a layer to apply an adjustment layer.

Click the Create New Fill or Adjustment Layer icon at the top of the Layers panel, and from the drop-down menu, choose your desired adjustment.

The Adjustment Layer icon and a thumbnail appear on the adjustment layer. The thumbnail represents the layer mask. And the dialog box specific to your adjustment appears in the Adjustments panel.

3. Make the necessary adjustments in the particular Adjustments panel.

To selectively allow only portions of your image to receive the adjustment, you can paint on the layer mask using the Brush or Pencil tool. Or you can make a selection and fill that selection with any shade of gray, from white to black. Another technique is to use the Gradient tool on the mask to create a gradual application of the adjustment, as shown in Figure 8-5.

As with image layers, you can adjust the opacity and blend modes of an adjustment layer. Reducing the opacity of an adjustment layer reduces the effect of the adjustment on the underlying layers.

Here are a few more tips on using adjustment layers:

To view your image without the adjustment, click the eye icon in the left column of the Layers panel to hide the adjustment layer.

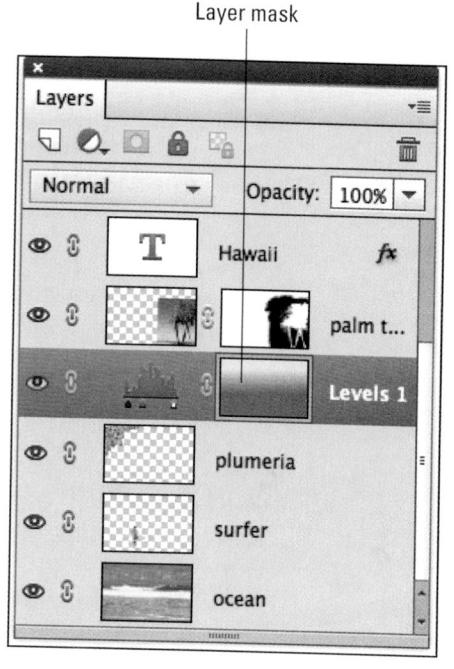

Figure 8-5: Layer masks control the amount of adjustment applied to your layers.

- ✓ To delete the adjustment layer, drag it to the trash icon on the Layers panel.
- To edit an adjustment layer, simply double-click the adjustment layer on the Layers panel. You can also choose Layer Cayer Content Options. In the dialog box that appears in the Adjustment panel, make any desired edits. The only adjustment layer that you can't edit is the Invert adjustment. It's either on or off.
- To use the adjustment panel controls, click an icon. From left to right, here's what the icons do:
 - Have the adjustment layer clip to the layer below. (It will affect only the layer directly beneath it, not all the underlying layers in the stack.)
 - Toggle the adjustment layer on and off.
 - Reset the adjustment layer settings back to the default.

Fill layers

A *fill layer* lets you add a layer of solid color, a gradient, or a pattern. Like adjustment layers, fill layers also include layer masks. You can edit, rearrange, duplicate, delete, and merge fill layers similarly to adjustment layers. You can blend fill layers with other layers by using the opacity and blend mode options on the Layers panel. Finally, you can restrict the fill layer to just a portion of your image by either making a selection first or painting on the mask later.

Follow these steps to create a fill layer:

1. Open an image.

Use an image that will look good with a frame or border of some kind. Remember that if you don't have a selection, the fill layer covers your whole image.

Click the Create New Fill or Adjustment Layer icon on the Layers panel. From the drop-down menu, choose a fill of a solid color, gradient, or pattern.

The dialog box specific to your type of fill appears.

3. Specify your options, depending on the fill type you chose in Step 2:

- Solid Color. Choose your desired color from the Color Picker. See Chapter 12 for details on choosing colors and also gradients and patterns.
- Gradient. Click the down-pointing arrow to choose a preset gradient from the drop-down panel, or click the gradient preview to display the Gradient Editor and create your own gradient.
- Pattern. Select a pattern from the drop-down panel. Enter a value to scale your pattern, if you want. Click Snap to Origin to make the origin of the pattern the same as the origin of the document. Select the Link with Layer option to specify that the pattern moves with the fill layer if you move that layer.

4. Click OK.

The fill layer appears on the Layers panel, as shown in Figure 8-6. Notice the layer mask that was created on the fill layer. We filled our entire layer mask with black, with just the exception of the outside edge to create a frame around our image.

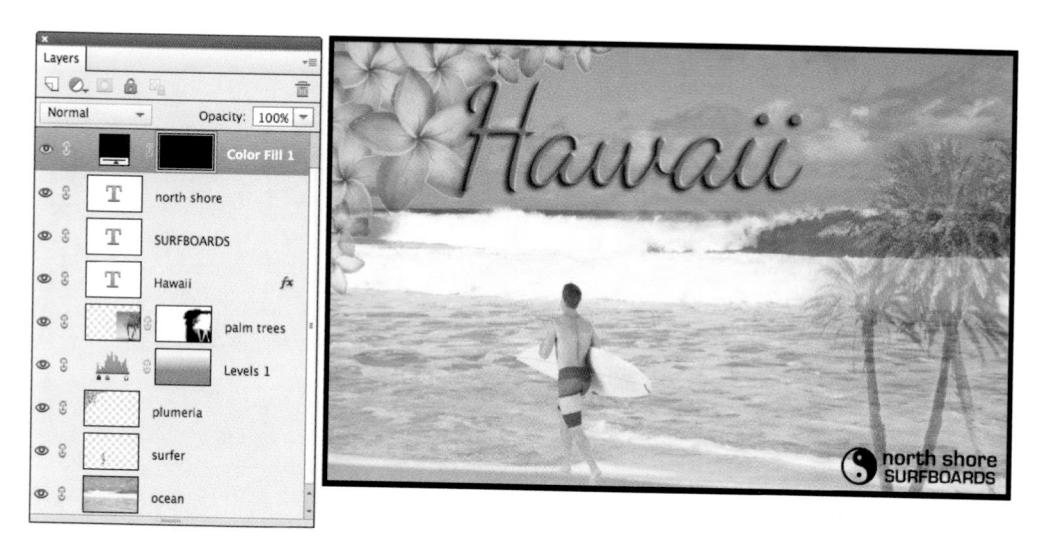

©istockphoto.com/ Kubrak78 Image #12642467, naomiwoods Image #9128343, 4x6, Image #20236672, goldhafen Image #1512452

Figure 8-6: Add a frame or border with a fill layer.

Shape layers

If you haven't made your way to Chapter 12 yet, you may be surprised to discover that Elements also lets you draw shapes with six different drawing tools. These shapes also have the bonus of being *vector*-based. This means that the shapes are defined by mathematical equations, which consist of points and paths, instead of pixels. The advantage of vector-based objects is that you can freely resize these objects without causing degradation. In addition, they're always printed with smooth edges, not with the jaggies you're familiar with seeing in pixel-based elements.

To create a shape layer, grab a shape tool from the Tools panel and drag it on your canvas. When you create a shape, it resides on its own, unique shape layer, as shown by the yin-and-yang logo in the bottom-right corner of Figure 8-6. As with other types of layers, you can adjust the blend modes and opacity of a shape layer. You can also edit, move, and transform the actual shapes. However, to apply filters, you must first *simplify* the shape layer. This process converts the vector paths to pixels.

Type layers

To add words to your images (refer to Figure 8-6), click your canvas with the Type tool selected and just type. It's really as easy as that. Well, you can specify options, such as a font family and size, in the Options, but when you click the Commit button on the image window, you create a type layer. On the Layers panel, the type layer displays a T icon. For details on working with type, check out Chapter 13.

Tackling Layer Basics

Image layers are the heart and soul of the layering world. You can create multiple image layers within a single image. Even more fun is creating a composite from several different images. Add people you like; take out people you don't. Pluck people out of boring photo studios and put them in exotic locales. The creative possibilities are endless. In the following sections, we cover all the various ways to create image layers.

Creating a new layer from scratch

If you're creating a new, blank file, you can select the Transparent option for your background contents. Your new file is created with a transparent layer and is ready to go. If you have an existing file and want to create a new, blank layer, here are the ways to do so:

- ✓ Click the Create a New Layer icon at the bottom of the Layers panel.
- Choose New Layer from the Layers panel menu.
- ∠ Choose Layer
 New
 Layer.

Note that if you create a layer by using either of the menu commands, you're presented with a dialog box with options. In that dialog box, you can name your layer and specify options for grouping, blending, and adjusting opacity. Provide a name for your layer and click OK. You can always adjust the other options directly on the Layers panel later.

You can also use the Copy and Paste commands without even creating a blank layer first. When you copy and paste a selection without a blank layer, Elements automatically creates a new layer from the pasted selection. A better method of copying and pasting between multiple images, however, is to use the drag-and-drop method, which we describe in the section "Dragging and dropping layers," later in this chapter.

The Copy Merged command on the Edit menu creates a merged copy of all visible layers within the selection.

After you create your layer, you can put selections or other elements on that layer by doing one or more of the following:

- Grab a painting tool, such as the Brush or Pencil, and paint on the layer.
- Make a selection on another layer or on the background within the same document, or from another image entirely, and then choose Edit Copy. Select your new, blank layer on the Layers panel and then choose Edit Apste.

©istockphoto.com/Kubrak78 Image #12642467

Figure 8-7: When you cut a selection from a layer, take note of the resulting hole in the original location.

Make a selection on another layer or on the background within the same document, or from another image, and then choose Edit Cut. Select your new, blank layer and then choose Edit Paste. Be aware that this action removes that selection from its original location and leaves a transparent hole, as shown in Figure 8-7.

Using Layer via Copy and Layer via Cut

Another way to create a layer is to use the Layer via Copy and Layer via Cut commands on the Layer menu. Make a selection on a layer or background and choose Layer New Layer via Copy or Layer via Cut. Elements automatically creates a new layer and puts the copied or cut selection on the layer. Remember that if you use the Layer via Cut command, your selection is deleted from its original location layer, and you're left with a transparent hole. If you use the background for the source, your background color fills the space. A reminder: You can use these two commands only within the same image. You can't use them among multiple images.

Duplicating layers

Duplicating layers can be helpful if you want to protect your original image while experimenting with a technique. If you don't like the results, you can always delete the duplicate layer. No harm, no foul.

To duplicate an existing layer, select it on the Layers panel and do one of four things:

- ✓ Drag the layer to the Create a New Layer icon at the top of the panel. Elements creates a duplicate layer with *Copy* appended to the name of the layer.
- Choose Duplicate Layer from the Layers panel menu.
- ✓ Choose Layer

 Duplicate Layer.
- ✓ Choose Layer

 New

 Layer via Copy (make sure you don't have an active selection when choosing this command.

If you use the menu methods, a dialog box appears, asking you to name your layer and specify other options. Provide a name for your layer and click OK. You can specify the other options later, if you want.

Dragging and dropping layers

The most efficient way to copy and paste layers between multiple images is to use the drag-and-drop method. Why? Because it bypasses your Clipboard, which is the temporary storage area on your computer for copied data. Storing data, especially large files, can bog down your system. By keeping your Clipboard clear of data, your system operates more efficiently. If you already copied data and it's lounging on your Clipboard, choose Edit Clear Clipboard Contents to empty your Clipboard.

Here's how to drag and drop layers from one file to another:

- 1. Select your desired layer in the Layers panel.
- 2. Grab the Move tool (the four-headed arrow) from the Tools panel.
- 3. Drag and drop the layer onto your destination file.

The dropped layer pops in as a new layer above the active layer in the image. You don't need to have a selection border to copy the entire layer. But if you want to copy just a portion of the layer, make your selection before you drag and drop with the Move tool. If you want the selected element to be centered on the destination file, press the Shift key while you drag and drop.

Here's a handy tip: If you have several elements (that aren't touching each other) on one layer and you want to select only one of the elements to drag and drop, use the Lasso tool to make a crude selection around the object without touching any of the other elements. Then press the Ctrl (# on the Macintosh) key and press the up-arrow key once. The element then becomes perfectly selected. You can now drag and drop with the Move tool.

Using the Paste into Selection command

The Paste into Selection command lets you put an image on a separate layer while also inserting that image into a selection border. For example, in Figure 8-8, we used this command to make it appear as though our surfer is in the water.

You can do the same by following these steps:

 Make your desired selection on the layer in your destination image.

In our figure, we selected the area in the water where the surfer would be positioned.

2. Select the image that will fill that selection.

The image can be within the same file or from another file. Our surfer was in another file.

- 3. Choose Edit⇔Copy.
- 4. Return to the destination image layer and choose Edit Paste into Selection.

©istockphoto.com/Kubrak78 Image#12642467, 4x6 Image #20236672

Figure 8-8: Use the Paste into Selection command to make one element appear as though it's coming out of another element.

Elements converts the selection border on the layer into a layer mask. The pasted selection is visible only inside the selection border. In our example, the surfer only shows inside the selected area. His ankles and feet are outside the border and therefore are hidden.

Moving a Layer's Content

Moving the content of a layer is a piece of cake: Grab the Move tool from the Tools panel, select your layer on the Layers panel, and drag the element on the canvas to your desired location. You can also move the layer in 1-pixel increments by using the keyboard arrow keys. Press Shift with the arrows to move in 10-pixel increments.

The Auto-Select Layer option in the Tool Options enables you to switch to a layer when you click any part of that layer's content with the Move tool. But be careful if you have a lot of overlapping layers because this technique can sometimes be more trouble than it's worth.

The Move tool has additional options. Here's the lowdown:

- ✓ Show Bounding Box. This option surrounds the contents of your layer with a dotted box that has handles, enabling you to easily transform your layer. Find details in the following section.
- ✓ Show Highlight on Rollover. Hover your mouse anywhere over the canvas to make an outline appear around the element on your layer. Click the highlighted layer to select it and then move it.
- Arrange submenu. This menu enables you to change your selected layer's position in the stacking order.
- Link Layers. This option, which resides not in the Tool Options, but in the Layers panel, connects the layers to make it easier to move (or transform) multiple layers simultaneously. Select a layer and then Ctrlclick (第-click on the Macintosh) to select more layers. Click the Link Layers option.
- ✓ **Align submenu.** Align your selected layers on the left, center, right, top, middle, and bottom. As with linking, select your first layer and then Shift-click to select more layers. Ctrl-click (ℋ-click on the Macintosh) to select non-consecutive layers. Choose an alignment option.
- ✓ Distribute submenu. Use this menu to evenly space your selected layers on the left, center, right, top, middle, and bottom. As with aligning, select your first layer and then Shift-click to select more layers. Ctrl-click (ૠ-click on the Macintosh) to select non-consecutive layers. Choose your desired distribution option.

Transforming Layers

When working with layers, you may need to scale or rotate some of your images. You can do so easily by applying the Transform and Free Transform commands. The methods to transform layers and selections are identical.

Here's how to transform a layer:

1. Select your desired layer.

You can also apply a transformation to multiple layers simultaneously by linking the layers first.

2. Choose Image⇔Transform⇔Free Transform.

A bounding box surrounds the contents of your layer. Drag a corner handle to size the contents. Press Shift while dragging to constrain the proportions. To rotate the contents, move the mouse cursor just outside a corner handle until it turns into a curved arrow, and then drag. To distort, skew, or apply perspective to the contents, right-click and choose the desired command from the context menu. You can also click the rotate, scale, and skew icons in the Tool Options, as well as enter your transform values numerically in the fields.

If you want to apply just a single transformation, you can also choose the individual Distort, Skew, and Perspective commands from the Image

Transform menu. Or, to rotate or flip, you can choose Image

Rotate.

3. When your layer is transformed to your liking, double-click inside the bounding box.

Try to perform all your transformations in one execution. Each time you transform pixels, you put your image through the *interpolation process* (analyzing the colors of the original pixels and "manufacturing" new ones). Done to the extreme, this process can degrade the quality of your image. This is why it's prudent to use the Free Transform command, rather than individual commands — so that all transformations can be executed in one fell swoop.

When the Move tool is active, you can transform a layer without choosing a command. Select the Show Bounding Box option in the Tool Options. This option surrounds the layer, or selection, with a box that has handles. Drag the handles to transform the layer or selection.

Adding Layer Masks

One of the best creative tools Elements has to offer is layer masks. *Masking* is essentially just another way of making a selection. Instead of making a selection with a single selection outline — either it is selected or it isn't — masks enable you to define your selection with up to 256 levels of gray (from white to black). You can therefore have varying levels of a selection.

Here's how it works. First, think of a layer mask as a sheet of acetate that hovers over your layer. With any of the painting tools (Brush tool, Gradient tool, and others), you apply black, white, or any shade of gray onto the layer mask. Where the mask is white, the image on the layer is selected and shows. Where the mask is black, the image is unselected and is hidden. And where the mask is gray, the image is partially selected; therefore it partially shows. The lighter the gray, the more the image shows. By default, the mask starts out completely white so that everything is selected and shows.

Here are some things you can do with layer masks:

Creatively blend one layer into another. If you want one image to gradually dissolve into another, using a layer mask is the way to go. Try using the Gradient tool with the black to white gradient selected to create a soft dissolve. You can use layer masks to blend images together in a realistic manner, as shown in Figure 8-9 where we combined a goldfish and a strange, bottled green beverage. In the figure, you can see where we painted with black to completely hide the original background of the fish image. We painted with gray on the fish to make it appear as if it is truly "swimming" in the green liquid. In other words, some of the liquid of the underly-

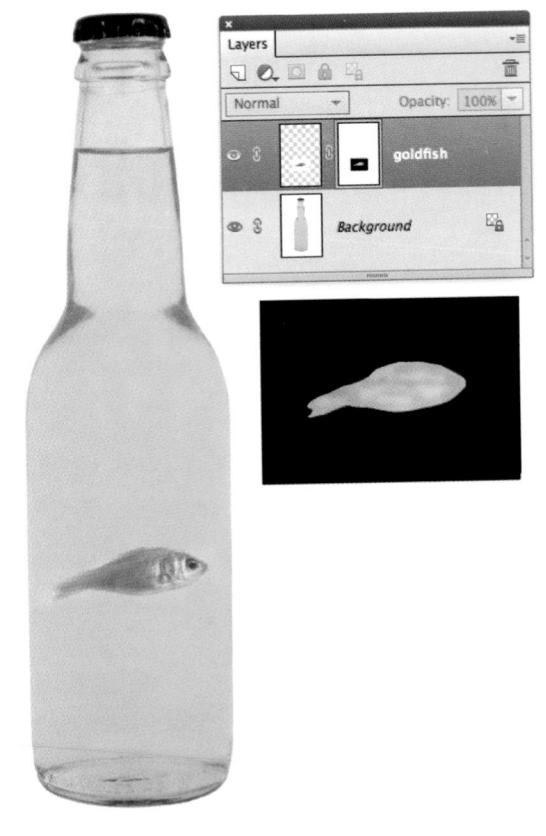

©istockphoto.com/joxxxxjo Image #2466705, Kameleon007 Image #2558590 Figure 8-9: Add a layer mask to gradually blend one layer into another.

ing bottle image will show through to the fish layer.

- Adjust your layer mask to selectively show and hide the effects of the adjustment layer. See the earlier section, "Adjustment layers."
- Apply a filter to your layer mask to create an interesting special effect.

One of the best aspects of layer masks is that you can endlessly edit them. Unlike just making a feathered selection, you can keep adjusting how much of your current layer or underlying images show. Or you can adjust how gradually one image blends into another: Simply change the areas of white, black, and gray on the layer mask by painting with any of

the painting tools. Just make sure you select the layer mask and not the image. When you select the layer mask thumbnail in the Layers panel, you see the appearance of an outline around the thumbnail.

You can't add a layer mask to a background. You must convert the background into a layer first.

Here are some other things to keep in mind when you use layer masks:

- ✓ To load the mask as a selection outline, simply Ctrl-click (ૠ-click on the Macintosh) the layer mask thumbnail in the Layers panel.
- ✓ To temporarily hide a mask, Shift-click the layer mask thumbnail in the Layers panel. Repeat to show the mask.
- ✓ To view the mask without viewing the image, Alt-click (Option-click on the Macintosh) on the Layer Mask thumbnail in the Layers panel. This can be helpful when editing a layer mask.
- To unlink a layer from its layer mask, click the link icon in the Layers panel. Click again to reestablish the link. By default, Elements links a layer mask to the contents of the layer. This link enables them to move together.
- ✓ To delete a layer mask, drag its thumbnail to the trash icon in the Layers panel.
- To apply a layer mask, drag the mask thumbnail to the trash icon in the Layers panel and be sure to click Apply in the dialog box. When you apply a layer mask, you fuse the mask to the layer so editing is no longer possible.

Note that many of the preceding commands are also available in the Layer↓ Layer Mask submenu.

Flattening and Merging Layers

Layers are fun and fantastic, but they can quickly chew up your computer's RAM and bloat your file size. And sometimes, to be honest, having too many layers can start to make your file tedious to manage, thereby making you less productive. Whenever possible, you should merge your layers to save memory and space. *Merging* combines visible, linked, or adjacent layers into a single layer (not a background). The intersection of all transparent areas is retained.

In addition, if you need to import your file into another program, certain programs don't support files with layers. Therefore you may need to flatten

your file before importing it. *Flattening* an image combines all visible layers into a background, including type, shape, fill, and adjustment layers. You're prompted as to whether you want to discard hidden layers, and any transparent areas are filled with white. We recommend, however, that before you flatten your image, you make a copy of the file with all its layers intact and save it as a native Photoshop file. That way, if you ever need to make any edits, you have the added flexibility of having your layers.

By the way, the only file formats that support layers are native Photoshop (.psd); Tagged Image File Format, or TIFF (.tif); and Portable Document Format, or PDF (.pdf). If you save your file in any other format, Elements automatically flattens your layers into a background. See Chapter 4 for details on these file types.

Flattening layers

To flatten an image, follow these steps:

1. Make certain that all layers you want to retain are visible.

If you have any hidden layers, Elements asks you whether you want to discard those hidden layers.

 ${\bf 2. \ Choose \ Flatten \ Image \ from \ the \ Layers \ panel \ menu \ or \ the \ Layer \ menu.}$

All your layers are combined into a single background, as shown in Figure 8-10.

If you mistakenly flatten your image, choose Edit Undo or use your Undo History panel. (If you're not familiar with the History panel, see Chapter 3 for details.)

Merging layers

You can merge your layers in a few ways. Here's how:

- Select only those layers you want to merge. Choose Merge Layers from the panel menu or the Layer menu.
- ✓ Display only those layers you want to merge. Click the eye icon on the Layers panel to hide those layers you don't want to merge. Choose Merge Visible from the Layers panel menu or the Layer menu.
- ✓ Arrange the layers you want to merge so that they're adjacent to each other on the Layers panel. Select the topmost layer of that group and choose Merge Down from the Layers panel menu or the Layer menu. Note that Merge Down merges your active layer with the layer directly below it.

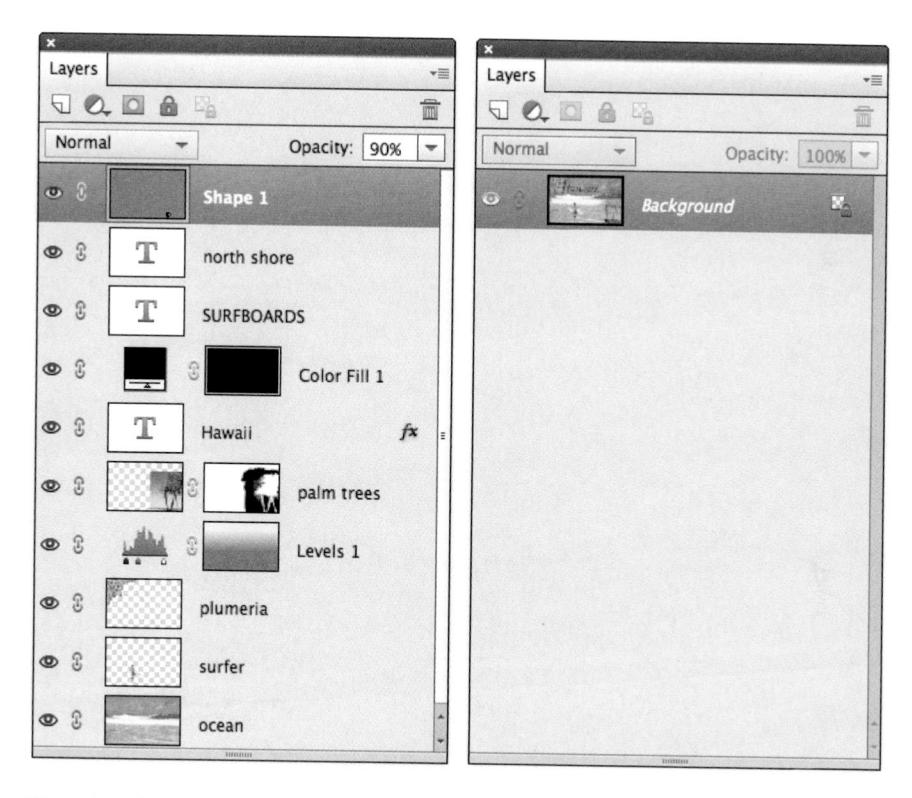

Figure 8-10: Flattening combines all your layers into a single background.
Simple Image Makeovers

In This Chapter

- Cropping and straightening your images
- Using one-step auto fixes
- Editing in Quick mode
- Fixing small imperfections

Lixing images quickly, without pain or hassle, is probably one of the most desirable features you'll find in Elements and one that we're sure you'll embrace frequently. Whether you're an experienced photographer or an amateur shutterbug, cropping away unwanted background, tweaking the lighting or color of an image, and erasing the minor blemishes of a loved one's face are all editing tasks you'll most likely tackle. With the simple image-make-over tools in Elements, these tasks are as easy as clicking a single button or making a few swipes with a brush.

Cropping and Straightening Images

Cropping a photo is probably one of the easiest things you can do to improve its composition. Getting rid of the unnecessary background around your subject creates a better focal point. Another dead giveaway of amateurish photography is crooked horizon lines. Not a problem. Elements gives you several ways to straighten those images after the fact. So, after your next photo shoot, launch the Elements Photo Editor and then crop and straighten your images before you show them off.

Cutting away with the Crop tool

The most common way to crop a photo is by using the Crop tool. Simple, quick, and easy, this tool gets the job done. Here's how to use it:

1. In either Expert or Quick mode, select the Crop tool from the Tools panel.

You can also press the C key. For details on the different editing modes, see Chapter 2. For full details on Quick mode, see the section "Editing in Quick Mode," later in this chapter.

2. Specify your aspect ratio and resolution options in the Tool Options under the image window.

Here are your choices:

- *No Restriction* allows you to freely crop the image at any size.
- *Use Photo Ratio* retains the original aspect ratio of the image when you crop.
- Preset Sizes offers a variety of common photographic sizes. When you crop, your image then becomes that specific dimension.

When you crop an image, Elements retains the original resolution of the file (unless you specify otherwise in the resolution option). Therefore, to keep your image at the same image size while simultaneously eliminating portions of your image, Elements must resample the file. Consequently, your image must have sufficient resolution so that the effects of the resampling aren't too noticeable. This is especially true if you're choosing a larger preset size. If all this talk about resolution and resampling is fuzzy, be sure to check out Chapter 4.

- *Width (W) and Height (H).* Enables you to specify a desired width and height to crop your image.
- Resolution. Specify a desired resolution for your cropped image.
 Again, try to avoid resampling your image.
- Pixels/in or Pixels/cm. Specify your desired unit of measurement.
- Overlay. Elements gives you an added tool to help you frame your image prior to cropping. Choose from the various options such as None, Grid, Rule of Thirds, or Golden Ratio.

Rule of Thirds is a long-time photographic principle that encourages placing most interesting elements, or your intended focal point, at one of four intersecting points in your grid of two vertical and two horizontal lines, as shown in Figure 9-1. See Chapter 17 for additional information.

 ${\it Grid}$ displays just that — a grid of intersecting horizontal and vertical lines — over the image.

Golden Ratio (aka Golden Rectangle) is another compositional principle, used by artists and architects throughout history, based on a rectangle that can then be divided into a square and rectangle — in which that resulting rectangle is also a golden rectangle. If you subdivide that rectangle into a square and rectangle, you will once again get another golden rectangle, and so on. The actual ratio works out to 1:1.618. You can crop your image into this magical golden rectangle. Also within the golden rectangle, the intersection of the two diagonals or in the very center (as you see in the overlay) is a great spot to put your focal point. Interestingly, the Rule of Thirds is really a simplified version of the Golden Ratio. Click the Flip button to flip your Golden Ratio overlay. Note that you can also rotate your overlay.

3. Drag around the portion of the image you want to retain and release the mouse button.

When you drag, a crop marquee bounding box appears. Don't worry if your cropping marquee isn't exactly correct. You can adjust it in Step 4.

The area outside the cropping marquee (called a *shield*) appears darker than the inside in order to better frame your image, as shown in Figure 9-1. If you want to change the color and opacity of the shield, or if you don't want it at all, change your Crop preferences by choosing Edit⇔Preferences⇔Display & Cursors. (On the Macintosh, choose Adobe Photoshop Elements Editor ⇔Preferences⇔Display & Cursors.)

4. Adjust the cropping marquee by dragging the handles of the crop marquee bounding box.

To move the entire marquee, position your mouse inside the marquee until you see a black arrowhead cursor, and then drag.

If you move your mouse outside the marquee, your cursor changes to a curved arrow. Drag with this cursor to rotate the marquee. This action allows you to both rotate and crop your image simultaneously — handy for straightening a crooked image. Just be aware that rotation, unless it's in 90-degree increments, also resamples your image.

5. Double-click inside the cropping marquee.

You can also just press Enter or click the green Commit button next to the marquee. Elements then discards the area outside the marquee. To cancel your crop, click the red Cancel button.

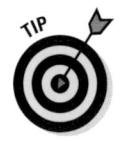

If you're in the Organizer, click the Instant Fix button in the bottom right corner. You'll find the Crop tool in the Photo Fix Options panel.

©istockphoto.com/gehringj Image #9063164

Figure 9-1: The shield and Rule of Thirds overlay allow for easy framing of your image.

Cropping with a selection border

You can crop an image by choosing Image Crop in either Expert or Quick mode. First, make a selection with any of the selection tools and then choose the command. You can use this technique with any selection border shape. That is, your selection doesn't have to be rectangular. It can be round or even freeform. Your cropped image doesn't take on that shape, but Elements crops as close to the boundaries of the selection border as it can. For details about making selections, see Chapter 7.

Straightening images

There may be times when you just didn't quite get that horizon straight when you took a photo of the beach. Or maybe you scanned a photo and it wasn't quite centered in the middle of the scanning bed. It's not a big deal. Elements gives you several ways to straighten an image.

Using the Straighten tool

This tool enables you to specify a new straight edge, and it then rotates the image accordingly. Here's how to use the Straighten tool:

- 1. In Expert mode, select the Straighten tool from the Tools panel (or press the P key).
- 2. Specify your desired setting from the Canvas Options in the Tool Options.

Here are your choices:

- *Grow or Shrink* rotates the image and increases or decreases the size of the canvas to fit the image area.
- *Remove Background* trims off background canvas outside the image area. This choice is helpful if you scan an image and white areas appear around your photo that you want removed.
- Original Size rotates your image without trimming off any background canvas.
- 3. (Optional) Select Rotate All Layers.

If you have an image with layers and you want all of them rotated, select this option.

4. Draw a line in your image to represent the new straight edge.

Your image is then straightened and, if you chose any of the crop options in Step 2, also cropped.

Using the Straighten menu commands

In addition to using the Straighten tool, you can straighten your images by using two commands on the Image menu, in either Expert or Quick mode:

- ✓ **To automatically straighten an image without cropping,** choose Image Rotate Straighten Image. This straightening technique leaves the canvas around the image.
- ✓ To automatically straighten and crop the image simultaneously, choose Image⇔Rotate⇔Straighten and Crop Image.

Recomposing Images

This great tool actually allows you to resize, or as the name implies, recompose, your image without losing any vital content. For example, if you need to have people in your shot closer together because you need the final, cropped image to be more square than rectangular, this tool can help. Here's how it works:

- 1. In Expert mode, select the Recompose tool from the Tools panel. You can also press the W key.
- 2. In the Tool Options, select the Mark for Protection Brush (the brush with a plus sign icon) and brush over the areas in your image that you want to keep or protect.

You can specify your brush size with the Size option slider. You can erase any mistakes by using the Erase Highlights Marked for Protection tool (eraser with a plus sign icon).

3. With the Mark for Removal Brush (brush with a minus sign icon), brush over the areas in your image that you want to remove or aren't vital to your final image, as shown in Figure 9-2.

You can specify your brush size with the Size option slider. You can erase any mistakes by using the Erase Highlights Marked for Removal tool (eraser with a minus-sign icon).

©istockphoto.com/alynst Image #11082865

Figure 9-2: Brush over areas you want to protect and remove in your image.

4. Specify any other desired settings in the Tool Options.

Here are the other options:

- *Threshold:* The slider determines how much recomposing appears in your adjustment. 100% totally recomposes your image. Experiment to get the results you want.
- Preset ratios. Choose from preset aspect ratios to have your image framed to those dimensions. Or choose No Restriction to have free reign.
- Width and Height. This option resizes your image to your specified dimensions.
- *Highlight Skin Tones (green man icon)*. Select this option to prevent skin tones from distorting when resizing.
- 5. Resize, or recompose, your image by dragging the corner or side handles, as shown in Figure 9-3, where I moved my bikes closer together.
- Click the Commit button (green check-mark icon) when you have your desired composition.

©istockphoto.com/alynst Image #11082865

Figure 9-3: Recompose your image to your desired size and aspect ratio without losing vital content.

Employing One-Step Auto Fixes

Elements has five automatic lighting-, contrast-, and color-correction tools that can improve the appearance of your images with just one menu command. These commands are available in either Expert or Quick mode, and

they're all on the Enhance menu. For more on Quick mode, see the section "Editing in Quick Mode," later in this chapter.

The advantage of these one-step correctors is that they're extremely easy to use. You don't need to have one iota of knowledge about color or contrast to use them. The downside to using them is that sometimes the result isn't as good as you could get via a manual color-correction method. And sometimes these correctors may even make your image look worse than before by giving you weird color shifts. But because these correctors are quick and easy, try them on an image that needs help. Usually, you don't want to use more than one of the auto fixes. If one doesn't work on your image, undo the fix and try another. If you still don't like the result, move on to one of the manual methods we describe in Chapter 10.

Auto Smart Fix

This all-in-one command is touted to adjust it all. It's designed to improve the details in shadow and highlight areas, and correct the color balance, as shown in Figure 9-4. The overexposed image on the left was improved quite nicely with the Auto Smart Fix command.

Figure 9-4: In a hurry? Apply the Auto Smart Fix command to quickly improve an image.

The Auto Smart Fix command, as well as the Auto Color, Auto Levels, Auto Contrast, Auto Sharpen, and Auto Red Eye Fix, are also available in the Organizer (in the Photo Fix Options pane), where you can apply the commands to several selected images simultaneously.

If the Auto Smart Fix was just too "auto" for you, you can crank it up a notch and try Adjust Smart Fix. This command is similar to Auto Smart Fix but gives

you a slider that allows you, not Elements, to control the amount of correction applied to the image.

Auto Levels

The Auto Levels command adjusts the overall contrast of an image. This command works best on images that have pretty good contrast (even range of tones and detail in the shadow, highlight, and midtone areas) to begin with and need just a minor amount of adjustment. Auto Levels works by *mapping*, or converting, the lightest and darkest pixels in your image to black and white, thereby making highlights appear lighter and shadows appear darker, as shown in Figure 9-5.

Figure 9-5: Auto Levels adjusts the overall contrast of an image.

Although Auto Levels can improve contrast, it may also produce an unwanted *colorcast* (a slight trace of color). If this happens, undo the command and try the Auto Contrast command instead. If that still doesn't improve the contrast, it's time to bring out the big guns. Try the Levels command we describe in Chapter 10.

Auto Contrast

The Auto Contrast command is designed to adjust the overall contrast in an image without adjusting its color. This command may not do as good a job of improving contrast as the Auto Levels command, but it does a better job of retaining the color balance of an image. Auto Contrast usually doesn't cause the funky colorcasts that can occur when you're using Auto Levels. This command works great on images with a haze, as shown in Figure 9-6.

Figure 9-6: The Auto Contrast command works wonders on hazy images.

Auto Color Correction

The Auto Color Correction command adjusts both the color and contrast of an image, based on the shadows, midtones, and highlights it finds in the image and a default set of values. These values adjust the amount of black and white pixels that Elements removes from the darkest and lightest areas of the image. You usually use this command to remove a colorcast or to balance the color in your image, as shown in Figure 9-7. Occasionally, this command can also be useful in correcting oversaturated or undersaturated colors.

Figure 9-7: Use Auto Color Correction to remove a colorcast.

Auto Sharpen

Photos taken with a digital camera or scanned on a flatbed scanner often suffer from a case of overly soft focus. Sharpening gives the illusion of increased focus by increasing the contrast between pixels. Auto Sharpen attempts to improve the focus, as shown in Figure 9-8, without overdoing it. What happens when you oversharpen? Your images go from soft to grainy and noisy. For more precise sharpening, check out the Unsharp Mask and Adjust Sharpness features we cover in Chapter 10.

Always make sharpening your last fix after you make all your other fixes and enhancements.

Figure 9-8: Use Auto Sharpen to improve focus.

Auto Red Eye Fix

This command is self-explanatory. The Auto Red Eye Fix command automatically detects and eliminates red-eye in an image. Red-eye happens when a person or an animal (where red-eye can also be yellow-, green-, or even blue-eye) looks directly into the flash.

If for some reason the Auto Red Eye Fix doesn't quite do the trick, you can always reach for the Red Eye tool on the Tools panel. Here's how to remove red-eye manually:

- 1. Select the Red Eye tool from the Tools panel.
- 2. Using the default settings, click the red portion of the eye in your image.

This one-click tool darkens the pupil while retaining the tonality and texture of the rest of the eye, as shown in Figure 9-9.

Figure 9-9: The Auto Red Eye Fix and the Red Eye tool detect and destroy dreaded red-eye.

- 3. If you're unhappy with the fix, adjust one or both of these settings in the Tool Options:
 - Pupil Radius. Use the slider to increase or decrease the size of the pupil.
 - Darken. Use the slider to darken or lighten the color of the pupil.

If you're trying to fix green-eye (or blue-eye) in animals, your best bet is to use the Color Replacement tool. See the section "Replacing one color with another," at the end of this chapter.

Editing in Quick Mode

Quick mode is a pared-down version of Expert mode that conveniently provides basic fixing tools and tosses in a few unique features, such as a beforeand-after preview of your image.

Here's a step-by-step workflow that you can follow in Quick mode to repair your photos:

1. Select one or more photos in the Organizer, click the Editor button at the bottom of the workspace, and then click the Quick button at the top of the workspace.

Or, if you're in Expert mode, select your desired image(s) from the Photo Bin and then select the Quick button at the top of the workspace.

Note that you can also open images by simply clicking the Open button and selecting your desired files.

2. Specify your preview preference from the View drop-down menu at the top of the workspace.

You can choose to view just your original image (Before Only), your fixed image (After Only), or both images side by side (Before & After) in either portrait (Vertical) or landscape (Horizontal) orientation, as shown in Figure 9-10.

Figure 9-10: Quick mode enables you to view before-and-after previews of your image.

3. Use the Zoom and Hand tools to magnify and navigate around your image. (See Chapter 2 for more on these tools.)

You can also specify the Zoom percentage by using the Zoom slider in the Tool Options or in the top-right of the workspace.

- 4. Choose your desired window view by selecting one of the following buttons located in the Tool Options: 1:1 (Actual Pixels), Fit Screen, Fill Screen (which zooms your image to fill your screen), or Print Size. You also have another Zoom slider located in the Tool Options.
- 5. Crop your image by using the Crop tool on the Tools panel.

You can also use any of the methods we describe in the "Cropping and Straightening Images" section, earlier in this chapter, except for the Straighten tool, which is exclusive to Expert mode.

- 6. To rotate the image in 90-degree increments, click the Rotate Counter Clockwise or Rotate Clockwise button in the left side of the workspace.
- 7. Apply any necessary auto fixes, such as Auto Smart Fix, Auto Levels, Auto Contrast, and Auto Color Correction.

All these commands are on the Enhance menu or in the Smart Fix, Levels, and Color sections in the right pane of the workspace.

Each of these fixes is described in detail in the section "Employing One-Step Auto Fixes," earlier in this chapter. Remember that usually one of the fixes is enough. Don't stack them on top of each other. If one doesn't work, click the Reset button in the top-right corner of the image preview and try another. If you're not happy with the results, go to Step 8. If you are happy, skip to Step 9.

8. If the auto fixes don't quite cut it, get more control by using the sliders available for Smart Fix, Exposure, Levels, Color, and Balance located on the right side of the workspace.

Here's a brief description of each available adjustment:

- Shadows. When you drag the slider to the right, it lightens the darker areas of your image without adjusting the highlights.
- *Highlights*. When you drag the slider to the right, it darkens the lighter areas of your image without adjusting the shadows.
- *Midtones*. Adjusts the contrast of the middle (gray) values and leaves the highlights and shadows as they are.
- Exposure. Adjusts the brightness or darkness of an image. Move the slider left to darken and right to lighten. The values are in increments of f-stops and range from -4 to 4.

- Saturation. Adjusts the intensity of the colors.
- Hue. Changes all colors in an image. Make a selection first to change the color of just one or more elements. Otherwise use restraint with this adjustment.
- Vibrance. Adjusts the saturation of an image by increasing the saturation of less saturated colors more than those that are area already saturated. Tries to minimize clipping (loss of color) as it increases saturation and preserves skin tones. Move the slider right to increase saturation. The values are in increments of f-stops and range from -1 to 1.
- *Temperature*. Adjusts the colors to make them warmer (red) or cooler (blue). You can use this adjustment to correct skin tones or to correct overly cool images (such as snowy winter photos) or overly warm images (such as photos shot at sunset or sunrise).
- *Tint.* Adjusts the tint after you adjust temperature to make the color more green or magenta.

If you still don't get the results you need, move on to one of the more manual adjustments that we describe in Chapter 10.

Note that you can also apply fixes to just selected portions of your image. Quick mode offers the Quick Selection tool for your selection tasks. For details on using this tool, see Chapter 7.

Here is a description of each tool:

- Red Eye tool. Try the Auto Red Eye Fix to remove red-eye from your people's eyes. But if it doesn't work, try using the Red Eye tool. This method is described in the section "Auto Red Eye Fix," earlier in this chapter.
- Whiten Teeth. This fix does what it says it whitens teeth. Be sure to choose an appropriate brush size from the Size slider in the Tool Options. Click the Brush Settings option to specify Hardness, Spacing, Roundness, and Angle of the brush tip. (For more on brush options, see Chapter 12.) Using a brush diameter that's larger than the area of the teeth also whitens/brightens whatever else it touches lips, chin, and so on. Click the teeth. Note that this tool makes a selection and whitens simultaneously. After your initial click, your selection option converts from New Selection to Add to Selection in the Tool Options. If you pick up too much in your dental selection, click the Subtract from Selection option and click the area you want to eliminate. When you're happy with the results of your whitening session, choose Select⇔Deselect or press Ctrl+D (ૠ+D on the Macintosh).

10. Sharpen your image either automatically (by clicking the Auto button under Sharpen in the right pane. You can also choose Enhance Auto Sharpen. If automatically sharpening doesn't do the fix, you can manually drag the Sharpen slider.).

This fix should always be the last adjustment you make on your image.

Fixing Small Imperfections with Tools

Elements provides you with several handy tools to correct minor imperfections in your photos. You can use the Clone Stamp tool to clone parts of your image, heal blemishes with the Healing Brush or Spot Healing Brush tools, lighten or darken small areas with the Dodge and Burn tools, soften or sharpen the focus with the Blur or Sharpen tools, and fix color with the Sponge or Color Replacement tools.

Cloning with the Clone Stamp tool

Elements enables you to clone elements without the hassle of genetically engineering DNA. In fact, the Clone Stamp tool works by just taking sampled pixels from one area and copying, or cloning, them onto another area. The advantage of cloning, rather than making a selection and then copying and pasting, is that it's easier to realistically retain soft-edged elements, such as shadows, as shown in Figure 9-11.

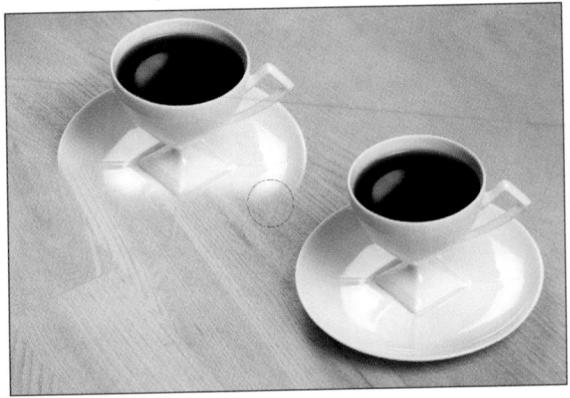

©istockphoto/Beano5 Image #14501558

Figure 9-11: The Clone Stamp tool enables you to realistically duplicate soft-edged elements, such as shadows.

The Clone Stamp doesn't stop there. You can also use this tool for fixing flaws, such as scratches, bruises, date/time stamp imprints from cameras,

and other minor imperfections. Although the birth of the healing tools (discussed in the following sections) has somewhat pushed the Clone Stamp tool out of the retouching arena, it can still do a good repair job in many instances.

Here's how to use the Clone Stamp tool:

- 1. In Expert mode, choose the Clone Stamp tool from the Tools panel.
- 2. In the Tool Options, choose a brush from the Brush Preset Picker panel and then use the brush as-is or adjust its size with the Size slider.

Keep in mind that the size of the brush you specify should be appropriate for what you're trying to clone or retouch. If you're cloning a large object, use a large brush. For repairing small flaws, use a small brush. Cloning with a soft-edged brush usually produces more natural results. For details on brushes, see Chapter 12.

3. Choose your desired Opacity and Blend Mode percentage.

For more on blend modes, see Chapter 11. To make your cloned image appear ghosted, use an opacity percentage of less than 100 percent.

4. Select or deselect the Aligned option.

With Aligned selected, the clone source moves when you move your cursor to a different location. If you want to clone multiple times from the same location, leave the Aligned option deselected.

5. Select or deselect the Sample All Layers option.

This option enables you to sample pixels from all visible layers for the clone. If this option is deselected, the Clone Stamp tool clones from only the active layer. Check out Chapter 8 for details about working with layers.

6. Click the Clone Overlay button if you want to display an overlay.

Displaying an overlay can be helpful when what you're cloning needs to be in alignment with the underlying image. In the Clone Overlay dialog box, check Show Overlay. Adjust the opacity for your overlay. If you select Auto Hide, when you release your mouse, you see a ghosted preview of how your cloned pixels will appear on the image. While you're cloning, however, the overlay is hidden. Select Clipped to have the overlay contained only within the boundaries of your brush. We think that this makes it easier to more precisely clone what you want. Finally, select Invert Overlay to reverse the colors and tones in your overlay.

7. Alt-click (Option-click on the Macintosh) the area of your image that you want to clone to define the source of the clone.

8. Click or drag along the area where you want the clone to appear.

While you drag, Elements displays a crosshair cursor along with your Clone Stamp cursor. The crosshair is the source you're cloning from, and the Clone Stamp cursor is where the clone is being applied. While you move the mouse, the crosshair also moves, so you have a continuous reference to the area of your image that you're cloning. Watch the crosshair, or else you may clone something you don't want.

If you're cloning an element, try to clone it without lifting your mouse. Also, when you're retouching a flaw, try not to overdo it. One or two clicks on each flaw is usually plenty. If you're heavy-handed with the Clone Stamp, you get a blotchy effect that's a telltale sign something has been retouched.

Retouching with the Healing Brush

The Healing Brush tool is similar to the Clone Stamp tool in that you clone pixels from one area onto another area. But the Healing Brush is superior in that it takes into account the tonality (highlights, midtones, and shadows) of the flawed area. The Healing Brush clones by using the *texture* from the sampled area (the *source*) and then using the *colors* around the brush stroke while you paint over the flawed area (the *destination*). The highlights, midtones, and shadow areas remain intact, giving you a realistic and natural repair that isn't as blotchy or miscolored as the repair you get with the Clone Stamp tool.

Here are the steps to heal a photo:

In Expert mode, open an image in need of a makeover and select the Healing Brush tool from the Tools panel.

You can also heal between two images, but be sure that they have the same color mode — for example, both RGB (red, green, blue). We chose a couple who are super photogenic, but might appreciate a little "tune-up," as shown in Figure 9-12.

2. Specify a size for the Healing brush tool in the Tool Options.

You can also adjust the hardness, spacing, angle, and roundness in the Brush Settings. For details on these options, see Chapter 12. Don't be shy. Be sure to adjust the size of your brush, as needed. Using the appropriate brush size for the flaw you're retouching is critical to creating a realistic effect.

3. Choose your desired blend mode.

For most retouching jobs, you probably should leave the mode as Normal. Replace mode preserves textures, such as noise or film grain, around the edges of your strokes.

©istockphoto.com/Yuri_Arcurs Image #10297652

Figure 9-12: Wipe out ten years in two minutes with the Healing Brush tool.

4. Choose one of these Source options:

- *Sampled* uses the pixels from the image. You use this option for the majority of your repairs.
- *Pattern* uses pixels from a pattern chosen from the Pattern Picker drop-down panel.

5. Select or deselect the Aligned option.

For most retouching tasks, you probably should leave Aligned selected. Here are the details on each option:

- With Aligned selected. When you click or drag with the Healing Brush, Elements displays a crosshair along with the Healing Brush cursor. The crosshair represents the sampling point, also known as the *source*. When you move the Healing Brush tool, the crosshair also moves, providing a constant reference to the area you're sampling.
- With Aligned deselected. Elements applies the source pixels from your initial sampling point, no matter how many times you stop and start dragging.

6. Select the Sample All Layers option to heal an image by using all visible layers.

If this option is deselected, then you heal from only the active layer.

To ensure maximum editing flexibility later, select the Sample All Layers option and add a new, blank layer above the image you want to heal. When you heal the image, the pixels appear on the new layer and not on the actual image; so, you can adjust opacity and blend modes and make other adjustments to the healed layer.

- 7. Choose Clone Overlay if desired. (See the previous section, "Cloning with the Clone Stamp tool," for details on using an overlay.)
- 8. Establish the sampling point by Alt-clicking (Option-clicking on the Macintosh).

Make sure to click the area of your image that you want to clone from. In our example, we clicked a smooth area of the forehead.

Release the Alt (Option on the Macintosh) key and click or drag over a flawed area of your image.

Keep an eye on the crosshair because that's the area you're healing from. We brushed over the wrinkles under and around the eyes, mouth, and forehead. (Refer to Figure 9-12.) This couple never looked so good, and they endured absolutely no recovery time.

Zeroing in with the Spot Healing Brush

Whereas the Healing Brush is designed to fix larger flawed areas, the Spot Healing Brush is designed for smaller imperfections, with one exception — the Content Aware option, which we explain in Step 4 in the following instructions. The Spot Healing Brush doesn't require you to specify a sampling source. It automatically takes a sample from around the area to be retouched. It's quick, easy, and often effective. But it doesn't give you control over the sampling source, so keep an eye out for less-than-desirable fixes.

Here's how to quickly fix flaws with the Spot Healing Brush tool:

- In Expert mode, open your image and grab the Spot Healing Brush tool. You can also press J or Shift J to cycle through the Healing Brush and Spot Healing Brush tools.
- 2. In the Tool Options, click the Brush Preset Picker and select a brush tip. You can further adjust the diameter by dragging the Size slider.

Select a brush that's a little larger than the flawed area you're fixing.

- 3. Choose a type in the Tool Options:
 - *Proximity Match*. This type samples the pixels around the edge of the selection to fix the flawed area.
 - *Create Texture*. This type uses all the pixels in the selection to create a texture to fix the flaw.
 - Content Aware. If you want to eliminate something larger than a mole or freckle, this is the option of choice where actual content from the image is used as a kind of patch for the flawed area. Large objects can be zapped away with the Content Aware option, as shown in Figure 9-13 where we eliminated the cannonballer. Note that you may have to paint over the offending object a couple of times to get your desired result. Also, a touch-up with the Clone Stamp or other healing tools may be needed.

©istockphoto.com/PeskyMonkey Image #4958932

Figure 9-13: Eliminate cannonballers and other offending objects with the Content Aware option.

Try Proximity Match first, and if it doesn't work, undo it and try Create Texture or Content-Aware.

4. Choose Sample All Layers to heal an image by using all visible layers.

If you leave this check box deselected, you heal from only the active layer.

5. Click, drag, or "paint" over the area you want to fix.

We painted over the cannonballer with the Spot Healing Brush and achieved realistic results, as shown in the after image in Figure 9-13.

Lightening and darkening with Dodge and Burn tools

The techniques of dodging and burning originated in the darkroom, where photographers fixed negatives that had overly dark or light areas by adding or subtracting exposure, using holes and paddles as an enlarger made prints. The Dodge and Burn tools are even better than their analog ancestors because they're more flexible and much more precise. You can specify the size and softness of your tool by simply selecting from one of the many brush tips. You can also limit the correction to various tonal ranges in your image — shadows, midtones, or highlights. Finally, you can adjust the amount of correction that's applied by specifying an exposure percentage.

Use these tools only on small areas (such as the girl's face shown in Figure 9-14) and in moderation. You can even make a selection prior to dodging and burning to ensure that the adjustment is applied only to your specific area. Also, keep in mind that you can't add detail that isn't there to begin with. If you try to lighten extremely dark shadows that contain little detail, you get gray areas. If you try to darken overly light highlights, you just end up with white blobs.

Figure 9-14: Use the Dodge and Burn tools to lighten and darken small areas.

Follow these steps to dodge or burn an image:

1. In Expert mode, choose either the Dodge (to lighten) or Burn (to darken) tool from the Tools panel.

Press O to cycle through the Dodge, Burn, and Sponge tools.

2. Select a brush from the Brush Preset Picker panel and also adjust the brush Size, if necessary.

Larger, softer brushes spread the dodging or burning effect over a larger area, making blending with the surrounding area easier.

3. From the Range drop-down menu, select Shadows, Midtones, or Highlights.

Select Shadows to darken or lighten the darker areas of your image. Select Midtones to adjust the tones of average darkness. Select Highlights to make the light areas lighter or darker.

In Figure 9-14, the original image had mostly dark areas, so we dodged the shadows.

4. Choose the amount of correction you want to apply with each stroke by adjusting the Exposure setting in the Tool Options.

Start with a lower percentage to better control the amount of darkening or lightening. Exposure is similar to the opacity setting that you use with the regular Brush tool. We used a setting of 10 percent.

5. Paint over the areas you want to lighten or darken.

If you don't like the results, press Ctrl+Z (#+Z on the Macintosh) to undo.

Smudging away rough spots

The Smudge tool, one of the focus tools, pushes your pixels around using the color that's under the cursor when you start to drag. Think of it as dragging a brush through wet paint. You can use this tool to create a variety of effects. When it's used to the extreme, you can create a warped effect. When it's used more subtly, you can soften the edges of objects in a more natural fashion than you can with the Blur tool. Or you can create images that take on a painterly effect, as shown in Figure 9-15. Keep an eye on your image while you paint. however, because you can start to eliminate detail and wreak havoc if you're not careful with the Smudge tool.

To use the Smudge tool, follow these steps:

©istockphoto.com/DenGuy Image #3790696

Figure 9-15: The Smudge tool can make your images appear to be painted.

1. In Expert mode, choose the Smudge tool from the Tools panel.

Press R to cycle through the Smudge, Blur, and Sharpen tools.

2. Select a brush from the Brush Preset Picker panel. Use the Size slider to fine-tune your brush diameter.

Use a small brush for smudging tiny areas, such as edges. Larger brushes produce more extreme effects.

- 3. Select a blending mode from the Mode drop-down menu.
- 4. Choose the strength of the smudging effect with the Strength slider or text box.

The lower the value, the lighter the effect.

5. If your image has multiple layers, select Sample All Layers to make Elements use pixels from all the visible layers when it produces the effect.

The smudge still appears on only the active layer, but the look is a bit different, depending on the colors of the underlying layers.

6. Use the Finger Painting option to begin the smudge by using the foreground color.

Rather than use the color under your cursor, this option smears your foreground color at the start of each stroke. If you want the best of both worlds, you can quickly switch into Finger Painting mode by pressing the Alt key while you drag. Release Alt to go back to Normal mode.

7. Paint over the areas you want to smudge.

Pay attention to your strokes because this tool can radically change your image. If you don't like the results, press Ctrl+Z (第+Z on the Macintosh) to undo the changes and then lower the Strength percentage (discussed in Step 4) even more.

Softening with the Blur tool

The Blur tool can be used to repair images, as well as for more artistic endeavors. You can use the Blur tool to soften a small flaw or part of a rough edge. You can add a little blur to an element to make it appear as though it was moving when photographed. You can also blur portions of your image to emphasize the focal point, as shown in Figure 9-16, where we blurred everything except the girl's face. The Blur

©istockphoto.com/Meanttobe Image #13397598

Figure 9-16: The Blur tool can be used to emphasize a focal point.

tool works by decreasing the contrast among adjacent pixels in the blurred area.

The mechanics of using the Blur tool and its options are similar to those of the Smudge tool, as we describe in the preceding section. When you use the Blur tool, be sure to use a small brush for smaller areas of blur.

Focusing with the Sharpen tool

If the Blur tool is yin, then the Sharpen tool is yang. The Sharpen tool increases the contrast among adjacent pixels to give the illusion that things are sharper. This tool needs to be used with restraint, however. Sharpen can quickly give way to overly grainy and noisy images if you're not cautious.

Use a light hand and keep the areas you sharpen small. Sometimes, the eyes in a soft portrait can benefit from a little sharpening, as shown in Figure 9-17. You can also slightly sharpen an area

©istockphoto.com/ekinsdesigns Image #3158746

Figure 9-17: Reserve the Sharpen tool for small areas, such as eves.

to emphasize it against a less-than-sharp background.

To use the Sharpen tool, grab the tool from the Tools panel and follow the steps provided for the Smudge tool in the section "Smudging away rough spots," earlier in this chapter. Here are some additional tips for using the Sharpen tool:

- Use a low value, around 25 percent or less.
- Remember that you want to gradually sharpen your element to avoid the nasty, noisy grain that can occur from oversharpening.
- Because sharpening increases contrast, if you use other contrast adjustments, such as Levels, you boost the contrast of the sharpened area even more.
- Select the new Protect Detail option to enhance the details in the image and minimize artifacts. If you leave this option unselected, your sharpening is more pronounced.

If you need to sharpen your overall image, try choosing either Enhance Unsharp Mask or Enhance Adjust Sharpness instead. These features offer more options and better control.

Sponging color on and off

The Sponge tool soaks up color or squeezes it out. In more technical terms, this tool reduces or increases the intensity, or *saturation*, of color in both color and grayscale images. Yes, the Sponge tool also works in Grayscale mode by darkening or lightening the brightness value of those pixels.

Like with the Blur and Sharpen tools, you can use the Sponge tool to reduce or increase the saturation in selected areas in order to draw attention to or away from those areas.

Follow these steps to sponge color on or off your image:

- 1. In Expert mode, choose the Sponge tool from the Tools panel.
 - Press O to cycle through the Sponge, Dodge, and Burn tools.
- 2. Select a brush from the Brush Preset Picker panel. Further adjust the Size of the brush tip if needed.

Use large, soft brushes to saturate or desaturate a larger area.

- 3. Choose either Desaturate or Saturate from the Mode drop-down menu to decrease or increase color intensity, respectively.
- Choose a flow rate with the Flow slider or text box.

The *flow rate* is the speed with which the saturation or desaturation effect builds while you paint.

Paint carefully over the areas you want to saturate or desaturate with color.

> In the example shown in Figure 9-18, we used saturation to make one of the graduates a focal

©istockphoto/Andresr Image #8312548

Figure 9-18: The Sponge tool increases or decreases the intensity of the color in your image.

point and desaturated the others.

Replacing one color with another

The Color Replacement tool allows you to replace the original color of an image with the foreground color. You can use this tool in a multitude of ways:

- Colorize a grayscale image to create the look of a hand-painted photo.
- Completely change the color of an element, or elements, in your image, as shown in Figure 9-19, where we painted the field of pumpkins behind the girl with the Color Replacement tool using the color black.
- Eliminate red-eye (or yellow-eye in animals) if other, more automated, methods don't work to your satisfaction.

©istockphoto.com/killerb10 Image #4233667

Figure 9-19: The Color Replacement tool replaces the color in your image with the foreground color.

What we particularly like about the Color Replacement tool is that it preserves all the tones in the image. The color that's applied isn't like the opaque paint that's applied when you paint with the Brush tool. When you're replacing color, the midtones, shadows, and highlights are retained. The Color Replacement tool works by first sampling the original colors in the image and then replacing those colors with the foreground color. By specifying different sampling methods, limits, and tolerance settings, you can control the range of colors that Elements replaces.

Follow these steps to replace existing color with your foreground color:

1. In Expert mode, select the Color Replacement tool from the Tools panel.

Press B to cycle through the Brush, Impressionist Brush, and Color Replacement tools.

 In the Tool Options, choose your desired brush tip from the Brush Preset Picker panel. Further adjust your brush Size as needed. Finally, adjust the hardness, spacing, roundness, and angle under Brush Settings.

3. Choose your desired blend mode.

Here's a brief rundown of each one:

- *Color.* The default, this mode works well for most jobs. This mode works great for eliminating red-eye.
- *Hue.* Similar to color, this mode is less intense and provides a subtler effect.
- Saturation. This mode is the one to use to convert the color in your image to grayscale. Set your foreground color to Black on the Tools panel.
- *Luminosity*. This mode, the opposite of Color, doesn't provide much of an effect.

4. Select your Limits mode.

You have these options:

- *Contiguous* replaces the color of adjacent pixels containing the sampled color.
- *Discontiguous replaces* the color of the pixels containing the sampled color, whether or not they're adjacent.

5. Set your Tolerance percentage.

Tolerance refers to a range of color. The higher the value, the broader the range of color that's sampled, and vice versa.

6. Set your Sampling method:

You have these options:

- Continuous allows you to sample and replace color continuously while you drag your mouse.
- *Once* replaces color only in areas containing the color that you first sample.
- Background Swatch replaces colors only in areas containing your current Background color.

7. Select the antialiasing option.

Antialiasing slightly softens the edges of the sampled areas.

8. Click or drag your image.

The foreground color replaces the original colors of the sampled areas. In Figure 9-19, we used a black foreground color.

If you want to be very precise, make a selection before you replace your color. We did this with the girl in Figure 9-19 so we could avoid "coloring outside the lines."

Correcting Contrast, Color, and Clarity

In This Chapter

- Correcting shadows, highlights, and contrast
- Removing colorcasts and adjusting hue and saturation
- Adjusting skin tones
- Removing noise and artifacts and repairing dust and scratches
- Working with color variations
- Sharpening and blurring your image
- Working with the Smart Brush tools

If you've tried the quick and easy automatic fixes on your images and they didn't quite do the job, you've come to the right place. The great thing about Elements is that it offers multiple ways and multiple levels of repairing and enhancing your images. If an auto fix doesn't cut it, move on to a manual fix.

If you're still not happy, you can consider shooting in Camera Raw format, as long as your camera can do so. Elements has wonderful Camera Raw support, enabling you to process your images to your exact specifications. (Covering Camera Raw, however, is beyond the scope of this book, but you can find a whole chapter about editing with Camera Raw in our other book, *Photoshop Elements 11 All-in-One For Dummies.*) Chances are good that if you can't find the tools to correct and repair your images in Elements, those images are probably beyond salvaging.

This chapter covers the manual fixes you can make to your photos to correct lighting, contrast, colorcasts, artifacts, dust, scratches, sharpening, and blurring. We also cover using the Smart Brush tools to selectively apply an image adjustment.

Editing Your Photos Using a Logical Workflow

With information in Chapter 9 (where we explain those quick fixes) and this chapter at your fingertips, try to employ some kind of logical workflow when you tackle the correction and repair of your images. By performing steps in a particular order, you will be less likely to exacerbate the flaws and more able to accentuate what's good. For example, we use the following workflow when editing photos:

- 1. Crop, straighten, and resize your images, if necessary.
- 2. After you have the images in their proper physical state, correct the lighting and establish good tonal range for your shadows, highlights, and midtones in order to display the greatest detail possible.
 - Often, just correcting the lighting solves minor color problems. If not, move on to adjusting the color balance.
- 3. Eliminate any colorcasts and adjust the saturation, if necessary.
- Grab the retouching tools, such as the healing tools and filters, to retouch any flaws.
- 5. Apply any enhancements or special effects, if desired.
- 6. Sharpen your image if you feel that it could use a boost in clarity and sharpness.

By following these steps and allocating a few minutes of your time, you can get all your images in shape to print, post, and share with family and friends.

Adjusting Lighting

Elements has several simple, manual tools you can use to fix lighting if the Auto tools that we describe in Chapter 9 didn't work or were just too, well, automatic for you. The manual tools offer more control over adjusting overall contrast, as well as bringing out details in shadow, midtones, and highlight areas of your images. Note that you can find all lighting adjustments in both Expert and Quick modes.

Fixing lighting with Shadows/Highlights

The Shadows/Highlights command offers a quick and easy method of correcting over- and underexposed areas, as shown on the left in Figure 10-1. This feature works especially well with images shot in bright, overhead light or in light coming from the back (backlit). These images usually suffer from having the subject partially or completely covered in shadows.

Figure 10-1: Correct the lighting in your images with the Shadows/Highlights adjustment.

To use the Shadows/Highlights adjustment, follow these steps:

- 1. In Expert or Quick mode, choose Enhance⇔Adjust Lighting⇔Shadows/ Highlights and make sure the Preview check box is selected.
 - When the dialog box appears, the default correction is automatically applied in your preview.
- If the default adjustment doesn't quite do the job, move the sliders (or enter a value) to adjust the amount of correction for your shadows (dark areas), highlights (light areas), and midtones (middle-toned areas).

Your goal is to reveal more detail in the dark and light areas of your image. If, after you do so, your image still looks like it needs more correction, add or delete contrast in your midtone areas.

3. Click OK to apply the adjustment and close the dialog box.

If you want to start over, press Alt (Option on the Macintosh) and the Cancel button becomes Reset. Click Reset to start again.

Using Brightness/Contrast

Despite its aptly descriptive moniker, the Brightness/Contrast command doesn't do a great job of brightening (making an image darker or lighter) or adding or deleting contrast. Initially, users tend to be drawn to this command because of its appropriate name and ease of use. But after users realize its limitations, they move on to better tools with more control, such as Shadows/Highlights and Levels.

The problem with the Brightness/Contrast command is that it applies the adjustment equally to all areas of your image. For example, a photo's highlights may need darkening, but all the midtones and shadows are perfect. The Brightness slider isn't smart enough to recognize that, so when you darken the highlights in your image, the midtones and shadows also become darker. To compensate for the unwanted darkening, you try to adjust the Contrast, which doesn't fix the problem.

The moral is, if you want to use the Brightness/Contrast command, select only the areas that need the correction, as shown in Figure 10-2. (For more on selections, see Chapter 7.) After you make your selection, choose Enhance⇔Adjust Lighting⇔Brightness/Contrast.

Figure 10-2: The Brightness/Contrast adjustment is best reserved for correcting selected areas (left) rather than the entire image (right).

Pinpointing proper contrast with Levels

If you want real horsepower when it comes to correcting the brightness and contrast (and even the color) in your image, look no further than the Levels command. Granted, the dialog box is a tad more complex than what you find with the other lighting and color adjustment commands, but when you understand how the Levels dialog box works, it can be downright user-friendly.

You can get a taste of what Levels can do by using Auto Levels, detailed in Chapter 9. The Levels command, its manual cousin, offers much more control. And unlike the primitive Brightness/Contrast control, Levels enables you to darken or lighten 256 different tones. Keep in mind that Levels can be used on your entire image, a single layer, or a selected area. You can also apply the Levels command by using an adjustment layer, as we describe in Chapter 8.

If you're serious about image editing, the Levels command is one tool you want to know how to use. Here's how it works:

1. In Expert or Quick mode, choose Enhance⇔Adjust Lighting⇔Levels.

We recommend using Expert mode for this command, where you'll have access to the Info panel in Step 2.

The Levels dialog box appears, displaying a *histogram*. This graph displays how the pixels of the image are distributed at each of the 256 available brightness levels. Shadows are shown on the left side of the histogram, midtones are in the middle, and highlights are on the right. Note that, in addition to viewing the histogram of the composite RGB channel (the entire image), you can view the histogram of just the Red, Green, or Blue channel by selecting one of them from the Channel panel menu.

Although you generally make changes to the entire document by using the RGB channel, you can apply changes to any one of an image's component color channels by selecting the specific channel from the Channel panel menu. You can also make adjustments to just selected areas, which can be helpful when one area of your image needs adjusting and others don't.

- 2. In Expert mode, choose Window♥Info to open the Info panel.
- 3. Set the black and white points manually by using the eyedroppers in the dialog box; first select the White Eyedropper tool and then move the cursor over the image.
- 4. Look at the Info panel, try to find the lightest white in the image, and then select that point by clicking it.

The lightest white has the highest RGB values.

5. Repeat Steps 3 and 4, using the Black Eyedropper tool and trying to find the darkest black in the image.

The darkest black has the lowest RGB values.

When you set the pure black and pure white points, the remaining pixels are redistributed between those two points.

You can also reset the white and black points by moving the position of the white and black triangles on the input sliders (just below the histogram). Or you can enter values in the Input Levels boxes. The three boxes represent the black, gray, and white triangles, respectively. Use the numbers 0 to 255 in the white and black boxes.

6. Use the Gray Eyedropper tool to remove any colorcasts by selecting a neutral gray portion of your image, one in which the Info panel shows equal values of red, green, and blue.

If your image is grayscale, you can't use the Gray Eyedropper tool.

If you're not sure where there's a neutral gray, you can also remove a colorcast by choosing a color channel from the Channel drop-down menu and doing one of the following:

- Choose the Red channel and drag the midtone slider to the right to add cyan or to the left to add red.
- Choose the Green channel and drag the midtone slider to the right to add magenta or to the left to add green.
- Choose the Blue channel and drag the midtone slider to the right to add yellow or to the left to add blue.
- 7. If your image requires it, adjust the output sliders at the bottom of the Levels dialog box.

Moving the black triangle to the right reduces the contrast in the shadows and lightens the image. Moving the white triangle to the left reduces the contrast in the highlights and darkens the image.

8. Adjust the midtones (or *gamma values*) with the gray triangle input slider.

The default value for gamma is 1.0. Drag the triangle to the left to lighten midtones and drag to the right to darken them. You can also enter a value.

9. Click OK to apply your settings and close the dialog box.

Your image should be greatly improved, as shown in Figure 10-3.

Figure 10-3: Improve the contrast of an image with the intelligent Levels command.

When you click the Auto button, Elements applies the same adjustments as the Auto Levels command, as we explain in Chapter 9. Note the changes and subsequent pixel redistribution made to the histogram after you click this button.

Adjusting Color

Getting the color you want can seem about as attainable as winning the state lottery. Sometimes an unexpected *colorcast* (a shift in color) can be avoided at the shooting stage, for example, by using (or not using, in some cases) a flash or lens filter or by setting the camera's white balance for lighting conditions that aren't present. After the fact, you can usually do a pretty good job of correcting the color with one of the many Elements adjustments. Occasionally, you may want to change the color of your image to create a special effect. Conversely, you also may want to strip out an image's color altogether to create a vintage feel. Remember that all these color adjustments can be applied to your entire image, a single layer, or just a selection. Whatever your color needs are, they'll no doubt be met in Elements.

All color adjustments can be found in either Expert or Quick mode, except for Defringe Layers, which is reserved for Expert mode only.

If you shoot your photos in the Camera Raw file format, you can open and fix your files in the Camera Raw dialog box. Remember that Camera Raw files haven't been processed by your camera. You're in total control of the color and the exposure.

Removing color casts automatically

If you ever took a photo in an office or classroom and got a funky green tinge in your image, it was probably the result of the overhead fluorescent lighting. To eliminate this green color cast, you can apply the Remove Color Cast command. This feature is designed to adjust the image's overall color and remove the cast.

Follow these short steps to correct your image:

1. In either Expert or Quick mode, choose Enhance⇔Adjust Color⇔ Remove Color Cast.

The Remove Color Cast dialog box appears. Move the dialog box to better view your image.

2. Click an area in your photo that should be white, black, or neutral gray, as shown in Figure 10-4.

Figure 10-4: Get rid of nasty color shifts with the Remove Color Cast command.

In our example, we clicked the sky in the image on the left.

The colors in the image are adjusted according to the color you choose. Which color should you choose? The answer depends on the subject matter of your image. Feel free to experiment. Your adjustment is merely a preview at this point and isn't applied until you click OK. If you goof up, click the Reset button, and your image reverts to its unadjusted state.

3. If you're satisfied with the adjustment, click OK to accept it and close the dialog box.

If the Remove Color Cast command doesn't cut it, try using the Color Variations commands or applying a photo filter (as we describe in the section "Adjusting color temperature with photo filters," later in this chapter). For example, if your photo has too much green, try applying a magenta filter.

Adjusting with Hue/Saturation

The Hue/Saturation command enables you to adjust the colors in your image based on their hue, saturation, and lightness. Hue is the color in your image. Saturation is the intensity, or richness, of that color. And lightness controls the brightness value.

Follow these steps to adjust color by using the Hue/Saturation command:

1. In either Expert or Quick mode, choose Enhance

Adjust Color

→ Adjust Hue/Saturation.

The Hue/Saturation dialog box appears. Be sure to select the Preview check box so that you can view your adjustments. Note that this command is also available in Guided mode.

2. Select all the colors (Master) from the Edit drop-down menu or choose one color to adjust.
- 3. Drag the slider for one or more of the following attributes to adjust the colors as described:
 - Hue. Shifts all the colors clockwise (drag right) or counterclockwise (drag left) around the color wheel.
 - Saturation. Increases (drag right) or decreases (drag left) the richness of the colors. Note that dragging all the way to the left gives the photo the appearance of a grayscale image.
 - Lightness. Increases the brightness values by adding white (drag right) or decreases the brightness values by adding black (drag left).

The top color bar at the bottom of the dialog box represents the colors in their order on the color wheel before you make any changes. The lower color bar displays the colors after you make your adjustments.

When you select an individual color to adjust, sliders appear between the color bars so that you can define the range of color to be adjusted. You can select, add, or subtract colors from the range by choosing one of the Eyedropper tools and clicking in the image.

The Hue/Saturation dialog box also lets you colorize images, a useful option for creating sepiacolored images.

4. (Optional) Select the Colorize option to change the colors in your image to a new, single color. Drag the Hue slider to change the color to your desired hue.

The pure white and black pixels remain unchanged, and the intermediate gray pixels are colorized.

Use the Hue/Saturation command, with the Colorize option, to create tinted photos, such as the one shown in Figure 10-5. You can also make selections in a grayscale image and apply a different tint to each selection. This can be especially fun with portraits. Tinted images can create a vintage or moody feel, and they can transform even mediocre photos into something special.

©istockphoto.com/NMaximova Image #17591577
Figure 10-5: Adjust the color, intensity, or brightness of your image with the Hue/
Saturation command.

Eliminating color with Remove Color

Despite all the talk in this chapter about color, we realize that there may be times when you don't want *any* color. With the Remove Color command, you can easily eliminate all the color from an image, layer, or selection. To use this one-step command, simply choose Enhance⇔Adjust Color⇔Remove Color.

Sometimes, stripping away color with this command can leave your image *flat*, or low in contrast. If this is the case, adjust the contrast by using one of Elements' many lighting fixes, such as Auto Levels, Auto Contrast, or Levels.

The Enhance©Convert to Black and White command, shown in Figure 10-6, enables you to convert a selection, a layer, or an entire image to grayscale. But, rather than just arbitrarily strip color like the Remove Color command does, the Convert to Black and White command enables you to select a conversion method by first choosing an image style. To further tweak the results, you can add or subtract colors (Red, Green, or Blue) or contrast by moving the Intensity sliders until your grayscale image looks the way you want. Note that you aren't really adding color; you're simply altering the amount of data in the color channels. For more information on channels, see Chapter 5.

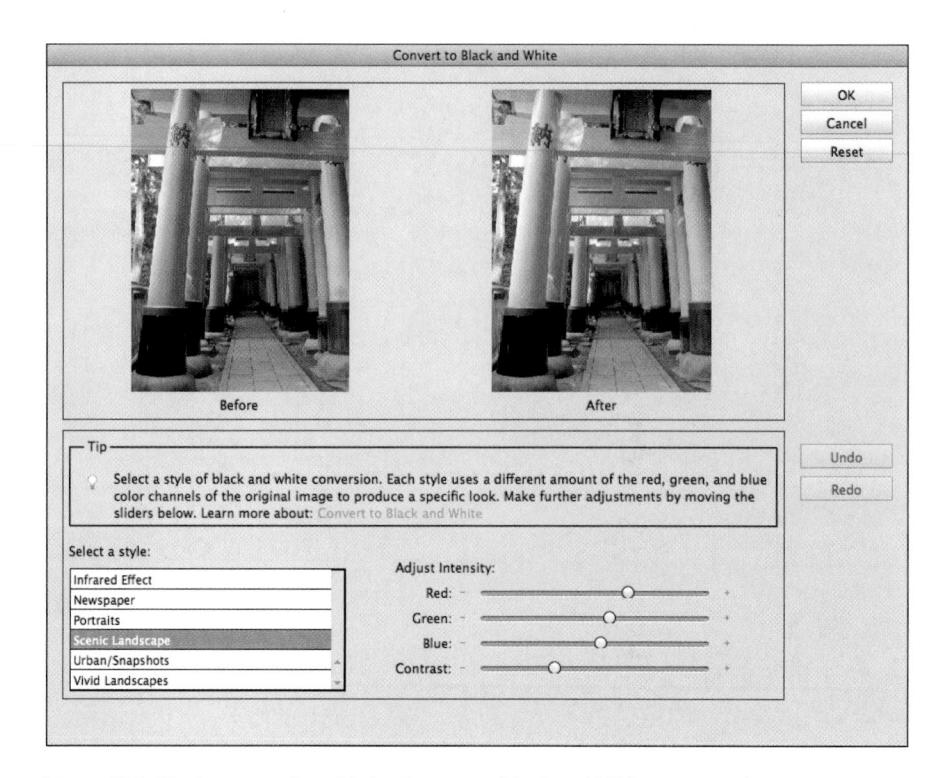

Figure 10-6: Wash away color with the Convert to Black and White command.

Switching colors with Replace Color

The Replace Color command enables you to replace designated colors in your image with other colors. You first select the colors you want to replace by creating a *mask*, which is a selection made by designating white (selected), black (unselected), and gray (partially selected) areas. See Chapter 8 for more details on masks. You can then adjust the hue and/or saturation of those selected colors.

Follow these steps to get on your way to replacing color:

- 1. In Expert or Quick mode, choose Enhance⇔Adjust Color⇔Replace Color.
 - The Replace Color dialog box appears. Make sure to select the Preview check box.
- 2. Choose either Selection or Image:
 - Selection shows the mask in the Preview area. The deselected areas are black, partially selected areas are gray, and selected areas are white.
 - Image shows the actual image in the Preview area.
- 3. Click the colors you want to select in either the image or the Preview area.
- 4. Shift-click or use the plus sign (+) Eyedropper tool to add more colors.
- 5. Press the Alt (Option on the Macintosh) key or use the minus sign (-) Eyedropper tool to delete colors.
- 6. To add colors similar to the ones you select, use the Fuzziness slider to fine-tune your selection, adding or deleting from the selection based on the Fuzziness value.

If you can't quite get the selection you want with the Fuzziness slider, try selecting the Localized Color Clusters option. This option enables you to select multiple clusters, or areas, of color and can assist in getting a cleaner, more precise selection, *especially when trying to select more than one color*.

Move the Hue and/or Saturation sliders to change the color or color richness, respectively. Move the Lightness slider to lighten or darken the image.

Be careful to use a light hand (no pun intended) with the Lightness slider. You can reduce the tonal range too much and end up with a mess.

- 8. View the result in the image window.
- 9. If you're satisfied, click OK to apply the settings and close the dialog box.

Figure 10-7 shows how we substituted the color of our tulips to change them from red to blue. $\,$

Correcting with Color Curves

Elements borrowed a much-used feature from Photoshop named Curves. However, Elements adds the word Color. and Color Curves doesn't have all the sophistication of its Photoshop cousin. Nevertheless, the Color Curves adjustment attempts to improve the tonal range in color images by making adjustments to highlights, shadows, and midtones in each color channel. (For more on channels, see Chapter 3.) Try using this command on images in which the foreground elements appear overly dark due to backlighting. Conversely, the adjustment is also designed to correct images that appear overexposed and washed out.

Here's how to use this great adjustment on a selection, a layer, or an entire image:

©istockphoto.com/toos Image #8696684

Figure 10-7: The Replace Color command enables you to replace one color with another.

The Adjust Color Curves dialog box appears. Make sure to select the Preview check box. Move the dialog box to the side so that you can view the image window while making adjustments.

- 2. Various curve adjustments appear in the Select a Style area. Select a style to make your desired adjustments while viewing your image in the After window.
- 3. If you need greater precision, use the highlights, brightness, contrast, and shadows adjustment sliders, as shown in Figure 10-8, and then adjust the sliders as desired.

The graph on the right represents the distribution of tones in your image. When you first access the Color Curves dialog box, the tonal range of your image is represented by a straight line. While you drag the sliders, the straight line is altered, and the tonal range is adjusted accordingly.

- 4. Click OK when you've adjusted the image satisfactorily.
- 5. To start over, click the Reset button.

Check out Figure 10-9 for another before-and-after image.

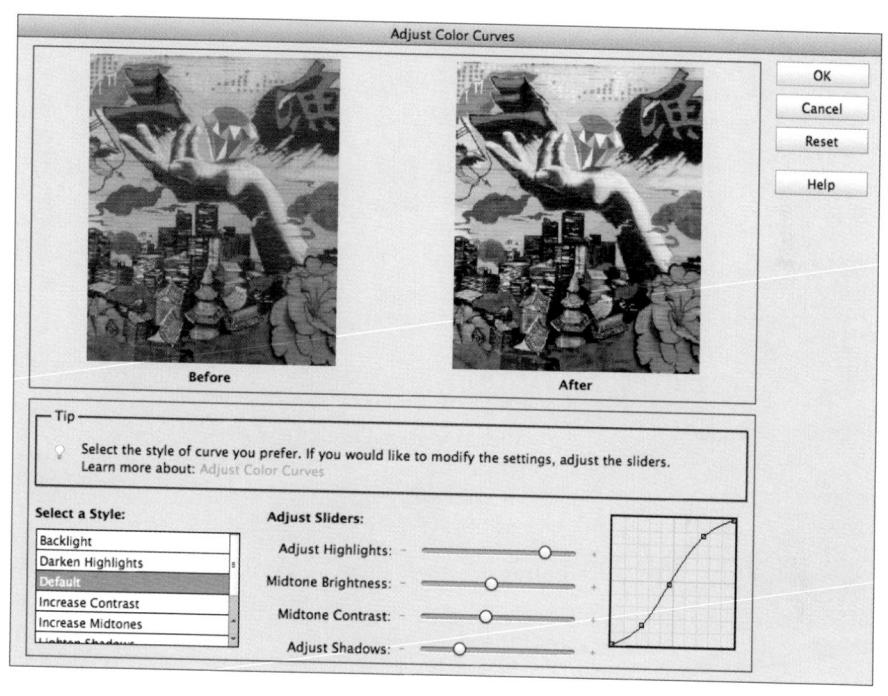

Figure 10-8: The Color Curves adjustment provides both basic and advanced adjustment controls.

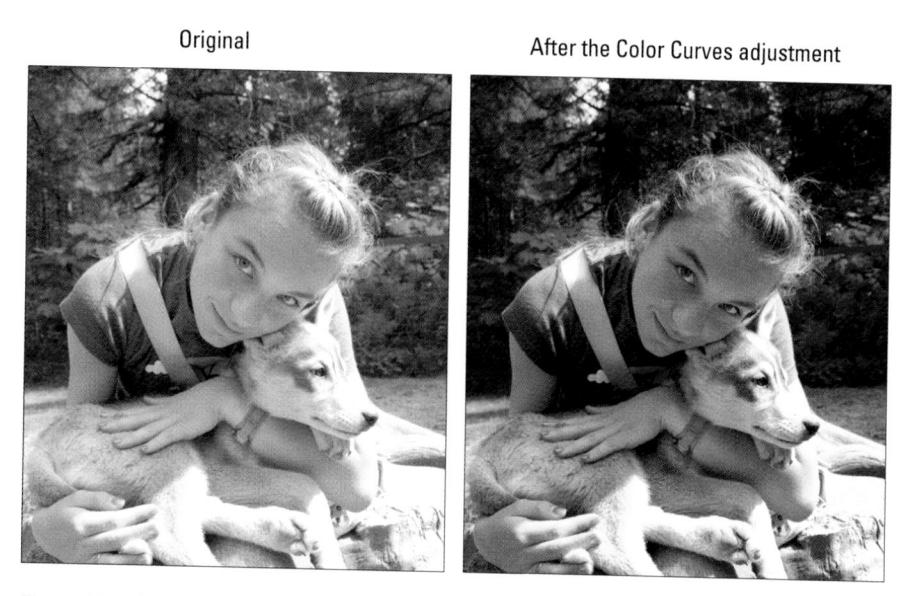

Figure 10-9: Color Curves improves tonal range in color images.

Adjusting skin tones

Occasionally, you may find that the loved ones in your photos have taken on a rather sickly shade of green, red, or some other non-flesh-colored tone. To rectify that problem, Elements has a command specifically designed to adjust the overall color in the image and get skin tones back to a natural shade.

Here's how to use this feature:

- Open your image in Expert or Quick mode, select the Preview check box, and do one or both of the following:
 - Select the layer that needs to be adjusted. If you don't have any layers, your entire image is adjusted.
 - Select the areas of skin that need to be adjusted. Only the selected areas are adjusted. This is a good way to go if you're happy with the color of your other elements and just want to tweak the skin tones. For more on selection techniques, see Chapter 7.
- 2. Choose Enhance⇔Adjust Color⇔Adjust Color for Skin Tone.

The Adjust Color for Skin Tone dialog box appears. This command is also found in Guided mode.

3. In the image window, click the portion of skin that needs to be corrected.

The command adjusts the color of the skin tone, as well as the color in the overall image, layer, or selection, depending on what you selected in Step 1.

- 4. If you're not satisfied with the results, click another area or fiddle with the Skin and Ambient Light sliders:
 - Tan adds or removes the amount of brown in the skin.
 - Blush adds or removes the amount of red in the skin.
 - Temperature adjusts the overall color of the skin, making it warmer (right toward red) or cooler (left toward blue).
- 5. When you're happy with the correction, click OK to apply the adjustment and close the dialog box.

The newly toned skin appears, as shown in Figure 10-10.

To start anew, click the Reset button. And, of course, to bail out completely, click Cancel.

Figure 10-10: Give your friends and family a complexion makeover with the Adjust Color for Skin Tone command.

Defringing layers

A telltale sign of haphazardly composited images is selections with fringe. We don't mean the cute kind hanging from your leather jacket or upholstery; we mean the unattractive kind that consists of background pixels that surround the edges of your selections, as shown in Figure 10-11.

Inevitably, when you move or paste a selection, some background pixels are bound to go along for the ride. These pixels are referred to as a *fringe* or *halo*. Luckily, the Defringe command replaces the color of the fringe pixels with the colors of neighboring pixels that don't contain the background color. In our example, we plucked the red flower out of a blue background and placed it on a white background. Some of the background pixels were included in our

selection and appear as a blue fringe. When we apply the Defringe command, those blue fringe pixels are changed to colors of nearby pixels, such as red, as shown in Figure 10-11.

Follow these steps to defringe your selection:

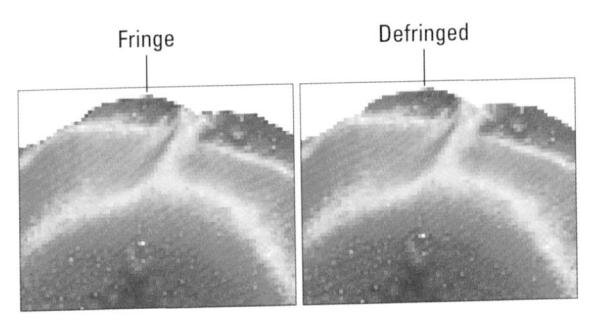

Figure 10-11: Remove the colored halo around your selections with the Defringe command.

1. In Expert or Quick mode, copy and

paste a selection onto a new or existing layer, or drag and drop a selection onto a new document.

For more on selections, see Chapter 7.

2. Choose Enhance⇔Adjust Color⇔Defringe Layer.

The Defringe dialog box appears.

3. Enter a value for the number of pixels you want to convert.

Try entering 1 or 2 first to see whether that does the trick. If not, you may need to enter a slightly higher value.

4. Click OK to accept the value and close the dialog box.

Correcting with Color Variations

Although we give you several ways in this chapter to eliminate color casts in an image, here's one more. The Color Variations command is a digital color-correction feature that's been around for years and is largely unchanged. That's probably because it's one of those great features that's easy to use and easy to understand, and it works. The command enables you to make corrections by visually comparing thumbnails of color variations of your image. You may use this command when you're not quite sure what's wrong with the color or what kind of color cast your image has.

Here's how to use the Color Variations command:

1. In Expert or Quick mode, choose Enhance[□]Adjust Color Color Variations.

The Color Variations dialog box appears, displaying a preview of your original image (before) and the corrected image (after), as shown in Figure 10-12.

- 2. Select a tonal range or color richness (if you're unsure which range to select, start with the Midtones):
 - *Shadows, Midtones, Highlights.* These adjust the dark, middle, or light areas in the image, respectively.
 - Saturation. This adjusts the color intensity or richness, making colors more intense (saturated) or less intense (desaturated). If your image is faded from time, be sure to increase the saturation after you correct any color cast issues.

Usually, just correcting the midtones is enough to get your image's color in order, but if it's not, you can always adjust the shadows and highlights, as well.

3. Specify how much adjustment you want with the Adjust Color Intensity slider.

Drag left to decrease the amount of adjustment and drag right to increase the amount.

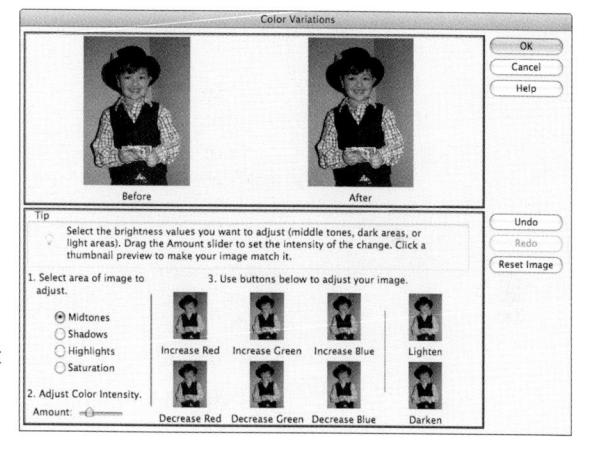

Figure 10-12: Color Variations enables you to visually correct your images by comparing thumbnails.

4. If you selected Shadows, Midtones, or Highlights in Step 2, adjust the color by clicking the various Increase or Decrease Color buttons. (If you selected Saturation, skip to Step 6.)

Click more than once if your initial application wasn't sufficient to correct the problem.

Be sure to keep an eye on the After thumbnail, which reflects your corrections while you make them.

- 5. Click the Darken or Lighten buttons to make the colors a little darker or lighter, respectively.
- 6. If you selected Saturation in Step 2, click the Less Saturation or More Saturation buttons.
- If you make a mistake or several mistakes, for that matter click the Undo button.

The Color Variations dialog box supports multiple levels of undo. If you botch something, you can always click the Reset Image button to start again. Keep in mind that you can't undo the Reset Image command after you click it. Click Cancel to bail entirely.

8. To apply your color adjustments and close the dialog box, click OK.

The Color Variations command is a great tool to correct those old, faded, green- (or some other unwanted color) tinted circa-yesteryear photos. The Color Variations command allows you to easily correct the color and saturation of these precious, but damaged, images. Remember to either decrease the offending color or add the color that's the opposite of the cast in the image. If it's too red, add cyan, and vice versa.

Adjusting color temperature with photo filters

Light has its own color temperature. A photo shot in a higher color temperature of light makes the image blue. Conversely, a photo shot in a lower color temperature makes the image yellow. In the old days, photographers placed colored glass filters in front of their camera lenses to adjust the color temperature of the light. They did this to either warm up or cool down photos, or to just add a hint of color for subtle special effects. Elements gives you the digital version of these filters with the Photo Filter command.

To apply the Photo Filter adjustment, follow these steps:

1. In Expert or Quick mode, choose Filter⇔Adjustments⇔Photo Filter.

The Photo Filter dialog box appears.

Note that you can also apply the photo filter to an individual layer by creating a photo-filter adjustment layer. For details, see Chapter 8.

2. In the dialog box, select Filter to choose a preset filter from the dropdown menu, or select Color to choose your own filter color from the Color Picker.

Here's a brief description of each of the preset filters:

- Warming Filter (85), (81), and (LBA). These adjust the white balance in an image to make the colors warmer, or more yellow. Filter (81) is like (85) and (LBA), but it's best used for minor adjustments.
- Cooling Filter (80), (82), and (LBB). These also adjust the white balance that's shown, but instead of making the colors warmer, they make the colors cooler, or bluer. Filter (82) is like (80) and (LBB), but it's designed for slight adjustments.

- Red, Orange, Yellow, and so on. The various color filters adjust the hue, or color, of a photo. Choose a color filter to try to eliminate a colorcast or to apply a special effect.
- 3. Adjust the Density option to specify the amount of color applied to your image.
- 4. Select the Preserve Luminosity option to prevent the photo filter from darkening your image.
- 5. Click OK to apply your filter and close the dialog box.

One way to minimize the need for color adjustments is to be sure you set your camera's white balance for your existing lighting conditions before shooting your photo.

Mapping your colors

Elements provides color mapper commands that change the colors in your image by mapping them to other values. You find the color mappers on the Filter Adjustments submenu. Figure 10-13 shows an example of each command, all of which are also briefly described in the following list:

- ✓ Equalize. This mapper first locates the lightest and darkest pixels in the image and assigns them values of white and black. It then redistributes all the remaining pixels among the grayscale values. The exact effect depends on your individual image.
- ✓ **Gradient Map.** This command maps the tonal range of an image to the colors of your chosen gradient. For example, colors (such as orange, green, and purple) are mapped to the shadow, highlight, and midtone areas.
- Invert. This command reverses all the colors in your image, creating a kind of negative. Black reverses to white, and colors convert to their complementary hues. (Blue goes to yellow, red goes to cyan, and so on.)
- ✓ Posterize. This command reduces the number of colors in your image. Choose a value between 2 and 255 colors. Lower values create an illustrative, poster-like look, and higher values produce a more photorealistic image.
- ✓ Threshold. Threshold makes your image black and white, with all pixels
 that are brighter than a value you specify represented as white, and
 all pixels that are darker than that value as black. You can change the
 threshold level to achieve different high-contrast effects.

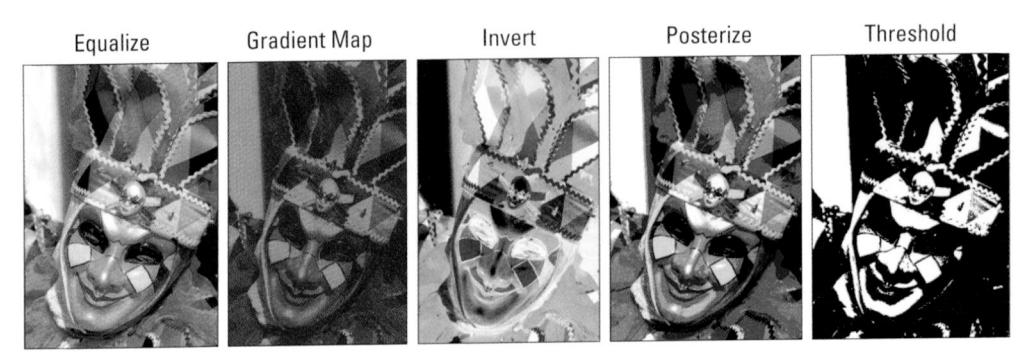

©istockphoto.com/raphotography Image #12799975

Figure 10-13: Change the colors in your image by remapping them to other values.

Adjusting Clarity

After your image has the right contrast and color, and you fix any flaws (as we describe in Chapter 9), you're ready to work on the overall clarity of that image. Although you may have fixed the nitpicky little blemishes with the healing tools, if your image suffers from an overall problem, like dust, scratches, or *artifacts* (blocky pixels or halos), you may need to employ the help of a filter. After you totally clean up your image, your last chore is to give it a good sharpening. Why wait until the bitter end to do so? Sometimes, while you're improving the contrast and color and getting rid of flaws, you can reduce the clarity and sharpness of an image. So you want to be sure that your image is as soft as it's going to get before you tackle your sharpening tasks. On the other hand, also be aware that sharpening increases contrast, so depending on how much of your image you're sharpening, you may need to go back and fine-tune it by using the lighting adjustments described in the section "Adjusting Lighting," earlier in this chapter.

Finally, with all this talk about sharpening, we know that you may find it strange when we say that you may also need to occasionally blur your image. You can use blurring to eliminate unpleasant patterns that occur during scanning, to soften distracting backgrounds to give a better focal point, or even to create the illusion of motion.

Removing noise, artifacts, dust, and scratches

Surprisingly, the tools you want to use to eliminate junk from your images are found on the Filter Noise submenu in Expert or Quick mode. With the exception of the Add Noise filter, the others help to hide noise, dust, scratches, and artifacts. Here's the list of junk removers:

- **Despeckle.** Decreases the contrast, without affecting the edges, to make the dust in your image less pronounced. You may notice a slight blurring of your image (that's what's hiding the junk), but hopefully the edges are still sharp.
- ✓ Dust & Scratches. Hides dust and scratches by blurring those areas of your image that contain the nastiness. (It looks for harsh transitions in tone.) Specify your desired Radius value, which is the size of the area to be blurred. Also, specify the Threshold value, which determines how much contrast between pixels must be present before they're blurred.

Use this filter with restraint because it can obliterate detail and make your image go from bad to worse.

- Median. Reduces contrast around dust spots. The process the filter goes through is rather technical, so suffice it to say that the light spots darken, the dark spots lighten, and the rest of the image isn't changed. Specify your desired radius, which is the size of the area to be adjusted.
- **Reduce Noise.** Designed to remove luminance noise and artifacts from your images. *Luminance noise* is grayscale noise that makes images look overly grainy. Specify these options to reduce the noise in your image:
 - Strength. Specify the amount of noise reduction.
 - Preserve Details. A higher percentage preserves edges and details but reduces the amount of noise that's removed
 - Reduce Color Noise. Remove random colored pixels.
 - Remove JPEG Artifact. Remove the blocks and halos that can occur from low-quality JPEG compression.

Blurring when you need to

It may sound odd that anyone would intentionally want to blur an image. But, if your photo is overly grainy or suffers from a nasty moiré (wavy) pattern (as described in the following list), you may need to blur the image to correct the problem. Often you may even want to blur the background of an image to deemphasize distractions, or to make the foreground elements appear sharper and provide a better focal point.

All the blurring tools are found on the Filter Blur menu in Expert or Quick mode, with the exception of the Blur tool, which is explained in Chapter 9:

Average. This one-step filter calculates the average value of the image or selection and fills the area with that average value. You can use it for smoothing overly noisy areas in your image.

- Blur. Another one-step filter, this one applies a fixed amount of blurring to the whole image.
- ✓ Blur More. This one-step blur filter gives the same effect as Blur, but more intensely.
- ✓ Gaussian Blur. This blur filter is probably the one you'll use most often. It offers a Radius setting to let you adjust the amount of blurring you desire.

Use the Gaussian Blur filter to camouflage moiré patterns on scanned images. A moiré pattern is caused when you scan halftone images. A halftone is created when a continuous tone image, such as a photo, is digitized and converted into a screen pattern of repeating lines (usually between 85 and 150 lines per inch) and then printed. When you then scan that halftone, a second pattern results and is overlaid on the original pattern. These two different patterns bump heads and create a nasty moiré pattern. The Gaussian Blur filter doesn't eliminate the moiré — it simply merges the dots and reduces the appearance of the pattern. Play with the Radius slider until you get an acceptable trade-off between less moiré and less focus. If you happen to have a descreen filter built into your scanning software, you can use that, as well, during the scanning of the halftone image.

- Motion Blur. This filter mimics the blur given off by moving objects. Specify the angle of motion and the distance of the blur. Make sure to select the Preview check box to see the effect while you enter your values.
- Radial Blur. Need to simulate a moving Ferris wheel or some other round object? This filter produces a circular blur effect. Specify the amount of blur you want. Choose the Spin method to blur along concentric circular lines, as shown in the thumbnail. Or, choose Zoom to blur along radial lines and mimic the effect of zooming in to your image. Specify your desired Quality level. Because the Radial Blur filter is notoriously slow, Elements gives you the option of Draft (fast but grainy), Good, or Best (slow but smooth). The difference between Good and Best is evident only on large, high-resolution images. Finally, indicate where you want the center of your blur by moving the blur diagram thumbnail.
- Smart Blur. This filter provides several options to enable you to specify how the blur is applied. Specify a value for the radius and threshold, both defined in the following section. Start with a lower value for both and adjust from there. Choose a quality setting from the drop-down menu. Choose a mode setting. Normal blurs the entire image or selection. Edge Only blurs only the edges of your elements and uses black and white in the blurred pixels. Overlay Edge also blurs just the edges, but it applies only white to the blurred pixels.
- Surface Blur. This filter blurs the surface or interior of the image, instead of the edges. If you want to retain your edge details, but blur everything else, use this filter.

If you have ever experimented with the aperture settings on a camera, you know that you can set how shallow or deep your depth of field is. Depth of field relates to the *plane of focus* (the areas in a photo that are in front of or behind the focal point, and that remain in focus) or how in-focus the foreground elements are when you compare them to the background elements. The new Lens Blur filter, shown in Figure 10-14, enables you to give the effect of a shallower depth of field after you have already captured your image, thereby enabling you to take a fully focused image and create this selective focus.

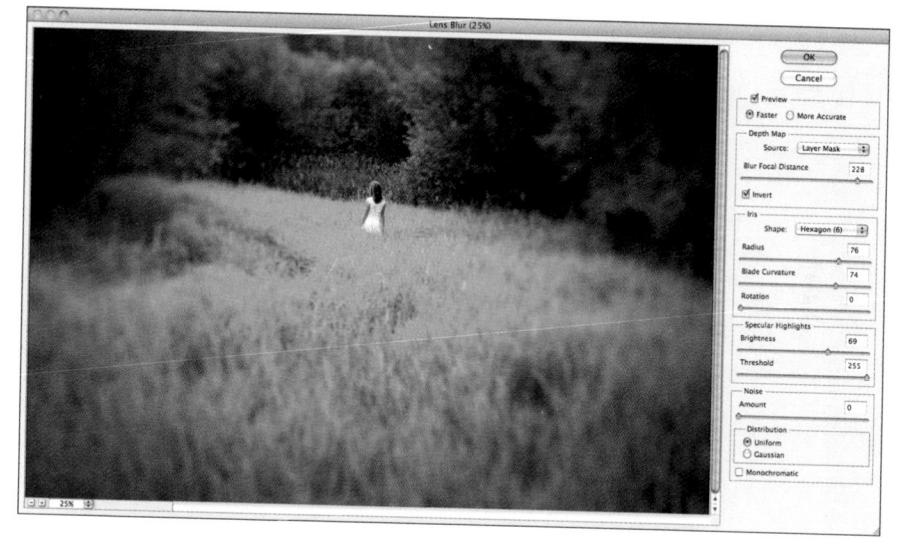

©istockphoto.com/TomFullum Image #15438998

Figure 10-14: Use the Lens Blur filter to create a shallow depth of field effect.

Here's how to use the Lens Blur filter:

- 1. Choose Filter⇔Blur⇔Lens Blur
- 2. Choose your Preview mode.

Faster gives you a quick preview, while More Accurate shows you the final rendered image.

3. Choose a Source from the drop-down menu for your depth map, if you have one. You can choose between a layer mask or transparency.

The filter uses a depth map to determine how the blur works.

A good way to create an image with this shallow depth of field effect is to create a layer mask on your image layer and fill it with a white to black gradient — black where you want the most focus, white where you want the least focus or most blur. Choose Transparency to make an image blurrier and more transparent.

4. Drag the Blur Focal Distance slider to specify how blurry or in focus an area of the image is. Or click the crosshair cursor on the part of the image that you want to be in full focus.

Dragging the slider enables you to specify a value You can also select Invert to invert, or reverse, the depth map source.

5. Choose an Iris shape, such as triangle or octagon, from the Shape drop-down menu.

The Iris settings are meant to simulate a camera lens. Specify the shape of the lens, as well as the radius (size of the iris), blade curvature (how smooth are the iris edges), and rotation of that shape.

6. Set the Brightness and Threshold values in the Specular Highlights area.

The Lens Blur filter averages the highlights of an image, which, if left uncorrected, cause some highlights to appear grayish. The Specular Highlights controls help to retain Specular Highlights, or those highlights that should appear very white. Set the Threshold value to specify which highlights should be *specular* (remain white). Set a Brightness value to specify how much to relighten any blurred areas.

7. Drag the Amount slider in the Noise area to add noise back into your image. Choose monochromatic to add noise without affecting the color.

Blurring obliterates any noise (or *film grain*) that an image may have. This absence of noise can cause the image to appear inconsistent or unrealistic, in many cases.

8. Click OK to apply the Lens Blur and exit the dialog box.

Sharpening for better focus

Of course, if your images don't need any contrast, color, and flaw fixing, feel free to jump right into sharpening. Sometimes, images captured by a scanner or a digital camera are a little soft, and it's not due to any tonal adjustments. Occasionally, you may even want to sharpen a selected area in your image just so that it stands out more.

First, let us say that you can't really improve the focus of an image after it's captured. But you can do a pretty good job of faking it. All sharpening tools work by increasing the contrast between adjacent pixels. This increased contrast causes the edges to appear more distinct, thereby giving the illusion that the focus is improved, as shown in Figure 10-15. Remember that you can also use the Sharpen tool for small areas, as described in Chapter 9. Here's a description of the two sharpening commands:

Figure 10-15: Sharpening mimics an increase in focus by increasing contrast between adjacent pixels.

- Unsharp Mask. Found on the Enhance menu in Expert or Quick mode, Unsharp Mask (which gets its odd name from a darkroom technique) is the sharpening tool of choice. It gives you several options that enable you to control the amount of sharpening and the width of the areas to be sharpened. Use them to pinpoint your desired sharpening:
 - Amount. Specify an amount (from 1 to 500 percent) of edge sharpening. The higher the value, the more contrast between pixels around the edges. Start with a value of 100 percent (or less), which usually gives good contrast without appearing overly grainy.
 - Radius. Specify the width (from 0.1 to 250 pixels) of the edges that the filter will sharpen. The higher the value, the wider the edge. The value you use is largely based on the resolution of your image. Low-resolution images require a smaller radius value. High-resolution images require a higher value.

Be warned that specifying a value that's too high overemphasizes the edges of your image and makes it appear too "contrasty" or even "goopy" around the edges.

A good guideline in selecting a starting radius value is to divide your image's resolution by 150. For example, if you have a 300 ppi image, set the radius at 2 and then use your eye to adjust from there.

• Threshold. Specify the difference in brightness (from 0 to 255) that must be present between adjacent pixels before the edge is sharpened. A lower value sharpens edges with very little contrast difference. Higher values sharpen only when adjacent pixels are very different in contrast. We recommend leaving Threshold set at 0 unless your image is very grainy. Setting the value too high can cause unnatural transitions between sharpened and unsharpened areas.

Occasionally, the values you enter for Amount and Radius may sharpen the image effectively but in turn create excess *grain*, or noise, in your image. You can sometimes reduce this noise by increasing the Threshold value.

Adjust Sharpness. When you're looking for precision in your image sharpening, Unsharp Mask is one option. The Adjust Sharpness command, as shown in Figure 10-16, is the other. This feature enables you to control the amount of sharpening applied to shadow and highlight areas. It also allows you to select from various sharpening algorithms.

Here are the various options you can specify:

- Amount and Radius. See the two descriptions in the preceding Unsharp Mask bullet list.
- Remove. Choose your sharpening algorithm. Gaussian Blur is the algorithm used for the Unsharp Mask command. Lens Blur detects detail in the image and attempts to respect the details while reducing the nasty halos that can occur with sharpening. Motion Blur tries to sharpen the blurring that occurs when you move the camera (or if your subject doesn't sit still).
- Angle. Specify the direction of motion for the Motion Blur algorithm, described in the preceding bullet.
- *More Refined*. This option runs the algorithm more slowly than the default speed for better accuracy.

Figure 10-16: The Adjust Sharpness command.

Working Intelligently with the Smart Brush Tools

The Smart Brush and Detail Smart Brush tools enable you to selectively apply an image adjustment or special effects that appear on all or part of your image. What's even more exciting is that these adjustments and effects are applied via an adjustment layer, meaning that they hover over your layers and don't permanently alter the pixels in your image. It also means that the adjustments can be flexibly edited and deleted, if so desired.

Follow these steps to use the Smart Brush tool:

1. In Expert mode, select the Smart Brush tool from the toolbar.

The tool icon looks like a house paint brush with an adjacent gear. You can also press F, or Shift+F, if the Detail Smart Brush tool is visible.

2. Select an adjustment category and then your particular preset adjustment from the Preset Picker drop-down menu in the Tool Options, as shown in Figure 10-17.

In the Preset menu, you can find adjustments ranging from Photographic effects, such as a vintage Yellowed Photo, to Nature effects, such as Create a Sunset (which gives a warm, orange glow to your image).

The Textures category, which has 13 presets such as Broken Glass and Old Paper. Use these textures with your smart brushes to jazz up backgrounds and other elements in your images. For example, if that white wall in your shot is less than exciting, give it a Brick wall texture. If the drop cloth behind your portrait to reduce background clutter is a tad boring, give it a satin ripple.

Choose your desired brush attributes, such as size. You can also adjust attributes such as hardness, spacing, roundness, and angle from the Brush Settings drop-down panel.

For more on working with brushes, see Chapter 12.

4. Paint an adjustment on the desired layer in your image.

Note that while you paint, the Smart Brush tool attempts to detect edges in your image and snaps to those edges. In addition, while you brush, a selection border appears.

A new adjustment layer is automatically created with your first paint stroke. The accompanying layer mask also appears on that adjustment layer. For more on adjustment layers, see Chapter 8.

5. Using the Add and Subtract Smart Brush modes in the Tool Options, fine-tune your adjusted area by adding and subtracting from it.

When you add and subtract from your adjusted area, you're essentially modifying your layer mask. Adding to your adjusted area adds white to your layer mask, and subtracting from your adjusted area adds black to your layer mask. For more on layer masks, see Chapter 8.

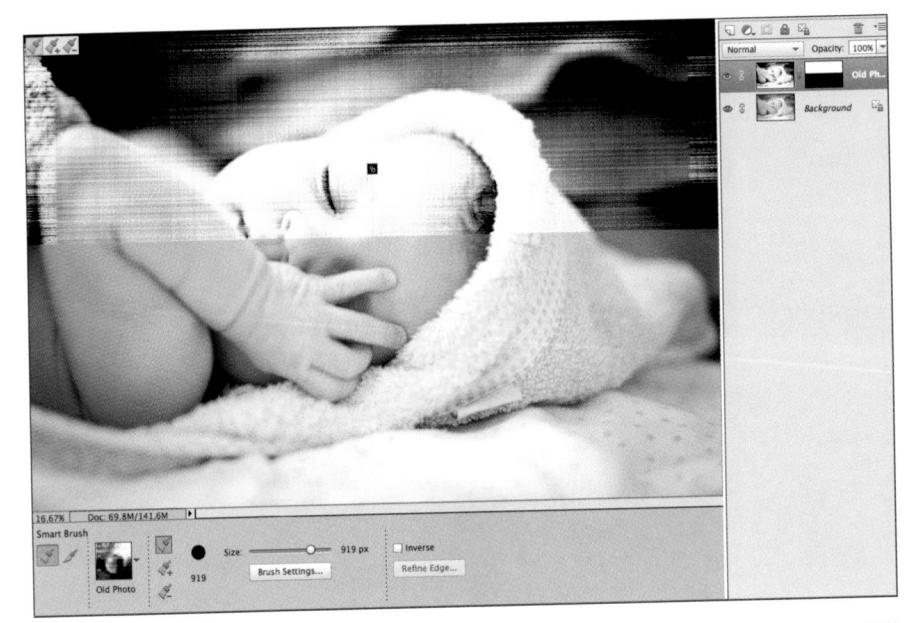

©istockphoto.com/KristinaGreke Image #17963386

Figure 10-17: The Smart Brush enables you to paint on adjustments.

6. If you feel you need to refine your selected area, select the Refine Edge option in the Tool Options.

For more on Refine Edge, see Chapter 7.

If you'd rather apply the adjustment to your unselected area, select the Inverse option on the Tool Options.

If you want to modify your adjustment, double-click the Adjustment Layer pin on your image. The pin is annotated by a small, square, blackand-red gear icon. After you double-click the pin, the dialog box corresponding to your particular adjustment appears. For example, if you double-click the Shoebox photo adjustment (under Photographic), you access the Hue/Saturation dialog box.

7. Make your necessary adjustments in the dialog box and click OK.

You can also right-click and select Change Adjustment Settings from the contextual menu that appears. Or you can select Delete Adjustment and Hide Selection from the same menu.

8. After you finish, simply deselect your selection by choosing Select⇔Deselect.

You can add multiple Smart Brush adjustments. After you apply one effect, reset the Smart Brush tool and apply additional adjustments.

Follow these steps to work with the Detail Smart Brush tool:

1. In Expert mode, select the Detail Smart Brush tool in the toolbar.

This tool shares the flyout menu with the Smart Brush tool. The tool icon looks like an art paint brush. You can also press F, or Shift+F, if the Smart Brush tool is visible.

- Select your desired adjustment category and then your particular preset adjustment from the Preset Picker drop-down menu in the Tool Options.
- 3. Choose a brush tip preset drop-down menu. Also choose your desired brush size.

Feel free to change your brush tip and size as needed for your desired effect. You can also choose other brush preset libraries from the Brush drop-down menu in the Brush tip preset menu. For more on working with brushes, see Chapter 12.

Several of the Special Effect adjustments are shown in Figure 10-18.

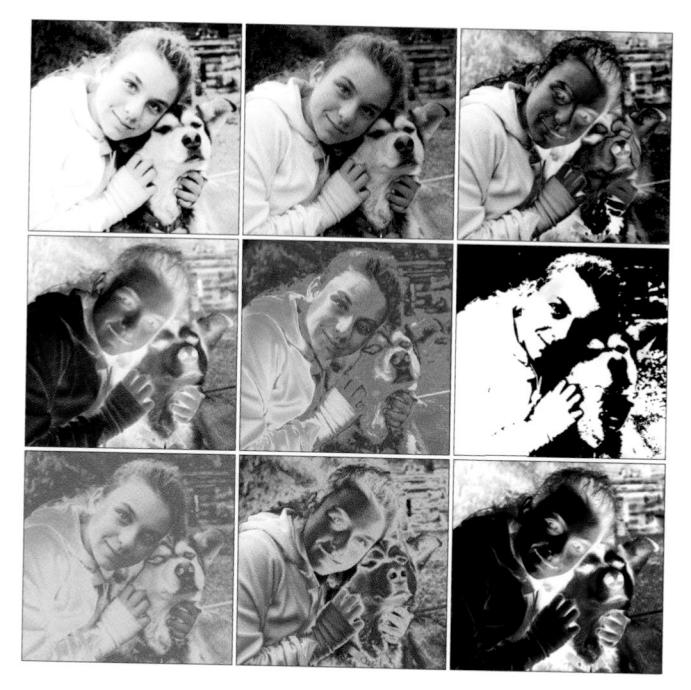

Figure 10-18: The Detail Smart Brush lets you paint on a variety of special effects.

Using touchscreen monitors

Elements supports touchscreen capability on both Windows and Macintosh platforms. Not only can you browse through images in the Organizer by flicking with your fingers, but you can even retouch and enhance your images using all the tools in your Tools panel with your fingers. Talk about digital finger-painting!

4. Paint an adjustment on the desired layer in your image.

A new adjustment layer is automatically created with your first paint stroke, along with an accompanying layer mask. For details on adjustment layers and layer masks, see Chapter 8.

5. Follow Steps 5 through 8 in the preceding list for the Smart Brush tool.

Part IV Exploring Your Inner Artist

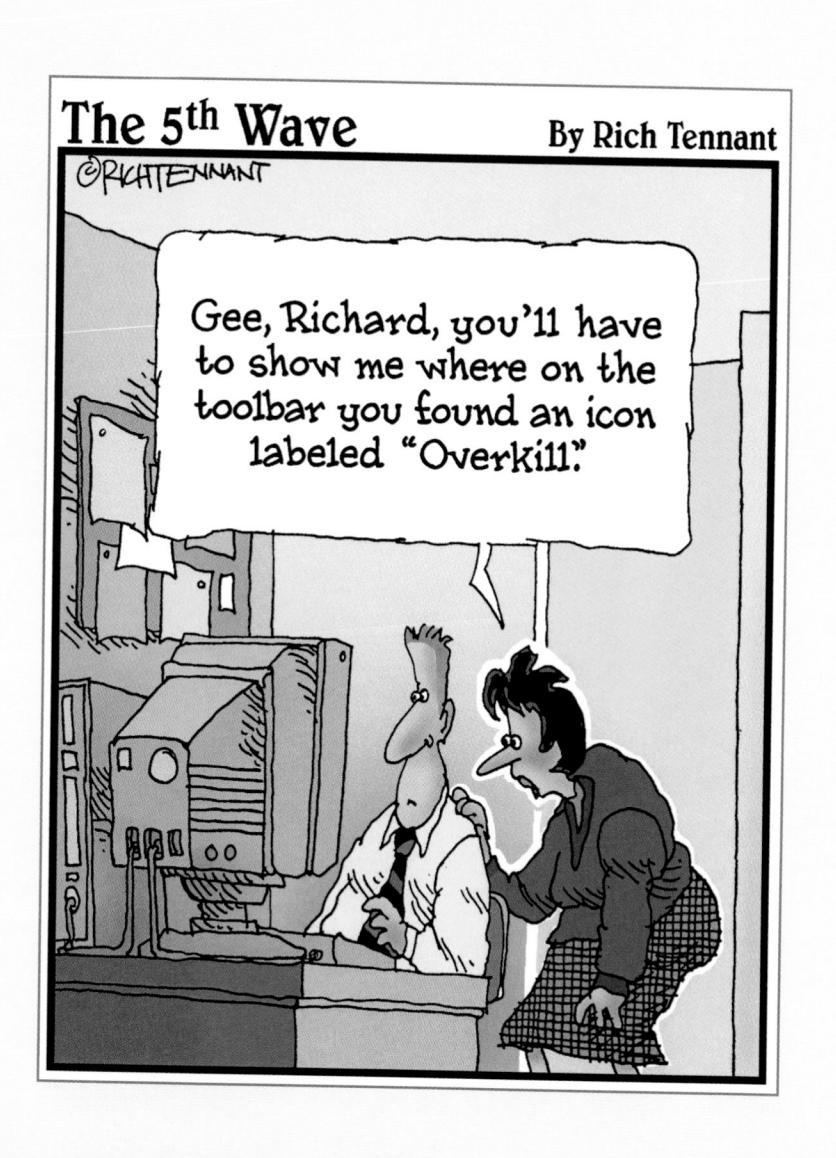

In this part . . .

elve into the world of the Photoshop Elements artist, where you can use tools to draw and paint on existing photos or create new, blank documents and create your own drawings. The tools rival an artist's analog tools, and Photoshop Elements capabilities are limited only by your imagination. In this part, you can find out how to apply different artistic effects by using many tools and customizing them for your own use, and you find tips for creating some dazzling images.

In addition to describing the artistic effects you can apply to your photos, this part tells you how to handle working with text. When it comes time for creating a poster, an advertisement, or some web icons, the text features in Elements offer you many options for creating headline type, body copy, and special type effects.

Playing with Filters, Effects, Styles, and More

In This Chapter

- Fooling with filters
- Getting familiar with the Filter Gallery
- Making digital taffy with Liquify
- Fixing camera distortion
- Enhancing with effects
- Using layer styles
- Changing colors with blend modes
- Compositing images with Photomerge

fter giving your images a makeover — edges cropped, color corrected, flaws repaired, focus sharpened — you may want to get them all gussied up for a night out on the town. You can do just that with filters, effects, layer styles, and blend modes. These features enable you to add that touch of emphasis, drama, whimsy, or just plain goofy fun. We're the first to admit that often the simplest art (and that includes photographs) is the best. That gorgeous landscape or the portrait that perfectly captures the expression on a child's happy face is something you may want to leave unembellished. But for the times when a little artistic experimentation is in order, turn to this chapter as your guide.

Having Fun with Filters

Filters have been around since the early days of digital imaging, when Photoshop was just a little bitty program. *Filters*, also called *plug-ins* because

they can be installed or removed independently, change the look of your image in a variety of ways, as shown in Figure 11-1. They can correct less-than-perfect images by making them appear sharper or by covering up flaws, as we describe in Chapter 10. Or they can enhance your images by making them appear as though they're painted, tiled, photocopied, or lit by spotlights. Just make sure you create a backup of your original image if you plan on saving your filtered one. The following sections give you the basics on how to apply a filter, as well as a few filtering tips.

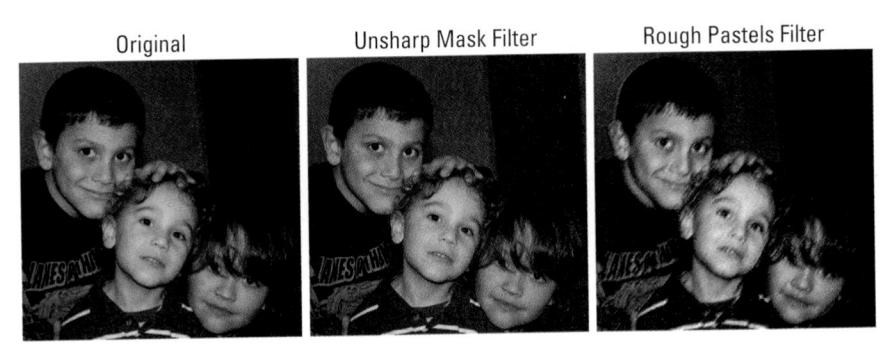

Figure 11-1: Use filters to correct image imperfections or to completely transform images.

Applying filters

You can apply a filter in three ways:

- ✓ The Filter menu. In either Expert or Quick mode, from the Filter menu, choose your desired filter category and then select a specific filter.
- ✓ The Effects panel. In Expert mode only, choose Windowr Effects to open the panel. Click the Filters tab at the top of the panel. Select your filter category from the drop-down menu directly under the Filters tab. Double-click the thumbnail of your desired filter or drag the filter onto your image window.
- ✓ The Filter Gallery. In either Expert or Quick mode, choose Filter-Filter Gallery to apply one or more filters in a flexible editing environment. The Filter Gallery is described in the section "Working in the Filter Gallery," later in this chapter.

When you're using the Filter Gallery, make a backup copy of your image (or at least create a duplicate layer) before you apply filters. Filters change the pixels of an image permanently, and when you exit the Filter Gallery, the filters you apply can't be removed, except for using the Undo command or History panel. But once those options are exhausted, you're stuck with the image as is.

You can't apply filters to images that are in Bitmap or Index Color mode. And some filters don't work on images in Grayscale mode. For a refresher on color modes, see Chapter 4.

Corrective or destructive filters

Although there are no hard-and-fast rules, most digital-imaging folks classify filters into two basic categories, *corrective* and *destructive*:

- Corrective filters usually fix some kind of image problem. They adjust color, improve focus, remove dust or artifacts, and so on. Don't get us wrong pixels are still modified. It's just that the basic appearance of the image remains the same, albeit hopefully improved. Two of the most popular corrective filters, Sharpen and Blur, are covered in Chapter 10.
- Destructive filters are used to create some kind of special effect. Pixels are also modified, but the image may look quite a bit different from its original. These kinds of filters create effects, such as textures, brush strokes, mosaics, lights, and clouds. They can also distort an image with waves, spheres, and ripples.

One-step or multistep filters

All corrective and destructive filters are one or the other:

- One-step filters have no options and no dialog boxes; select the filter and watch the magic happen.
- Multistep filters act almost like mini-applications.

When you choose a multistep filter, this opens a dialog box that has options for you to specify. The options vary widely depending on the filter, but most come equipped with at least one option to control the intensity of the filter. A multistep filter appears on the menu with an ellipsis following its name, indicating that a dialog box opens when you choose the command.

Fading a filter

Sometimes you don't want the full effect of a filter applied to your image. Fading a filter a bit softens the effect and can make it look less "computerish." Here's what you can do:

1. Choose Layer⇔Duplicate Layer.

The Duplicate Layer dialog box appears.

2. Click OK.

- 3. Apply your desired filter to the duplicate layer.
- 4. Use the blend modes and opacity settings located on the Layers panel to merge the filtered layer with the original unfiltered image.
- 5. (Optional) With the Eraser tool, selectively erase portions of your filtered image to enable the unfiltered image to show through.

For example, if you applied a Gaussian Blur filter to soften a harshly lit portrait, try erasing the blurred portion that covers the subject's eyes to let the unblurred eyes of the layer below show through. The sharply focused eyes provide a natural focal point.

Instead of erasing, you can also apply a layer mask to selectively show and hide portions of your filtered image. For details on layer masks, see Chapter 8.

Selectively applying a filter

Up to this point in the book, we refer to applying filters to your *images*. But we use this word rather loosely. You don't necessarily have to apply filters to your entire image. You can apply filters to individual layers or even to selections. You can often get better effects when you apply a filter just to a portion of an image or layer. For example, you can blur a distracting background so that the person in your image gets due attention. Or, as shown in Figure 11-2, you can apply an Ocean Ripple or Wave filter to the ocean, leaving your surfer unfiltered to avoid that "overly Photoshopped" effect.

©istockphoto.com/schutzphoto Image #9642901

Figure 11-2: Selectively applying a filter can prevent an image from looking overly manipulated.

Exercising a little restraint in applying filters usually produces a more attractive image.

Working in the Filter Gallery

When you apply a filter, don't be surprised if you're presented with a gargantuan dialog box. This *editing window*, as it's officially called, is the Filter Gallery. You can also access it by choosing Filter Filter Gallery. In the flexible Filter Gallery, you can apply multiple filters, tweak their order, and edit them *ad nauseam*.

Follow these steps to work in the Filter Gallery:

1. In either Expert or Quick mode, choose Filter⇔Filter Gallery.

The Filter Gallery editing window appears, as shown in Figure 11-3.

Show/hide applied filter

Const (SDN)

Const

©istockphoto.com/redhumv Image #7936392

Delete effect layer

Figure 11-3: Apply and edit multiple filters in the Filter Gallery.

In the center of the editing window, click your desired filter category folder.

The folder expands and shows the filters in that category. A thumbnail displays each filter's effect.

3. Select your desired filter.

You get a large, dynamic preview of your image on the left side of the dialog box. To preview a different filter, just select it. Use the magnification controls to zoom in and out of the preview. To hide the Filter menu and get a larger preview box, click the arrow to the left of the OK button.

4. Specify any settings associated with the filter.

The preview is updated accordingly.

- 5. When you're happy with the results, click OK to apply the filter and close the editing window.
- 6. If you want to apply another filter, click the New Effect Layer button at the bottom of the editing window.

This step duplicates the existing filter.

7. Choose your desired new filter, which then replaces the duplicate in the Applied Filters area of the dialog box.

Each filter you apply is displayed in the lower-right area of the Filter Gallery dialog box. To delete a filter, select it and click the Delete Effect Layer button. To edit a filter's settings, select it from the list and make any changes. Keep in mind that when you edit a filter's settings, the edit may affect the look of any subsequent filters you've applied. Finally, you can rearrange the order of the applied filters. Doing so changes the overall effect, however.

8. When you're completely done, click OK to apply the filters and close the editing window.

Distorting with the Liquify filter

The Liquify filter is really much more than a filter. It's a distortion that allows you to manipulate an image as though it were warm taffy. You can interactively twist, pull, twirl, pinch, and bloat parts of your image. You can even put your image on a diet, as we did in Figure 11-4. In fact, most ads and magazine covers feature models and celebrities whose photos have "visited" the Liquify filter once or twice. You can apply this distortion filter on the entire image, on a layer, or on a selection. This *überfilter* comes equipped with a mega-dialog box that has its own set of tools and options, as shown in Figure 11-4.

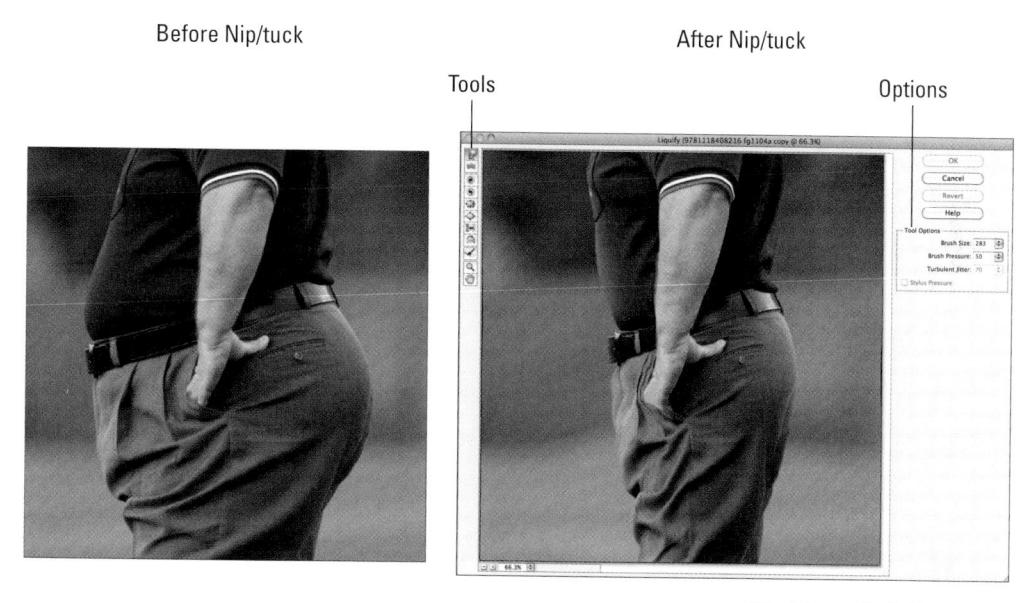

©istockphoto.com/RBFried Image #1531763

Figure 11-4: The Liquify filter enables you to interactively distort your image.

Follow these steps to turn your image into a melted Dalí-esque wannabe:

1. In either Expert or Quick mode, choose Filter⇔Distort⇔Liquify.

Your image appears in the preview area.

2. Choose your distortion weapon of choice.

You also have a number of tools to help zoom and navigate around your image window.

Here's a description of each tool to help you decide which to use. (The letter in parentheses is the keyboard shortcut.)

- *Warp (W):* This tool pushes pixels forward while you drag, creating a stretched effect. Use short strokes or long pushes.
- *Turbulence (T)*: Drag to randomly jumble your pixels. Use this tool to re-create maelstroms of air, fire, and water with clouds, flames, and waves. Adjust how smooth the effect is by dragging the Turbulent Jitter slider in the Tool Options. The higher the value, the smoother the effect.

- Twirl Clockwise (R) and Twirl Counterclockwise (L): These options rotate pixels either clockwise or counterclockwise. Place the cursor in one spot, hold down the mouse button, and watch the pixels under your brush rotate; or drag the cursor to create a moving twirl effect.
- *Pucker (P):* Click and hold or drag to pinch your pixels toward the center of the area covered by the brush. To reverse the pucker direction (*bloat*), press the Alt (Option on the Macintosh) key while you hold or drag.
- *Bloat (B):* Click and hold or drag to push pixels toward the edge of the brush area. To reverse the bloat direction *(pucker)*, press the Alt (Option on the Macintosh) key while you hold or drag.
- Shift Pixels (S): This tool moves pixels to the left when you drag the tool straight up. Drag down to move pixels to the right. Drag clockwise to increase the size of the object being distorted. Drag counterclockwise to decrease the size. To reverse any direction, press the Alt (Option on the Macintosh) key while you hold or drag.
- Reflection (M): This tool drags a reversed image of your pixels at a 90-degree angle to the motion of the brush. Hold down the Alt (Option on the Macintosh) key to force the reflection in the direction opposite the motion of the brush. This tool works well for making reflections on water.
- *Reconstruct (E):* See Step 4 for an explanation of this tool's function.
- *Zoom (Z):* This tool, which works like the Zoom tool on the Elements Tools panel, zooms you in and out so that you can better see your distortions.
 - You can zoom out by holding down the Alt (Option on the Macintosh) key when you press Z. You can also zoom by selecting a magnification percentage from the pop-up menu in the lower-left corner of the dialog box.
- *Hand (H)*: This tool works like the Hand tool on the Elements Tools panel. Drag with the Hand tool to move the image around the preview window.

3. Specify your options in the Tool Options.

- *Brush Size*. Drag the pop-up slider or enter a value from 1 to 600 pixels to specify the width of your brush.
- *Brush Pressure*. Drag the pop-up slider or enter a value from 1 to 100 to change the pressure. The higher the pressure, the faster the distortion effect is applied.

- *Turbulent Jitter*. Drag the pop-up slider or enter a value from 1 to 100 to adjust the smoothness when you're using the Turbulence tool.
- Stylus Pressure. If you're lucky enough to have a graphics tablet and stylus, click this option to select the pressure of your stylus.
- 4. (Optional) If you get a little carried away, select the Reconstruct tool, and then hold down or drag the mouse on the distorted portion of the image that you want to reverse or reconstruct.

Note that the reconstruction occurs faster at the center of the brush's diameter. To partially reconstruct your image, set a low brush pressure and watch closely while your mouse drags across the distorted areas.

5. Click OK to apply the distortions and close the dialog box.

If you mucked things up and want to start again, click the Revert button to get your original, unaltered image back. This action also resets the tools to their previous settings.

Correcting Camera Distortion

If you've ever tried to capture a looming skyscraper or cathedral in the lens of your camera, you know that it often involves tilting your camera and putting your neck in an unnatural position. And then, after all that, what you end up with is a distorted view of what was an impressive building in real life, as shown with the before image on the left in Figure 11-5. Fortunately, that's not a problem with Elements. The Correct Camera Distortion filter fixes the distorted perspective created by both vertical and horizontal tilting of the camera. As a bonus, this filter also corrects other kinds of distortions caused by lens snafus.

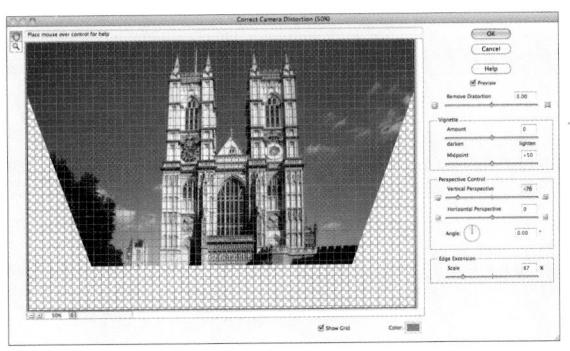

©istockphoto.com/veni Image #4193924

Figure 11-5: The Correct Camera Distortion filter fixes distortions caused by camera tilt and lens flaws.

Here's how to fix all:

- 1. In either Expert or Quick mode, choose Filter Correct Camera Distortion.
- 2. In the Correct Camera Distortion dialog box, be sure to select the Preview option.
- 3. Specify your correction options:
 - Remove Distortion. Corrects lens barrel, which causes your images to appear spherized or bloated. This distortion can occur when you're using wide-angle lenses. It also corrects pincushion distortion, which creates images that appear to be pinched in at the center, a flaw that's found when using telephoto or zoom lenses. Move the slider while keeping an eye on the preview. Use the handy grid as your guide for proper alignment.
 - Vignette Amount. Adjusts the amount of lightening or darkening around the edges of your photo that you can get sometimes from incorrect lens shading. Change the width of the adjustment by specifying a midpoint value. A lower midpoint value affects more of the image. Then move the Amount slider while viewing the preview.
 - *Vertical Perspective*. Corrects the distorted perspective created by tilting the camera up or down. Again, use the grid to assist in your correction. We used the vertical perspective to correct Westminster Abbey shown in Figure 11-5. It is a nice shot as is, but it could use a little tweaking.
 - *Horizontal Perspective*. Also corrects the distorted perspective. Use the grid to make horizontal lines (real and implied) in your image parallel. For better results, set the angle of movement under the Angle option.
 - Angle. Enables you to rotate the image to compensate for tilting the camera. You may also need to tweak the angle slightly after correcting the vertical or horizontal perspective.
 - Edge Extension Scale. When you correct the perspective on your image, you may be left with blank areas on your canvas. You can scale your image up or down to crop into the image and eliminate these holes. Note that scaling up results in interpolating your image up to its original pixel dimensions. Basically, interpolation means Elements analyzes the colors of the original pixels in your image and creates new ones, which are then added to the existing ones. This often results in less than optimum quality. Therefore, if you do this, be sure to start with an image that has a high-enough pixel dimension, or resolution, to avoid severe degradation. For more on resolution, see Chapter 4.

- Show Grid. Shows and hides the grid, as needed. You can also choose the color of your grid lines.
- * Zoom Tool. Zooms in and out for your desired view. You can also use plus (+) and minus (-) icons and the Magnification pop-up menu in the bottom-left corner of the window.
- Hand Tool. Moves you around the image window when you are zoomed in.
- 4. Click OK to apply the correction and close the dialog box.

Exploring New Filters

For the first time ever, Elements is getting its very own set of filters. Prior to this new version of Elements, all the filters were hand-me-downs from Photoshop. You'll find the three new filters under the Filter-Sketch submenu. To really get a feel for the cool effects these filters can create, we invite you to open a couple of your favorite images and play with the various presets and settings.

Creating a comic

Here are the steps to apply the new Comic filter on an image:

- 2. In the filter dialog box, choose from four presets, as shown in Figure 11-6.
- 3. Using the sliders, adjust the default settings for the Color and Outline areas of the filtered image:
 - Soften. Creates rounder or rougher areas of colors.
 - Shades. A higher value adds more tonal levels.
 - Steepness. A higher value makes the colored areas more defined and contrasty.
 - Vibrance. Brightens the overall color of the image.
 - Thickness. Affects the thickness and blackness of the outlined strokes.
 - \bullet ${\it Smoothness}.$ Fine-tunes your edges and enhances the overall filter effect.

If you want to reset your sliders back to the default values for the preset, hold down the Alt (Option on the Mac) key and the Cancel button in the dialog box changes to a Reset button.

- 4. Adjust your view as needed by using the following controls.
 - Zoom. Zoom in and out for your desired view. You can also use the 1:1 view (recommended) or Fit in Window view.
 - *Hand Tool.* Moves you around the image window when you are zoomed in.
- 5. Click OK to apply the filter and close the dialog box.

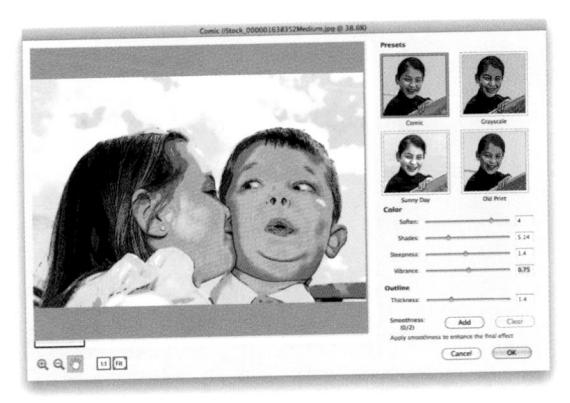

©istockphoto.com/ImagesbyTrista Image #1638352

Figure 11-6: The new Comic filter turns a photo into an illustration.

Getting graphic

The new Graphic Novel filter takes a bit of experimentation to create the effect you want. At least it did for us. But once you get your settings established, the look is pretty fun. Follow these steps to apply the new Graphic Novel filter on your favorite photo:

- 1. In either Expert or Quick mode, choose Filter⇔Sketch⇔Graphic Novel.
- 2. In the filter dialog box, choose from four presets, as shown in Figure 11-7.
- 3. Using the sliders, adjust the default settings for the filtered image:
 - Darkness. A higher value creates more areas of lightness.
 - Clean Look. A higher value makes smoother, more refined strokes.
 - Contrast. The higher the value, the more contrasty and, overall, darker — an image appears. A lower value will produce a lowercontrast, light-gray image.
- *Thickness*. Affects the thickness and blackness of the outlined strokes. A higher value produces a "goopier" stroke appearance.
- Smoothness. Fine tunes your edges and enhances the overall filter effect.

If you want to reset your sliders back to the default values for the preset, hold down the Alt (Option on the Mac) key and the Cancel button in the dialog box changes to Reset.

- 4. Adjust your view as needed by using the following controls.
 - Zoom. Zoom in and out for your desired view. You can also use the 1:1 view (recommended) or Fit in Window view.
 - Hand Tool. Moves you around the image window when you are zoomed in.
- 5. Click OK to apply the filter and close the dialog box.

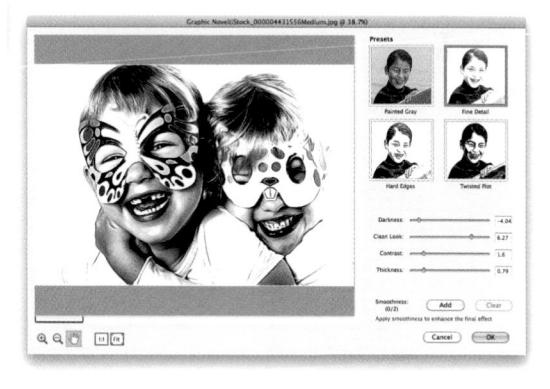

©istockphoto.com/pamspix Image #4431556

Figure 11-7: Create an image worthy of a graphic novel.

Using the Pen & Ink filter

Here are these steps to apply the new Pen & Ink filter on your photo:

- 1. In either Expert or Quick mode, choose Filter

 Sketch

 Pen & Ink.
- 2. In the filter dialog box, choose from four presets, as shown in Figure 11-8.

- 3. From here you can adjust the default setting of the sliders for the various settings for the Ink and Pen areas of the filtered image:
 - Detail. A higher value creates finer, crisper edges.
 - Width. A higher value creates thicker, goopier strokes, while a lower value creates crisper strokes.
 - Darkness. A higher value creates more areas of darkness.
 - Contrast. The higher the value, the more contrasty the image and more dark ink strokes are applied.
 - Hue. Adjust the slider to select your desired color along the color ramp.
 - Contrast. A higher value adds more contrast, darkness, and colored areas.
 - Fill. Fills the image with more areas of color and less white.

- 4. Adjust your view as needed by using the following controls.
 - Zoom. Zoom in and out for your desired view. You can also use the 1:1 view (recommended) or Fit in Window view.
 - Hand Tool. Moves you around the image window when you are zoomed in.
- 5. Click OK to apply the filter and close the dialog box.

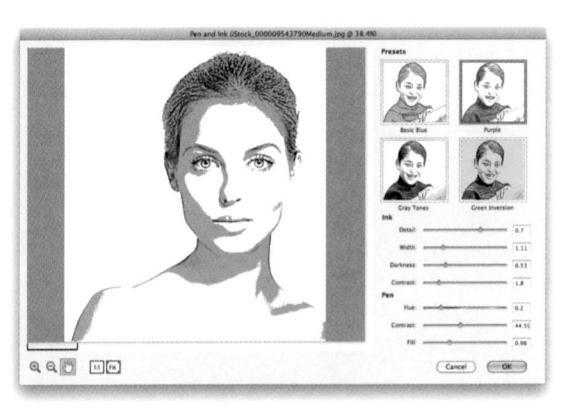

©istockphoto.com/iconogenic Image #9543790

Figure 11-8: Create a cartoon-like image with the Pen & Ink filter.

Dressing Up with Photo and Text Effects

In addition to the multitude of filters at your disposal, Elements also provides a lot of effects that you can apply to enhance your photos, as shown in Figure 11-9. Note that some effects automatically create a duplicate of the selected layer, whereas other effects can work only on flattened images. (See Chapter 8 for details on layers.) Finally, unlike with filters, you can't preview how the effect will look on your image or type, nor do you have any options to specify.

Here are the short steps to follow to apply an effect:

1. Select your desired image layer in the Layers panel.

Or, if you're applying the effect to just a selection, make the selection before applying the effect.

- 3. Select the Effects button at the top of the panel.

©istockphoto.com/Graffizone Image #5421076

Figure 11-9: Enhance your images by adding effects to your image and type layers.

- 4. Select your desired category of effects from the drop-down menu in the upper-right area of the panel:
 - Frame. Includes effects that enhance the edges of the layer or selection.
 - Faded Photo, Monotone Color, Old Photo, and Vintage Photo. This group of effects makes your image fade from color to grayscale, appear as a single color, or look like an old pencil sketch or a photo on old paper.
 - *Misc Effects*. Includes a wide variety of effects to make your image appear as though it's snowing, made of lizard skin or neon tubes, or painted with oil pastels.
 - Show All. Shows all the effects described in this list.

5. On the Effects panel, double-click your desired effect or drag the effect onto the image.

Note that you can view your styles and effects by thumbnails or by list. To change the view, click the down-pointing arrow in the upper-right corner of the panel to access the menu commands.

You can also apply an effect to type. Select your type layer and follow Steps 2 to 5 in the preceding list. Note that a dialog box alerts you that the type layer must be simplified before the effect can be applied. Simplifying that layer, of course, means you lose the ability to edit the text. Chapter 13 covers working with type in detail.

Adding Shadows, Glows, and More

Layer styles go hand in hand with filters and photo effects. Also designed to enhance your image and type layers, layer styles range from simple shadows and bevels to the more complex styles, such as buttons and patterns. The wonderful thing about layer styles is that they're completely nondestructive. Unlike filters, layer styles don't change your pixel data. You can edit them or even delete them if you're unhappy with the results.

Here are some important facts about layer styles:

- Layer styles can be applied only to layers. If your image is just a background, convert it to a layer first.
- Layer styles are dynamically linked to the contents of a layer. If you move or edit the contents of the layers, the results are updated.
- When you apply a layer style to a layer, an fx symbol appears next to the layer's name on the Layers panel. Double-click the fx to bring up the Style Settings dialog box and perform any editing that's necessary to get the look you want.

Applying layer styles

Layer styles are stored in a few different libraries. You can add shadows, glows, beveled and embossed edges, and more complex styles, such as neon, plastic, chrome, and various other image effects. A sampling of styles is shown in Figure 11-10.

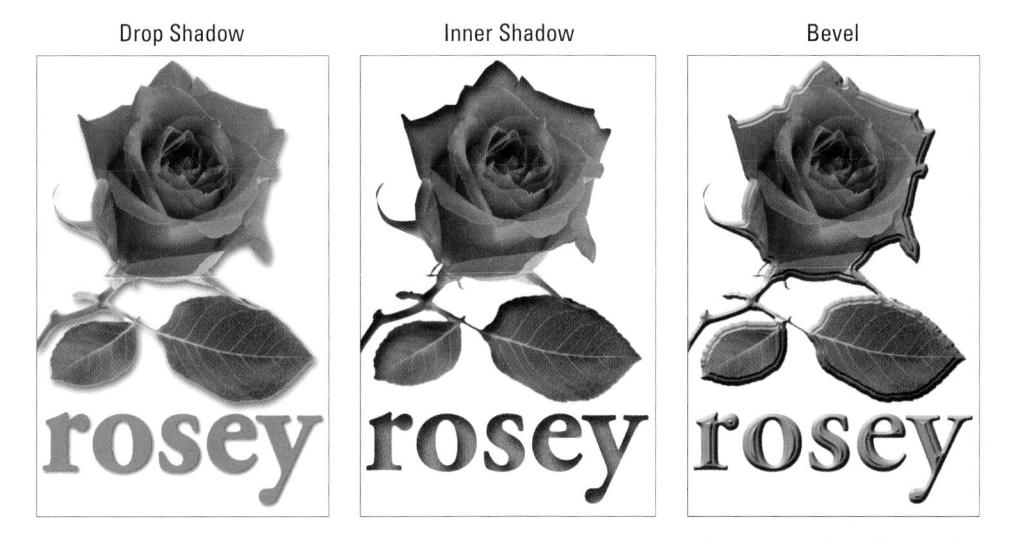

©istockphoto.com/skdonnell Image #1217074

Figure 11-10: Add dimension by applying shadows and bevels to your object or type.

Here are the steps to apply a style and a description of each style library:

- 1. Select your desired image, shape, or type layer on the Layers panel.
- 2. Choose Window Effects.
- 3. Select the Styles button at the top of the Effects panel.
- 4. Select your desired library of styles from the drop-down menu in the upper-right area of the panel:
 - *Bevels*. Bevels add a three-dimensional edge on the outside or inside edges of the contents of a layer, giving the element some dimension. Emboss styles make elements appear as though they're raised off or punched into the page. You can change the appearance of these styles, depending on the type of bevel chosen. Adjust parameters, such as the lighting angle, distance (how close the shadow is to the layer contents), size, bevel direction, and opacity.
 - *Drop and Inner Shadows*. Add a soft drop or inner shadow to a layer. Choose from the garden-variety shadow or one that includes noise, neon, or outlines. You can adjust the lighting angle, distance, size, and opacity, as desired.

- Outer and Inner Glows. Add a soft halo that appears on the outside or inside edges of your layer contents. Adjust the appearance of the glow by changing the lighting angle, size, and opacity of the glow.
- *Visibility*. Click Show, Hide, or Ghosted to display, hide, or partially show the layer contents. The layer style remains fully displayed.
- *Complex and others.* The remaining layer styles are a cornucopia of different effects ranging from simple glass buttons to the more exotic effects, such as Groovy and Rose Impressions. You can customize all these layer styles to a certain extent by adjusting the various settings, which are similar to those for other styles in this list.
- 5. On the Layer Styles panel, double-click your desired effect or drag the effect onto the image.

The style, with its default settings, is applied to the layer. Note that layer styles are cumulative. You can apply multiple styles — specifically, one style from each library — to a single layer.

To edit the style's settings, either double-click the fx icon on the Layers panel or choose Layer⇔Layer Style⇔Style Settings.

You can also apply layer styles to type layers, and the type layer doesn't need to be simplified.

Working with layer styles

Here are a few last tips for working with layer styles:

- ✓ **Delete a layer style or styles.** Choose Layer Style Clear Layer Style or drag the fx icon on the Layers panel to the trash icon.
- ✓ Copy and paste layer styles onto other layers. Select the layer containing the layer style and choose Layer Layer Style. Copy Layer Style. Select the layer(s) on which you want to apply the effect and choose Layer Layer Style. Paste Layer Style. If it's easier, you can also just drag and drop an effect from one layer to another while holding down the Alt (Option on the Macintosh) key.
- ✓ Scale a layer style. Choose Layer Layer Style Scale Effects. Select Preview and enter a value between 1 and 1,000 percent. This action allows you to scale the style without scaling the element.

Mixing It Up with Blend Modes

Elements sports a whopping 25 blend modes. *Blend modes* affect how colors interact between layers and also how colors interact when you apply paint to a layer. Not only do blend modes create interesting effects, you can also easily apply, edit, or remove blend modes without touching your image pixels.

The various blend modes are located on a drop-down menu at the top of your Layers panel in Expert mode. The best way to get a feel for the effect of blend modes is not to memorize the descriptions we give you in the following sections. Instead, grab an image with some layers and apply each of the blend modes to one or more of the layers to see what happens. The exact result varies, depending on the colors in your image layers.

General blend modes

The Normal blend mode needs no introduction. It's the one you probably use the most. Dissolve is the next one on the list and, ironically, is probably the one you use the least. (Both blend modes are illustrated in Figure 11-11.)

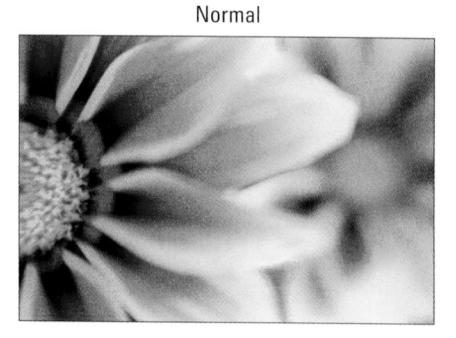

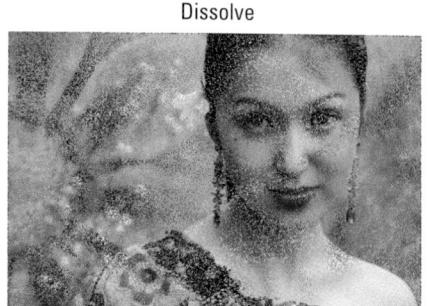

©istockphoto.com/OlsenMatt Image #2195921, Elpiniki Image #1861345

Figure 11-11: The Dissolve blend mode allows pixels from one layer to peek randomly through another.

- ✓ Normal: The default mode displays each pixel unadjusted. Note that you can't see the underlying layer at all with the Normal blend mode.
- ✓ **Dissolve:** This mode can be seen only on a layer with an opacity setting of less than 100 percent. It allows some pixels from lower layers, which are randomized, to show through the target (selected) layer.

Darken blend modes

These blend modes produce effects that darken your image in various ways, as shown in Figure 11-12.

- Darken: Turns lighter pixels transparent if the pixels on the target layer are lighter than those below. If the pixels are darker, they're unchanged.
- Multiply: Burns the target layer onto the layers underneath, thereby darkening all colors where they mix. When you're painting with the Brush or Pencil tool, each stroke creates a darker color, as though you're drawing with markers.
- Color Burn: Darkens the layers underneath the target layer and burns them with color, creating a contrast effect, like applying a dark dye to your image.
- ✓ Linear Burn: Darkens the layers underneath the target layer by decreasing the brightness. This effect is similar to Multiply but often makes parts of your image black.
- ✓ Darker Color: When blending two layers, the darker color of the two colors is visible.

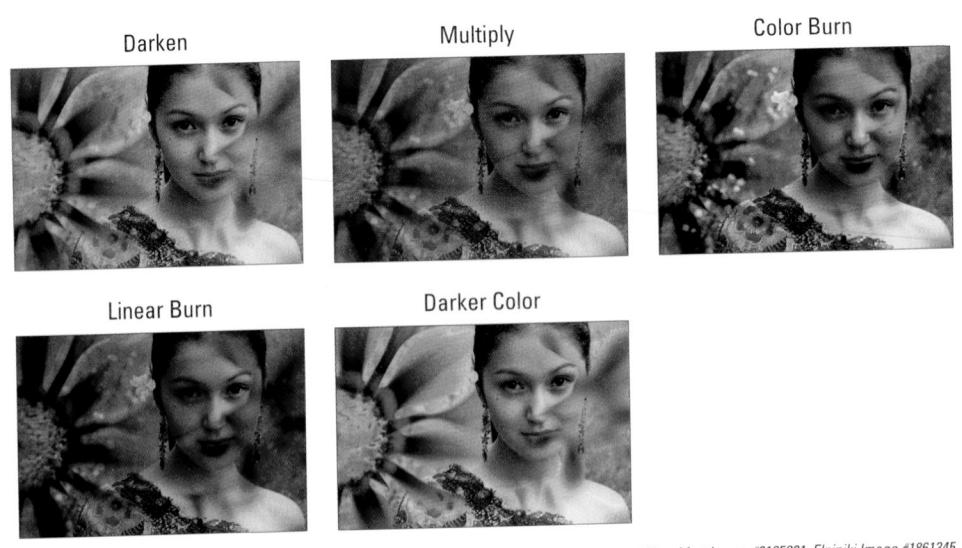

©istockphoto.com/OlsenMatt Image #2195921, Elpiniki Image #1861345

Figure 11-12: These blend modes darken your image layers.

Lighten blend modes

The lighten blend modes are the opposite of the darken blend modes. All these blend modes create lightening effects on your image, as shown in Figure 11-13.

- Lighten: Turns darker pixels transparent if the pixels on the target layer are darker than those below. If the pixels are lighter, they're unchanged. This effect is the opposite of Darken.
- ✓ **Screen:** Lightens the target layer where it mixes with the layers underneath. This effect is the opposite of Multiply.
- Color Dodge: Lightens the pixels in the layers underneath the target layer and infuses them with colors from the top layer. This effect is similar to applying a bleach to your image.
- Linear Dodge: Lightens the layers underneath the target layer by increasing the brightness. This effect is similar to Screen but often makes parts of your image white.
- ✓ Lighter Color: When blending two layers, the lighter color of the two colors is visible.

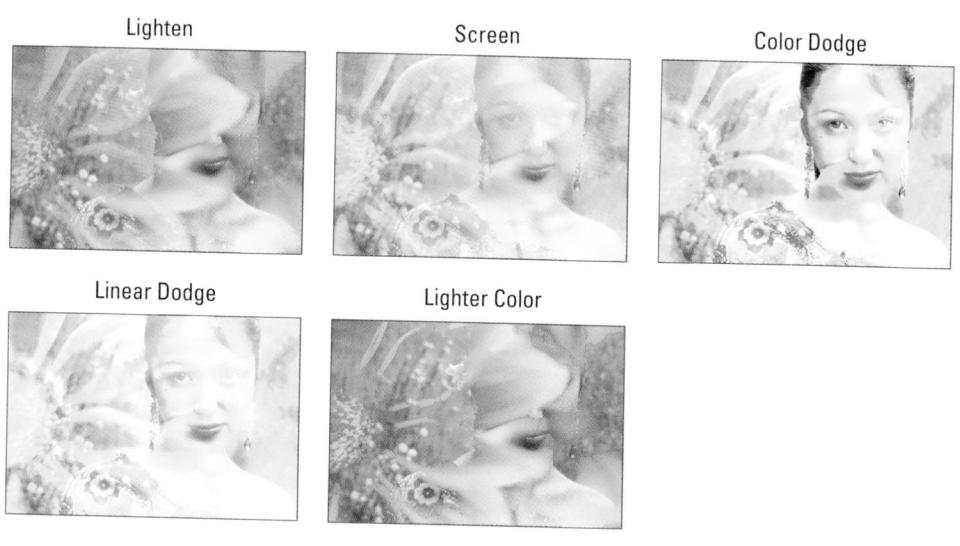

©istockphoto.com/OlsenMatt Image #2195921, Elpiniki Image #1861345
Figure 11-13: These blend modes lighten vour image lavers.

Lighting blend modes

This group of blend modes plays with the lighting in your layers, as shown in Figure 11-14.

- Overlay: Overlay multiplies the dark pixels in the target layer and screens the light pixels in the underlying layers. It also enhances the contrast and saturation of colors.
- ✓ Soft Light: This mode darkens the dark (greater than 50 percent gray) pixels and lightens the light (less than 50 percent gray) pixels. The effect is like shining a soft spotlight on the image.
- ✓ Hard Light: This mode multiplies the dark (greater than 50 percent gray) pixels and screens the light (less than 50 percent gray) pixels. The effect is similar to shining a bright, hard spotlight on the image.
- ✓ **Vivid Light:** If the pixels on the top layer are darker than 50 percent gray, this mode darkens the colors by increasing the contrast. If the pixels on the top layer are lighter than 50 percent gray, the mode lightens the colors by decreasing the contrast.
- ✓ **Linear Light:** If the pixels on the top layer are darker than 50 percent gray, the mode darkens the colors by decreasing the brightness. If the pixels on the top layer are lighter than 50 percent gray, the mode lightens the colors by increasing the brightness.
- ▶ Pin Light: If the pixels on the top layer are darker than 50 percent gray, the mode replaces pixels darker than those on the top layer and doesn't change lighter pixels. If the pixels on the top layer are lighter than 50 percent gray, the mode replaces the pixels lighter than those on the top layer and doesn't change pixels that are darker. The mode is usually reserved for special effects.
- ✓ Hard Mix: This mode is similar to Vivid Light but reduces the colors to a total of eight cyan, magenta, yellow, black, red, green, blue, and white. This mode creates a posterized effect.

Inverter blend modes

The inverter blend modes invert your colors and tend to produce some radical effects, as shown in Figure 11-15.

- ✓ Difference: Produces a negative effect according to the brightness values on the top layers. If the pixels on the top layer are black, no change occurs in the underlying layers. If the pixels on the top layer are white, the mode inverts the colors of the underlying layers.
- Exclusion: Like Difference, but with less contrast and saturation. If the pixels on the top layer are black, no change occurs in the underlying layers. If the pixels on the top layer are white, this mode inverts the colors of the underlying layers. Medium colors blend to create shades of gray.

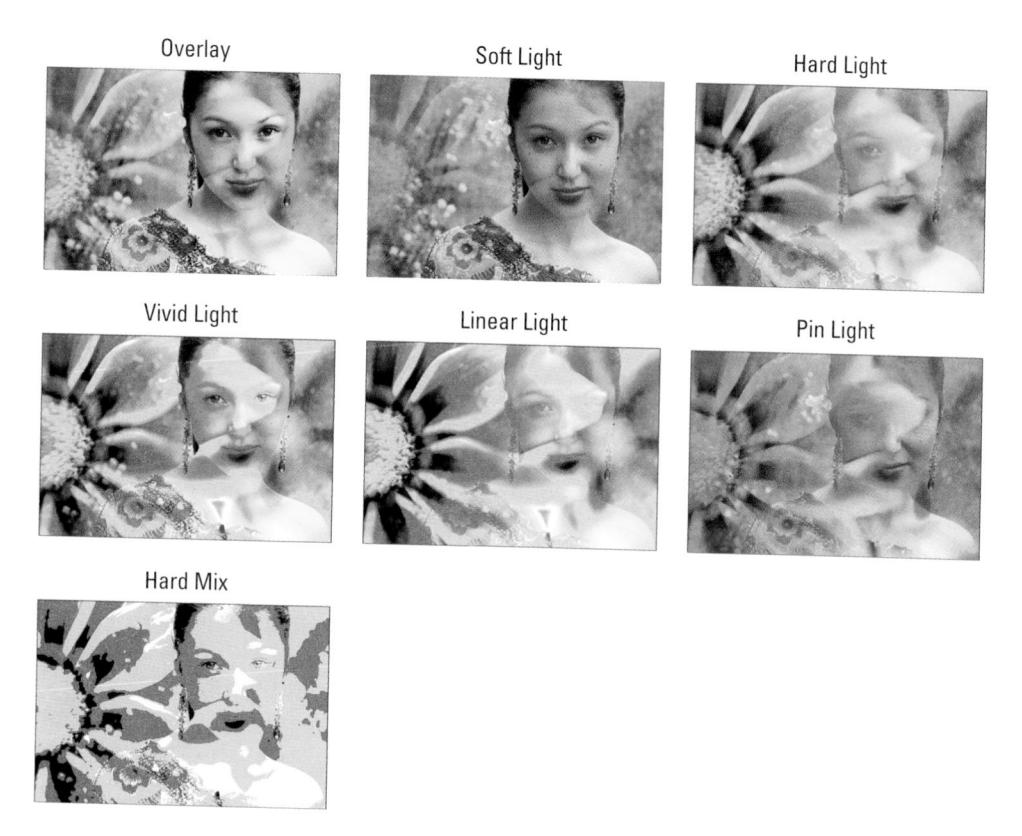

©istockphoto.com/OlsenMatt Image #2195921, Elpiniki Image #1861345 Figure 11-14: Some blend modes adjust the lighting between your image layers.

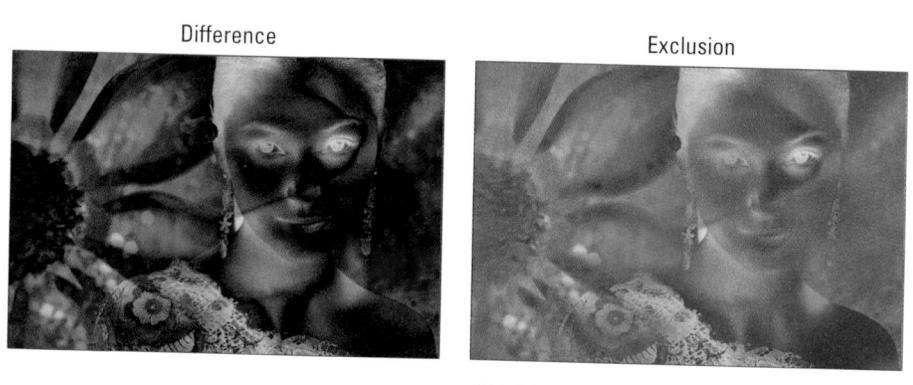

©istockphoto.com/OlsenMatt Image #2195921, Elpiniki Image #1861345 Figure 11-15: Difference and Exclusion blend modes invert colors.

HSL blend modes

These blend modes use the HSL (hue, saturation, lightness) color model to mix colors, as shown in Figure 11-16.

- ✓ Hue: Blends the *luminance* (brightness) and *saturation* (intensity of the color) of the underlying layers with the *hue* (color) of the top layer.
- Saturation: Blends the luminance and hue of the underlying layers with the saturation of the top layer.
- ✓ Color: Blends the luminance of the underlying layers with the saturation and hue of the top layer. This mode enables you to paint color while preserving the shadows, highlights, and details of the underlying layers.
- Luminosity: The opposite of Color, this mode blends the hue and saturation of the underlying layers with the luminance of the top layer. This mode also preserves the shadows, highlights, and details from the top layer and mixes them with the colors of the underlying layers.

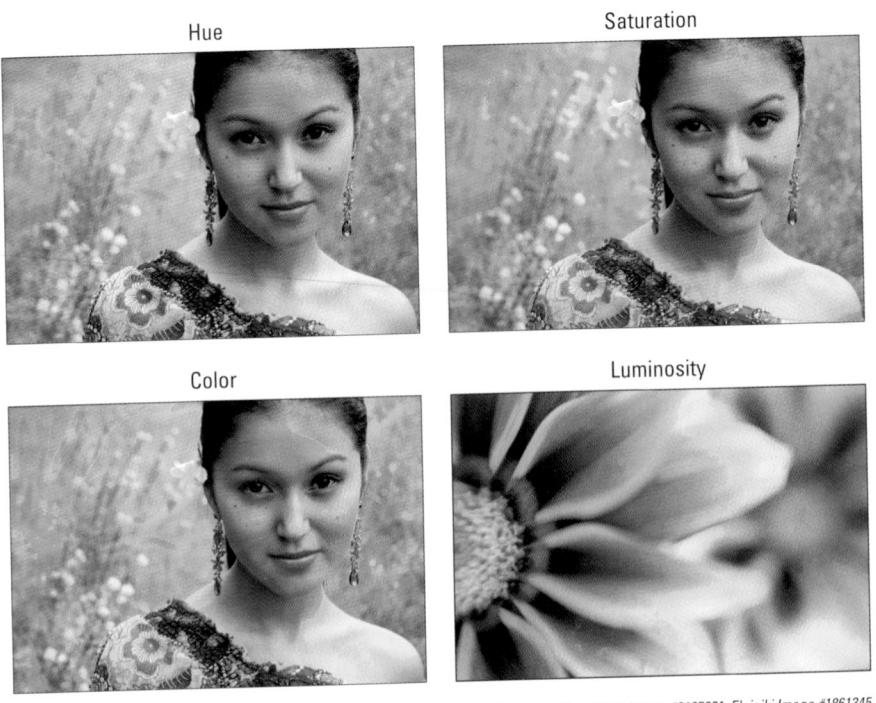

©istockphoto.com/OlsenMatt Image #2195921, Elpiniki Image #1861345

Figure 11-16: Some blend modes mix colors based on the actual hue, richness, and brightness of color.

Using Photomerge

The awesome Photomerge features help you to create fabulous composites from multiple images. Whether it's creating the perfect shot of a group of friends or of your favorite vacation spot (without the passing cars and people), the Photomerge feature is the go-to tool to get it done. The following sections tell you how the Photomerge commands help to create the special type of composite image you need.

Note that all Photomerge commands can be accessed in all three Photo Editor modes or in the Organizer.

Photomerge Panorama

The Photomerge Panorama command enables you to combine multiple images into a single panoramic image. From skylines to mountain ranges, you can take several overlapping shots and stitch them together into one.

The following tips can help you start with good source files that will help you successfully merge photos into a panorama:

- ✓ Make sure that when you shoot your photos, you overlap your individual images by 15 to 40 percent, but no more than 50 percent.
- Avoid using distortion lenses (such as fish-eye) and your camera's zoom setting.
- Try to keep the same exposure settings for even lighting.
- Try to stay in the same position and keep your camera at the same level for each photo. If possible, using a tripod and moving both the tripod and camera along a level surface, taking the photos from the same distance and angle is best. However, if conditions don't allow for this, using a tripod and just rotating the head is the next best method. Be aware, however, that it can be harder to keep the lighting even, depending on the angle of your light source relative to the camera. You can also run into perspective-distortion issues with your shots.

Follow these steps to create a Photomerge Panorama image:

The first Photomerge dialog box opens.

2. Select Files or Folder from the Use drop-down menu.

- 3. Click Add Open Files to use all open files, or click the Browse button and navigate to where your files or folder are located.
- 4. Choose your desired mode under Layout.

Here's a brief description of each mode:

- Auto. Elements analyzes your images.
- Perspective. If you shot your images with perspective or at extreme angles, this is your mode. Try this mode if you shot your images with a tripod and rotating head.
- Cylindrical. If you shot your images with a wide-angle lens or you have those 360-degree, full-panoramic shots, this is a good mode.
- Spherical. This projection method aligns images by rotating, positioning, and uniformly scaling each image. It may be the best choice for pure panoramas, but you can also find it useful for stitching images together using common features.
- Collage. This mode is handy when stitching together a 360-degree panorama, in which you have a wide field of view, both horizontally and vertically. Use this option for shots taken with a wideangle lens.
- Reposition. Elements doesn't take any distortion into account; it simply scans the images and positions them as best it can.

If you choose any of the preceding modes, Elements opens and automatically assembles the source files to create the composite panorama in the work area of the dialog box. If it looks good, skip to Step 7.

Elements alerts you if it can't automatically composite your source files. You then have to assemble the images manually.

• *Interactive Layout.* This option opens the work area pane, as shown in Figure 11-17. Elements tries to align and stitch the images the best it can, but you may have to manually complete or adjust the panorama.

Before clicking OK, select from the following options:

Blend Images Together. Corrects the color differences that can occur from blending images with different exposures.

Vignette Removal. Corrects exposure problems caused by lens *vignetting* (when light at the edges of images is reduced and the edges are darkened).

Geometric Distortion Correction. Corrects lens problems such as radial distortions — barrel distortion (bulging out) and pincushion distortion (pinching in).

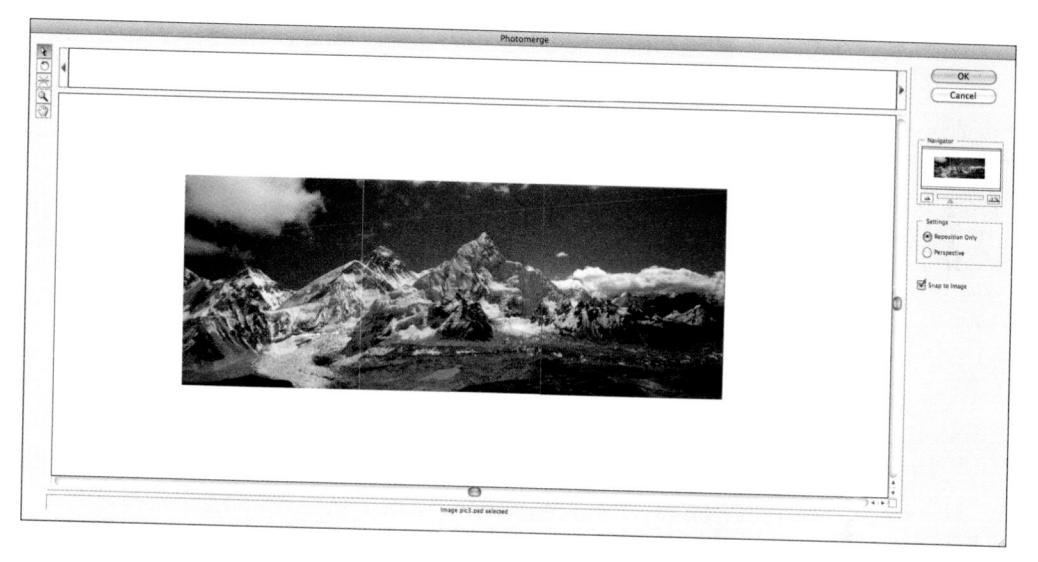

©istockphoto.com/weareadventurers Image #2375031

Figure 11-17: Combine multiple images into a single panorama with Photomerge.

Note that with any of the modes, Elements leaves your merged image in layers. You'll also notice that a layer mask has been added to each layer to better blend your panoramic image. For more on layer masks, see Chapter 8.

5. If Elements hasn't already done so, drag the image thumbnails from the lightbox area (the small white area at the top) onto the work area with the Select Image tool (the arrow).

Or you can simply double-click the lightbox thumbnail to add it to the composition.

- 6. Arrange and position your images:
 - Select Image tool. Positions the images.
 - Rotate Image tool. Makes rotations.
 - Zoom and Move View tools. Helps view and navigate around your panorama.
 - Navigator view box. Zooms into and out of your composition when you drag the slider.
 - Snap to Image option. Enables overlapping images to automatically snap into place.

7. To adjust the vanishing point, first select the Perspective option in the Settings area and click your desired image with the Set Vanishing Point tool.

Elements changes the perspective of the composition. By default, Elements selects the center image as the vanishing point. If necessary, you can move the other images.

Note that when you select the Perspective setting, Elements links non–Vanishing Point images to the Vanishing Point image. To break the link, click the Normal Setting button or separate the images in the work area.

8. Click OK to create the panorama.

The Clean Edges dialog box may ask you if you would like Elements to fill in the edges of your panorama. We recommend you say yes. Rather than cropping off any gaps around the edges of your image, Elements analyzes your content and then gives you a content-aware fill. The file opens as a new, unsaved file in Elements. Note that you can also click the Save Composition button to save the file as a Photomerge Composition (.pmg) file. We would avoid this approach, however, because the file format isn't very compatible with other programs.

Photomerge Group Shot

We all know how hard it is to get a group of people to all look great in one shot. Well, Photomerge Group Shot lets you take multiple group photos and merge the best of them to get that perfect shot.

Here are the steps to create a Photomerge Group Shot image:

- 1. Select two or more photos from your Photo Bin.
- 3. Take your best overall group shot and drag it from the Photo Bin onto the Final window.
- 4. Select one of your other photos in the Photo Bin to use as your source image. Drag it to the Source window.
- 5. With the Pencil tool, draw a line around the portions of the Source photo you want to merge into your Final photo, as shown in Figure 11-18.

You can choose to show your pencil strokes and/or show your regions, which will be highlighted with an overlay.

6. Repeat Steps 4 and 5 with any remaining photos.

If your photos aren't aligned, you can use the Alignment tool under the Advanced Options.

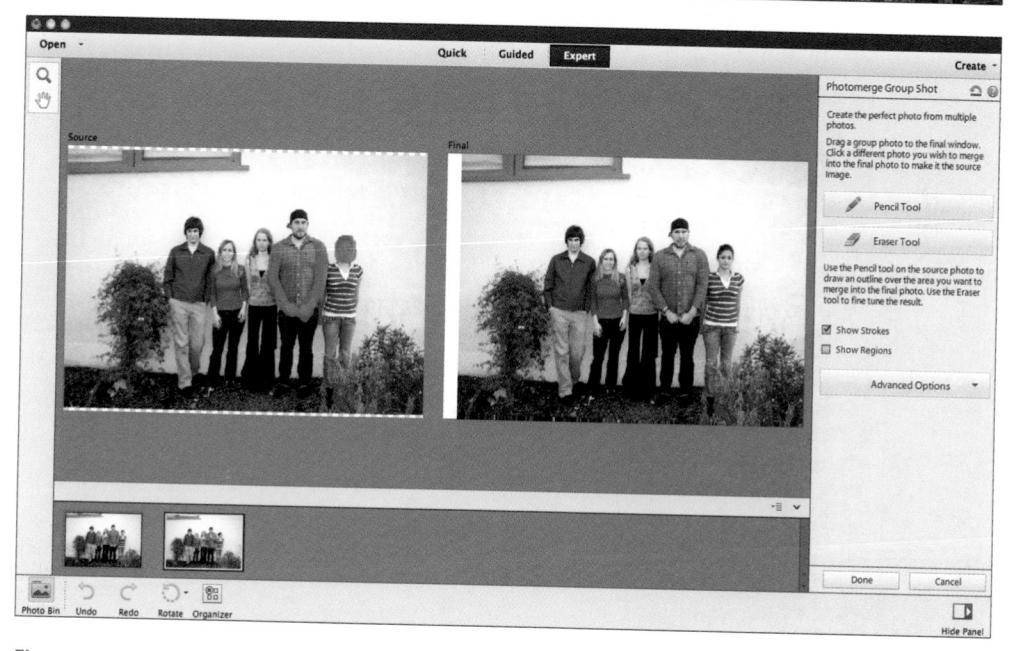

Figure 11-18: Get the perfect group shot from several images.

- 7. With the Alignment tool, click your source image and position the three target markers on three key locations. Do the same on the final image and choose similar locations.
- 8. Click the Align Photos button.

As with Photomerge Panorama, the more alike in framing, size, and so on, that your source and final images are, the better the merged result.

Note that if you see any noticeable seams on your final image around the copied area, you can click the Pixel Blending button to help smooth over those flaws.

Photomerge Faces

Photomerge Faces, a more fun than useful tool, lets you blend features from multiple faces to get a kind of hybrid face. To create a hybrid human by using the Photomerge Faces feature, select two or more photos from your Project Bin

and choose File New Photomerge Faces in any of the edit modes. Use the Alignment and Pencil tools to choose how you'd like to merge the photos, similar to the steps described in the section "Photomerge Group Shot."

- 9. (Optional) If you make a mess of things, click the Reset button.
- 10. When you're satisfied with the result, click Done.

The file opens as a new file in Elements.

Photomerge Scene Cleaner

Photomerge Scene Cleaner (see Figure 11-19) sounds like a tool you might see in an episode of CSI to mop up a crime scene, but it isn't quite that gory. This member of the Photomerge commands family enables you to create the optimum image by allowing you to eliminate annoying distractions, such as cars, passersby, and so on.

To get the best source images for a clean scene, be sure to take multiple shots of your scene from the same angle and distance. It also works best when the elements you want to eliminate are moving.

Follow these steps to create a Photomerge Scene Cleaner composite:

- 1. Select two or more photos from your Photo Bin.
- 2. Choose Enhance → Photomerge → Photomerge Scene Cleaner in any of the edit modes.

Elements attempts to auto-align your images the best it can.

- 3. Take your best overall shot of the scene and drag it from the Photo Bin onto the Final window.
- 4. Select one of your other photos in the Photo Bin to use as your source image. Drag it to the Source window.
- With the Pencil tool, draw a line around the elements in the final photo that you want to be replaced by content from the source photo.
- 6. Repeat Steps 4 and 5 with the remaining shots of the scene.

If your photos aren't aligned, you can use the Alignment tool under the Advanced Options.

7. With the Alignment tool, click your source image and position the three target markers on three key locations.

Do the same on the final image, choosing similar locations.

8. Click the Align Photos button, as shown in Figure 11-19.

Again, as with the other Photomerge commands, the more similar your starting source images are (framing, angle), the better the merged result.

If you see any noticeable seams on your final image around the copied area, click the Pixel Blending button to help smooth over those flaws.

- 9. If you make a mess of things, click the Reset button and start over.
- 10. When you're satisfied with the result, click Done.

The resulting image opens as a new file in Elements.

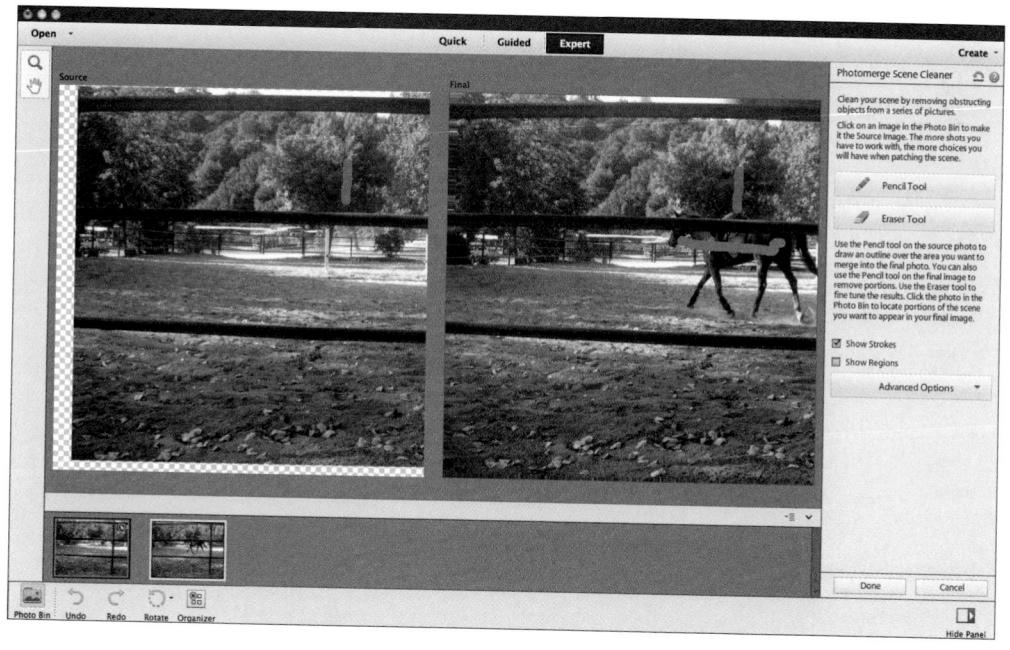

Figure 11-19: Eliminate annoying distractions with Photomerge Scene Cleaner.

Photomerge Exposure

Sometimes you need to capture a shot that poses an exposure challenge — your foreground and background require different exposure settings. This dilemma often occurs in shots that are backlit. For example, suppose you have a person in front of an indoor window in the day or someone in front of a lit nighttime cityscape. With Photomerge Exposure, you can take shots with two different exposure settings and let the command blend them together for the perfect shot.

You can shoot your initial images using *exposure bracketing* (shooting at consecutive exposure camera settings) or with a flash and then without. Elements will be able to detect all these camera settings. We recommend that you use a tripod, if possible, to keep your shots aligned. This will help the blending algorithm do its job.

Here's how to use this great command:

- 1. Select two or more photos from your Photo Bin.
- 2. In any of the edit modes, choose Enhance⇔Photomerge ⇔Photomerge Exposure.
- 3. If you have done a good job keeping your shots aligned, leave the mode on Automatic.

Select the quickie Simple Blending option and Elements automatically blends the two images. Select the Smart Blending option to access sliders to adjust the Highlights, Shadows, and Saturation settings for finer tuning of the resulting images. If you muck things up, click the Reset button.

- 4. If you feel the need for even more control, click the Manual mode tab.
- 5. In Manual mode, choose your first shot from the Photo Bin and drag it to the Final window. If your other image isn't already the source image, drag it from the Photo Bin to the Source window.
- 6. With the Pencil tool, draw over the well-exposed areas you want to retain in the source image.

As you draw, your final image will show the incorporation of those drawn areas, as shown in Figure 11-20.

7. If you mistakenly draw over something you don't want, grab the Eraser tool and erase the Pencil tool marks.

Choose the appropriate option to have your preview show strokes or regions.

8. You can further control the blending by dragging the Transparency slider.

Dragging to the right will blend less of the source areas into the final image. Check the Edge Blending option to get an even better blend of the two images.

9. If your photos aren't aligning correctly, grab the Alignment tool under Advanced Options.

With the Alignment tool, click your source image and position the three target markers on three key locations.

Do the same on the final image, choosing similar locations.

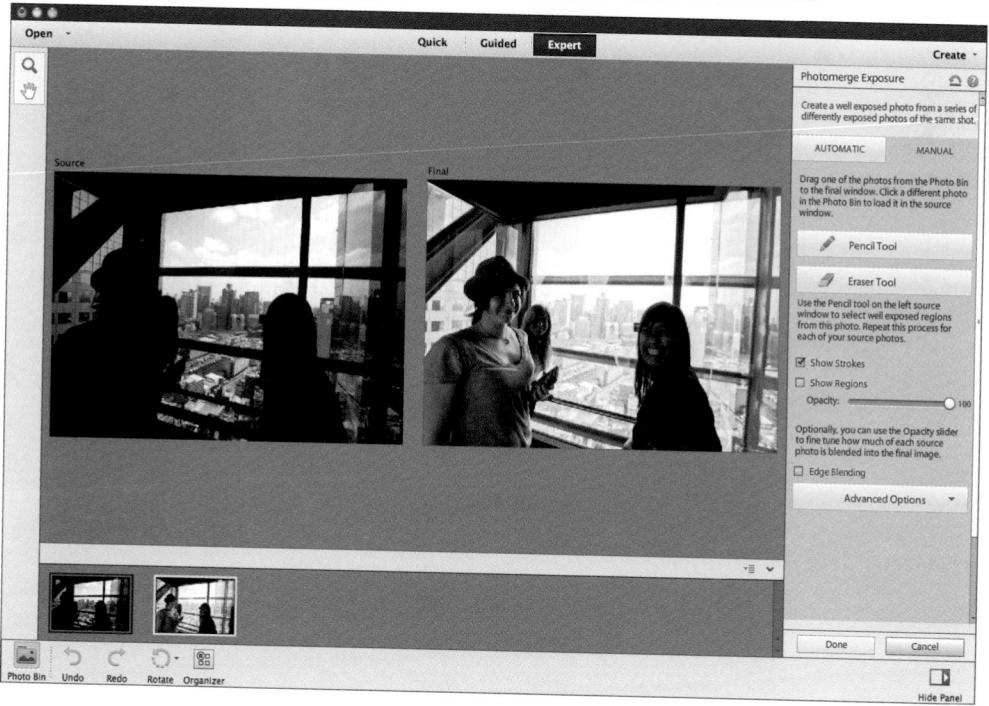

Figure 11-20: Combine images shot with two different exposures into a hero shot.

©Jake Starley

10. Click the Align Photos button.

Again, as with the other Photomerge commands, the more similar your starting source images are (framing, angle), the better the merged result.

- 11. Again, if you make a mess of things, click the Reset button.
- 12. When you're satisfied with the result, click Done.

The image opens as a new, layered file in Elements. The blended image appears on Layer 1. The background is your starting Final image. You can either flatten the layered file, which keeps the appearance of Layer 1, or you can double-click your background to convert it to a layer and then delete it by dragging it to the trash icon in the Layers panel.

Photomerge Style Match

You can match or apply the style of one image onto another image. It is hard to explain exactly what Adobe defines as "style," but basically tonal properties are transferred from one image to another. But rather than read a definition of the feature, it's best to spend a couple of minutes trying it.

Here are the steps to transfer a style from one image onto another:

- 1. Select a photo from your Photo Bin *onto* which you would like to transfer a style.
- 2. In any of the edit modes, choose Enhance⇔Photomerge ⇒Photomerge Style Match.
- 3. Your selected photo appears in the right window as your source (After) image.
- 4. Drag an image from the Style Bin to the left window to act as your sample (Style) image *from* which your desired style will be transferred.

To add more images to the Style Bin, click the green plus sign and choose to add sample images from either the Organizer or your hard drive.

- 5. Adjust the following sliders, as shown in Figure 11-21:
 - Intensity. Specifies the intensity or strength of the style transfer.
 Keep the number low to blend more of the original image with the styled image.
 - Clarity. Specifies how clearly the style transfer appears.
 - Details. Enhances or decreases details in the styled image.

Note that the results depend on your chosen images, so experiment with the preceding options to get your desired result.

- 6. Further define the styled image by adjusting the following options under Basic mode:
 - *Style Eraser.* Paint with this tool to erase the style from areas on your source image.
 - Style Painter. Paint with this tool to add the style to areas on your source image.
 - Soften Stroke Edges. Drag the slider to clean up your image and remove any seams between the styled and original image areas.
 - Transfer Tones. Select the check box to transfer the tonal values of the source image onto the styled image.
- 7. You can use more than one image as your sample image. To do so, simply repeat Steps 4 through $6.\,$
- 8. Again, if you make a mess of things, click the Reset Panel button (blue curved arrow icon) in the top right of the panel.
- 9. When you're satisfied with the result, click Done.

The file opens as a new file in Elements.

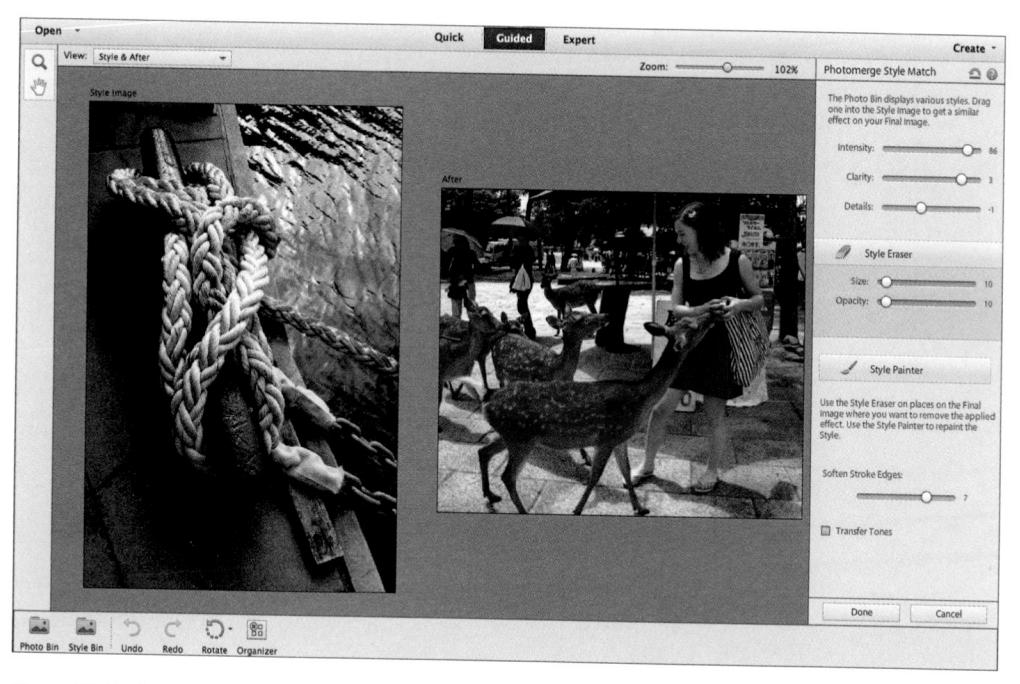

Figure 11-21: Copy a style from one image to another.

Drawing and Painting

In This Chapter

- Choosing colors
- Drawing with the Pencil tool
- Painting with the Brush tool
- Filling and outlining your selections
- Pouring color with the Paint Bucket tool
- Creating gradients and patterns
- Creating and editing shapes of all sorts

Elements is such a deluxe, full-service image-editing program that it doesn't just stop at giving you tools to select, repair, organize, and share your images. It figures that you may need to add a swash of color, either freeform with a brush or pencil, or in the form of a geometric or organic shape. Don't worry: This drawing and painting business isn't just for those with innate artistic talent. In fact, Elements gives you plenty of preset brushes and shapes that you can use. If you can pick a tool and drag your mouse, you can draw and paint.

low

Choosing Color

Before you start drawing or painting, you may want to change your color to something other than the default black. If you read the earlier chapters in this book, you may have checked out the Elements Tools panel and noticed the two overlapping color swatches at the bottom of the panel. These two swatches represent two categories of color: foreground and background.

Here's a quick look at how they work with different tools:

- ✓ When you add type, paint with the Brush tool, or create a shape, you're using the foreground color.
- On the background layer of an image, when you use the Eraser tool, or when you increase the size of your canvas, you're accessing the background color.
- When you drag with the Gradient tool, so long as your gradient is set to the default, you're laying down a blend of color from the foreground to the background.

Elements gives you three ways to choose your foreground and background colors: the Color Picker, the color swatches, and the Eyedropper tool, which samples color in an image. In the following sections, we explore each one.

Working with the Color Picker

By default, Elements uses a black foreground color and a white background color. If you're experimenting with color and want to go back to the default color, press the D key. If you want to swap between foreground and background colors, press the X key. If you want any other color, click your desired swatch to change either the foreground or background color. This action transports you to the Color Picker, as shown in Figure 12-1.

Here are the steps to choose your color via the Color Picker:

1. Click either the foreground or background color swatch on the Tools panel.

The Color Picker appears.

- 2. Drag the color slider or click the color bar to get close to the general color you desire.
- 3. Choose the exact color you want by clicking in the large square, or *color field*, on the left.

The circle cursor targets your selected color. The two swatches in the upper-right corner of the dialog box represent your newly selected color and the original foreground or background color.

The numeric values on the right side of the dialog box also change according to the color you selected. If you happen to know the values of your desired color, you may also enter them in the text boxes. RGB (red, green, blue) values are based on brightness levels, from 0 (black) to 255 (white). You can also enter HSB (hue, saturation, brightness) values, or the hexadecimal formula for web colors.

4. When you're happy with your color, click OK.

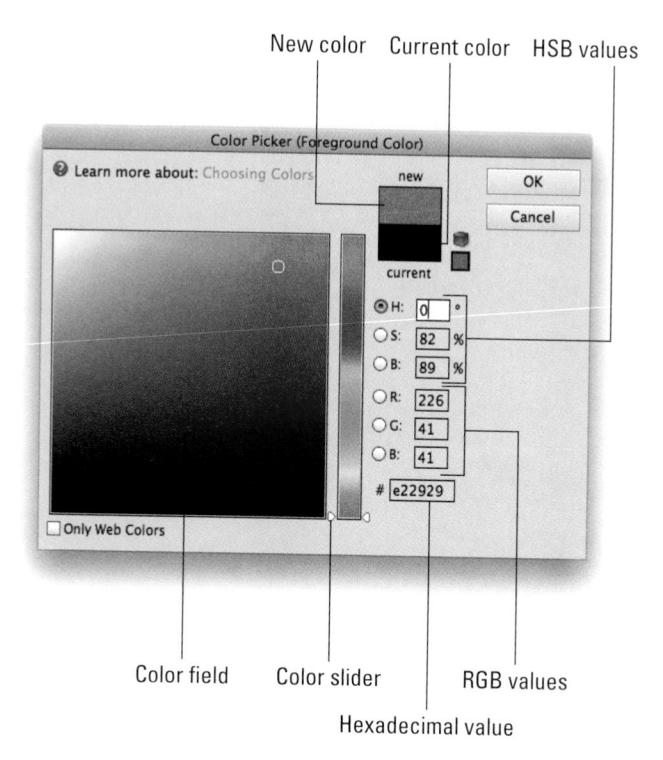

Figure 12-1: Choose your desired color from the Color Picker.

Dipping into the Color Swatches panel

Another way Elements enables you to choose a foreground or background color is by selecting a color on the Color Swatches panel. The Color Swatches panel is a digital version of the artist's paint palette. In addition to preset colors, you can mix and store your own colors for use now and later. You can have palettes for certain types of projects or images. For example, you may want a palette of skin tones for retouching portraits. Choose Window Color Swatches to bring up the panel, as shown in Figure 12-2.

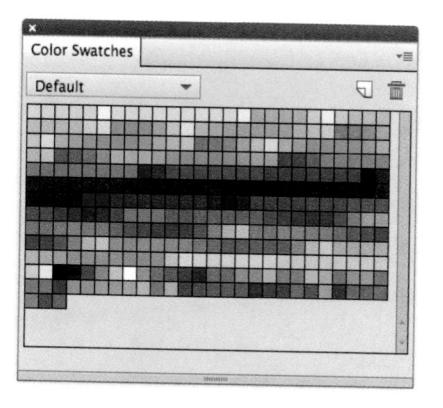

Figure 12-2: Choose and store colors in the Color Swatches panel.

To grab a color from the Color Swatches panel, click the color swatch you want. By the way, it doesn't matter which tool you have. As soon as you move the tool over the panel, it temporarily converts to an eyedropper that samples the color and makes it your new foreground or background color.

Although the Color Swatches panel is a breeze to use, here are a few tips to help you along:

- **Change the background color.** Either first select the background swatch on the Tools panel or Ctrl-click (策-click on the Macintosh) a swatch.
- ✓ Use preset colors. To load a particular preset swatch library, select it from the drop-down menu at the top of the Color Swatches panel. Elements offers libraries specific to web graphics, photo filters, and Windows and Mac OS systems.
- Add a color to the Color Swatches panel. Choose New Swatch from the panel menu. You can also simply click an empty portion of the panel. Name your swatch and click OK.
- ✓ Save swatches. Choose Save Swatches from the panel menu in the upper-right corner of the panel. We recommend saving the swatch library in the default Color Swatches folder in the Presets folder. If by chance this folder doesn't come up by default, just navigate to the Color Swatches folder by following this partial path: Adobe\Photoshop Elements 11.0\Presets\Color Swatches (Windows) or Adobe/Adobe Photoshop Elements 11/Presets/Color Swatches (Macintosh).
- ✓ Save swatches for Exchange. Choose this command to save your swatches for use in another Adobe program. Name the swatch set, and save it in the same folder listed in the previous list item.
- ✓ Load swatches. If you want to load a custom library created by you or someone else, choose Load Swatches from the panel menu. In the dialog box, select your desired library from the Color Swatches folder. The new library is added to your current library.
 - You can also work with swatches by using the Preset Manager. For more on the Preset Manager, see Chapter 3.
- ✓ Delete swatches. To delete a swatch, drag it to the trash icon at the bottom of the panel or Alt-click (Option-click on the Macintosh) the swatch.
- ✓ Change the panel's appearance. Click the panel menu in the upper-right corner to choose from Small or Large Thumbnail (swatch squares) or Small or Large List (swatch squares with a name).
- Replace your current swatch library with a different library. Choose Replace Swatches from the panel menu. Choose a library from the Color Swatches folder.

Sampling with the Eyedropper tool

Another way that Elements enables vou to choose color is via the Eyedropper tool. The Eyedropper tool comes in handy when you want to sample an existing color in an image and use it for another element. For example, you may want your text to be the same color as the green background in the image shown in Figure 12-3. Grab the Eyedropper tool (or press I) and click a shade of green in the background. The tool samples the color and makes it your new foreground color. You can then create the type with your new foreground color.

Here are a few things to remember when you're using the Eyedropper tool:

✓ Sample a new foreground or background color. Obviously, you can select either the foreground or background swatch on the Tools panel before you sample a color. But if the foreground color swatch is active, holding down the Alt key (Option key on the Macintosh) so

©istockphoto.com/millerpd Image #3417360

Figure 12-3: The Eyedropper tool enables you to sample color from your image to use with other elements, such as type.

(Option key on the Macintosh) samples a new background color, and vice versa.

- ✓ Choose a color from any open image. If you have multiple images open, you can even sample a color from an image that you're not working on!
- ✓ Choose your sample size in the Tool Options. You can select the color of just the single pixel you click (Point Sample), or Elements can average the colors of the pixels in a 3-x-3- or 5-x-5-pixel area.
- ✓ Make colors web-safe. If you right-click your image to bring up the context menu, you have a hidden option: Copy Color as HTML. This option provides the web hexadecimal color formula for that sampled color and copies it to the Clipboard. You can then paste that formula into an HTML file or grab the Type tool and choose Edit⇔Paste to view the formula in your image.
- Choose to sample All Layers or just the Current Layer. If you have multiple layers in your image, you can now choose to sample from all of those layers or just your currently active layer.

✓ Toggle between the Eyedropper and other tools. Elements, multitasker that it is, enables you to temporarily access the Eyedropper tool when you're using the Brush, Pencil, Color Replacement, Gradient, Paint Bucket, Cookie Cutter, or Shape tool. Simply press the Alt (Option on the Macintosh) key to access the Eyedropper tool. Release the Alt (Option on the Macintosh) key to go back to your original tool.

Getting Artsy with the Pencil and Brush Tools

If you want to find out how to paint and draw with a color you've chosen, then you've come to the right place. The Pencil and Brush tools give you the power to put your creative abilities to work, and the following sections show you how.

When you use these two tools, you benefit immensely from the use of a pressure-sensitive digital drawing tablet. The awkwardness of trying to draw or paint with a mouse or trackpad disappears and leaves you with tools that behave much closer to their analog ancestors.

Drawing with the Pencil tool

Drawing with the Pencil tool creates hard edges. You can't get the soft, feathery edges that you can with the Brush tool. In fact, the edges of a pencil stroke can't even be *anti-aliased*. (For more on anti-aliasing, see the following section.) Keep in mind that if you draw anything other than vertical or horizontal lines, your lines will have some jaggies when they're viewed up close. But hey, don't diss the Pencil just yet. Those hard-edged strokes can be perfect for web graphics. What's more, the Pencil tool can erase itself, and it's great for digital sketches, as shown in Figure 12-4.

Follow these steps to become familiar with the Pencil tool:

You can also press the N key. By default, the Pencil tool's brush tip is the 1-pixel brush.

Yes, even though the Pencil tip is hard-edged, we still refer to it as a brush.

Figure 12-4: The Pencil tool can

be used for digital drawings.

Illustration by Chris Blair

2. Choose your desired pencil options, beginning with a brush preset. Click the arrow and select your desired brush from the Brush Preset Picker dropdown panel.

To load another preset library, click the Brushes menu at the top of the panel.

Remember that you aren't limited to the standard old brush strokes. Check out the Assorted and Special Effects brushes found in the

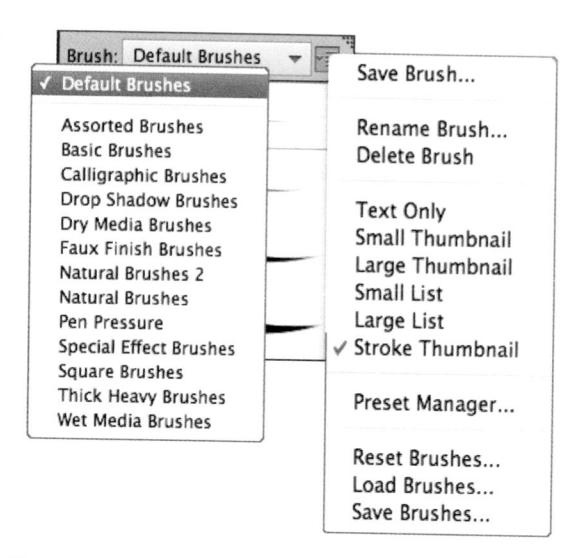

Figure 12-5: Choose from other brush libraries.

Brush drop-down menu at the top of the Brush Preset Picker panel, as shown in Figure 12-5. You'll be surprised by the interesting brushes lurking on these panels. Use them to create standalone images or to enhance your photographic creations.

Access the menu on the Brush Preset picker panel menu to save, rename, or delete individual brushes and also save, load, and reset brush libraries. For more on these operations, see the following section.

3. Choose your brush Size.

If you want to change the size of that brush tip, drag the Size slider.

4. If you want the background to show through your strokes, adjust the opacity by dragging the slider or entering an opacity percentage less than 100 percent.

The lower the percentage, the more the background images show through. $\,$

Your strokes must be on a separate layer above your images for you to be able to adjust the opacity and blend modes after you draw them. For more on layers, see Chapter 8.

5. Select a blend Mode.

Blend modes alter the way the color you're applying interacts with the color on your canvas. You can find more about blend modes in Chapter 11.

6. (Optional) Select Auto Erase if you want to enable that option.

This option removes portions of your pencil strokes. For example, say that your foreground color is black and your background color is white, and you apply some black strokes. With Auto Erase enabled, you apply white if you drag back over the black strokes. If you drag over the white background, you apply black.

7. Click and drag with the mouse to create your freeform lines.

To draw straight lines, click at a starting point, release the mouse button, and then Shift-click at a second point.

Painting with the Brush tool

The Brush tool creates soft-edged strokes. How soft those strokes are depends on which brush you use. By default, even the hardest brush has a slightly soft edge because it's anti-aliased. *Anti-aliasing* creates a single row of partially filled pixels along the edges to produce the illusion of a smooth edge. You can also get even softer brushes, which use feathering. For details on feathering, see Chapter 7.

The Brush tool shares most of the options found in the Pencil tool, except that the Auto Erase feature isn't available. Here's the lowdown on the unique Brush options:

- Airbrush. Click the Airbrush button in the Options to apply the Airbrush Mode. In this mode, the longer you hold down the mouse button, the more paint the Brush pumps out and the wider the airbrush effect spreads.
- Tablet Settings. If you're using a pressure-sensitive digital drawing tablet, check the settings you want the tablet to control, including size, scatter, opacity, roundness, and hue jitter. The harder you press with the stylus, the greater the effect of these options.
- **Brush Settings.** These options, referred to as brush *dynamics*, change while you apply your stroke. See Figure 12-6 for an example of each one. These options include:

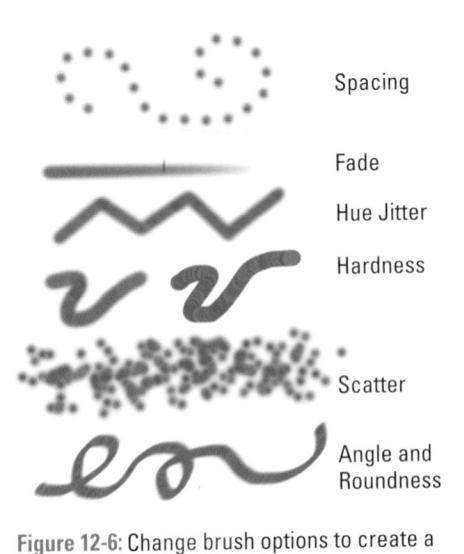

- Fade. The lower the value, the more quickly the stroke fades. However, 0 creates no fade.
- *Hue Jitter.* Vary the stroke between the foreground and background colors. The higher the value, the more frequent the variation.
- *Scatter*. The higher the value, the higher the number of brush marks and the farther apart they are.
- *Spacing*. The higher the number, the more space between marks.
- *Hardness*. The higher the value, the harder the brush.
- *Roundness*. A setting of 100 percent is totally circular. The lower the percentage, the more elliptical your brush becomes.
- *Angle*. If you create an oval brush by adjusting the roundness (see the following bullet), this option controls the angle of that oval brush stroke. It's so much easier to drag the points and the arrow on the diagram than to guesstimate values in the text boxes.

You can lock in these brush dynamics by selecting the Set This As a Default check box; this ensures that every brush you select adopts these settings.

- Save Brush. Allows you to save a custom brush as a preset. See the following section for details.
- ✓ Rename Brush. Don't like your brush's moniker? Change it with this option.
- **✓ Delete Brush.** Don't like your entire brush? Eliminate it with this option.
- ✓ The display options. Not a single command, rather a set of commands that enable you to change the way your brush tips are displayed. The default view is Stroke Thumbnail, which displays the appearance of the stroke. These commands include Text Only, Small and Large Thumbnail, and Small and Large List.
- **Reset Brushes.** Reverts your current brush library to the default.
- ✓ **Save Brushes.** Saves custom brushes in a separate library.
- ✓ Load Brushes. Loads a preset or custom brush library.

You can also manage brush-tip libraries by using the Preset Manager. See Chapter 3 for information on using the Preset Manager.

Creating your own brush

After playing with all the various options, if you really like the Franken-brush you've created, feel free to save it as a preset that you can access in the future. Choose Save Brush from the panel menu on the Brush Preset Picker panel. Name the brush and click OK. Your new custom brush shows up at the bottom of the Brush Preset Picker drop-down panel.

There's one additional way to create a brush. Elements allows you to create a brush from all or part of your image. The image can be a photograph or something you've painted or drawn.

Here's how to create a brush from your image:

1. Select part of your image with any of the selection tools.

If you want to use the entire image or entire layer, deselect everything. For more on selections, see Chapter 7.

2. Choose Edit⇔Define **Define Brush from** Selection.

You see one command or the other. depending on what you do in Step 1.

3. Name the brush and click OK.

The new brush shows up at the bottom of your Brush Preset Picker drop-down panel. Note that your brush is only a grayscale version of your image. When you use the brush, it automatically applies the color you've selected as your foreground color, as shown in Figure 12-7.

©istockphoto.com/ericmichaud Image #3173552

Figure 12-7: Create a custom brush from a portion of your image.

Using the Impressionist Brush

In this section, we introduce the Impressionist Brush. This tool is designed to paint over your photos in a way that makes them look like fine art paintings. You can set various options that change the style of the brush strokes.

Here's how to use this artistic brush:

1. Select the Impressionist Brush from the Tools panel.

It looks like a brush with a curlicue next to it. You can also press B to cycle through the brushes.

2. Set your brush options.

The Brushes presets (Size, Mode, and Opacity options) are identical to those found with the Brush tool, described in the section "Painting with the Brush tool," earlier in this chapter. You can also find some unique options on the Advanced dropdown panel in the Tool Options:

- Style. This drop-down menu contains various brush stroke styles, such as Dab and Tight Curl.
- Area. Controls the size of your brush stroke. The larger the value, the larger the area covered.
- Tolerance. Controls how similar color pixels have to be before they're changed by the brush stroke.

©istockphoto.com/agmit Image #1725665

Figure 12-8: The Impressionist Brush turns your photo into a painting.

3. Drag on your image and paint with your brush strokes, as shown on the left side in Figure 12-8.

The best way to get a feel for what this tool does is to open your favorite image, grab the tool, and take it for a test drive.

Filling and Outlining Selections

At times, you may want to create an element on your canvas that can't quite be created with a brush or pencil stroke. Maybe it's a perfect circle or a five-point star. If you have a selection, you can fill or stroke that selection to create that element, rather than draw or paint it on. The Fill command adds a color or a pattern to the entire selection, whereas the Stroke command applies the color to only the edge of the selection border.

6

Fill 'er up

You won't find a Fill tool on the Tools panel. Elements decided to avoid the overpopulated panel and placed the Fill and Stroke commands on the Edit menu.

Here are the simple steps to fill a selection:

 Grab the selection tool of your choice and create your selection on a new layer.

Although you don't have to create a new layer to make a selection to fill, we recommend it. That way, if you don't like the filled selection, you can delete the layer, and your image or background below it remains safe. See Chapter 7 for more on selections and Chapter 8 for details on working with layers.

Select either the foreground or background color and then choose a fill color.

See "Choosing Color," earlier in this chapter, if you need a refresher.

3. Choose Edit⇔Fill Selection.

The Fill Layer dialog box, shown in Figure 12-9, appears.

If you want to bypass the Fill Layer dialog box (and the rest of these steps), you can use these handy keyboard shortcuts instead:

> • To fill the selection with the foreground color, press Alt+Backspace (Option+Delete on the Macintosh).

Figure 12-9: Fill your selection or layer with color or a pattern.
- *To fill it with the background color*, press Ctrl+Backspace (第+Delete on the Macintosh).
- 4. Choose your desired fill from the Use drop-down menu.

You can select whether to fill with the foreground or background color. You also can choose Color, Pattern, Black, 50% Gray, or White. If you select Color, you're transported to the Color Picker. If you choose Pattern, you must then choose a pattern from the Custom Pattern drop-down panel. For more on patterns, see the section "Working with Patterns," later in this chapter.

If you don't have an active selection border in your image, the command says Fill Layer, and your entire layer is filled with your color or pattern.

5. In the blending area, you can specify whether to preserve transparency, which enables you to fill only the portions of the selection that contain pixels (the nontransparent areas).

Although you can also choose a *blend mode* (how the fill color interacts with colors below it) and opacity percentage, we urge you not to adjust your blend mode and opacity in the Fill Layer dialog box. Make those adjustments on your layer later, by using the Layers panel commands, where you have more flexibility for editing.

6. Click OK.

The color or pattern fills the selection.

Outlining with the Stroke command

Stroking a selection enables you to create colored outlines, or *borders*, of selections or layers. You can put this border inside or outside the selection border or centered on it. Here are the steps to stroke a selection:

- 1. Choose a foreground color and create a selection.
- 2. Choose Edit Stroke (Outline) Selection.

The Stroke dialog box opens.

3. Select your desired settings.

Many settings are the same as those found in the Fill Layer dialog box, as we explain in the preceding section. Here's a brief rundown of the options that are unique to strokes:

- Width. Enter a width of 1 to 250 pixels for the stroke.
- *Location*. Specify how Elements should apply the stroke: outside the selection, inside the selection, or centered on the selection.

4. Click OK to apply the stroke.

We gave a 30-pixel centered stroke to our selection, as shown in Figure 12-10.

Splashing On Color with the Paint Bucket Tool

The Paint Bucket tool is a longtime occupant of the Tools panel. This tool, whose icon looks just like a bucket, behaves like a combination of the Fill command and the Magic Wand tool. It makes a selection based on similarly colored pixels and then immediately fills that selection with color or a pattern. Like the Magic Wand tool, this tool is most successful when you have a limited number of colors, as shown in Figure 12-11.

To use the Paint Bucket tool, simply click inside the selection you want to fill. Before you click, however, specify your options:

- ✓ Color. Choose between a fill of the foreground color or a pattern. If you want to use the foreground color, leave Pattern deselected.
- ✓ Pattern. If you select Pattern, choose a preset pattern from the drop-down panel. For more details on patterns, see the section "Working with Patterns," later in this chapter.
- Mode. Select a blending mode to change how your fill color interacts with the color below it.
- Opacity. Adjust the opacity to make your fill more or less transparent.
- ✓ **Tolerance.** Choose a tolerance level that specifies how similar in color a pixel must be before it's selected and then filled. The lower the value, the more similar the color must be. For more on tolerance, see the section on the Magic Wand in Chapter 7.

Figure 12-10: Stroke a selection to create a colored border.

©istockphoto.com/nicolesy Image #2695305
Figure 12-11: The Paint Bucket
tool makes a selection and fills
it at the same time.

- Anti-aliasing. Choose this option to smooth the edges between the filled and unfilled areas.
- Contiguous. If selected, this option selects and fills only pixels that are touching within your selection. If the option is deselected, pixels are selected and filled wherever they lie within your selection.
- All Layers. This option selects and fills pixels within the selection in all layers that are within your tolerance level.

Working with Multicolored Gradients

If one color isn't enough for you, you'll be pleased to know that Elements enables you to fill a selection or layer with a gradient. A *gradient* is a blend of two or more colors that gradually dissolve from one to another. Elements provides a whole slew of preset gradients, but creating your own custom gradient is also fun and easy.

Applying a preset gradient

Similar to colors, patterns, and brushes, gradients have a whole group of presets that you can apply to your selection and layers. You can also load other libraries of gradients from the Gradient panel menu.

Here's how to apply a preset gradient:

1. Make the selection you want to fill with a gradient.

We recommend making the selection on a new layer so that you can edit the gradient later without harming the underlying image.

If you don't make a selection, the gradient is applied to the entire layer or background.

- 2. Select the Gradient tool from the Tools panel or press the G key.
- 3. In the Tool Options, click the down-pointing arrow on the Gradient Picker swatch.

The Gradient Picker drop-down panel appears.

4. Choose a preset gradient.

Remember that you can choose other preset libraries from the Gradient panel menu. Libraries, such as Color Harmonies and Metals, contain interesting presets.

5. Choose your desired gradient type by clicking one of the icons.

See Figure 12-12 for an example of each type.

6. Choose from the following options in the Tool Options:

- Mode. Select a blending mode to change how the color of the gradient interacts with the colors below it.
- Opacity. Specify how opaque or transparent the gradient is.
- Reverse. Reverse the order in which the colors are applied.
- Transparency. Deselect this option to make Elements ignore any transparent areas in the gradient, making them opaque instead.
- Dither. Add noise, or random information, to pro- Figure 12-12: Choose from one of five gradiduce a smoother gradient that prints with less banding (weird stripes caused by printing limitations).

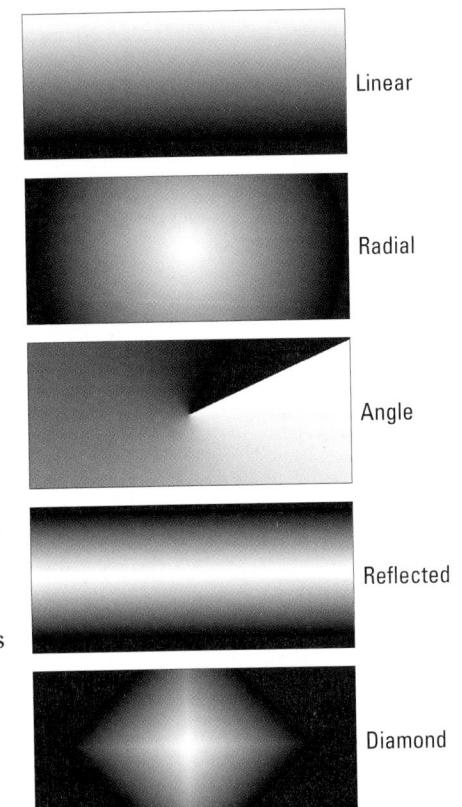

ent types.

- 7. Position your gradient cursor at your desired starting point within your selection or layer.
- 8. Drag in any direction to your desired end point for the gradient.

Longer drags result in a subtler transition between colors, whereas shorter drags result in a more abrupt transition. Hold down the Shift key to restrain the direction of the gradient to multiples of a 45-degree angle.

9. Release the mouse button to apply the gradient.

We applied an Orange Yellow radial gradient from the Color Harmonies 2 preset library to a selection of a sun in Figure 12-13. We selected the Reverse option and dragged from the center of the sun to the tip of the top ray.

Customizing gradients

If you can't find the exact gradient you need, you can easily create your own. The Gradient Editor lets you create your own custom gradient using as many colors as you want. After you create a custom gradient, you can save it as a preset to reuse in the future.

Follow these steps to create a custom gradient:

- 1. Select the Gradient tool from the Tools panel.
- 2. Click the Edit button in the Tool Options.

Figure 12-13: We filled our sun selection with a radial Orange Yellow gradient.

The Gradient Editor dialog box opens, as shown in Figure 12-14.

Figure 12-14: Use the Gradient Editor to edit and customize gradients.

- 3. Pick an existing preset to use as the basis for your new gradient.
- 4. Choose your gradient type, either Solid or Noise, from the drop-down menu.

A Noise gradient contains random colors. Interestingly, each time you create a Noise gradient, the result is different.

Note that as soon as you start to edit the existing gradient, the name of the gradient changes to Custom.

- 5. Choose your options for either a Solid or Noise gradient, depending on what you chose in Step 4:
 - If you chose Solid, adjust the Smoothness percentage to determine how smoothly one color blends into another.
 - If you chose Noise, you can choose which Color Model to use to set the color range. You can also adjust the Roughness, which affects how smoothly or abruptly the color transitions from one to another. Click Restrict Colors to avoid oversaturated colors. The Add Transparency option adds transparency to random colors. Click the Randomize button to randomly generate a new gradient. You can then skip to Step 15 to finish the gradient-making process.
- 6. If you're creating a solid gradient, begin choosing the first color of your gradient by clicking the left color stop under the gradient bar. (Refer to Figure 12-14.)

The triangle on top of the stop turns black to indicate that you're working with the starting point of the gradient.

7. Choose the starting color by double-clicking the left color stop and selecting a color from the Color Picker that appears.

In the Stops area, you can also click the Color swatch to access the Color Picker. If you click on the Color down-pointing arrow, you will access the Color Swatches drop-down menu where you can choose from various Preset Swatch libraries from the top of the panel.

- 8. Select the ending color by clicking the right color stop. Repeat Step 7 to define the color.
- 9. Change the percentage of one color versus the other by moving the starting or ending point's color stop to the left or right. Drag the midpoint slider (a diamond icon) to where the colors mix equally, 50-50.

You can also change the position of the midpoint by typing a value in the Location box.

- 10. To add another color, click below the gradient bar at the position you want to add the color. Define a color in the same way you did in Steps 7 to 9.
- 11. Repeat Step 10 to add colors.

12. To add transparency to your gradient, select an opacity stop (refer to Figure 12-14) and adjust the Opacity slider to specify the amount of transparency you desire.

By default, a gradient has colors that are 100-percent opaque. You can fade a gradient to transparency so that the portion of the image under the gradient shows through.

You can also add opacity stops in the same way you add color stops.

- 13. Adjust your color and opacity stops and their midpoint sliders to vary the percentages of each color.
- 14. You can also redefine any of the colors. To delete a color stop, drag it up or down off the gradient bar.
- 15. When you're done, name your gradient and click the New button.

Your gradient is added to the Presets menu.

After all that work, you may want to consider saving your gradients for later use. To save a gradient, click the Save button in the Gradient Editor dialog box. Save the current presets, with your new gradient, under the current library's name or a new name altogether. You can later load that preset library. You can also manage your gradient presets with the Preset Manager, as we explain in Chapter 3.

Working with Patterns

If you've ever seen someone wearing leopard-print pants with an argyle sweater and a plaid blazer, you're familiar with patterns. Not always pretty when used without restraint, patterns can be used to occasionally fill selections or layers. You can also stamp your image by using the Pattern Stamp tool. You can even retouch by using a pattern with the Healing Brush tool. Elements offers a lot of preset patterns to keep you happy. If you're not happy with Elements' selection, you can create your own, of course.

Applying a preset pattern

Although you can apply patterns by using many different tools, this chapter sticks with applying patterns as fills. To fill a layer or selection with a preset pattern, follow these steps:

1. Choose the layer or selection you want to fill with a pattern.

Again, we recommend making your selection on a new layer above your image for more flexible editing later on.

- 2. Choose Edit⇔Fill Selection or Fill Layer and choose Pattern from the Use drop-down menu.
- 3. Click the down-pointing arrow and select a pattern from the **Custom Pattern drop-down** panel, as shown in Figure 12-15.

If you don't see a pattern to your liking, choose another preset library by clicking the panel pop-up menu and choosing another preset library at the bottom of the submenu.

4. Choose any other fill options you want to apply, such as Mode, Opacity, or Preserve Transparency.

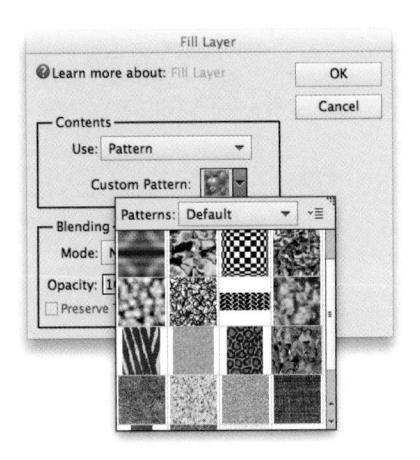

Figure 12-15: Fill your selection with one of the many Elements preset patterns.

For details on these options, see the section "Filling and Outlining Selections," earlier in this chapter.

5. Click OK to fill the layer or selection with the chosen pattern.

Creating a new pattern

You may someday want to create your own pattern. Patterns can be easily created from any existing photo or painting you create in Elements. You can even scan your signature or logo, define it as a pattern, and use it with the Pattern Stamp tool to sign all your work.

To create your own pattern, follow these steps:

- 1. Open the photographic, painted, or scanned image that contains the area you want to use as a pattern.
- 2. Use the Rectangular Marquee tool to select the area you want to convert into a pattern.

Make sure that your Feather option is set to 0 or the pattern command won't be available.

If you don't make a selection, Elements uses your entire layer as a basis for the pattern.

3. Choose Edit⇔Define Pattern from Selection or Edit⇔Define Pattern.

The Pattern Name dialog box appears.

4. Enter a name for your pattern.

Your new pattern now appears in every Pattern panel, wherever it may lurk in Elements.

In addition to filling your selection with a pattern, you can stamp on a pattern with the Pattern Stamp tool. Press S to select the Pattern Stamp tool. If you get the Clone Stamp tool, press S again. Choose your desired pattern from the Pattern Picker drop-down menu and your desired brush tip from the Brush Preset Picker drop-down menu. Select your brush Size, Opacity, and Mode, and then brush your pattern on your image. You can also select the Impressionist option to have your pattern appear more "painterly."

Creating Shapes of All Sorts

In this section, we leave the land of pixels and head into uncharted territory — Vectorville. Before we discuss the ins and outs of creating shapes, here's a little overview that explains the difference between pixels and vectors:

- Pixel images describe a shape in terms of a grid of pixels. When you increase the size of a pixel-based image, it loses quality and begins το look blocky, mushy, and otherwise nasty. For more details on resizing pixelbased images and the ramifications of doing so, see Chapter 4.
- Vectors describe a shape mathematically. The shapes comprise paths made up of lines, curves, and anchor points. Because vector shapes are math-based, you can resize them without any loss of quality whatsoever.

In Figure 12-16, you can see both types of images.

When you create a shape in Elements, you're creating a vector-based element. Shapes reside on a special kind of layer called, not surprisingly, a *shape layer*. Use shapes to create simple logos, web buttons, and other small spot illustrations.

Figure 12-16: Elements images can be vector-based (top) or pixel-based (bottom).

Drawing a shape

Elements offers an assortment of shape tools for you to choose from. Follow these steps to draw a shape in your document:

1. Choose your desired shape tool from the Tools panel.

You can also press U to cycle through the shape tools. All the following tools have associated Geometry options, which are described in the section "Specifying Geometry options," later in this chapter. Here are the available tools:

- Rectangle and Ellipse. As with their Marquee counterparts, you can hold down the Shift key while dragging to produce a square or circle: hold down the Alt (Option on the Macintosh) key to draw the shape from the center outward.
- Rounded Rectangle. This tool works like the regular Rectangle but with the addition of a radius value used to round off the corners of the rectangle.
- Polygon. This tool creates a polygon with a specified number of sides, from 3 to 100.
- Star. This tool creates a polygon or star with a specified number of sides/vertices, from 3 to 100.
- Line. This tool draws a line with a width from 1 to 1,000 pixels. You can also add arrowheads at either end.
- Custom. Custom is the most varied shape tool. You have numerous preset custom shapes to choose from. As with any shape, hold down Shift to constrain proportions or the Alt (Option on the Macintosh) key to draw from the center out.

2. In the Tool Options, click the down-pointing arrow to access Geometry options. By default, the option is set to Unconstrained.

For detailed explanations on the various Geometry options, see the upcoming sections.

If you chose the Custom Shape tool in Step 1, click the Custom Shapes Preset picker down-pointing arrow to access the pop-up Shapes panel and choose your desired shape. You can access more preset shape libraries via the pop-up menu at the top of the panel.

3. Select your desired color from the Color drop-down menu.

Click the color-wheel icon in the bottom-right corner to access the Color Picker for additional color choices.

4. Select a style from the Style picker drop-down panel.

To jazz up the shape with bevels and other fancy edges, choose a style from the panel. For more on styles, see Chapter 11.

5. Drag in the document to draw the shape you defined.

The shape appears in the image window on its own shape layer. Check out the Layers panel to see this phenomenon. Figure 12-17 shows our shape, a Japanese hairstyle, from the Dressup preset library, which we add to in the following section.

Figure 12-17: Custom shapes run the gamut from the ordinary to the exotic, such as this hairstyle.

Drawing multiple shapes

After you create a shape layer, you can draw additional shapes on that layer. You can add, subtract, overlap, and intersect shapes in exactly the same way you do with selections. (See Chapter 7.) Just follow these steps:

1. Select your desired state button in the Tool Options.

You can choose from the following options:

- New Shape Layer. Creates your initial shape layer.
- Add to Shape Area. Combines and joins two or more shapes.
- Subtract from Shape Area. Subtracts one shape from another shape.
- Intersect Shape Areas. Creates a shape from only the areas that overlap.
- Exclude Overlapping Shape Areas. Creates a shape from only the areas that don't overlap.

2. Choose your desired shape tool and draw the next shape.

We completed the shape by adding the face, as shown in Figure 12-18.

Specifying Geometry options

Geometry options help define how your shapes look. Click the down-pointing arrow in the Tool Options to access the Geometry options described in the sections that follow.

Rectangle and Rounded Rectangle Geometry options

Here are the Geometry options for the Rectangle and Rounded Rectangle shapes:

Figure 12-18: Add to your shape layer.

- Unconstrained. Enables you to have free rein to draw a rectangle at any size or shape.
- ✓ Square. Constrains the shape to a perfect square.
- ✓ Fixed Size. Lets you draw rectangles in fixed sizes, as specified by your width and height values.
- ✓ Proportional. Allows you to define a proportion for the rectangle. For example, specifying 2W and 1H makes a rectangle twice as wide as it is high.
- **From Center.** Enables you to draw from the center out.

Working with Type

In This Chapter

- Understanding type basics
- Creating point, paragraph, and path type
- Setting type options
- Editing type
- Simplifying (rasterizing) type
- Masking with type
- Stylizing and warping type

Ithough we spout on in this book about how a picture says a thousand words, we would be terribly negligent if we didn't at least give a nod to the power of the written word as well. You may find that you never need to go near the type tools. That's fine. We won't be offended if you skip right past this chapter.

Then again, you may have an occasional need to add a caption, a headline, or maybe even a short paragraph to an image. Although it's by no means a word-processing or even page-layout program, Elements does give you ample tools for creating, editing, stylizing, and even distorting type.

Understanding Type Basics

Elements has seven type tools. Two of them are for entering horizontally oriented type, and two are for entering vertically oriented type. Don't worry about the vertical type tools. Although you can use them, they're really designed for the Asian market, to enter Chinese and Japanese characters. The remaining three tools are for creating type on a selection, shape, or path.

Tools

The horizontal and vertical type tools are identical in their attributes, so we just cover the two horizontal type tools from here on, and for the sake of simplicity, we just call them the Type and Type Mask tools:

✓ Type. Use this tool to enter type. This type is created on its own type layer, except when used in Bitmap mode or Indexed Color mode, neither of which supports layers.

We refer to layers a lot in this chapter, so if your layer knowledge is rusty, check out Chapter 8.

✓ Type Mask. This tool doesn't create actual type; instead, it creates a selection border in the shape of the type you want to enter. The selection border is added to the active layer. You can do anything with a type selection that you can do with any other selection. (Chapter 7 is your one-stop guide to selections.)

The remaining three type tools all create type on a path in different ways:

- ✓ Text On Selection. This tool enables you to draw on your image to
 create a selection, similar to the Quick Selection tool. The selection converts into a path, upon which you can then enter text, which flows along
 that path.
- ✓ Text On Shape. This tool enables you to draw any chosen shape from your shapes menu, upon which you then enter and apply your text.
- ✓ Text On Custom Path. Finally, this tool lets you draw any custom path that you desire on your image. Enter text on that custom path and it adheres to that path.

The three path type tools all create a type layer. Find out how to use these tools in the upcoming section, "Creating Path Type."

A path has three components — anchor points, straight segments, and curved segments. The path essentially hovers above the image in its own "space," thereby not altering or marking the image in any way. The path in this context is merely a track upon which the text can flow. You can alter the path to your liking by using the Refine Path option. Find out more in the "Creating Path Type" section.

Modes

You can enter text in Elements in three different modes: point type, paragraph type, and path type. Both the Type and Type Mask tools can enter either a point or paragraph type. Here's a brief description of each one (for the step-by-step process of creating the text, see the following sections):

- ✓ Point. Use this mode if you want to enter only a few words. To create point type, select the Type tool, click in your image, and, well, type. The text appears while you type and continues to grow. In fact, it even continues past the boundary of your image!
 - Remember that point type *never* wraps around to a new line. To wrap to the next line, you must press Enter (Return on a Macintosh).
- ✓ Paragraph. Use this mode to enter longer chunks (or constrained blocks) of text on an image. To create paragraph type, click and drag your type tool to create a text bounding box, and then type. All the text is entered in this resizable bounding box. If a line of text is too long, Elements automatically wraps it around to the next line.
- ✓ **Path.** Elements also offers the capability of placing text along a path via three unique type tools. Double-click the path and type; the text appears, adhering to the shape of the path.

Formats

Elements is capable of displaying and printing type in two different formats. Each format has its pros and cons, and which format you use depends on your needs. Here's the lowdown on each one:

- ✓ Vector. All text in Elements is initially created as vector type. Vector type provides scalable outlines that you can resize without producing jaggy edges in the diagonal strokes. Vector type remains fully editable and always prints with optimum quality, appearing crisp and clean. Vector type is the default type format in Elements.
- ✓ Raster. When Elements converts vector type into pixels, the text is rasterized. Elements refers to this rasterization process as simplifying. When text is simplified, it's no longer editable as text but is converted into a raster image. You usually simplify your vector type when you want to apply filters to the type to produce a special effect or when you want to merge the type with the image. You can't resize simplified type without losing some quality or risking jagged edges. For more details, see the section "Simplifying Type," later in this chapter.

Creating Point Type

The majority of your type entry will most likely be in *point type mode*. Point type is useful for short chunks of text, such as headlines, labels, logos, and headings for Web pages.

Point type is so called because it contains a single anchor point, which marks the starting point of the line of type. Remember that point-type lines don't wrap automatically, as you can see in Figure 13-1.

Point type doesn't wra

Figure 13-1: Point type doesn't wrap automatically, but instead can run off your image into a type Neverland.

Follow these steps to create point type:

- 1. Open the Photo Editor and choose Expert mode.
- 2. Open an image or create a new, blank Elements file (File⇔New⇔ Blank File).
- 3. Select the Horizontal Type tool from the Tools panel.

You can also press T to cycle through the various type tools. Additionally, you can also select the particular Type tool you want from the Tool Options.

4. On the image, click where you want to insert your text.

Your cursor is called an *I-beam*. When you click, you make an insertion point.

A small, horizontal line about one-third of the way up the I-beam shows the baseline (the line on which the text sits) for horizontal type.

5. Specify your type options from the Tool Options.

All the options are described in detail in the section "Specifying Type Options," later in this chapter.

6. Type your text and press Enter (Return on a Macintosh) to begin a new line.

When you press Enter (or Return), you insert a hard return that doesn't move.

7. When you finish entering the text, click the Commit button (the green check-mark icon) near your text.

You can also commit the type by pressing Enter on the numeric keypad or by clicking any other tool on the Tools panel. A new type layer with your text is created. Type layers appear on your Layers panel and are indicated by the T icon.

Creating Paragraph Type

If you have larger chunks of text, it's usually more practical to enter the text as paragraph type. Entering paragraph type is similar to entering text in a word-processing or page-layout program, except that the text is contained inside a bounding box. When you type and come to the end of the bounding box, Elements automatically wraps the text to the next line.

To enter paragraph type, follow these steps:

- 1. Open the Photo Editor and choose Expert mode.
- 2. Open an image or create a new, blank Elements file.
- 3. Select the Horizontal Type tool from the Tools panel, or press T to cycle through the various type tools.

You can also select the particular Type tool you want from the Tool Options.

- 4. On the image, insert and size the bounding box by using one of two methods:
 - Drag to create a bounding box close to your desired size. After you
 release the mouse button, you can drag any of the handles at the
 corners and sides of the box to resize it.
 - Hold down the Alt (Option on the Macintosh) key and click the image. The Paragraph Text Size dialog box appears. Enter the exact dimensions of your desired bounding box. When you click OK, your specified box appears, complete with handles for resizing later.
- 5. Specify your type options from the Tool Options.

Options are described in detail in the following section.

6. Enter your text; to start a new paragraph, press Enter (Return on a Macintosh).

Each line wraps around to fit inside the bounding box, as shown in Figure 13-2.

If you type more text than can squeeze into the text box, an overflow icon appears. Just resize the text box by dragging a bounding box handle.

7. Click the Commit button (the green check-mark icon) next to the text box or press Enter on the numeric keypad.

Elements creates a new type layer.

Paragraph type wraps automatically without your assistance, so there's no need to enter a hard return as you type.

Figure 13-2: Paragraph type automatically wraps to fit within your bounding box.

Creating Path Type

If you want your type to flow in a circle, wave, stair step, or any other shape, you're in luck. Elements provides three type tools that enable you to do just that. The great thing is that path type is easy to create, totally editable, and the type resides on its very own layer.

Using the Text On Selection tool

You can create path type by first creating a selection of your image, which is similar to the way you create a selection with the Quick Selection tool. Here's how:

- 1. Open the Photo Editor and choose Expert mode.
- 2. Open an image or create a new, blank Elements file.
- 3. Select the Text On Selection tool from the Tools panel, or press T to cycle through the various type tools.

You can also select the particular Type tool you want from the Tool Options.

- 4. On the image, "paint" (drag) over your desired selection.
- 5. Refine your selection by adding or subtracting from the selection in one of four ways:
 - Press the Shift key and drag around the additional area that you want to include in your selection.

- Press the Alt (Option on the Macintosh) key and drag around the area that you want to subtract from your selection.
- Select the Add to Selection or Subtract from Selection buttons in the Tool Options and drag around your desired areas.
- Drag the Offset slider right to expand, or left to contract, your selection.

You can specify additional options, which are common to all the type tools; these are described in detail in the following section, "Specifying Type Options."

6. When your selection is complete, click the green Commit check-mark icon to convert your selection to a path.

If you want to start over, click the red Cancel (slashed circle) icon to do so.

7. Position your mouse over the path, and when the cursor icon changes to an I-beam (capital letter I with a crooked line crossing over), click the path and type your text.

The text wraps along the path. If you type more text than can fit on the path, an overflow icon appears.

8. When you're done entering your text, click the Commit icon.

Elements creates a new type layer. You can edit any attributes, such as font and size, just as you can with point or paragraph text. See the upcoming section "Editing Text," for details.

Using the Text On Shape tool

This tool enables you to create type that flows along the perimeter of any shape. To do so, follow these steps:

- 1. Open the Photo Editor and choose Expert mode.
- 2. Open an image or create a new, blank Elements file.
- 3. Select the Text On Shape tool from the Tools panel, or press T to cycle through the various type tools.

You can also select the particular Type tool you want from the Tool Options.

- 4. Select your desired shape from the shape options in the Tool Options.
- 5. Drag your tool over the image to create the shape.
 - To constrain your proportions, hold down the Shift key while dragging.
 - To draw from the center outward, hold down the Alt (Option on the Macintosh) key while dragging.

6. You can transform your shape by choosing Image Transform Shape and choosing your desired transformation from the submenu. For details on transformations, see the upcoming section, "Editing Text."

You can specify additional options, which are common to all the type tools; these are described in detail in the following section, "Specifying Type Options."

7. Position your mouse over the path, and when the cursor icon changes to an I-beam (capital letter I with a crooked line crossing over), click the path and type your text.

The text wraps along the shape's path, as shown in Figure 13-3.

©istockphoto.com/fpm Image #6201684

Figure 13-3: Text can now adhere to any path that you create.

If you type more text than can fit on the path, an overflow icon appears.

8. When you are done entering your text, click the Commit icon.

Elements creates a new type layer. You can edit any attributes, such as font and size, just as you can with point or paragraph text. See the section "Editing Text," for details.

You can also refine your shape path by using the Refine Path tool (labeled "Modify"), which appears in the Tool Options when the Text on Custom Path tool is selected. Just be sure that you have your type layer selected before working with this option.

Using the Text On Custom Path tool

If you want to create your own path or shape as the basis for your type, this is the tool for you. Here's how:

- 1. Open the Photo Editor and choose Expert mode.
- 2. Open an image or create a new, blank Elements file.

3. Select the Text On Custom Path tool from the Tools panel, or press T to cycle through the various type tools.

You can also select the particular Type tool you want from the Tool Options.

- 4. Drag your tool over the image to create the custom path of your choice.
- 5. Refine your path by selecting the Refine Path option (labeled "Modify") in the Tool Options. Drag the anchor points or path segments with the tool to get your desired shape.

You can also transform your custom path by choosing Image

Transform Shape. For details on transformations, see the upcoming section, "Editing Text."

You can specify additional options, which are common to all the type tools; these are described in detail in the following section, "Specifying Type Options."

6. Position your mouse over the path, and when the cursor icon changes to an I-beam (capital letter I with a crooked line crossing over), click the path and type your text.

The text wraps along the shape's path.

If you type more text than can fit on the path, an overflow icon appears.

7. When you're done entering your text, click the Commit icon.

Elements creates a new type layer. You can edit any attributes, such as font and size, just as you can with point or paragraph text. See the section "Editing Text," for details.

8. To create a new custom path, select the background layer and begin again.

Specifying Type Options

You can find several character and paragraph type settings among the Tool Options, as shown in Figure 13-4. These options enable you to specify your type to your liking and pair it with your images.

Figure 13-4: Specify your type options, such as font family and size, before you type.

Here's an explanation of each available option in the Tool Options:

✓ Font Family. Select the font you want from the drop-down list. Elements provides a WYSIWYG (What You See Is What You Get) font menu. After each font name, the word Sample is rendered in the actual font — no more selecting a font without knowing what it really looks like.

You also find one of these abbreviations before each font name to let you know what type of font it is:

- a: Adobe Type 1 (PostScript) fonts
- *TT:* TrueType fonts
- O: OpenType fonts

Fonts with no abbreviation are bitmapped fonts.

- ✓ Font Style. Some font families have additional styles, such as light or condensed. Only the styles available for a particular font appear in the list. This is also a WYSIWYG menu.
- Font Size. Select your type size from the drop-down list or just type a size in the text box. Note that type size is most commonly measured in points (72 points equals about 1 inch at a resolution of 72 ppi). You can switch to millimeters or pixels by choosing Edit⇔Preferences⇔Units & Rulers (on the Macintosh, Adobe Photoshop Elements Editor⇔Preferences⇔Units & Rulers).
- ✓ Text Color. Click the color swatch to select a color for your type from the Color Picker. You can also choose a color from the Swatches panel.
- Leading. Leading (pronounced *LED-ding*) is the amount of space between the baselines of lines of type. A *baseline* is the imaginary line on which a line of type sits. You can choose Auto Leading or specify the amount of leading to apply. When you choose Auto Leading, Elements uses a value of 120 percent of your type point size. Therefore 10-point type gets 12 points of leading. Elements adds that extra 20 percent so that the bottoms of the lowest letters don't crash into the tops of the tallest letters on the line below them.
- ✓ **Text Alignment.** These three options align your horizontal text on the left or right, or in the center. If you happen to have vertical text, these options rotate 90 degrees clockwise and change into top, bottom, and center vertical settings.

Anti-aliasing. Select this option to slightly smooth out the edges of your text. Anti-aliasing softens that edge by 1 pixel, as shown in Figure 13-5. For the most part, you want to keep this option turned on. The one occasion in which you may want it turned off is when you're creating small type to be displayed onscreen, such as on web pages. The soft edges can sometimes be tough to read.

Faux Bold. Use this option to create a fake bold style when a real bold style (which you'd choose under Font Style) doesn't exist. Be warned that. although the sky won't fall, applying faux styles can distort the proportions of a font. You should use fonts with real styles, and if they don't exist, oh well.

Figure 13-5: Anti-aliasing softens the edges of your type.

- Faux Italic. This option creates a phony oblique style and carries the same warning as the Faux Bold option.
- ✓ Underline. This setting (obviously) underlines your type, like this.
- Strikethrough. Choose this option to apply a strikethrough style to your text.
- ✓ **Style.** Click this option to access a drop-down panel of preset layer styles that you can apply to your type. Note that this option is accessible after you have committed your type. For more on this option and the Create Warped Text option (described in the last bullet), see "Stylizing and Warping Type," later in this chapter.
- ✓ Change the Text Orientation. Select your type layer and then click this option to switch between vertical and horizontal type orientations.
- Create Warped Text. This fun option lets you distort type in more than a dozen ways.

Editing Text

Remember that you can apply type settings either before or after you enter your text.

To correct typos, add and delete type, or change any of the type options, simply follow these steps:

1. Select the Type tool from the Tools panel.

- 2. Select your desired type layer on the Layers panel or click within the text to automatically select the type layer.
- 3. Do one of the following:
 - Change the font family, size, color, or other type option. If you want to change all the text, simply select that type layer on the Layers panel. To select only portions of the text, highlight the text by dragging across it with the I-beam of the Type tool. Then select your changes in the Tool Options; see "Specifying Type Options" earlier in this chapter for details about your options for the Type tool.
 - *Delete text*. Highlight the text by dragging across it with the I-beam of the Type tool. Then press the Backspace key (Delete on the Macintosh).
 - *Add text*. Make an insertion point by clicking your I-beam within the line of text. Then, type your new text.

Note that these editing steps apply to all types of text — point, paragraph, and path.

4. When you're done editing your text, click the Commit button.

You may also occasionally need to transform your text. To do so, make sure that the type layer is selected on the Layers panel. Then choose Image⇔Transform⇔Free Transform. Grab a handle on the bounding box and drag to rotate or scale. Press Ctrl (ℜ on the Macintosh) and drag a handle to distort. When you're done, double-click inside the bounding box to commit the transformation. For more details on transformations, see Chapter 8.

For path type, applying the transformation command will enable you to change the shape of your path, but not the actual type itself. When you double-click the bounding box, the type will then rewrap along the transformed path.

Simplifying Type

As we explain in the section "Understanding Type Basics," earlier in this chapter, Elements can display and print type in two different formats: vector and raster.

Remember that as long as you keep type in a vector format on a type layer, you can edit and resize that type all day long.

Occasionally, however, you may need to *simplify* your type — to convert your type into pixels. After it's simplified, you can apply filters, paint on the type, and apply gradients and patterns. If you're working with layers and flatten your image (merge your layers into a single background image), your type layer is also simplified and merged with the other pixels in your image. By the way, if you try to apply a filter to a type layer, Elements barks at you that the type layer must be simplified before proceeding and gives you the opportunity to click OK (if you want to simplify) or Cancel.

To simplify your type, select the type layer on the Layers panel and choose Layer. Simplify Layer. Your type layer is then converted (the T icon disappears) into a regular layer on which your type is payed disappeared as a supplier of the type of type of type of the type of typ

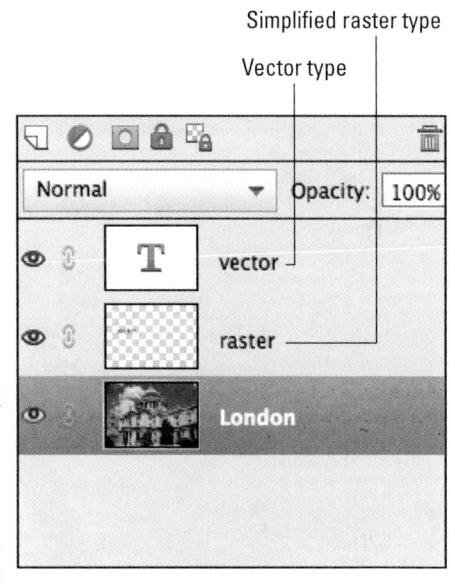

Figure 13-6: Simplifying your type layer converts vector type into pixels.

which your type is now displayed as pixels against a transparent background, as shown in Figure 13-6.

To avoid having to re-create your type from scratch, make all necessary edits before simplifying. This includes sizing your text. After you simplify your type, you can't resize your text without risking the dreaded jaggies. The other downside to remember about simplified type is that although it looks identical to vector type onscreen, it never prints as crisply and cleanly as vector type. Even at higher-resolution settings, a slight jagged edge always appears on simplified type. So, if you're experimenting with painting or filters on your type, just make a duplicate of your type layer before simplifying it and then hide that layer.

Masking with Type

Using the Type Mask tool epitomizes the combination of type and image. Unlike its conventional cousin, the Type Mask tool doesn't create a new layer. Instead, it creates a selection on the active layer. Type Mask is the tool of choice for filling text with an image or cutting text out of an image so that the background shows through, as shown in Figure 13-7.

A selection is a selection, no matter how it was created. So, even though type mask selections look like letters, they act like selections. You can move, modify, and save them.

©istockphoto.com/Akirastock Image #8791096

Figure 13-7: The Type Mask tool enables you to cut type out of solid color or image layers.

Here are the steps to create a type mask:

- 1. In the Photo Editor in Expert mode, open the image of your choice. We selected a stone texture.
- 2. Convert your background into a layer by double-clicking the word *Background* on the Layers panel, and then click OK.

This step enables you to jazz up the type with styles later on.

- 3. Choose the Horizontal Type Mask tool from the Tools panel.
- 4. Specify your type options (such as font family, style, and size) in the Tool Options.
- 5. Click the image, and type your desired text. When you're done, click the Commit button.

A selection border in the shape of your type appears on your image.

- 6. Choose Select[□]Inverse, which deselects your letter selections and selects everything else.
- 7. Press the Backspace (Delete on a Macintosh) key to delete everything outside your selection border.

Your type is now filled with your image.

- 8. Choose Select⇔Deselect.
- 9. Experiment with applying layer styles to your type.

Choose Window ☐ Effects, or click the Effects tab in the top-right corner of the workspace. Click the Styles button located at the top of the Effects panel. Select the type of layer styles you desire from the drop-down menu at the top of the panel, such as Drop Shadows or Bevels. Finally, double-click the exact style you want. We used a drop shadow and an inner bevel in Figure 13-8. See Chapter 11 for more about layer styles.

CHISELED IN STONE

©istockphoto.com/LordRunar Image #5498150

Figure 13-8: Fill type with imagery by using the Type Mask tool.

If you want to admire your type against a solid background, as we did, create a new layer, choose Edit⇔Fill Layer, and then choose your desired color from the Use drop-down menu.

Stylizing and Warping Type

If you've tried your hand at creating a type mask, you know that Elements is capable of much more than just throwing a few black letters at the bottom of your image. With a few clicks here and there, you can warp, distort, enhance, and stylize your type. If you're not careful, your creative typography can outshine your image.

Adjusting type opacity

If you checked out Chapter 8 before reading this chapter, you know that *layers* are a digital version of the old analog transparency sheets. You can change element opacity on layers to let the underlying layer show through in varying degrees. This is also possible on a type layer. Peek at Figure 13-9 to see how varying the opacity percentage of your type layer makes more of the underlying layer show through. In Figure 13-9, the underlying layer is an image of water.

To change the opacity of a type layer, simply select the layer on the Layers panel, click the arrow to the right of the Opacity percentage, and drag the slider. The lower the percentage, the less opaque the type (and the more the underlying layer shows through).

©istockphoto.com/Mikosch Image #2592893

Figure 13-9: You can vary the opacity of type layers to allow the underlying layer to peek through.

Applying filters to your type

One of the most interesting things you can do with type in Elements that you can't do in a word-processing or page-layout program is apply special effects, such as filters. You can make type look like it's on fire, underwater, or on the move — as shown in Figure 13-10, where we applied a motion blur.

The only caveat is that

type has to be simplified

first before a filter can be

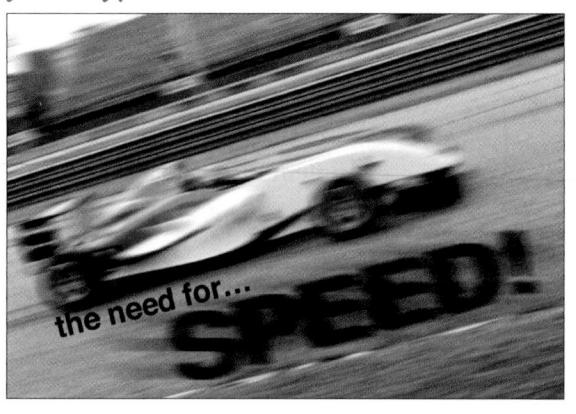

©istockphoto.com/EduLeite Image #13233892

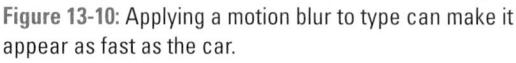

applied. Be sure to do all your text editing before you move to the filtering stage.

Applying the filter is as easy as selecting the simplified type layer on the Layers panel and choosing a filter from the Filter menu. For more on filters, see Chapter 11.

Painting your type with color and gradients

Changing the color of text is as easy as highlighting it and selecting a color from the Color Picker. But what if you want to do something a little less conventional, such as apply random brush strokes of paint across the type, as we did in the top image shown in Figure 13-11? It's really easier than it looks. Again, as with applying filters to text, the only criterion is that the type has to be simplified first. After that's done, select a color, grab the Brush tool with settings of your choice, and paint. In our example, we used the Granite Flow brush, found in the Special Effect Brushes presets. We used a diameter of 39, 15, and 6 pixels and just swiped our type a few times.

Figure 13-11: Bring your type to life with color (top) or a gradient (bottom).

If you want the color or gradient to be confined to the type area, select the text by either Ctrlclicking (\mathbb{H}-clicking on a Macintosh) the layer containing the text or locking the layer's transparency on the Layers panel.

You can also apply a gradient to your type. Here are the steps to follow after simplifying your type:

- 1. Select the Gradient tool from the Tools panel.
- 2. In the Tool Options, click the down-pointing arrow next to the Gradient Picker to access the Gradient Picker panel.
- 3. Choose your desired gradient.

If you want to create a custom gradient, find out how in Chapter 12.

4. Position your gradient cursor on the text where you want your gradient to start; drag to where you want your gradient to end.

Don't like the results? Drag again until you get the look you want. You can drag at any angle and to any length, even outside your type. In the bottom image shown in Figure 13-11, we used the copper gradient and just dragged from the top of the letters to the bottom. We also locked the transparent pixels on the layer to confine the gradient to just the type area.

Warping your type

If horizontal or vertical text is just way too regimented for you, try the Warp feature. The best part about the distortions you apply is that the text remains fully editable. This feature is fun and easy to use. Click the Create Warped Text button at far right of the Tool Options. (It's the T with a curved line below it.) This action opens the Warp Text dialog box, where you find a vast array of distortions on the Style drop-down menu with descriptive names such as Bulge, Inflate, and Squeeze.

After selecting a warp style, you can adjust the orientation, amount of bend, and degree of distortion by dragging the sliders. The Bend setting affects the amount of warp, and the Horizontal and Vertical Distortions apply perspective to that warp. Luckily, you can also view the results while you adjust. We could give you technical explanations of these adjustments, but the best way to see what they do is to just play with them. See Figure 13-12 to get a quick look at a few warp styles. The names speak for themselves.

You can also use the Transform command, such as scale and skew, to manipulate text. See Chapter 8 for details on transforming.

Figure 13-12: Text remains fully editable after applying distortions with the Warp command.

Part V Printing, Creating, and Sharing

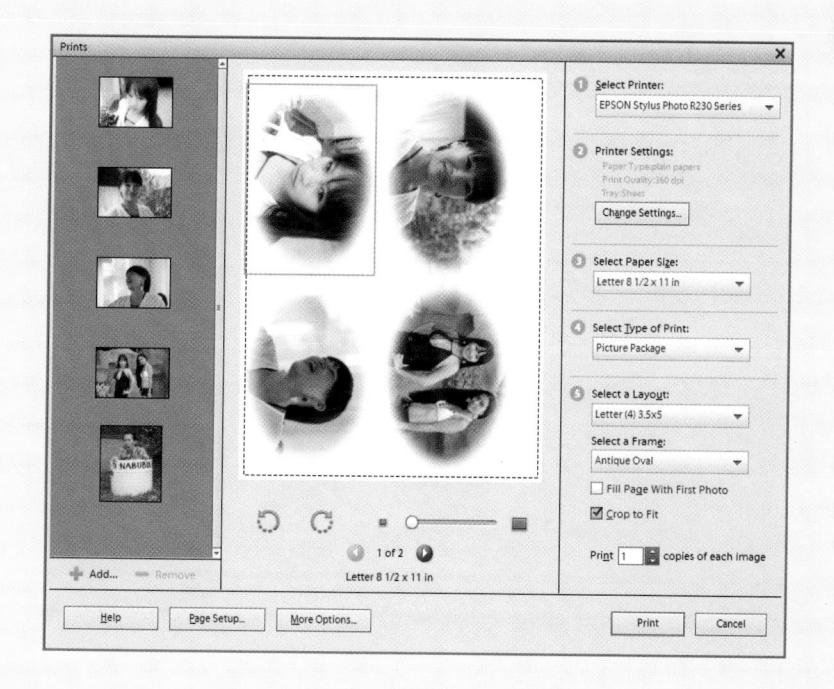

In this part . . .

he focus of this part is photo output and deployment. As is the case with so many other editing features, you have abundant opportunities to output your files. Beginning with the most familiar method, which is simply printing to your desktop color printer, we talk about how to get the best results on your printed images. We start with printing to your personal desktop printer and then cover issues related to submitting photos to commercial photo labs and service centers.

In addition to printing, you have a number of options for sharing images onscreen or online, and they're all covered in the final chapters, where you can find out about slide shows and video discs, and about web hosting, e-mailing, and sharing via online services. The opportunities are enormous, and you may want to look over all that Photoshop Elements has to offer related to photo output and file sharing.

Getting It on Paper

In This Chapter

- Preparing files for printing
- Working with printer profiles
- Using print setups
- Looking at other print options
- Ordering prints online

erhaps the greatest challenge to individuals using programs like Photoshop Elements (and even the professionals who use its grand-daddy, Adobe Photoshop) is getting what you see on your monitor to render a reasonable facsimile on a printed page. You can find all sorts of books on color printing — how to get color right, how to calibrate your equipment, and how to create and use color profiles — all for the purpose of getting a good match between your computer monitor, your printer, and the paper used to print your output. It's downright discouraging to spend a lot of time tweaking an image so that all the brilliant blue colors jump out on your computer monitor, only to find that all those blues turn to murky purples when the photo is printed.

If you read Chapters 3 and 4, you're ahead of the game because you know a little bit about color management, color profiles, and printer resolutions. After you check out those chapters, your next step is to get to know your printer and understand how to correctly print your pictures.

In this chapter, we talk about options — many options — for setting print attributes for printing to your own color printer. If you need to, reread this chapter a few times just to be certain that you understand the process for printing good-quality images. A little time spent here will, we hope, save you some headaches down the road.

Getting Pictures Ready for Printing

The first step toward getting your photos to your desktop printer is to prepare each image for optimum output. You have several considerations when you're preparing files, including the ones in this list:

- ✓ **Set resolution and size.** See your printer's documentation to find out what resolution the manufacturer recommends. As a general rule, 200 to 300 ppi (pixels per inch) works best for most printers printing on high-quality paper. If you print on plain paper, you often find that lower resolutions work just as well or even better. Chapter 4 explains setting size and resolution in detail.
- Make all brightness and color corrections before printing. Make sure that your pictures appear their best before sending them off to your printer. If you have your monitor properly calibrated, as we discuss in Chapter 3, you should see a fair representation of what your pictures will look like before you print them. Chapters 9 and 10 cover corrections.
- Decide how color will be managed before you print. You can color-manage output to your printer in three ways, as we discuss in the next section. Know your printer's profiles and how to use them before you start to print your files.
- ✓ **Get your printer ready.** Finally, when printing to desktop color printers, always be certain your ink cartridges have ink and the nozzles are clean. Make sure you use the proper settings for paper and ink when you send a file to your printer. Be sure to review the manual that came with your printer so you know how to perform all the steps required to make a quality print.

Working with Color Printer Profiles

In Chapter 3, we talk about creating color profiles for your monitor and selecting a color workspace. The final leg in a color-managed workflow is to convert color from your color workspace profile to your printer's color profile. Basically, this conversion means that the colors you see on your monitor in your current workspace are accurately converted to the color that your printer can reproduce. To print accurate color, a color profile designed for your printer and the paper you use needs to be installed on your computer.

You can manage color in Photoshop Elements in three ways when it comes time to print your files:

- Printer Manages Colors. This method permits your desktop color printer to decide which profile to use when you print your photo. Your printer makes this decision according to the paper you select. If you choose Epson Premium Glossy Photo Paper, for example, your printer chooses the profile that goes along with that particular paper. If you choose another paper, your printer chooses a different color profile. This method is all automatic, and color profile selection is made when you print your file.
- Photoshop Elements Manages Colors. When you make this choice, color management is taken out of the hands of your printer and is controlled by Elements. You must choose a color profile after making this choice. If color profiles are installed by your printer, you can choose a color profile from the list of profiles that match your printer and the paper source.
- No Color Management. You use this choice if you have a color profile embedded in one of your pictures. You'll probably rarely use this option. Unless you know how to embed profiles or receive files with embedded profiles from other users, don't make this choice in the Print dialog box. Because very few Elements users work with files with embedded profiles, we skip covering this method of printing your files.

Each of these three options requires you to decide how color is managed. You make choices (as we discuss later in this chapter, when we walk you through the steps for printing) about whether to color-manage your output. These selections are unique to the Print dialog box and more specifically to the More Options dialog box for your individual printer.

Color profiles are also dependent upon the ink being used, and refilling cartridges with generic ink can (in some cases) result in colors shifting. Similarly, if the nozzles aren't clean and delivering ink consistently, you may see very strange results.

Printing a photo with the printer managing color

Without going into all the settings you have to choose from in the Print and More Options dialog boxes, for now we look at printing a photo and managing color. We explain more print options that are available later in this chapter, in the section "Setting Print Options."

For the following example, we use an Epson printer. If you have a different printer, some of the dialog boxes and terms may appear different. With a little careful examination of the Print dialog box, you should be able to apply the following steps for any printer:

1. With a photo open in the Photo Editor, choose File⇔Print, or press Ctrl+P (無+P on the Macintosh).

The Print dialog box that opens contains all the settings you need to print a file, as shown in Figure 14-1.

2. Click Page Setup at the bottom of the Print dialog box and select the orientation of your print. Click OK.

Your choices are either Portrait or Landscape. After you click OK, you're returned to the Print dialog box.

- 3. Choose your printer from the Select Printer drop-down menu.
- 4. Set the print attributes.

Select the paper size, type of print, print size, and number of copies you want. (Note the items shown in Figure 14-1.)

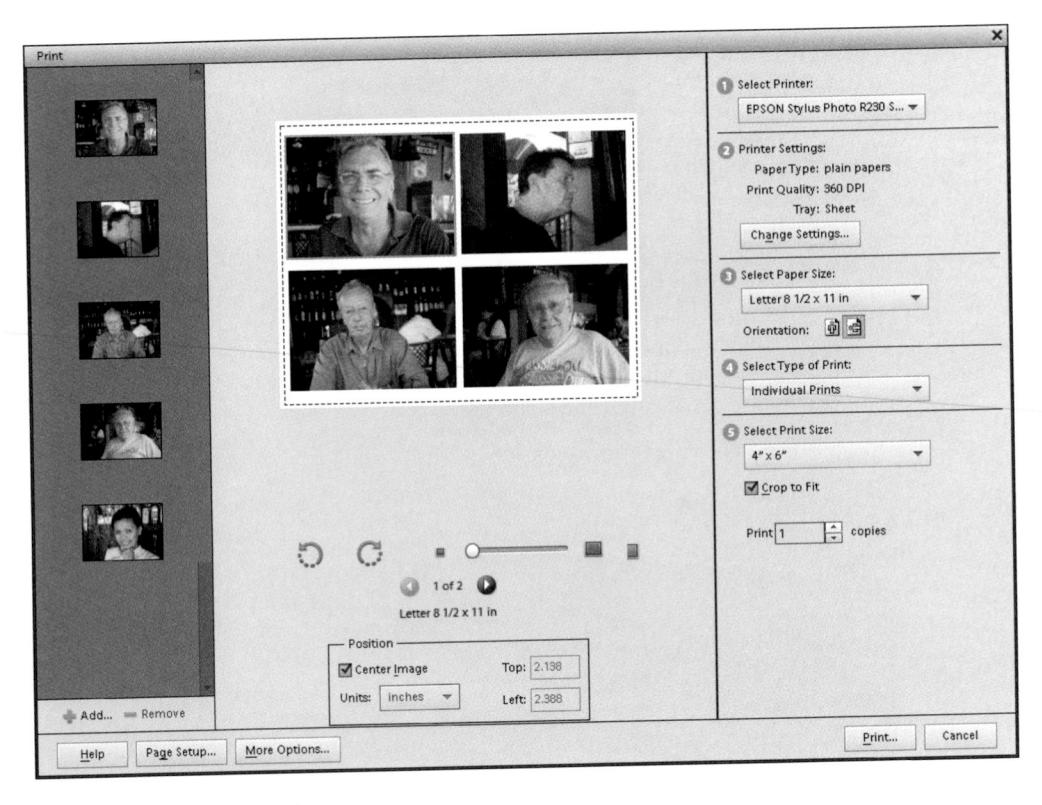

Figure 14-1: The Print dialog box.
5. Click More Options and choose Color Management in the More Options dialog box.

In the Color Management area, shown in Figure 14-2, choose how to manage color when you print files.

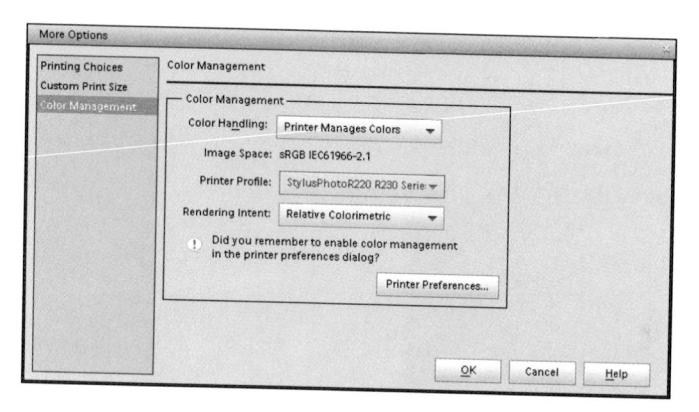

Figure 14-2: Look over the Color Management area in the More Options dialog box for options on how to manage color.

6. From the Color Handling drop-down menu, select Printer Manages Colors. Click OK.

This choice uses your current workspace color — either sRGB or Adobe RGB (1998) — and later converts the color from your workspace to the printer output file when you open the Print dialog box. (We introduce color workspaces in Chapter 3.)

7. Set the printer preferences.

- On Windows, click the Printer Preferences button in the More Options dialog box. The printing preferences dialog box for your printer driver opens, as shown in Figure 14-3. Proceed to Step 8. Note that you can also click OK in the More Options dialog box and click Change Settings (item 2 in the right panel of the Print dialog box) to open the same printer preferences dialog box.
- On the Macintosh, you don't have a Printer Preferences button in the More Options dialog box and there is no button for Change Settings in the Print dialog box. Just set the color settings in the More Options dialog box, click OK, and then click Print. The Mac OS X Print dialog box opens. You need to make two choices here.

First, open the pop-up menu below the Pages item in the Print dialog box and choose Print Settings, as shown in Figure 14-4. From the Media Type pop-up menu, choose the paper for your output.

The second selection that Macintosh users need to make is Color Management. Open the Print Settings pop-up menu and choose Color Management, as shown in Figure 14-5. Make sure the default setting of Color Controls is selected; this setting is used when the printer manages color. Click Print.

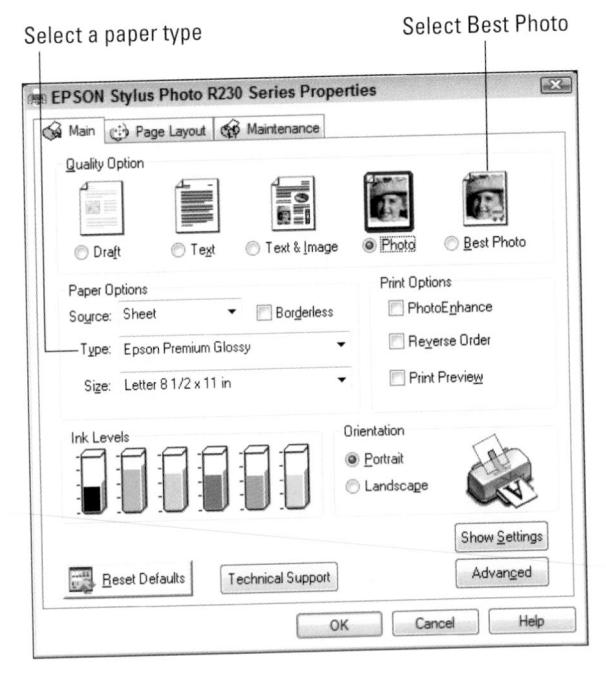

Figure 14-3: Click Preferences in the first dialog box that opens, and the selected printer preferences dialog box opens.

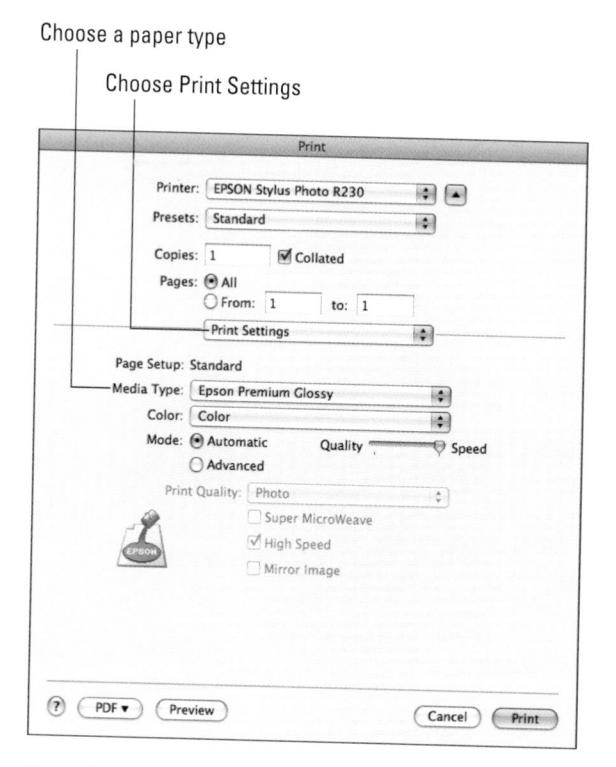

Figure 14-4: Choose Print Settings on the Macintosh and make a choice for the paper you use for the output.

8. (Windows only) Set print attributes from your printer's dialog box.

Select a paper type, such as Epson Premium Glossy (or another paper from the Type drop-down menu that you may be using; refer to Figure 14-3). Then click the Best Photo radio button.

Now it's time to color-manage your file. This step is critical in your print-production workflow.

9. (Windows only) Click the Advanced button and then, in the Warning dialog box that appears, simply click Continue.

The Printing Preferences dialog box opens, displaying advanced settings, as shown in Figure 14-6.

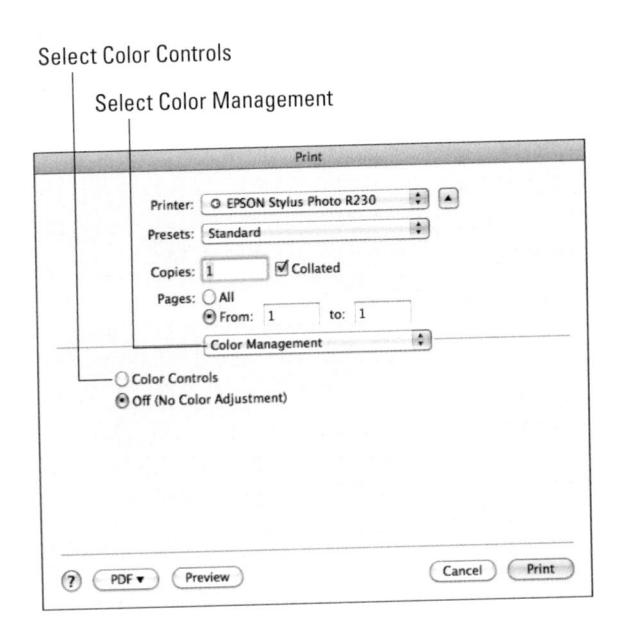

Figure 14-5: Choose Color Management and make sure Color Controls is selected.

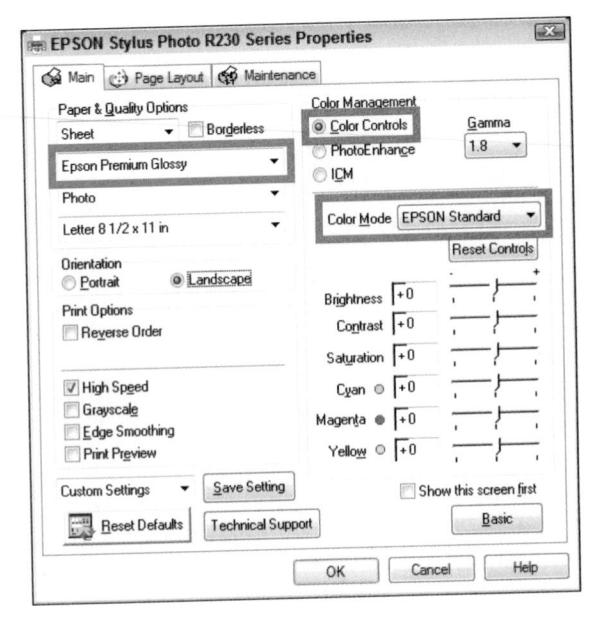

Figure 14-6: Click Advanced and then click Continue to access the advanced settings in the Epson printer driver.

Here are the most important choices:

- Select a paper type. In this example, we printed out a letter-size photo on Epson Premium Glossy paper, so we chose those settings in the Paper & Quality Options section of the dialog box. Choose the same paper here as you did in Step 8.
- Turn on color management. Because you're letting the printer driver determine the color, you need to be certain that the Color Controls radio button is active. This setting tells the printer driver to automatically select a printer profile for the paper type you selected.
- Set the color mode. Don't use Epson Vivid. This choice produces inferior results on photos. Choose Best Photo, the Epson Standard, or Adobe RGB, depending on your printer.

If you frequently print files using the same settings, you can save your settings by clicking the Save Setting button.

11. (Windows only) To print the photo, click OK and then click OK again in the Print dialog box.

Your file is sent to your printer. The color is converted automatically from your source workspace of sRGB or Adobe RGB (1998) to the profile the printer driver automatically selects for you.

Printing a photo with Elements managing color

Another method for managing color when you're printing files is to select a printer profile from the available list of color profiles installed with your printer. Whereas in the preceding section, you used your printer to manage color, this time you let Photoshop Elements manage the color.

The steps in this section are the same as the ones described in the preceding section (for printing files for automatic profile selection) when you're setting up the page and selecting a printer. Choosing File Print opens the Print dialog box. To let Elements handle the color conversion, follow these steps in the Print dialog box:

1. Choose File⊕Print from the Organizer or Photo Editor (Windows) or from the Photo Editor (Macintosh). In the Print dialog box, click More Options to open the More Options dialog box. Click Color Management in the left pane to display the color management options. Click Photoshop Elements Manages Colors.

2. From the Printer Profile drop-down menu, select the color profile designed for use with the paper you've chosen.

In this example, we use a profile designed for a specific printer, as shown in Figure 14-7. (Note that custom color profiles you acquire from a profiling service come with recommended color-rendering intents. For this paper, Relative Colorimetric is recommended and is selected on the Rendering Intent dropdown menu, as you can see in Figure 14-7.)

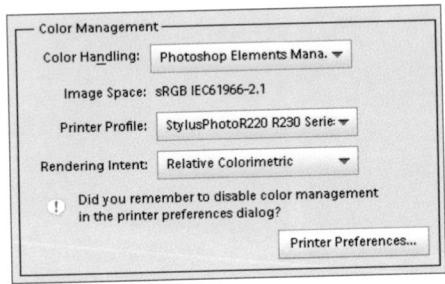

Figure 14-7: Choose a printer profile that matches the paper you use.

3. Click the Printer Preferences button.

You arrive at the same dialog box shown in Figure 14-3. On the Macintosh, you arrive at the same dialog box shown in Figure 14-4.

4. Click the Best Photo radio button. From the Type drop-down menu, select the recommended paper choice. On the Macintosh, you make your paper choice as shown in Figure 14-4.

Custom color profiles are also shipped with guidelines for selecting proper paper.

5. Click Advanced and click Continue to arrive at the same dialog box shown earlier in Figure 14-6. On the Macintosh, you choose Color Management from the pop-up menu to arrive at the same dialog box shown in Figure 14-5.

The paper choice selection is automatically carried over from the previous Properties dialog box; see Figure 14-6. The one setting you change is in the Color Management section.

 Click the ICM (Image Color Management) radio button and check Off (No Color Adjustment), as shown in Figure 14-8. On the Macintosh, click the Off (No Color Adjustment) radio button (refer to Figure 14-5).

Because you selected the color profile in Step 2 and you're letting Elements manage the color, be sure the Color Management feature is turned off. If you don't turn off Color Management, you end up double-profiling your print.

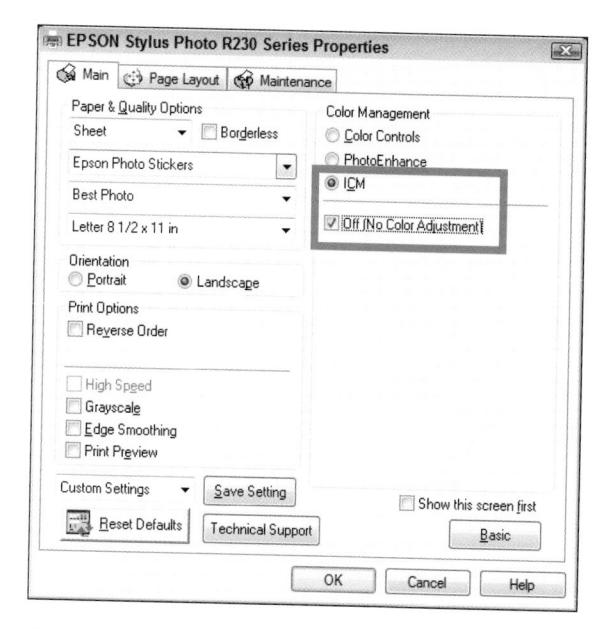

Figure 14-8: Click ICM and choose Off (No Color Adjustment).

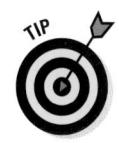

Deciding whether to manage color is simplified in Photoshop Elements. In the Color Management area of the dialog box, a message appears each time you make a selection from the Color Handling drop-down menu. Right below the Rendering Intent drop-down menu, you see a message asking if you remembered to turn color management on or off. Each time you make a selection for the color handling, pause a moment and read the message (shown in Figure 14-7). This is your reminder that you need to follow the recommendation to properly handle color.

Each time you print a file — whether it be a single photo, a contact sheet, a photo package, or other type of print — you use the same steps for color management. In the next section, we talk about a number of options you have for printing photos, but remember that you need to manage the color for each type of print you want.

Printing from the Organizer in Windows

In Photoshop Elements 11, the Print dialog boxes from the Organizer and the Photo Editor are almost identical in Windows. No longer is there disparity in regard to features and options between the dialog boxes. Unfortunately, on the Macintosh, printing is handled only in the Photo Editor.

You find one single difference when printing from the Organizer versus the Photo Editor in Windows: When you click More options and Color Management in the left panel, the color profiling options are different in the Organizer.

In the following figure, you can see the color profile choices are much different than those in Figure 14-2. When you print from the Organizer,

your color profiling options are more limited than when you print from the Photo Editor.

In terms of everyday use, if you find that printing photos works well by choosing the sRGB or Adobe RGB profile you can print from the Organizer. When you need to use the color management options discussed in the earlier sections in this chapter, then print your files from the Photo Editor.

On the Macintosh, you cannot print from the Organizer. Choosing File Print in the Organizer automatically prompts you to open your file in the Photo Editor where all printing on the Macintosh is performed.

Printing Choices Custom Print Size Color Management	Color Management		
		sRGB IEC61966-2.1 Same as Source	

Various sources offer alternatives for purchasing inks. You can purchase third-party inks for your printer, use refillable ink cartridges, or have your printer modified to hold large ink tanks that last much longer than the manufacturer-supplied cartridges. These alternatives provide you with significant savings when purchasing inks.

However, using any inks other than manufacturer-recommended inks can produce color problems. Each developer provides printer profiles specific for their recommended inks. With third-party inks, you don't have the advantage of using color profiles that have been tested by a printer manufacturer. If getting the most accurate color on your prints is important to you, use only those inks and papers recommended by your printer manufacturer.

Getting Familiar with the Print Dialog Box

Because the Print dialog box options are identical in the Organizer and the Photo Editor in Windows (with the exception for color profile management; see the nearby sidebar), you find the same menus and buttons when you choose File&Print from either the Organizer or the Photo Editor. On the Macintosh, you can print only from Photo Editor.

The individual items you find in either dialog box (see Figure 14-9) include

- **A. Image Thumbnails.** When you select multiple images in the Organizer, all the selected images appear in a scrollable window on the left side of the dialog box.
- **B. Scroll bar.** When so many photos are selected that they all cannot be viewed in the thumbnail list on the left side of the dialog box, you can use the scroll bar to see all images.

Figure 14-9: The Print dialog box from either the Organizer or Photo Editor (Windows) or the Photo Editor (Macintosh).

C. Add/Remove. If the Print dialog box is open and you want to add more photos to print, click the Add (+) icon to open the Add Photos dialog box. A list of thumbnails appears, showing all photos in the current open catalog. Check the check boxes adjacent to the thumbnails to indicate the photos you want to add to your print queue. You can also choose an entire catalog, albums, photos marked with keyword tags, and photos that have a rating.

If you want to remove a photo from the list to be printed, click the photo in the scrollable list in the Print dialog box and click the Remove (-) icon.

- **D. Help.** Click the Help button to open help information pertaining to printing photos.
- **E. Page Setup.** Click this button to open the Page Setup dialog box. See "Using Page Setup" later in this chapter.
- **F. More Options.** Click More Options to open another dialog box where you can choose additional options. (See the section "Using More Options," later in this chapter.)
- **G. Scroll Print Preview.** Click the arrows to go through a print preview for all images in the list. Move the slider to zoom photos in the Print Preview.
- H. Print Preview. This image displays a preview of the image to be printed.
- I. Print. Click Print after making all adjustments in the Print dialog box.
- **J. Cancel.** Clicking Cancel dismisses the dialog box without sending a photo to the printer.
- K. Select Printer. Choose a target printer from the drop-down menu.
- **L. Printer Settings (Windows only).** Click this button to open properties unique to the selected printer.
- M. Select Paper Size. Choose from print sizes that your printer supports. This list may change when you choose a different printer from the Select Printer drop-down menu.
- N. Select Type of Print. On Windows, you have three options available Print Individual Prints, Contact Sheets, or Picture Packages. On the Macintosh, these options are found as separate menu commands in the File menu in Expert mode. For more information on contact sheets and picture packages, see the section "Exploring Other Print Options," later in this chapter.

- **O. Select Print Size.** Select from the print size options that your printer supports.
- **P. Crop to Fit.** Check this box to crop an image to fit the selected paper size.
- Q. Print __ Copies of Each Page. By default, one page is printed. You can choose to print multiple pages by entering the number you want in the text box.

Using Page Setup

When you click the Page Setup button in the Print dialog box, the Page Setup dialog box opens. In this dialog box, you can select print attributes that may be unique to your printer. However, you can control the options for most desktop printers in the Print dialog box.

Using More Options

When printing photos from the Organizer or Photo Editor (Windows) or Photo Editor only (Macintosh), click the More Options button in the Print dialog box. The More Options dialog box opens; refer to Figure 14-2.

If you've used Photoshop Elements prior to version 8, notice that the More Options dialog box has changed. As shown in Figure 14-2, you have three categories listed in the left pane:

- Printing Choices. Similar to what was available in earlier versions of Elements.
- Custom Print Size. Various settings for the output size.
- Color Management. Handles color profile selection and color management options.

In version 9, these three items moved from the Print dialog box to the More Options dialog box.

When you want to manage color in Elements, as we explain earlier in the section "Working with Color Printer Profiles," you need to open the More Options dialog box.

The default selection is Printing Choices when you open the More Options dialog box. Choices available for printing your photos include

- ✓ Photo Details. Check the check boxes for the detail items you want printed as labels on your output.
- ✓ **Iron-on Transfer.** This option is used for heat transfer material such as Mylar, LexJet, and other substrates that require *E-down* printing (emulsion-down printing, where the negative and the image are flipped).
- **✓ Border.** Check the boxes to print a border on the photo prints.
- Trim Guidelines. Check the Print Crop Marks checkbox to print crop marks

Exploring Other Print Options

The basic principles of color management are used each time you send a file to your printer. Up to this point, we have talked about printing a single photo. Elements provides you with a variety of other choices for printing files without borders, as well as a number of choices for printing photos with decorative frames, picture packages, and contact sheets.

You have choices in the Organizer or Expert Photo Edit mode for printing multiple images as either a contact sheet or picture package. From within Expert Photo Edit mode in Windows, when you choose to print a contact sheet or picture package, Elements switches you to the Organizer view. You then proceed in the Organizer and leave Expert Photo Edit mode.

As an example, look at Figure 14-10. In the Print dialog box we chose Picture Package from the Select Type of Print drop-down menu and we added an Antique Oval frame. Elements displays a preview of your choices in the Preview pane.

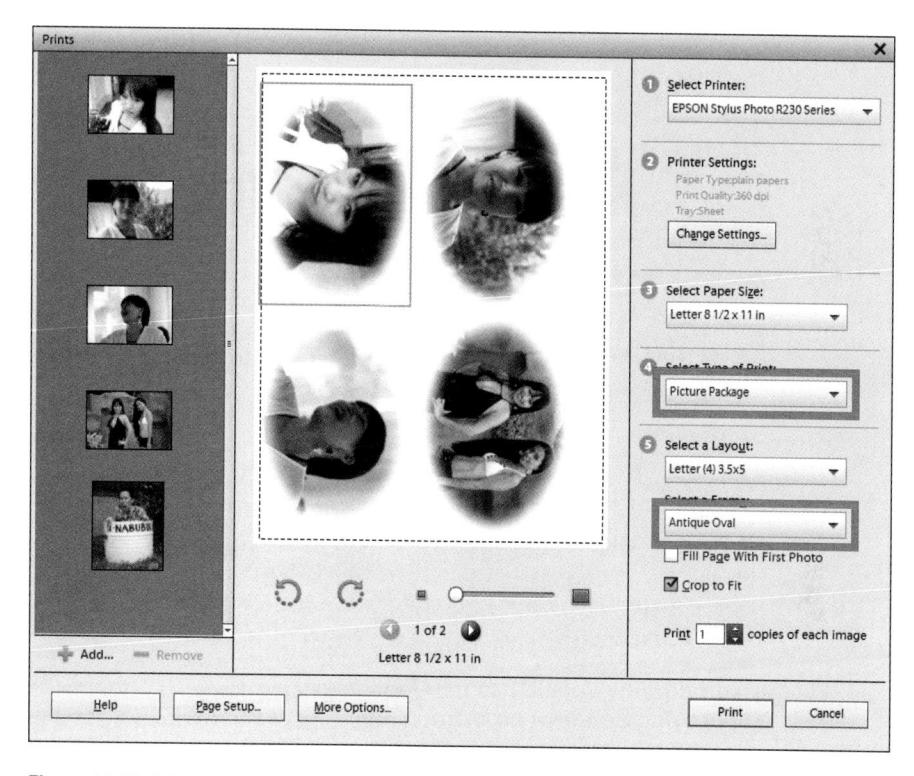

Figure 14-10: Printing a Picture Package with an Antique Oval frame.

with the acceptable standards for online hosts, where you eventually expect to send your creations, and the kinds of devices people are likely to use to view your creations.

Planning ahead

Before you choose a sharing activity and ultimately begin work on a creation, you need to ask a few questions:

What device(s) are going to display my creations? When it comes to viewing photos and movies, you have choices that include computers (including desktops, notebooks, and netbooks), handheld devices such as mobile phones and tablets (such as the Apple iPad), and TVs. If you want your creations to be viewable on all devices, then you need to use different Elements tools and file formats than you would use for showing creations exclusively on a TV or on a computer.

Consider two things regarding devices and viewing your creations:

- Adobe Flash. Some online hosts convert your video uploads to Adobe Flash. If you want to share photos with iPhone/iPod/iPad users (more than one hundred million and counting), then stay away from any host that supports Flash-only conversions.
- **Storage space.** Hosts vary greatly in terms of space allocated for storing content. If you want to share large video files, be certain the storage host you choose allocates enough storage space to permit you to upload your files.
- What storage hosts are the most popular? From within Photoshop Elements, you can export directly to Facebook, Flickr, Adobe Photoshop Showcase, Kodak EasyShare Gallery, and SmugMug Gallery. Some of these providers may be new to you.

In Elements 11 you also have a direct link to YouTube. On Windows systems, you can create movie files and flipbooks that can be shared on YouTube. If you have Adobe Premiere Elements for Windows or the Macintosh, you can export your video creations directly from within the Organizer to YouTube.

Just be aware that the services supported in the Share panel all perform similar functions: Photos and videos are uploaded and people you invite to see your creations can access them. The most popular online sharing services include the following:

• Facebook. Facebook is a private online service that's clearly among the most popular worldwide for sharing photos. Facebook offers you up to 200 photos maximum per album, up to 1024MB

for each video, and unlimited space for all your albums and videos. When you submit videos to Facebook, the videos are transcoded to Adobe Flash for viewing on computers. but also contain coding for viewing on iPhone/iPod/ iPad; see Figure 15-1. This is all transparent to the user. You just upload a video in any one of more than a dozen different formats, and any device can view the video. Facebook is clearly the leader for hosting all your creations.

• Flickr. Whereas Facebook provides you with near limitless options, Flickr (operated by Yahoo!) is much more restrictive. Flickr assesses maximum storage per user according to bandwidth. You can

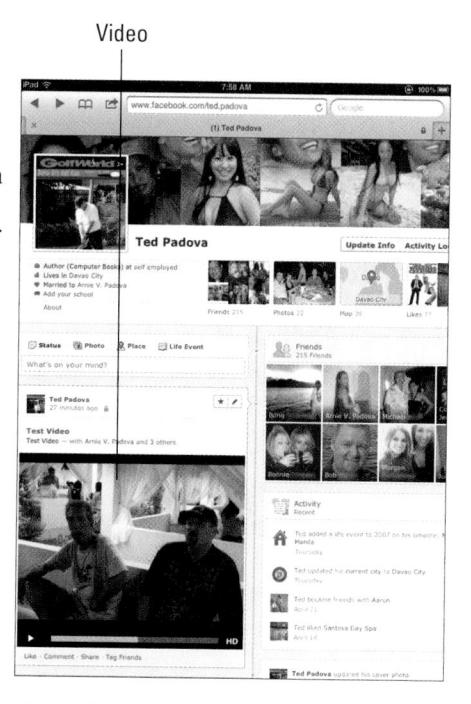

Figure 15-1: Video on Facebook is shown here on an Apple iPad.

only upload so many times, and then you have to wait until the next month to upload additional photos. It's much more limiting than other services, and video files are restricted to small sizes. You can upgrade to a premium account for a fee, but why bother when you can get it all free with a much better user interface on Facebook?

- **MySpace**. MySpace is great until you want to share videos with iPhone/iPod/iPad users. MySpace videos are transcoded to Adobe Flash, and the Apple devices can't see them.
- **Photoshop Showcase.** Much of the user interface for Photoshop Showcase (operated by Adobe) is Adobe Flash. If you want to share videos with iPhone/iPod/iPad users, they can get to the site, but many items can't be viewed on iOS devices.
- What types of creations can I share? Obviously, you can upload individual photos to any one of the online services. You can use the Share panel and choose to share directly to Flickr, Facebook, SmugMug

Gallery, YouTube, Vimeo, and Photoshop Showcase. Also in the Share panel is CEIVA Photo Frame, where you can place orders for photo frames and share photos. In addition to uploading single photos to a service, some of the creations you might want to share include the following:

- Slide shows. On Windows, you can create a slide show and choose to export the slide show as a movie file (.wmv) or a PDF. On the Macintosh, you are limited to PDF only. If you work on Windows, export to .wmv and upload your file to an online host. If you use Facebook, all devices show your creations. Slide shows have an additional benefit in supporting audio files. You can add audio to the creations, and the audio plays on all devices if you upload them to Facebook. If you try to upload the same file to Flickr, more often than not, the file will be too large to host.
- Flipbooks. Flipbooks are Windows-only creations. Flipbooks are similar to slide shows, except that they don't include transition effects and audio support. You can easily upload flipbooks to both Facebook and Flickr. Unless you have a huge number of photos, you aren't likely to run into a file size constraint when uploading to Flickr.
- Webhosting. If you want to host videos on your own website and make the videos available to iPhone/iPod/iPad users as well as computer users, you need a little help from Adobe Premiere Elements. In Premiere Elements you can export video for mobile devices, and the resultant file can be viewed on an iPhone/iPod/iPad as well as a computer. Also, Premiere Elements supports some of the services on the Macintosh that you don't have available in Photoshop Elements, such as slideshows exported as movie files and flipbooks.

Understanding Adobe Revel

Adobe Revel is a web hosting service for storing your photos in the cloud, and Revel enables you to view your photos on all your devices, such as computers, smart phones, tablets, notebooks, and so on. When you edit a photo, the photo is automatically updated on all devices.

Elements 11 has a direct link in the Share panel to Adobe Revel — but only on the Macintosh. As of this writing, Adobe Revel is a Mac-only service. Adobe will soon support Adobe Revel for Windows and Android systems. When the development for Windows 8 is complete, we're likely to see a maintenance upgrade for Elements that supports Revel in the Share panel.

One thing to know about Adobe Revel is that it is, as of this writing, a subscription service. You have a 30-day free trial period and after that you have to pay \$5.99 USD per month.

If you want to store photos in the cloud, you have alternate free services such as iCloud, Facebook, Flickr, MySpace, and for videos YouTube and Vimeo.

Understanding some common setup attributes

The Create and Share panels are available in the Organizer. When you're in the Photo Editor, only the Create panel is available. For this chapter we'll stick to the Share panel and in Chapter 16 we cover using the Create panel.

The Share panel is almost identical on Windows and the Macintosh. The only exceptions you find in Elements 11 are that Photo Mail is restricted to Windows users only and Adobe Revel, as of this writing, is only available on the Macintosh. In Figure 15-2 you can see the Share panel as it appears on Windows (left) and on the Macintosh (right).

When you choose an option in the Share panel by clicking one of the buttons, one of two interfaces appears. Some choices provide you options within the Share panel, and other choices open a window

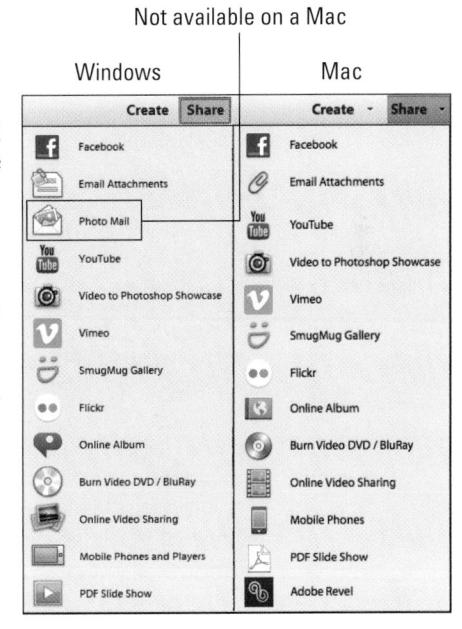

Figure 15-2: The Share panel as it appears in Windows (left) and on the Macintosh (right).

where you log on to an account for sharing photos. Those choices, such as Online Album and Photo Mail (Windows), provide editing options directly in the Share panel. The choices for sharing photos with other services open windows for logging on to your account and proceeding through steps to prepare and upload images.

In the sections ahead, we explore using the different interfaces and making choices for preparing photos for sharing.

Creating an Online Photo Album

When you want to use the Share panel, you must be in the Organizer. Click Share in the top right corner and locate Online Album in the middle of the panel. The term *Online* is a bit misleading here because you can use this sharing option for both online and local file creations.

Understanding export options

The process for creating an album is the same, regardless of the destination you want for your file. When you select photos (or don't have any photos selected) in the Organizer and click Online Album, the Share panel displays three options for your output, as shown in Figure 15-3.

Options for sharing albums in the Share panel, shown in Figure 15-3, include

Photoshop Showcase. This item was formerly known as Photoshop.com in earlier versions of Elements. Photoshop Showcase is a free online hosting service and, because it's so marvelous in this version of Elements, we offer details about it in the section "Exporting to Photoshop Showcase" later in this chapter.

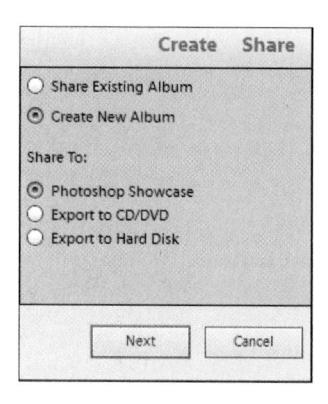

Figure 15-3: Choose a destination for your album in the Share To area in the Share panel.

- **Export to CD/DVD (Windows only).** Use this option to write an album to a CD or DVD that can be viewed on your DVD player.
- Export to Hard Disk. Choose this option to export files to a folder. After the files are exported, you can view the album locally on your hard drive by using your web browser, or upload the files to a website so any visitor can view the album.

Exporting to Photoshop Showcase

Let's face it: Sharing media means you want others to see your wonderful creations. Inasmuch as you can export your files to CD/DVD and your hard disk, you really don't share the items. The files are stored for later deployment that is the actual sharing function.

The wonderful Photoshop Elements Development Team at Adobe Systems made the process for sharing photos much easier. In just a few steps, you can create and distribute your creations to family and friends. We guarantee that once you use the new Photoshop Showcase feature in Elements, you will return to the Share panel and export to Photoshop Showcase time and again.

The nice thing about using Photoshop Showcase for sharing is that the Adobe Development Team made it so easy for you to assemble a professional-looking creation in an Adobe Flash environment. To see how easy it is to create an album and show it off on Photoshop Showcase, follow these steps:

- 1. Open the Organizer and select the photos you want to use for your project.
- 2. Click Share in the Panel Bin and choose Online Album from the panel options (see Figure 15-2).

If you have an album ready to use, click the radio button adjacent to that album. (Note that all your existing albums appear ready for use in the Share panel.)

In our example we choose Create New Album to start a new album.

3. Select the Photoshop Showcase radio button (refer to Figure 15-3).

You can first select photos in the Media Browser, and then click Share and then click Online Album in the Share panel. All the selected photos are added to a new album.

4. Click Next at the bottom of the Share panel.

The Share panel displays two tabs: Content and Sharing (see Figure 15-4).

(Optional) On the Content tab, add or delete photos from the album you're about to share.

If you want to add photos from your album, you can drag photos from the Media Browser to the Content tab. To delete photos, click a photo to select it and click the Trash icon at the bottom of the panel.

Figure 15-4: Drag photos to the Content panel to add more photos to your creation.

6. Click the Sharing tab to display options for your album, as shown in Figure 15-5.

If you create a new album instead of using an existing album, type a name in the Album Name text box shown in Figure 15-5.

7. Choose a template.

At the top of the window, you find a number of different template choices. Click a template, and a preview is shown in the image pane as shown in Figure 15-5.

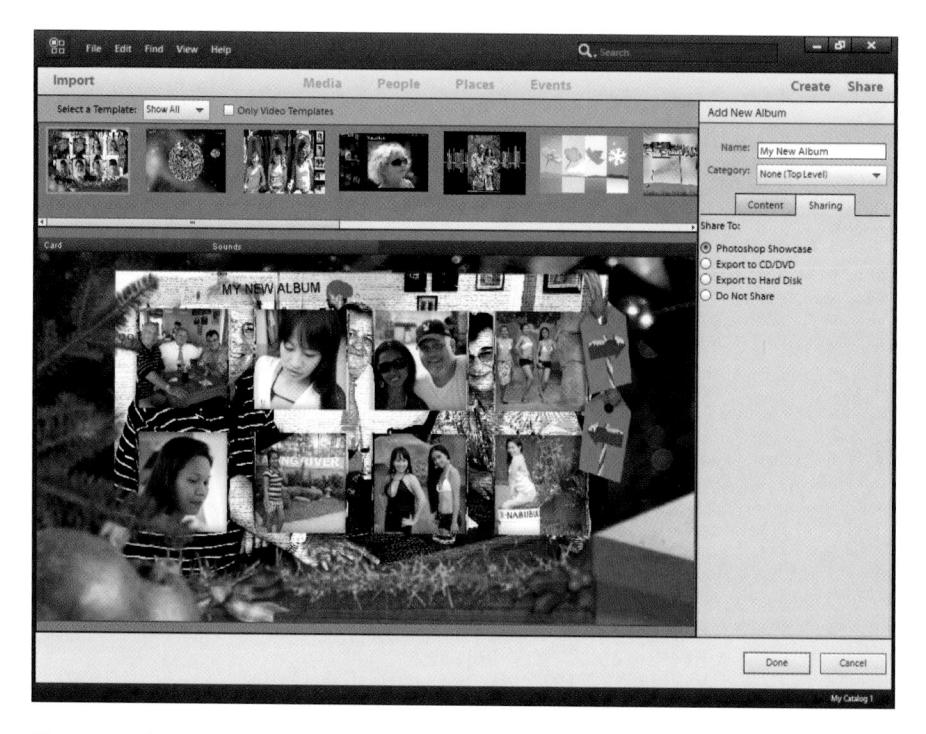

Figure 15-5: Choose a template in the Sharing tab.

8. Click Done.

Elements works away preparing your media. Wait for the process to complete before moving on. After the files are processed the Photoshop Showcase wizard opens.

These steps continue in the next section, where we talk more about "Using Photoshop Showcase."

Using Photoshop Showcase

This section is a continuation of the steps used to produce a creation and prepare it for Photoshop Showcase. Follow the steps in the preceding section, "Exporting to Photoshop Showcase," to move on to the next steps here:

1. Log on to Photoshop Showcase.

After you prepare files for uploading to Photoshop Showcase and click the Done button in the Share panel, you arrive at the Photoshop

Showcase wizard. The first screen prompts you to log on with an existing account ID (your e-mail address and password) and provides you a button to click for joining Photoshop Showcase if you are not currently a member. If you're not a member, follow the onscreen guide that walks you through the sign-up process. After you log on, click the Next button.

2. Preview the album and album name and click Next.

After you log on to Photoshop Showcase, the first screen that appears displays a preview of your album and the album name (as shown in Figure 15-6). Be certain you are uploading the correct album by looking over the details in the screen. If you want to change the name of your album, you can type a new name in the Name Your Gallery text box. When you're satisfied you have the correct album and name, click Next to move on to the new screen in the wizard.

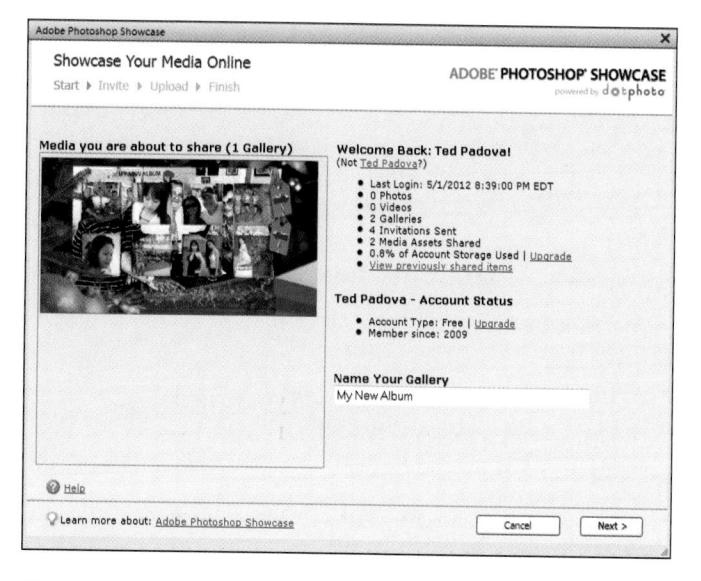

Figure 15-6: Look over the preview to be certain you are uploading the desired album.

3. Identify the recipients.

The next screen provides you options for adding recipients and their e-mail addresses. To add new contacts, click the Add New Contact link, shown in Figure 15-7.

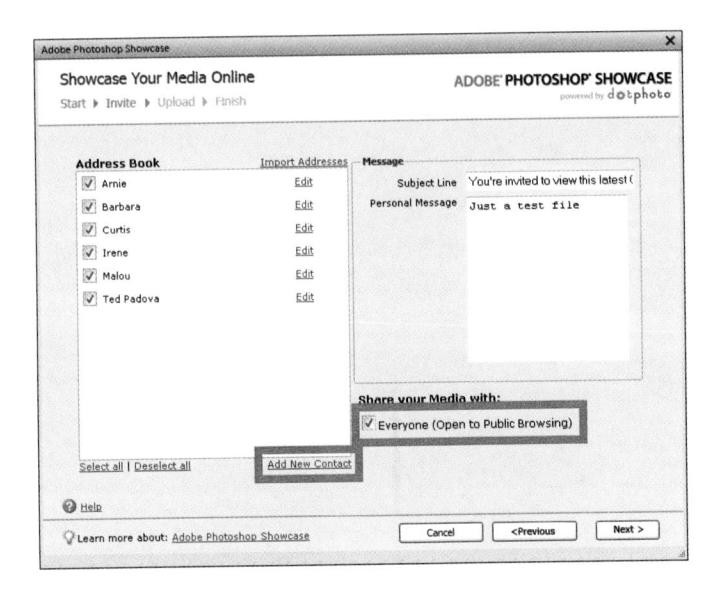

Figure 15-7: Add Recipients.

Recipients can visit your Photoshop Showcase account. If you want visitors to see your album, check the Everyone (Open to Public Browsing) checkbox. Visitors don't need an account to see your creations.

4. At the top of the right panel, type a subject line and a text message. Click Next when you're done.

At this point Photoshop Showcase uploads your files. Be certain to wait until the upload is finished and you see the Finish (confirmation) screen in the wizard.

5. View the upload.

After the upload finishes, the next wizard screen displays a button titled *View This Gallery*. Click the button to view the gallery in your default web browser as shown in Figure 15-8.

Viewing Photoshop Showcase galleries

Simplicity is built into the entire Photoshop Showcase experience especially for those who receive your invitations to view your photos. Photoshop Showcase automatically generates and sends e-mails for you from your recipient list.

When users open a Photoshop Showcase e-mail, they see a simple invitation to view your gallery. The user clicks the SEE IT NOW button in the e-mail (see Figure 15-9) and the default web browser opens the web page where your gallery is stored. There's no need to type a URL. Photoshop Showcase makes it easy for you and your family/friends to see your galleries.

Figure 15-8: A gallery is viewed in a web browser.

Figure 15-9: Click SEE IT NOW and your gallery opens in your default web browser.

E-Mailing Photos

Rather than save your file from Elements and then open your e-mail client (such as Outlook or Apple Mail) and select the photo to attach to an e-mail message, you can use Elements to easily share photos via e-mail with one click.

When you want to e-mail a photo or a creation like some of those we talk about in Chapter 16, follow these steps:

- 1. In the Organizer, select the photos you want to e-mail to a friend.
- 2. Open the Share panel and select Email Attachments.
- 3. Choose a quality setting for the attachment and click Next.

Drag the slider labeled Quality, and observe the file size noted at the bottom of the panel where you see Estimated Size, as shown in Figure 15-10. If the file is large, you may need to resize it in the Image Size dialog box before e-mailing the photo. Chapter 4 explains how to resize images.

4. Add recipients or bypass this option.

The next panel provides settings for adding a message and adding recipients from an Address Book.

You can bypass adding recipients from your Address Book. If no recipients are listed in the Select Recipients panel, you can add recipient e-mail addresses in the new message window in your e-mail client.

Click Next, and the photo(s) are attached to a new e-mail message in your default e-mail client.

Elements attaches media to a new e-mail message. You need to toggle to your e-mail client in order to see the message and send the mail.

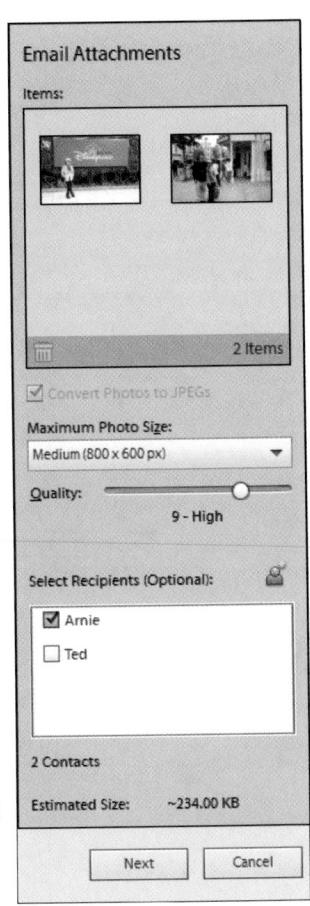

Figure 15-10: Set Quality to a medium setting for faster uploads to your mail server.

6. Review the To, Subject, and Attach fields to be certain the information is correct, and then click the Send button.

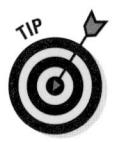

By default, Elements uses your primary e-mail client application, which may or may not be the e-mail program you use. You can change the default e-mail client by pressing Ctrl+K (\mathbb{H}+K on the Macintosh) to open the Preferences dialog box when you're in the Organizer, and then clicking Sharing on the left pane. From a drop-down menu in the Sharing preferences, select the e-mail client application that you want Elements to use.

Working with Adobe Premiere Elements

Several options in the Share and Create panels require that you use Adobe Premiere Elements. The items denoted as Burn Video DVD/BluRay, Online Video Sharing, and Mobile Phones and Players all require Adobe Premiere Elements.

If any of these items interest you, you can download a free trial of Adobe Premiere Elements and work with it for 30 days. If Premiere Elements is a tool you find worthwhile, you can purchase it from the Adobe Store. If you're perusing this book and have not yet purchased Elements 11, you can purchase the Adobe Photoshop Elements 11 and Adobe Premiere Elements 11 bundle. The bundle purchase is much lower in price than buying the products separately.

All download and purchase information is handled on Adobe's website. Just click one of the options for video sharing in the Share panel, and you are prompted to download a trial version of Premiere Elements.

Sharing Your Photos on Social Networks

You have a variety of options for sharing photos and placing orders on a number of different service networks. We don't have enough space in this book to detail each and every service that Elements supports, so we'll walk through a few of the more popular services as an example for connecting with a service provider. If other services interest you, poke around and explore options for the services you use.

Previous users of Elements will immediately notice that services such as Flickr, Facebook, and SmugMug Gallery have been promoted from options nested in the More Options drop-down menu to buttons shown in the Share panel.

Sharing photos on Flickr and Facebook

Uploading photos to Flickr and Facebook involves the same process. You first select photos, albums, or creations in the Organizer and then click either the Flickr or Facebook button in the Share panel.

You need to authorize Elements to communicate with Flickr or Facebook before uploading any content. Click the Authorize button, and you proceed to a log-on page where you supply your account sign-in and password information.

After you are logged in to a site, the process for uploading images is quite easy, as you can see in Figure 15-11, where we logged in to Facebook.

Figure 15-11: After authorizing Facebook, the Share to Facebook window permits you to upload selected photos to your Facebook account.

Attribute choices in the Share to Facebook window are straightforward and easy to follow. Here's what you find:

- If you want to add more photos, click the plus (+) button. Selecting a thumbnail in the window and clicking the minus (-) button deletes the photo.
- ✓ You can choose to add photos to existing Facebook albums or create a new album by making the respective radio button choice, as you see in Figure 15-11.

Notice that you also have privacy options. For Facebook, open the Who Can See These Photos? drop-down menu and make a choice for whom you want to see your photos. In Flickr, you have choices for Private and Public. Within the Private option, you have choices for visibility to Friends or Family.

After a photo is uploaded to Flickr or Facebook, you see the photo appearing on your wall or in a photo collection (as shown in Figure 15-12).

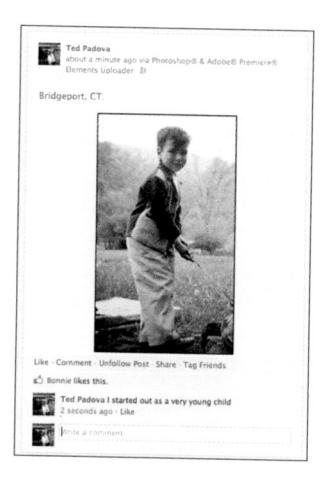

Figure 15-12: Uploaded photo as it appears on Facebook.

Using other online services

Once you become familiar with uploading photos to a service, you can easily follow similar steps to upload photos to any of the services that are supported by Elements. You first encounter the window to authorize an account. When setting up a new account, you can log on to the service and create the new account.

When you enter a site for sharing photos, printing photos, or creating items such as photo frames, follow the easy online steps that each service provides.

Making Creations

In This Chapter

- Understanding creations
- Understanding common creation assembly
- Creating slide shows
- Creating other projects
- Making photo prints
- Creating photo collages
- Creating Photo Stamps

dobe Photoshop Elements offers you a number of creations that can be shared onscreen or in print. From both the Create and Share panels in the Panels Bin in the Organizer and both editing modes, you have a number of menu choices for making creations designed for sharing.

In Chapter 15, we look at creating files for screen and web viewing. In this chapter, we talk about creations designed for print and sharing. It's all here in Photoshop Elements, for both Windows and Macintosh users.

Getting a Grip on Creations

In Chapter 15 we look at the Share panel and how many different share options are accessed only from the Organizer. The Create panel differs from the Share panel — not only in content but also in location. You can open the Create panel from either the Organizer or the Photo Editor.

When you click Create above the Panels Bin, from either the Organizer or the Photo Editor, you find almost identical options on Windows and the Macintosh. There's only one exception. On the Macintosh you won't find a creation opportunity for a Slideshow as you can see in Figure 16-1. This feature is unique for Windows users.

As you look at the Create panel in Figure 16-1, note the first five items at the top of the panel on Windows and the Macintosh. When you make a creation from one of the first five items, the settings, adjustments, features, and such are almost identical in terms of the creation process. What you create, of course, is quite different depending on what item you click in the panel, but the process is very similar. We talk about the basic assembly procedures in the section that follows.

Figure 16-1: The Create panel on Windows (left) and Macintosh (right).

Grasping Creation-Assembly Basics

Creations such as photo books, photo collages, photo calendars, greeting cards, and Photo Stamps (most of which we talk about in this chapter) shown in Figure 16-1 are intended for output to either print or screen sharing.

Many creation options follow a similar set of steps to produce a file that is shared with other users or sent to an online printing service. In the Panels Bin, you can find all you need to make a new project by choosing layouts and producing a creation. Here are the common steps you'll find when making a choice from the Create panel:

1. Select photos.

In the Organizer or in the Photo Bin in the Photo Editor, select the photos you want to use for your creation. Sort photos or use keyword tags (as we explain in Chapters 5 and 6) to simplify finding and selecting photos you want to use for a creation.

2. Click a choice in the Create tab.

Click the Create tab, and the Create panel in the Panels Bin opens. Click an option for the type of creation you want — Photo Book, Photo Calendar, Greeting Card, Photo Collage, and so on.

3. Choose a size.

After you select the kind of creation you want to make, a wizard opens where you choose the options you want. In the left column, choose a size for the output. In Figure 16-2, we selected to make a Photo Book, and the sizes are displayed in the left column.

4. Choose a theme/layout.

Many of the creation options enable you to select a template. When you click a creation option on the Create panel, the panel changes to display choices for various themes, backgrounds, and borders. You make choices by clicking the theme or background. In Figure 16-2 you can see the Themes column for a Photo Book creation.

5. Number of pages.

Elements automatically creates the number of pages to accommodate the number of photos you selected in the Organizer or the Photo Bin. Note that some creations require a minimum number of photos to produce a project. Photo Book, for example, requires a minimum of 20 pages.

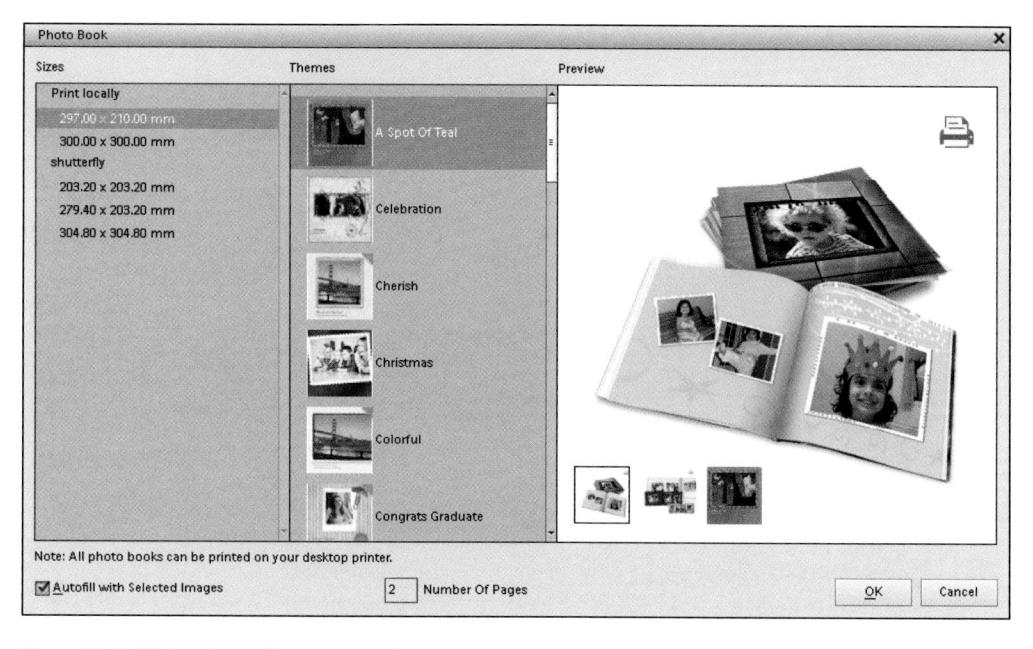

Figure 16-2: Click a theme for your creation.

6. Choose options in the Create Panel.

After you click OK, the Create panel changes to a wizard and displays three icons at the bottom of the panel. The first icon is Pages. You can add or delete pages when you click this icon. Click the second icon, and you see many choices for different layouts, as shown in Figure 16-3. You can click different layouts and view the results in the wizard. The third icon is Graphics. Use the Graphics panel to add artwork and text. Explore each item and choose options available for editing your creation.

7. Select options in the creation's Advanced Mode.

The wizard is a separate interface apart from the Organizer and the Photo Editor. Using it means you lose access to all editing tools.

Elements provides you with the Photo Editor Tools panel via an Advanced option in the creation wizard. Click Advanced Mode in the upper-left corner of the wizard, and the window changes to display the Tools panel and provide access to the menus for making edits on photos in the creation, as you can see in Figure 16-4.

8. Click the output option.

At the bottom of the wizard, click Save to save the file as a Photoshop Elements Project. You can return to the project and

Figure 16-3: The Layout panel offers choices for many different layouts.

edit it at a later time. If you wish to print your creation, click the Print icon at the bottom of the window. Before the output is generated, look over the preview of your creation. If you're in Advanced mode, click Basic Mode at the top of the window and scroll through the pages to preview the creation.

Whether you want to create a Photo Book, a Calendar, or any one of the other first five options in the Create panel, you follow the same steps.

When you make a creation that will ultimately be shared with other users or sent to an online service for printing, keep in mind that you *must* first select the photos you want in your creation. For example, creating a photo book by clicking the Photo Book button on the Create panel first requires you to select photos.

Figure 16-4: Advanced Mode provides you with the Photo Editor tools where you can edit photos in your creation before saving or printing.

The reason you must first select photos — in either the Organizer or Photo Bin — is because the creation process involves using a wizard to set the attributes for your creation. You leave either the Organizer or Photo Bin when you begin the process; Elements makes no provision for you to drag and drop photos from the Organizer or Photo Bin to the wizard.

Creating a Slide Show (Windows Only)

This *Million Dollar Baby* is no *Mystic River* — it's simply *Absolute Power!* Well, maybe you won't travel the same path from Rowdy Yates to multiple Academy Award—winning director and filmmaker Clint Eastwood, but even Mr. Eastwood might be impressed with the options for moviemaking with the Photoshop Elements slideshow creations. When he's not rolling out his Panaflex camera, he may just want to take photos of the grandkids and do the directing and producing, as well as the editing, right in Photoshop Elements.

The rest of us can channel our own Clint Eastwood by using the powerful features of the Photoshop Elements Slide Show Editor to create PDF slide shows and movie files. It's so easy that Elements promises you won't be Unforgiven.

Creating a Slide Show project (Windows)

You create a project file in the Slide Show Editor and then export it for a number of different uses. In this section, you find out how to create and save your project. In the following section, you dive into exporting.

A Photoshop Elements project has an advantage over a PDF document in regard to revising the content. You can simply open your project, make revisions, and produce the slide show — something you cannot do with a PDF file.

Here's how you go about creating a Slide Show project that you can edit and export later:

1. Open the Organizer and select the pictures you want to use in your slide show.

You can also choose files you may have open in the Photo Bin in the Photo Editor.

2. Click the Create button in the Panels Bin and click Slide Show.

The Slide Show Preferences dialog box opens. Just about everything in the dialog box can be adjusted in the Slide Show Editor, so don't worry about making choices here. If you want to keep the Slide Show Preferences dialog box from reappearing when you make slide show creations, deselect the Show This Dialog Each Time a New Slide Show Is Created check box.

3. Click OK in the Slide Show Preferences dialog box.

The Slide Show Editor opens, as shown in Figure 16-5.

4. If your Slide Show Editor doesn't show a screen similar to the one in Figure 16-5, click the Maximize button in the upper-right corner of the window.

This way, you can see the Storyboard at the bottom of the screen and the Panels Bin on the right side of the editor.

5. (Optional) Create a Pan & Zoom view.

When slides are shown, you can zoom and pan a slide. Click the Enable Pan & Zoom check box and click the Start thumbnail. A rectangle appears in the preview area. Move any one of the four corner handles in or out to resize the rectangle. Clicking inside the rectangle and dragging the mouse enables you to move the rectangle around the preview.

Figure 16-5: The Slide Show Editor is where you create slide shows.

For the end zoom position, click the End thumbnail and size the rectangle to a zoomed view or a view where you want to stop the zoom. Notice in Figure 16-5 that the End thumbnail is selected and the rectangle is sized down to the zoom area on a portion of the photo.

6. (Optional) Add a graphic.

A library of graphics appears on the Extras pane in the Panels Bin. Drag a graphic to a slide. If you want a blank slide to appear first and then add text and graphics to the blank slide, click Add Blank Slide on the Shortcuts bar at the top of the editor.

7. (Optional) Add text.

Click the Text tool on the Extras pane in the Panels Bin, and drag a text style to the blank slide or the opening slide in the slide show. After you drag text to a slide, the Properties pane opens in the Panels Bin. The

text you drag to the slide becomes a placeholder. To edit the text, click Edit Text in the Properties pane. You can also select a font, style, size, color, and alignment. After setting the type attributes, click inside the text and move it to the position you want.

8. (Optional) Set transitions.

The icons between the slides in the Storyboard (at the bottom of the Slide Show Editor) indicate a default transition. You can change transition effects for each slide independently or for all the slides in the show. Click the right-pointing arrow on the right side of a transition icon to open a pop-up menu containing a number of different transitions, as shown in Figure 16-6. If you want to apply the same transition to all slides, choose Apply to All at the top of the menu commands.

Be conservative with the transition effects. Too many transitions of different types can make the slide show appear amateurish and be distracting to the viewers.

9. (Optional) Add audio and media.

You can add audio to the slide show by choosing Add Mediar Audio from Organizer (or from Folder). Select an audio file and click OK.

Figure 16-6: Click a right-pointing arrow on a transition to open the Transitions pop-up menu.

You can also add movie files to your slide show. A movie file can be added on top of a slide or on a new slide. When the slide show is played, the video file plays. Choose Add Media⇔Photos and Videos from Organizer (or from Folder).

This same set of commands can also be used to add more pictures to the slide show.

10. (Optional) Record your own sounds.

If you want to add narration, click the Narration tool (represented by a microphone icon to the right of the Text tool) in the Panels Bin, and the Extras panel changes to provide you with tools to record a sound or import a sound file. Note that this option requires that you have a microphone properly configured on your computer.

11. (Optional) Fit slides to the audio.

If you have 3 minutes of audio and the slide duration is 2 minutes and 30 seconds, you can, with a single mouse-click, fit the slide duration uniformly to fit the 3-minute audio time. Just click the Fit Slides to Audio button below the preview image.

If you want to manually adjust time for slide durations, click the down arrow on the time readout below the slide thumbnails in the Storyboard.

12. Click Output on the Shortcuts bar and then, in the dialog box that opens, type a name and click Save.

Your project is added to the Organizer and is available for further editing later. Or you can open the project to save in a number of different output formats, as we explain in the following section.

13. Preview the slide show.

Before exporting the slide show, you can see a preview by clicking the buttons directly below the image preview area. If you want a full-screen preview, click the Full Screen Preview button on the Shortcuts bar and click the Play button.

This section does not yet export the slides to a file. It simply saves a project that you can reopen and edit. To create the slide show file, follow the directions in the next section, "Exporting to slides and video."

If you don't like the order of the slides when you open the Slide Show Editor, you can easily reorder the slides by dragging them back and forth along the timeline.

Exporting to slides and video

After creating a project, you have a number of output options. You can write a project to disc for archival purposes and include slide shows on a video CD (videodisc) or DVD. You can e-mail a slide show to another user, share a project online, write a project compatible for display on a TV, or save to either a PDF slide show or Windows movie file.

To write a PDF slide show or a movie file, follow these steps:

1. In the Organizer window, double-click the project thumbnail.

The project opens in the Adobe Photoshop Elements Slide Show Editor.

2. Click the Output tool on the Shortcuts bar.

The Slide Show Output Wizard opens, as shown in Figure 16-7 on Windows.

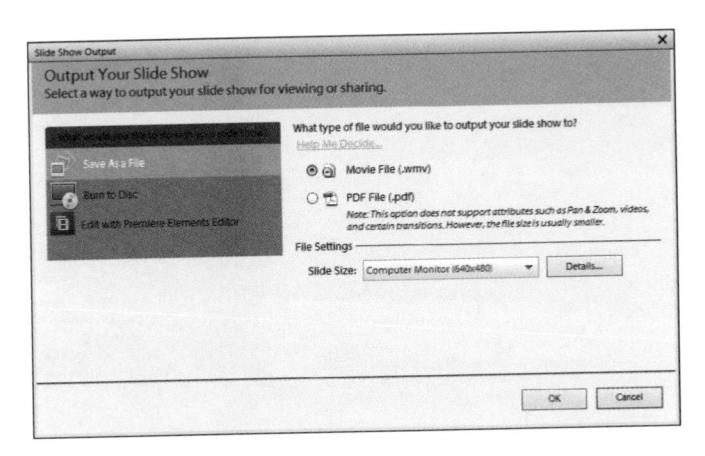

Figure 16-7: Select Output in the Photoshop Elements Slide Show Editor to open the Slide Show Output Wizard.

3. Select the type of file you want to export and click OK:

- Movie File (.wmv). Select this option to export a Windows media video file. Your exported video can be viewed in Elements or in the Windows Media Player. You can import the video in all programs that support .wmv files.
- *PDF File (.pdf)*. Select this option if you want to create a PDF slide show. If you create a PDF slide show, some of the animation features, such as zooming slides and transition effects, aren't shown in the resultant PDF document. Users can view the slide show using the free Adobe Reader software.

To learn how to convert video for viewing on iPhone and iPad and viewing PDF documents on these devices, you need more information than we can cover in this book. There's quite a bit to understand regarding video formats. For more information regarding iOS devices and video format conversions, see *Photoshop Elements 11 All-in-One For Dummies*, which we also wrote.

4. In the dialog box that opens, prompting you to add your output file to the Organizer, click Yes.

You can now easily view the file by double-clicking it in the Organizer window.

If you use an iPhone, iPod, or iPad, and have Adobe Premiere Elements installed, you can choose the last option in the Slide Show Output Wizard: Edit with Premiere Elements Editor. In Premiere Elements, you can export directly to iPod/iPhone format, which is readable on all your iOS devices as well as Macintosh computers.

Making Additional Creations

Unfortunately, we don't have room in this book to cover each creation. If you want more detail on all the creation types, see *Photoshop Elements 11 All-in-One For Dummies*. Fortunately, many of the other creation types are intuitive and easy to master. To create instant videos, you need Adobe Premiere Elements. Other readily available items include photo books, greeting cards, photo stamps, calendars, flipbooks (Windows only), and burning creations to CD/DVDs (Windows only). With each creation type, Elements provides you with many different editing options. Explore each of the creations available to you and consult the online Help file for steps you can follow.

Part VI The Part of Tens

In this part . . .

he Part of Tens offers a couple of fun chapters to help you take your photography and Elements skills a little further. In Chapter 17, you can find our top ten tips for composing better photos. Find out about the rule of thirds, framing, and other simple tricks that can make your photos look better than ever. Also, in Part VI, we introduce the creations that Elements helps you make, but why stop there? Chapter 18 offers even more ideas for projects you can create for your home or work, such as flyers, posters, inventories, and more.

MAN A TOWN

Ten Tips for Composing Better Photos

In This Chapter

- Finding a focal point and using the rule of thirds
- ▶ Cutting the clutter and framing your shot
- Employing contrast, leading lines, and viewpoints
- Using light and giving direction
- Considering direction of movement

e can help you take photographs that are interesting and well composed. Some of these tips overlap and contain common concepts, but they're all free; they don't require any extra money or equipment.

Find a Focal Point

One of the most important tools for properly composing a photo is establishing a *focal point* — a main point of interest. The eye wants to be drawn to a subject.

Keep these tips in mind to help find your focal point:

- Pick your subject and then get close to it.
- Include something of interest in scenic shots.
- When it's appropriate, try to include an element in the foreground, middle ground, or background to add depth and a sense of scale.

Use the Rule of Thirds

When you're composing your shot, mentally divide your frame into vertical and horizontal thirds and position your most important visual element at any intersecting point; see Figure 17-1. When you're shooting landscapes, remember that a low horizon creates a dreamy and spacious feeling and that a high horizon gives an earthy and intimate feeling. For close-up portraits, try putting the face or eyes of a person at one of those points.

©istockphoto.com/cgbaldauf Image #7047812

Figure 17-1: Position your subject at one of the intersecting points on the rule-of-thirds grid.

If you have an autofocus camera, you need to lock the focus when you're moving from center.

Cut the Clutter

Here are some ways you can cut the clutter from your background:

- Try to fill the frame with your subject.
- Shoot at a different angle.
- Move around your subject.
- Move your subject.
- Use background elements to enhance your subject.
- ightharpoonup Use space around a subject to evoke a certain mood.
- ✓ If you're stuck with a distracting background, use a wider aperture (such as f/4).

Frame Your Shot

When it's appropriate, use foreground elements to frame your subject. Frames lead you into a photograph. You can use tree branches, windows, archways, and doorways, as shown in Figure 17-2. Your framing elements don't always have to be sharply focused. Sometimes, if they're too sharp, they distract from the focal point.

©istockphoto.com/Photomorphic Image #3125827

Figure 17-2: Use elements that frame your subject.

Employ Contrast

Just remember, "Light on dark, dark on light."

A light subject has more impact and emphasis if it's shot against a dark background, and vice versa, as shown in Figure 17-3. Keep in mind, however, that contrast needs to be used carefully. Sometimes it can be distracting, especially if the high-contrast elements aren't your main point of interest.

Use Leading Lines

Leading lines are lines that lead the eye into the picture and, hopefully, to a point of interest. The best leading lines enter the image from the lower-left corner. Roads, walls, fences, rivers, shadows, skyscrapers, and bridges provide natural

©istockphoto.com/cpshell Image #9056415

Figure 17-3: High-contrast shots demand attention.

leading lines, especially in scenic or landscape photos. The photo shown in Figure 17-4 of the Great Wall of China is an example of curved leading lines.

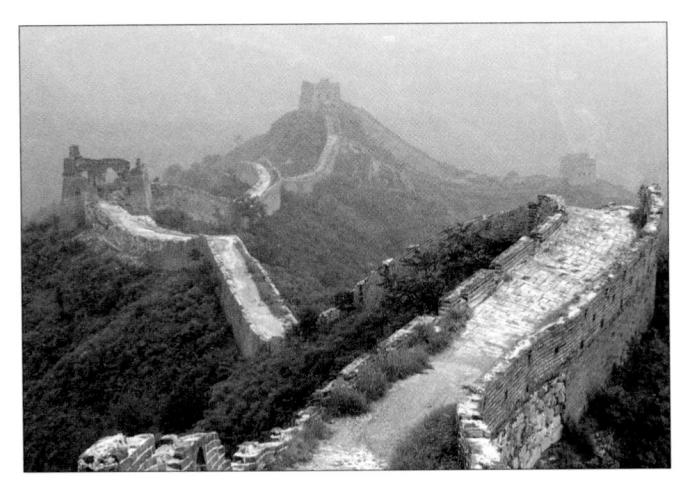

©istockphoto.com/stray_cat Image #2188656

Figure 17-4: You don't have to trek to China to find leading lines, although you may not find a longer unbroken curve than the Great Wall.

Experiment with Viewpoints

Not much in the world looks fascinating when photographed from a height of 5 to 6 feet off the ground. Try to break out of this common mode by taking photos from another vantage point. Experiment with taking a photo from above the subject (bird's-eye view) or below it (worm's-eye view). A different angle may provide a more interesting image.

Use Light

Here are a few tips about light:

- ✓ The best light is in early morning and later afternoon.
- Avoid taking portraits at midday.
- Overcast days can be great for photographing, especially portraits.
- *▶ Backlighting* can produce dramatic results. See Figure 17-5.

- Ensure that the brightest light source isn't directed into the lens to avoid *lens flare*.
- Use a flash in low light.
- Get creative.

©istockphoto.com/helicefoto Image #16473327

Figure 17-5: Backlighting can yield dramatic images.

Give Direction

Don't be afraid to play photo stylist:

- Get someone to help direct.
- ✓ Give directions about where you want people to stand, look, and so on. See Figure 17-6.
- Designate the location.
- Arrange people around props, such as trees or cars.
- Use a variety of poses.
- Try to get people to relax.

©istockphoto.com/MaszaS Image #2575210

Figure 17-6: Provide direction to the people you're photographing while also trying to capture their personalities.

Consider Direction of Movement

When the subject is capable of movement, such as a car, person, or animal, make sure that you leave more space in front of the subject than behind it, as shown in Figure 17-7. Likewise, if a person is looking out onto a vista, make sure that you include that vista.

Figure 17-7: Leave space in the frame for your subject to move into.

Ten More Project Ideas

In This Chapter

- Embellishing your computer screen
- Advertising in flyers and online auctions
- Decorating your duds
- Going big with posters
- Creating a household inventory or project documentation
- Sprucing up your homework

hile Elements already gives you a wide array of creations to make—from photo books to greeting cards to CD covers, there are even more things you can do easily with the program. In this chapter, you find ideas for using your inventory of digital images to make your life more productive, more organized, and more fun. This chapter just scratches the surface. Before you know it, there won't be anything that doesn't include your photos.

Screen Savers

If you have two or more photos you want to use, you can create a screen saver in Windows or Mac OS. Follow these steps in Windows 7:

- 1. Select the desired photos from the Organizer.
- 2. Choose File⇔Export As New File(s). In the Export New Files dialog box that appears, choose JPEG as the file type.

3. Select your photo size and choose a quality setting.

We recommend using a size that matches the resolution setting you're using for your monitor. Use a quality setting of 12 for maximum quality.

- 4. Click the Browse button.
- Click the Make New Folder button, save the photos as JPEGs to that folder, and name the folder something appropriate, such as Screen Saver. Click OK.
- 6. Choose whether to use the original names of your files or a common base name, such as screen 1, screen 2, and so on.
- 7. Click Export.

If all goes well, Elements informs you that it has executed the command.

- 8. Click OK.
- 9. Choose Start⇔Control Panel.
- 10. Click Appearance and Personalization in the Control Panel window. Under Personalization, click Change Desktop Theme. Then, click Screen Saver in the bottom-right corner.
- 11. In the Screen Saver Settings window, choose Photos from the Screen Saver drop-down menu. Click Settings.
- 12. In the Photos Screen Saver Settings window, select Use Pictures and Videos From. Click Browse and go to the folder containing your desired images.
- 13. Click OK and then click Save.
- 14. Specify your other options, such as wait time, power settings, and so on.
- Click Apply and then click OK to close the window. Close the Control Panel window as well.

Macintosh users can create custom screen savers even more easily:

- 1. Choose System Preferences from the Apple menu.
- 2. Click Desktop & Screen Saver and then click the Screen Saver tab.
- 3. To choose one of your photos, click the plus sign and choose Add Folder of Pictures. Find the folder with your images and choose the photo.
- 4. Specify options.
- 5. Click Test to see a preview. If you're happy, click the Close button in the top-left corner.

Flyers, Ads, and Online Auctions

Whether you're selling puppies or advertising an open house, adding a photo to an ad or flyer really helps to drive home your message. Here are the abbreviated steps to quickly create an ad or flyer:

- 1. In Expert mode, choose File⇔New⇔Blank File.
- 2. In the New dialog box, enter your specs and then click OK.

Enter the final dimensions and resolution for your desired output. If you want to print your ad or flyer on your desktop printer or at a service bureau, a good guideline for resolution is 300 pixels per inch (ppi). Leave the color mode as RGB and the Background Contents as White.

To fill your background with color, as in Figure 18-1, choose Edit Fill Layer and choose Color from the Contents pop-up menu. Choose your desired color in the Color Picker and then click OK.

©istockphoto.com/WebSubstance Image #13474004

Figure 18-1: Quickly put together ads and flyers.

3. Open your photos and then drag and drop them onto your new canvas with the Move tool. Each image is on a separate layer.

Make sure to choose Window⇔Images⇔Cascade or Tile to view all your canvases at the same time.

4. Select the Type tool, click the canvas, add your desired text, and then position your type with the Move tool.

I added a drop shadow to my type. If you want to do so as well, select your Type layer and in the Styles panel of the Effects panel (Window Effects), choose Drop Shadows from the pop-up menu. Double-click the shadow of your choice.

- 5. When you're done, choose File⇔Save.
- Name your file, choose Photoshop (.PSD) from the Format drop-down menu, and make sure that the Layers and Color check boxes are selected.

If you're taking your document to a copy shop, then you should save your document as a Photoshop PDF (.pdf) file.

- 7. If you want to save a copy of your ad or flyer in the Organizer, select the Include in Elements Organizer check box. In addition, select Layers, ICC Profile (Embed Color Profile on the Macintosh), and Use Lower Case Extension (Windows only) options.
- 8. Click Save.

Clothes, Hats, and More

Buy plain, white T-shirts at your local discount store or plain aprons and tote bags at a craft or fabric store. Then, buy special transfer paper at your office supply, big-box, or computer store. Print your photos on the transfer paper (be sure to flip the images horizontally first), iron the print onto the fabric, and you've got yourself a personalized gift for very little cash.

Posters

You can get posters and large prints at many copy shops and even your local Costco. Call and talk to a knowledgeable rep so you know exactly how to prepare your file. Here are a few questions to ask:

- ✓ What file format and resolution should the file be?
- ✓ What print sizes do you offer?
- Do you provide mounting and lamination services?

Household and Business Inventories

Shoot pictures of your items. In the Organizer, select the image and choose Edit Add Caption to include makes, models, purchase dates, and dollar values of each piece. Then, create a single PDF document from those multiple files by creating a slide show. Chapter 15 explains how to create the slide show PDF. After the PDF is finished, you can upload it to a cloud storage site online or burn a DVD and store it somewhere else (in a safety deposit box or other secure location).

Project Documentation

If you're taking a class or workshop, take your camera to class (if the instructor doesn't mind). Documenting the positions or steps of that new yoga, pottery, or gardening class can help you practice or re-create it on your own. Import your desired photos into the Organizer and create notes on each step of the project in the caption area, and output the images to a PDF.

School Reports and Projects

Have to write a paper on the habits of the lemurs of Madagascar? Trek down to your local zoo and have a photo shoot. Create a simple collage of lemurs eating, sleeping, and doing the other things that lemurs do. You can use the Photo Collage command on the Create panel or create a custom collage by making selections (see Chapter 7) and dragging and dropping them onto a blank canvas.

Blogs

Creating a simple blog is a great way to share not only your latest and greatest photos, but also recent news about family and friends. Check out http://blogger.com, http://wordpress.com, or http://livejournal.com.

Wait — There's More

Before you start taking your photos to the next dimension, consider a few extra ideas: Make fun place cards for dinner party guests; create your own business cards or letterhead; design your own bookmarks, bookplates, and notepads; or label storage boxes with photos of their contents. Check out www.kodak.com for a slew of projects.

Index

• A •	size of images, 16–18
- /1 -	skin tones, 238–239
accessing	Tolerance settings, 153–155
Guided Mode, 51–52	type opacity, 334
tools, 42	adjustment layers, 178, 181–183
Actions (Panel Bin), 47	Adjustments panel, 45
Actions panel, 44–45	Adobe Flash, 358
Add Event (Organizer), 103	Adobe Partner Services preferences
Add Noise filter, 244	(Organizer), 65
Add People (Organizer), 102	Adobe Premiere Elements, 358, 369
Add Places (Organizer), 103	Adobe Revel, 360–361
adding	ads, 395–396
colors to Swatches panel, 296	Advanced Search Options, 132–137
files from folders and removable media,	Airbrush button (Brush tool), 300
13–14	Albums (Organizer), 101
glows, 272–274	albums, photo
icons to keyword tags, 105	about, 99–100
images to Organizer, 13–16	adding rated files, 110–112
layer masks, 178, 191–193	benefits of, 113
people in Media Browser, 18–20	creating, 108–113
people tags, 20	editing, 112
rated files to photo albums, 110–112	Smart Albums, 113–115
to selections, 155	algorithm, 80
shadows, 272–274	All Layers option (Paint Bucket tool), 307
Adjust Sharpness command, 250	All Media/Sort By (Organizer), 101
adjusting	Amount (tool option), 171
background color, 296	anchor point, 322
clarity, 244–250	antialiasing, 147, 166, 298, 307, 328
color, 231–244	Anti-aliasing option (Paint Bucket tool), 307
Color Swatches panel appearance, 296	Apple
color temperature with photo filters,	Camera Connection Kit, 27
242–243	iPhoto, 25
color with Hue/Saturation command,	iTunes, 26
232–233	QuickTime format, 96
lighting, 226–231	applying
resolution, 76–78	filters, 258–259, 260–261, 334
selections, 155–156	filters to type, 334
shape color, 317	Grow command, 172
shape color, see	

Photoshop Elements 11 For Dummies

applying (continued) layer masks, 193 layer styles, 272–274 marquee options, 146–148 preset gradients, 307–308 preset patterns, 311–312 Similar command, 172 artifacts, removing, 244–245 Artwork panel, 45 aspect, 147 assembling creations, 374–377 auctions, online, 395–396 audio formats, 96 Auto Color Correction command, 206 Auto Contrast command, 205–206 Auto Levels command, 205 Auto mode (Photomerge), 282 Auto Red Eye Fix command, 207-208, 211 Auto Sharpen command, 207 Auto Smart Fix command, 204-205 Average filter, 245

• B •

B (Bloat) tool, 264 backgrounds, 176–177, 296, 388 backing up catalogs, 119-121 photos and files, 121 Bicubic resampling method, 78 Bicubic Sharper resampling method, 78 Bicubic Smoother resampling method, 78 Bilinear resampling method, 78 bit depths, 21 bitmap file format, 91 bitmap mode, 81–83 Blend Images Together mode (Photomerge), 282 blend modes about, 275 Color, 280 Color Burn, 276

Color Dodge, 277 Darken, 276 Darker Color, 276 Difference, 278, 279 Dissolve, 275 Exclusion, 278, 279 general, 275 Hard light, 278, 279 Hard Mix, 278, 279 HSL, 280 Hue, 280 inverter, 278–279 Lighten, 277 Lighter Color, 277 lighting, 278 Linear Burn, 276 Linear Dodge, 277 Linear Light, 278, 279 Luminosity, 280 Multiply, 276 Normal, 275 Overlay, 278, 279 Pin Light, 278, 279 Saturation, 280 Screen, 277 Soft Light, 278, 279 Vivid light, 278, 279 Bloat (B) tool, 264 blogs, 397 Blur filter, 246 Blur More filter, 246 Blur tool, 220-221 blurring tools, 245–248 BMP file format, 91–92, 95 Border command, 172 Brightness/Contrast command, 228 Brush Presets Picker (Eraser tool), 164 Brush Settings (Background Eraser tool), 165 Brush Settings (Brush tool), 300-301 Brush tool, 300-301

brushes, creating, 302

Burn tool, 217–219
business inventories, 397
buttons
Airbrush (Brush tool), 300
Close (Photo Editor), 36
Create (Photo Editor), 33
Features (Organizer), 101
Organizer, 11, 34
Page Setup (Print dialog box), 353
Photo Editor, 11

calibrating monitors, 68–69 Camera Connection Kit (Apple), 27 camera distortion, correcting, 265–267 Camera preferences (Organizer), 64 Cancel (Organizer), 64 Cancel (Photo Editor), 61 captions, searching, 134 Card Reader (Organizer), 64 Catalog Manager, 118–119 cataloging files, 117-121 catalogs, 119-121 CDs copying files from, 14–16 exporting to, 362 Change the Text Orientation option, 329 changing background color, 296 clarity, 244-250 color, 231–244 Color Swatches panel appearance, 296 color temperature with photo filters, 242-243 color with Hue/Saturation command, 232-233 lighting, 226-231 resolution, 76-78 selections, 155-156 shape color, 317

size of images, 76–78

Tolerance settings, 153–155 type opacity, 334 choosing color, 293-298 color workspaces, 69-70 Convert to Black and White command, 85-86 resolutions, 80 clarity, adjusting, 244–250 clipping mask, 180 Clone Stamp tool, 212–214 cloning shapes, 317 Close button (Photo Editor), 36 closing photos in image windows, 35 clothes, 396 clutter, background, 388 CMYK mode, 81 collage, 176 Collage mode (Photomerge), 282 color about, 66-67, 68 adding to Swatches panel, 296 adjusting, 231–244 adjusting skin tones, 238–239 calibrating monitors, 68–69 choosing, 293-298 choosing color workspaces, 69-70 Color Curves, 236-237 Color Variations command, 240-242 Defringe command, 239-240 Hue/Saturation command, 232-233 mapping, 243-244 painting type with, 335 Photo Filter adjustment, 242-243 profiles, 70 Remove Color command, 234 removing color casts automatically, 231 - 232Replace Color command, 235 shape, 317 Color blend mode, 280

skin tones, 238–239

Photoshop Elements 11 For Dummies

Color Burn blend mode, 276 Modify, 172 color casts, 231-232 Panorama (Photomerge), 281–284 color channels, 66 Paste, 186 Color Curves, 236-237 Paste into Selection, 189 Color Dodge blend mode, 277 Posterize, 243 Color Management for Digital Remove Color, 234 Photographers For Dummies (Padova Replace Color, 235 Reselect, 169 and Mason), 69 color modes, 20, 71-72, 91 Revert, 56 Color option (Paint Bucket tool), 306 Select All, 169 Color Picker, 294-295 Shadows/Highlights, 226–227 color printer profiles, 340–350 Similar, 172 Color Replacement tool, 223-224 Smooth, 172 Color Swatches panel, 45, 295–296 Straighten menu, 201 color temperature, 242–243 Threshold, 243 Color Variations command, 240–242 Undo, 54 Comic filters, 267-268 Unsharp Mask, 249–250 commands composing images, 387–392 Adjust Sharpness, 250 composite, 176 Auto Color Correction, 206 CompuServe GIF file format, 92, 95 Auto Contrast, 205–206 Content Aware option, 216–217 Auto Levels, 205 content in layers, moving, 189–190 Auto Red Eye Fix, 207–208, 211 context menus, 127 Auto Sharpen, 207 contextual menus, 40 Auto Smart Fix, 204-205 contiguous, 165, 166, 178 Border, 172 Contiguous option (Paint Bucket tool), 307 Brightness/Contrast, 228 contrast, 151, 171, 389 Color Variations, 240–242 Contrast command, 172 Contrast, 172 controlling Convert to Black and White, 85–86 Organizer, 63–65 Copy Merged, 186 Photo Editor, 60–62 Defringe, 239–240 conventions, explained, 2–3 Deselect, 169 Convert to Black and White command, Equalize, 243 85-86 Expand, 172 converting Gradient Map, 243 to bitmap mode, 81-83 Grow, 172 to grayscale mode, 83-86 Hue-Saturation, 232-233 to Indexed Color mode, 86-87 Invert, 243 vector-based shapes into pixel-based Layer via Copy, 187 shapes, 317 Layer via Cut, 187 Cookie Cutter tool, 162-163 Magic Extractor, 166-168 Cooling filter, 242

Copy command, 186 Copy Merged command, 186 copying files from CDs, DVDs, and USB flash drives, 14-16 Correct Camera Distortion filter, 265–267 correcting camera distortion, 265-267 color with Color Curves, 236-237 color with Color Variations command, 240-242 corrective filters, 259 Create button (Photo Editor), 33 Create panel, 45-46 Create Warped Text option, 329 Create/Share (Organizer), 102 creating adjustment layers, 178, 182 brushes, 302 Comic filters, 267-268 elliptical selections, 144-148 fill layers, 184 image views, 46 images, 47-49 keyword tags, 103-104 layers, 178, 186–187 online photo albums, 362-367 paragraph type, 323-324 path type, 324-327 patterns, 312-313 photo albums, 108-113 Photomerge Group Shot images, 284-285 Photomerge Panorama images, 281-284 Photomerge Scene Cleaner composites, 286-287 point type, 321–322 Pop Art style images, 52 rectangular selections, 144-148 shape layers, 185 shapes, 313-317 slide shows, 377-382 Smart Albums, 113-115

type masks, 332–333 versions, 139-140 creations about, 373-374 assembling, 374-377 creating slide shows, 377-382 Crop tool, 198-200 cropping Crop tool, 198-200 with selection borders, 200 Current Tool (Photo Editor), 38 custom keyword tags, 105-106 Custom Shape Geometry options, 316 customizing gradients, 309-311 presets, 65-66 cutting background clutter, 388 Cylindrical mode (Photomerge), 282

Darken blend mode, 276 darkening images, 217–219 Darker Color blend mode, 276 date, searching by, 133 Decontaminate Colors (tool option), 171 default keyword tags, 106-107 defining selections, 143–144 Defringe command, 239-240 Delete option (Preset Manager dialog box), 66 deleting adjustment layers, 183 brushes, 301 layer masks, 193 layers, 179 shapes, 317 swatches, 296 desaturating layers, 84-85 Deselect command, 169 Despeckle filter, 245

Photoshop Elements 11 For Dummies

destination, 214 destructive filters, 259 Detail Smart Brush tool, 252-254 Details (Organizer View menu), 122 DIB file format, 91–92, 95 Difference blend mode, 278, 279 dimensions of images, 75 directing people in shoots, 391-392 direction of movement, 392 discontiguous, 165 Display & Cursors preferences (Photo Editor), 62 display resolution, 73 displaying brushes, 301 images onscreen, 73-75 Layers panel, 177 Dissolve blend mode, 275 Document Dimensions (Photo Editor), 37 Document Profile (Photo Editor), 37 Document Sizes (Photo Editor), 37 documentation (project), 397 Dodge tool, 217-219 Done option (Preset Manager dialog box), 66 Downloader feature, 14-16 downsampling, 76 dragging and dropping layers, 188 drawing and painting Brush tool, 300-301 choosing color, 293-298 Color Picker, 294-295 Color Swatches panel, 45, 295-296 creating brushes, 302 creating shapes, 313-317 Eyedropper tool, 297-298 filling selections, 304-305 gradients, 307-311 Impressionist brush, 303 Paint Bucket tool, 306-307 patterns, 311–313

Pencil tool, 298–300 Stroke tool, 305–306 drives hard, 10–11, 121 USB flash, 14–16 duplicates, searching, 136–137 duplicating layers, 178, 187–188 dust, removing, 244–245 Dust & Scratches filter, 245 DVDs copying files from, 14–16 exporting to, 362

· E ·

E (Reconstruct) tool, 264 Edit menu, 39 Edit tools (Organizer), 125 editing about, 59 adjusting clarity, 244-250 adjusting color, 231-244 adjusting lighting, 226-231 adjustment layers, 183 color, 66-70 controlling Organizer, 63-65 controlling Photo Editor, 60-62 customizing presets, 65–66 with logical workflows, 226 photo albums, 112 shapes, 317 Smart Brush tools, 251-254 text, 329-330 Editing preferences (Organizer), 64 editing window (Filter Gallery), 261 Editor (Organizer), 103 E-down printing, 354 effects, 271-272 Effects panel, 44, 258 Efficiency (Photo Editor), 38

Elements (Photoshop). See also specific feathering, 146-147, 170 topics Features buttons (Organizer), 101 audio and video formats supported, 96 file extensions, 89 bitmap mode, compared with Windows file formats, 71-72, 91-96, 194 bitmap mode, 82 File menu, 38-39 creating calendar backups with, 120–121 File Names (Organizer View menu), 122 Downloader, 14-16 Filename (Photo Editor), 36 Help, 56-57 Filename option (Save/Save As dialog launching, 11-12 box), 88 managing color for printing, 347-350 filenames, viewing, 47 menu, 38 files Ellipse Geometry options, 316 adding from folders and removable Elliptical Marquee tool, 144–145 media, 13-14 elliptical selections, 144–148 adding to photo albums, 110-112 e-mailing photos, 368-369 backing up, 121 Enhance menu, 39 cataloging, 117-121 Equalize command, 243 copying from CDs, DVDs, and USB flash Eraser tools, 163–166 drives, 14-16 events, 130-131 formats, 91-96 Exchange, saving swatches for, 296 grouping, 138-140 Exclusion blend mode, 278, 279 hiding, 138 Exit (Slideshow toolbar), 127 saving, 87-96 Expand command, 172 saving for web, 89-90 exporting Files preferences (Organizer), 64 options, 362 fill layers, 180, 184-185 projects to slides and videos, 381-382 filling selections, 304-305 Exposure (Photomerge), 287-290 Filmstrip (Slideshow toolbar), 126 Exposure adjustment (Quick mode), 210 Filter Gallery, 258, 261–262 exposure bracketing, 287 Filter menu, 39, 258 extensions (file), 89 filters Eyedropper tool, 297-298 about, 257-258 applying, 258-259, 260-261, 334 applying to type, 334 Average, 245 Facebook, 358-359, 370-371 Blur, 246 Faces (Photomerge), 286 Blur More, 246 fading filters, 259-260 Comic, 267-268 Faux Bold option, 329 Cooling, 242 Faux Italic option, 329 Correct Camera Distortion, 265–267 Favorites panel, 44

corrective, 259

Despeckle, 245

Feather (tool option), 171

Photoshop Elements 11 For Dummies

filters (continued) destructive, 259 Dust & Scratches, 245 fading, 259–260 Filter Gallery, 258, 261–262 Gaussian Blur, 246 Graphic Novel, 268-269 Lens Blur, 247-248 Liquify filter, 262-265 Median, 245 Motion Blur, 246 multistep, 259 one-step, 259 Pen & Ink, 269-270 Radial Blur, 264 Reduce Noise, 245 Smart Blur, 246 Surface Blur, 246 Warming, 242 Fix (Slideshow toolbar), 127 Flash (Adobe), 358 flattening layers, 193–194 Flickr, 359, 370-371 flipbooks, 360 floating windows, 33 flyers, 395–396 focal points, 387 folders adding files from, 13–14 importing photos from, 16 Font Size option, 328 Font Style option, 328 Format option (Save/Save As dialog box), 88 formats, file, 91-96, 321 Forum option, 57 framing shots, 389 freeform selections, 148-152 Frequency (Magnetic Lasso tool), 151 Full Screen view (Organizer), 122-127

• G •

galleries, viewing in Photoshop Showcase, 366-367 Gaussian Blur filter, 246 General preferences (Organizer), 64 General preferences (Photo Editor), 62 Geometric Distortion Correction (Photomerge), 282 Geometry options, 315-316 .GIF file format, 92, 95 glows, adding, 272-274 Gradient Map command, 243 gradients applying preset, 307-308 customizing, 309–311 multicolored, 307-311 painting type with, 335 Graphic Novel filter, 268-269 Graphics panel, 44 grayscale images, 21 grayscale mode, 83-86 grid, 62 Grid preferences (Photo Editor), 62 Group Shot (Photomerge), 284-285 grouping files, 138-140 Grow command, 172 Guided Mode, 51-54

• H •

H (Hand) tool, 264
H (height), 147–148
halftone, 246
Hand (H) tool, 264
hard disk, exporting to, 362
hard drives
backing up photos on second, 121
organizing photos and media on, 10–11
Hard Light blend mode, 278, 279
Hard Mix blend mode, 278, 279
hats, 396

Healing Brush, 212, 214-216 height (H), 147-148 help, 40, 56-57 Help (Organizer), 64 Hidden Files (Organizer View menu), 122 Hide Panel (Organizer), 102 hiding files, 138 layer masks, 193 layers, 178 Highlights adjustment (Quick mode), 210 Histogram panel, 45 history, searching by, 135 History panel, 45 history states, 55 hosts (storage), 358 household inventories, 397 HSL blend modes, 280 Hue adjustment (Quick mode), 211 Hue blend mode, 280 Hue/Saturation command, 232-233

icons adding to keyword tags, 105 explained, 5–6 Panel Bin (Photo Editor), 34 Image Capture feature, 23 image layers, 181 Image menu, 39 Image Size dialog box, 76–77 Image window (Photo Editor), 34, 35–38 image windows, resizing, 37 images adding to Organizer, 13-16 Auto Color Correction command, 206 Auto Contrast command, 205-206 Auto Levels command, 205 Auto Red Eye Fix command, 207–208 Auto Sharpen command, 207 Auto Smart Fix command, 204–205

backing up, 121 Blur tool, 220-221 Burn tool, 217-219 Clone Stamp tool, 212-214 closing in image windows, 35 Color Replacement tool, 223-224 composing, 387-392 creating, 47-49 creating views, 46 cropping, 197-200 darkening, 217-219 dimensions, 75 displaying onscreen, 73-75 Dodge tool, 217-219 editing in Quick mode, 208-212 e-mailing, 368-369 grayscale, 21 Healing Brush, 214-216 importing from folders, 16 one-step auto correction, 203-208 opening in image windows, 35 organizing groups with keyword tags, 103 - 108organizing on hard drives, 10–11 phoning in, 25–27 pixel, 313 Pop Art style, 52 printing, 73 raster, 72, 321 rating, 108–109 recomposing, 160–162, 202–203 requirements, 20–21 resolution, 20 scanning many at one time, 23-24 Sharpen tool, 221–222, 248 size, 76-78 Smudge tool, 219-220 Sponge tool, 222 Spot Healing Brush, 212, 216–217 stacking, 138-139 straightening, 197, 201

undocking, 33

vector, 72, 313, 321 viewing, 18, 183 viewing in Media Browser, 18 viewing in slideshows, 122-127 importing about, 9 adding images to Organizer, 13–16 from iPhoto, 25 launching Photoshop Elements, 11-12 Media Browser, 17–20 organizing photos and media on hard drives, 10-11 phoning in images, 25–27 photos from folders, 16 scanners, 20-24 Impressionist Brush tool, 303 improving performance of catalogs, 119 Indexed Color mode, 86-87 Info (Slideshow toolbar), 127 Info panel, 45 Information box (Photo Editor), 37 Instant Fix (Organizer), 102 Interactive Layout mode (Photomerge), 282 interpolation process, 191 intersecting selections, 156 inventories, 397 inversing selections, 169 Invert command, 243 inverter blend modes, 278-279 iPhoto (Apple), 25 iTunes (Apple), 26

• 7 •

JPEG file format, 92–93, 95 JPG file format, 92–93, 95

• K •

Key Concepts option, 57 keyboard shortcuts, 42–43

keyword tags
about, 105
creating, 103–104
custom, 105–106
default, 106–107
organizing image groups with, 103–108
sub-categories, 107–108
viewing, 103–104
Keyword Tags and Albums preferences
(Organizer), 64
Keyword/Info (Organizer), 102
Kodak (website), 397

. [.

L (Twirl Counterclockwise) tool, 264 Lasso tools, 148-152 launching Photo Editor, 30–31 Photoshop Elements, 11–12 preferences in Photo Editor, 60–61 layer masks, 178, 191–193 Layer menu, 39, 179-180 layer styles applying, 272–274 working with, 274 Layer via Copy command, 187 Layer via Cut command, 187 layers about, 175-177 adding layer masks, 178, 191–193 adjustment, 178, 181–183 creating, 178, 186–187 defringing, 239–240 deleting, 179 desaturating, 84–85 dragging and dropping, 188 duplicating, 178, 187–188 fill, 184-185 flattening, 193–195 hiding, 178

image, 181 Layer menu, 39, 179-181 Layer via Copy command, 187 Layer via Cut command, 187 Layers panel, 43, 177-179 linking, 179 locking, 179 merging, 193-195 moving content in, 189-190 Paste into Selection command, 189 rearranging, 178 renaming, 179 Select menu, 179, 180-181 selecting, 178 selecting elements in, 178 shape, 180, 185-186 transforming, 190-191 types, 181-186 viewing, 178 Layers panel, 43, 177–179 Layout (Photo Editor), 34 leading lines, 389-390 Leading option, 328 Learn More About: The Preset Manager option (Preset Manager dialog box), 66 Lens Blur filter, 247–248 Levels, 228-231 Lighten blend mode, 277 lightening images, 217-219 Lighter Color blend mode, 277 lighting about, 390-391 adjusting, 226-231 Brightness/Contrast command, 228 Levels, 228-231 Shadows/Highlights command, 226-227 lighting blend modes, 278 Limits (Background Eraser tool), 165 line art, 21 Line Geometry options, 316

Linear Burn blend mode, 276 Linear Dodge blend mode, 277 Linear Light blend mode, 278, 279 linking layers, 179 Liquify filter, 262-265 Load option (Preset Manager dialog box), 66 loading brushes, 301 layer masks as selection outlines, 193 selections, 172-173 swatches, 296 locking layers, 179 logical workflows, 226 Luminosity blend mode, 280 LZW lossless compression scheme, 95

• M •

M (Reflection) tool, 264 Macintosh backing up photos, 121 iPhoto, 25 Organizer, compared with on Windows, 128 scanners for, 23 Magic Extractor command, 166-168 Magic Wand, 152-155 Magnetic Lasso tool, 148, 151-152 Magnification box (Photo Editor), 36 mapping colors, 243-244 maps, placing pictures on, 128-130 marking files as hidden, 138 marquee options, applying, 146-148 Marquee tool, 146-148 marquees. See selections masking with type, 331-333 Mason, Don (author) Color Management for Digital Photographers For Dummies, 69

media adding files from removable, 13-14 organizing on hard drives, 10-11 Media Browser about, 17–18, 103 adding people in, 18-20 viewing images in, 18 Media Types (Organizer View menu), 122 Media-Analysis preferences (Organizer), 65 Median filter, 245 Media/People/Places/Events (Organizer), 101 Menu Bar (Organizer), 101 Menu Bar (Photo Editor), 32, 38-40 merging layers, 193–195 metadata, searching, 135-136 Midtones adjustment (Quick mode), 210 Mode option (Paint Bucket tool), 306 modes about, 80-81 bitmap, 81-83 grayscale, 83-86 Indexed Color, 86-87 Photo Editor, 32 type, 320-321 modes, blend about, 275 Color, 280 Color Burn, 276 Color Dodge, 277 Darken, 276 Darker Color, 276 Difference, 278, 279 Dissolve, 275 **Exclusion**, 278, 279 general, 275 Hard light, 278, 279 Hard Mix, 278, 279 HSL, 280 Hue, 280 inverter, 278-279 Lighten, 277

Lighter Color, 277 lighting, 278 Linear Burn, 276 Linear Dodge, 277 Linear Light, 278, 279 Luminosity, 280 Multiply, 276 Normal, 275 Overlay, 278, 279 Pin Light, 278, 279 Saturation, 280 Screen, 277 Soft Light, 278, 279 Vivid light, 278, 279 Modify commands, 172 moiré pattern, 246 monitors calibrating, 68–69 touchscreen, 254 More option (Preset Manager dialog box), 66 Motion Blur filter, 246 Move tool, 189-190 moving layer content, 189-190 shapes, 317 MP3 format, 96 multicolored gradients, 307–311 Multiply blend mode, 276 multistep filters, 259 My Folders (Organizer), 102 MySpace, 359

navigating
Organizer preferences, 63–64
Photo Editor preferences, 60–61
Navigator panel, 45
Nearest Neighbor resampling method, 78
New dialog box, 49
New Feature icon, 5

Next (Photo Editor), 61 Next Media (Slideshow toolbar), 126 noise, removing, 244–245 noncontiguous, 178 Normal blend mode, 275 notes, searching, 134

Obermeier, Barbara (author) Photoshop Elements 11 All-in-One For Dummies, 2, 225, 383 objects, searching, 137 OK (Organizer), 64 OK (Photo Editor), 61 one-step filters, 259 online auctions, 395-396 online photo albums, creating, 362–367 onscreen, choosing resolutions for, 80 Opacity (Eraser tool), 164 opacity, type, 334 Opacity option (Paint Bucket tool), 306 Open menu (Photo Editor), 33 opening images in image windows, 35 Preferences dialog box in Photo Editor, 60 Preset Manager dialog box, 66 Option key (Macintosh), 146 options exporting, 362 type, 327–329 Organize (Slideshow toolbar), 127 Organize tools (Organizer), 125 Organizer about, 117 Add Event, 103 Add People, 102 Add Places, 103 adding images to, 13–16 Adobe Partner Services preferences, 65 Albums, 101

All Media/Sort By, 101 button, 11, 34 Camera preferences, 64 Cancel, 64 Card Reader, 64 cataloging files, 117-121 comparing on Windows and Macintosh, 128 controlling, 63-65 Create/Share, 102 Edit tools, 125 Editing preferences, 64 Editor, 103 events, 130-131 Features buttons, 101 Files preferences, 64 Full Screen view, 122-127 General preferences, 64 grouping files, 138-140 Help, 64 Hide Panel, 102 Instant Fix. 102 Keyword Tags and Albums preferences, 64 Keyword/Info, 102 launching Photo Editor from, 30 Media-Analysis preferences, 65 Media/People/Places/Events, 101 Menu Bar, 101 My Folders, 102 navigating preferences, 63-64 OK, 64 Organize tools, 125 Panel Bin, 102 placing pictures on maps, 128-130 printing from in Windows, 350 Restore Default Settings, 64 Rotate, 102 Scanner preferences, 64 Search, 101 search options, 131–137 Sharing preferences, 65

Slide Show, 103 Slideshow toolbar, 126-127 Status Bar, 102 Undo/Redo, 102 viewing options, 122-128 window components, 100-103 Zoom, 103 organizing image groups with keyword tags, 103-108 media on hard drives, 10-11 photos on hard drives, 10-11 outlines. See selections outlining selections, 305-306 Output To (tool option), 171 Overlay blend mode, 278, 279

P (Pucker) tool, 264 Padova, Ted (author) Color Management for Digital Photographers For Dummies, 69 Photoshop Elements 11 All-in-One For Dummies, 2, 225, 383 Page Setup button (Print dialog box), 353 Paint Bucket tool, 306-307 painting and drawing Brush tool, 300-301 choosing color, 293-298 Color Picker, 294-295 Color Swatches panel, 45, 295–296 creating brushes, 302 creating shapes, 313–317 Evedropper tool, 297–298 filling selections, 304-305 gradients, 307-311 Impressionist brush, 303 Paint Bucket tool, 306-307 patterns, 311-313 Pencil tool, 298-300

with Quick Selection tool, 159-160 with Selection Brush, 156–158 Stroke tool, 305-306 type with color, 335 Panel Bin (Organizer), 102 Panel Bin (Photo Editor), 32 panels (Photo Editor), 43–46 Panels Options menu (Photo Editor), 34 Panes list (Photo Editor), 61 Panorama command (Photomerge), 281 - 284Paragraph mode, 321 paragraph type, creating, 323-324 Paste command, 186 Paste into Selection command, 189 Path mode, 321 path type, creating, 324-327 Pattern option (Paint Bucket tool), 306 patterns applying presets, 311-312 creating, 312-313 .PDD file format, 91, 95 .PDF file format, 93, 96, 194 .PDP file format, 93, 96 Pen & Ink filter, 269-270 Pencil tool, 298-300 people adding in Media Browser, 18-20 tagging, 20 Performance preferences (Photo Editor), 62 Perspective mode (Photomerge), 282 phoning in images, 25-27 photo albums about, 99-100 adding rated files, 110-112 benefits of, 113 creating, 108–113 editing, 112 Smart Albums, 113–115 Photo Bin (Photo Editor), 34, 46-47 Photo Bin Options menu (Photo Editor), 34 Photo Bin/Tool Options (Photo Editor), 33 Photo tabs, 33 Photo Editor. See also layers Plug-ins preferences, 62 about, 29-30 preferences, 60-61 button, 11 Prev., 61 Cancel, 61 Quick Mode, 49-51 Close button, 36 Reset, 61 components, 32-49 Revert command, 56 contextual menus, 40 Rotate, 34 controlling, 60-62 Saving Files preferences, 62 Create button, 33 Scratch Sizes, 37-38 creating images, 47–49 Scroll bars, 36 Current Tool, 38 selecting from Tool Options, 43 Display & Cursors preferences, 62 Size box, 37 Document Dimensions, 37 Timing, 38 Document Profile, 37 Tools panel, 33, 34, 40–43 Document Sizes, 37 Transparency preferences, 62 Efficiency, 38 Type preferences, 62 Filename, 36 Undo command, 54 General preferences, 62 Undo History panel, 55–56 Grid preferences, 62 Undo/Redo, 33 Guided Mode, 51-54 Units & Rulers preferences, 62 help, 56-57 photo effects, 271–272 Image window, 34, 35–38 photo filters, 242-243 image window, 35-38 Photo Project Format, 92, 95 Information box. 37 Photo Stack, 53 launching, 30-31 Photo tabs (Photo Editor), 33 Layout, 34 Photomerge Magnification box, 36 about, 53, 281 Menu Bar, 32, 38-40 Exposure, 287–290 menu bar, 38-40 Faces, 286 Next, 61 Group Shot, 284-285 OK, 61 Panorama command, 281-284 Open menu, 33 Scene Cleaner, 286–287 Panel Bin, 32 Style Match, 290–291 panels, 43-46 photos Panels Options menu, 34 adding to Organizer, 13-16 Panes list, 61 Auto Color Correction command, 206 Performance preferences, 62 Auto Contrast command, 205–206 Photo Bin, 34, 46-47 Auto Levels command, 205 Photo Bin Options menu, 34 Auto Red Eye Fix command, 207-208

Auto Sharpen command, 207

Photo Bin/Tool Options, 33

photos (continued)	straightening, 197, 201
Auto Smart Fix command, 204–205	undocking, 33
backing up, 121	vector, 72, 313, 321
Blur tool, 220–221	viewing, 18, 183
Burn tool, 217–219	viewing in Media Browser, 18
Clone Stamp tool, 212–214	viewing in slideshows, 122–127
closing in image windows, 35	Photoshop Elements. See also specific
Color Replacement tool, 223–224	topics
composing, 387–392	audio and video formats supported, 96
creating, 47–49	bitmap mode, compared with Windows
creating views, 46	bitmap mode, 82
cropping, 197–200	creating calendar backups with, 120–121
darkening, 217–219	Downloader, 14–16
dimensions, 75	Help, 56–57
displaying onscreen, 73–75	launching, 11–12
Dodge tool, 217–219	managing color for printing, 347–350
editing in Quick mode, 208–212	menu, 38
e-mailing, 368–369	Photoshop Elements 11 All-in-One For
grayscale, 21	Dummies (Obermeier and Padova),
Healing Brush, 214–216	2, 225, 383
importing from folders, 16	Photoshop file format, 91, 95, 194
one-step auto correction, 203–208	Photoshop PDF file format, 93, 96
opening in image windows, 35	Photoshop Showcase
organizing groups with keyword tags,	about, 359, 362
103–108	exporting to, 362–364
organizing on hard drives, 10–11	using, 364–366
phoning in, 25–27	viewing galleries, 366–367
pixel, 313	pictures, placing on maps, 128–130
Pop Art style, 52	Pin Light blend mode, 278, 279
printing, 73	Pixar file format, 93, 96
raster, 72, 321	pixel images, 313
rating, 108–109	pixels
recomposing, 160–162, 202–203	about, 67, 71, 72
requirements, 20–21	image dimensions, 75
resolution, 20	resolution, 73–75
scanning many at one time, 23–24	placing pictures on maps, 128–130
Sharpen tool, 221–222, 248	plane of focus, 247
size, 76–78	Play/Pause (Slideshow toolbar), 126
Smudge tool, 219–220	plug-ins, 21–23. See also filters
Sponge tool, 222	Plug-ins preferences (Photo Editor), 62
Spot Healing Brush, 212, 216–217	PNG file format, 93–94, 96
stacking, 138–139	Point mode, 321

point type, creating, 321–322 Polygon Geometry options, 316 Polygonal Lasso tool, 148, 150 Pop Art style images, 52 Portable Document Format, 194 Posterize command, 243 posters, 396 preferences Organizer, 63-64 Photo Editor, 60-61 Premiere Elements (Adobe), 358, 369 preset colors, 296 Preset Manager dialog box, 65-66 Preset Type option (Preset Manager dialog box), 66 presets customizing, 65–66 gradients, 307-308 Prev. (Photo Editor), 61 Previous Media (Slideshow toolbar), 126 Print dialog box, 351-354 printing about, 339 choosing resolutions for, 80 color printer profiles, 340-350 Elements managing color, 347–350 images, 73 options, 354–355 preparing for, 340 Print dialog box, 351-354 printer managing color, 341-347 process color, 81 profiles, color, 70 project documentation, 397 project ideas, 393-397 Proximity Match option, 216-217 .PSD file format, 91, 95, 194 .PSE file format, 92, 95 Pucker (P) tool, 264 .PXR file format, 93, 96

• Q •

Quick Mode, 49–51, 208–212 Quick Selection tool, 159–160 QuickTime (Apple), 96

• R •

R (Twirl Clockwise) tool, 264 Radial Blur filter, 246 Radius (tool option), 171 raster images, 72, 321 rating images, 108-109 rearranging layers, 178 Recompose tool, 160-162 recomposing images, 202-203 Reconstruct (E) tool, 264 Rectangle Geometry options, 315-316 Rectangular Marquee tool, 144-145 rectangular selections, 144-148 Reduce Noise filter, 245 Refine Radius tools (tool option), 171 Reflection (M) tool, 264 Remember icon, 5 removable media, adding files from, 13 - 14Remove Color command, 234 removing artifacts, 244-245 color casts automatically, 231–232 color with Remove Color command, 234 dust, 244-245 noise, 244-245 scratches, 244-245 Rename option (Preset Manager dialog box), 66 renaming brushes, 301 layers, 179 repairing catalogs, 119 Replace Color command, 235

416 Photoshop Elements 11 For Dummies _____

replacing swatch libraries, 296	Save/Save As dialog box, 88–89
reports, school, 397	saving
Reposition mode (Photomerge), 282	brushes, 301
requirements, images, 20–21	files, 87–96
resampling	files for web, 89–90
about, 76	selections, 172–173
changing image size and resolution,	swatches, 296
76–78	Saving Files preferences (Photo Editor), 62
results of, 78–79	Scanner preferences (Organizer), 64
Reselect command, 169	scanners
reselecting selections, 169	about, 20
Reset (Photo Editor), 61	for Macintosh, 23
resetting brushes, 301	many photos at one time, 23–24
resizing	plug-ins for Windows, 21–23
image windows, 37	Scene Cleaner (Photomerge), 286–287
with Recompose tool, 160–162	school reports/projects, 397
resolution	scratch disk, 61
about, 71–72, 73–75	Scratch Sizes (Photo Editor), 37–38
changing, 76–78	scratches, removing, 244–245
choosing, 80	Screen blend mode, 277
image, 20	screen savers, 393–394
for printing, 340	Scroll bars (Photo Editor), 36
Restore Default Settings (Organizer), 64	SCSI (Small Computer Systems Interface)
Revel (Adobe), 360–361	device, 20
Revert command, 56	Search (Organizer), 101
RGB mode, 66, 82–83	searching
.RLE fire format, 91–92, 95	about, 131–132
Rotate (Organizer), 102	Advanced Search Options, 132–137
Rotate (Photo Editor), 34	captions, 134
Rounded Rectangle Geometry options,	by date, 133
315–316	duplicates, 136–137
rule of thirds, 388	by history, 135
3	metadata, 135–136
• S •	notes, 134
	objects, 137
S (Shift Pixels) tool, 264	similarities, 136–137
Sample All Layers (Magic Eraser tool), 166	for untagged items, 133–134
sampling, 297–298	Select All command, 169
Saturation adjustment (Quick mode), 211	Select menu, 39, 169–173, 179, 180–181
Saturation blend mode, 280	selecting
Save Set option (Preset Manager dialog	color, 293–298
box), 66	color workspaces, 69–70

Convert to Black and White command. shape layer, 180, 185–186 85-86 shapes, 313-317 elements in layers, 178 sharing layers, 178 about, 357 resolutions, 80 Adobe Premiere Elements, 358, 369 shapes, 317 Adobe Revel, 360–361 from Tool Options, 43 common setup attributes, 361 tools, 42-43 e-mailing photos, 368-369 selection borders, 200. See also on Facebook, 370-371 selections on Flickr, 370-371 Selection Brush, 156-158 online photo albums, 362-367 selections options, 357-361 about, 143 Photoshop Showcase, 362–367 adding to, 155 planning ahead for, 358–360 Cookie Cutter tool, 162-163 on social networks, 369-371 defining, 143-144 Sharing preferences (Organizer), 65 elliptical, 144-148 Sharpen tool, 221–222, 248 Eraser tools, 163–166 sharpening, 248-250 feathering, 170 Shift + Alt, 145-146 filling, 304-305 Shift Edge (tool option), 171 freeform, 148-152 Shift Pixels (S) tool, 264 intersecting, 156 shots, framing, 389 inversing, 169 Show All Controls (Slideshow toolbar), 127 loading, 172–173 showing Magic Extractor command, 166-168 brushes, 301 Magic Wand, 152–155 images onscreen, 73-75 modifying, 155-156 Layers panel, 177 outlining, 305-306 Similar command, 172 Quick Selection Tool, 159-160 similarities, searching, 136-137 Recompose tool, 160–162 simplifying type, 330-331 rectangular, 144-148 size refining edges of, 170-171 image, 76-78 reselecting, 169 for printing, 340 saving, 172-173 Size (Eraser tool), 164 Select menu. 169-173 Size box (Photo Editor), 37 Selection Brush, 156–158 skin tones, adjusting, 238-239 subtracting from, 156 Slide Show (Organizer), 103 setting preferences for Organizer, 64–65 slides, exporting projects to, 381–382 Settings (Slideshow toolbar), 126 Slideshow toolbar (Organizer), 126–127 shadows, adding, 272-274 slideshows, 122-127, 360, 377-382 Shadows adjustment (Quick mode), 210 Small Computer Systems Interface (SCSI) Shadows/Highlights command, 226–227 device, 20

Smart Albums, creating, 113–115 Smart Blur filter, 246 Smart Brush tool, 252–254 Smart Radius (tool option), 170 Smooth (tool option), 171 Smooth command, 172 Smudge tool, 219–220 social networks, sharing photos on, 369 - 371Soft Light blend mode, 278, 279 source, 214 specifying type options, 327–329 Spherical mode (Photomerge), 282 splitting catalogs, 119 Sponge tool, 222 Spot Healing Brush, 212, 216–217 stacking images, 138–139 stacking order, 177 Star geometry options, 316 Status Bar (Organizer), 102 storage hosts, 358 storage space, 358 Straighten menu commands, 201 Straighten tool, 201 straightening images, 201 Strikethrough option, 329 Stroke tool, 305–306 Style Match (Photomerge), 290-291 Style option, 329 stylizing type, 333–336 subtracting from selections, 156 Support option, 57 Surface Blur filter, 246 swatches, 296 Swatches panel, 296 switching between catalogs, 119 colors with Replace Color command, 235 Sync Panning and Zooming (Slideshow toolbar), 126

• T •

T (Turbulence) tool, 263 Tablet Pressure (Magnetic Lasso tool), 151 Tablet Settings (Brush tool), 300 Tagged Image File Format, 194 tagging about, 99-100 keyword tags, 103–108 people, 20 Technical Stuff icon, 6 teeth, whitening, 211 Temperature adjustment (Quick mode), 211 text, editing, 329-330 Text Alignment option, 328 Text Color option, 328 text effects, 271–272 Text On Custom Path tool, 320, 326–327 Text On Selection tool, 320, 324–325 Text On Shape tool, 320, 325–326 Theme (Slideshow toolbar), 126 Threshold command, 243 TIFF file format, 94–95, 96, 194 Timeline (Organizer View menu), 122 Timing (Photo Editor), 38 Tint adjustment (Quick mode), 211 Tip icon, 6 Tolerance (Background Eraser tool), 165 Tolerance option (Paint Bucket tool), 306 Tolerance setting (Magic Wand), 153–155 Tool tips, 57 tools accessing, 42 Blur, 220–221 blurring, 245–248 Brush, 300–301 Burn, 217–219 Clone Stamp, 212–214 Color Replacement, 223-224

Cookie Cutter, 162-163

Crop, 198-200 Detail Smart Brush, 252-254 Dodge, 217-219 E (Reconstruct), 264 Edit (Organizer), 125 Elliptical Marquee, 144–145 Eraser, 163-166 Eyedropper, 297–298 H (Hand), 264 Impressionist Brush, 303 L (Twirl Counterclockwise), 264 Lasso, 148-152 M (Reflection), 264 Magnetic Lasso, 148, 151–152 Marquee, 146-148 Move, 189-190 Organize (Organizer), 125 P (Pucker), 264 Paint Bucket, 306-307 Pencil, 298-300 Polygonal Lasso, 148, 150 Pucker (P), 264 Quick Selection, 159-160 R (Twirl Clockwise), 264 Recompose, 160–162 Reconstruct (E), 264 Rectangular Marquee, 144–145 Refine Radius, 171 Reflection (M), 264 S (Shift Pixels), 264 selecting, 42–43 selecting from options, 43 Sharpen, 221-222, 248 Shift Pixels (S), 264 Smart Brush, 252-254 Smudge, 219-220 Sponge, 222 Straighten, 201 Stroke, 305-306 T (Turbulence), 263

Text on Custom Path tool, 320, 326-327 Text On Selection, 320, 324-325 Text On Shape, 320, 325–326 Turbulence (T), 263 Twirl Clockwise (R), 264 Twirl Counterclockwise (L), 264 Type, 320 Type Mask, 320, 331-333 W (Warp), 263 Warp (W), 263 Z (Zoom), 171, 264 Zoom (Z), 171, 264 Tools panel (Photo Editor), 33, 34, 40-43 touchscreen monitors, 254 transforming layers, 190-191 shapes, 317 Transparency preferences (Photo Editor), 62 Turbulence (T) tool, 263 Twirl Clockwise (R) tool, 264 Twirl Counterclockwise (L) tool, 264 type about, 319 adjusting opacity, 334 applying filters, 334 creating paragraph type, 323–324 creating path type, 324–327 creating point type, 321–322 editing text, 329–330 formats, 321 masking with, 331-333 modes, 320-321 simplifying, 330-331 specifying options, 327-329 stylizing, 333-336 tools, 320 warping, 333-336 Type (Eraser tool), 164 type layer, 186

Type Mask tool, 320, 331–333 type masks, 332–333 Type preferences (Photo Editor), 62 Type tool, 320

· U ·

Underline option, 329
Undo command, 54
Undo History panel, 55–56
undocking photos, 33
Undo/Redo (Organizer), 102
Undo/Redo (Photo Editor), 33
Units & Rulers preferences (Photo Editor), 62
unlinking layers from layer masks, 193
Unsharp Mask command, 249–250
untagged items, searching for, 133–134
upsampling, 76
USB flash drives, copying files from,
14–16

. U .

vector images, 72, 313, 321
versions, creating, 139–140
Vibrance adjustment (Quick mode), 211
video formats, 96
Video Tutorials option, 57
videos, exporting projects to, 381–382
View (Slideshow toolbar), 126
View menu, 39, 122
View mode (tool option), 170
viewing
filenames, 47
galleries in Photoshop Showcase,
366–367
images, 18, 183

images in Media Browser, 18 keyword tags, 103–104 layer masks, 193 layers, 178 photos in slideshows, 122–127 viewpoints, 390 Vignette Removal mode (Photomerge), 282 Vivid Light blend mode, 278, 279

• W •

W (Warp) tool, 263 Warming Filter, 242 Warning! icon, 5 Warp (W) tool, 263 warping type, 333–336 WAV format, 96 web, saving files for, 89–90 web hosting, 360 websites Kodak, 397 Wiley support, 6 Welcome screen, launching Photo Editor from, 30 whitening teeth, 211 Width (Magnetic Lasso tool), 151 width (W), 147–148 Wiley support, 6 Window menu, 39-40 Windows backing up photos and files, 121 bitmap mode, compared with Elements bitmap mode, 82 creating slide shows, 378–381 Organizer, compared with on Macintosh, 128 plug-ins, 21-23 printing from Organizer in, 350

windows, floating, 33 WMV format, 96 workspaces, choosing color, 69–70

YouTube, 358

• Z •

Z (Zoom) tool, 171, 264 ZIP lossless compression scheme, 95 Zoom (Organizer), 103 Zoom (Z) tool, 171, 264

e & Mac

2 For Dummies, Edition 1-118-17679-5

ne 4S For Dummies, Edition
1-118-03671-6

touch For Dummies, Edition

1-118-12960-9 OS X Lion

Dummies 1-118-02205-4

ging & Social Media

√ille For Dummies -1-118-08337-6

book For Dummies, Edition 1-118-09562-1

n Blogging Dummies -1-118-03843-7

ter For Dummies, Edition -0-470-76879-2

dPress For Dummies, Edition -1-118-07342-1

iness

h Flow For Dummies -1-118-01850-7

sting For Dummies, Edition -0-470-90545-6

Job Searching with Social Media For Dummies 978-0-470-93072-4

QuickBooks 2012 For Dummies 978-1-118-09120-3

Resumes For Dummies, 6th Edition 978-0-470-87361-8

Starting an Etsy Business For Dummies 978-0-470-93067-0

Cooking & Entertaining

Cooking Basics For Dummies, 4th Edition 978-0-470-91388-8

Wine For Dummies, 4th Edition 978-0-470-04579-4

Diet & Nutrition

Kettlebells For Dummies 978-0-470-59929-7

Nutrition For Dummies, 5th Edition 978-0-470-93231-5

Restaurant Calorie Counter For Dummies, 2nd Edition 978-0-470-64405-8

Digital Photography

Digital SLR Cameras & Photography For Dummies, 4th Edition 978-1-118-14489-3

Digital SLR Settings & Shortcuts For Dummies 978-0-470-91763-3 Photoshop Elements 10

Photoshop Elements 10 For Dummies 978-1-118-10742-3

Gardening

Gardening Basics For Dummies 978-0-470-03749-2

Vegetable Gardening For Dummies, 2nd Edition 978-0-470-49870-5

Green/Sustainable

Raising Chickens For Dummies 978-0-470-46544-8

Green Cleaning For Dummies 978-0-470-39106-8

Health

Diabetes For Dummies, 3rd Edition 978-0-470-27086-8

Food Allergies For Dummies 978-0-470-09584-3

Living Gluten-Free For Dummies, 2nd Edition 978-0-470-58589-4

Hobbies

Beekeeping For Dummies, 2nd Edition 978-0-470-43065-1

Chess For Dummies, 3rd Edition 978-1-118-01695-4

2nd Edition 978-0-470-61842-4 eBay For Dummies, 7th Edition

978-1-118-09806-6

Drawing For Dummies,

Knitting For Dummies, 2nd Edition 978-0-470-28747-7

Language & Foreign Language

English Grammar For Dummies, 2nd Edition 978-0-470-54664-2

French For Dummies, 2nd Edition 978-1-118-00464-7

German For Dummies, 2nd Edition 978-0-470-90101-4

Spanish Essentials For Dummies 978-0-470-63751-7

Spanish For Dummies, 2nd Edition 978-0-470-87855-2

able wherever books are sold. For more information or to order direct: U.S. customers visit www.dummies.com or call 1-877-762-2974. U.K. customers visit www.wileyeurope.com or call (0) 1243 843291. Canadian customers visit www.wiley.ca or call 1-800-567-4797.

Math & Science

Algebra I For Dummies, 2nd Edition 978-0-470-55964-2

Biology For Dummies, 2nd Edition 978-0-470-59875-7

Chemistry For Dummies, 2nd Edition 978-1-1180-0730-3

Geometry For Dummies, 2nd Edition 978-0-470-08946-0

Pre-Algebra Essentials For Dummies 978-0-470-61838-7

Microsoft Office

Excel 2010 For Dummies 978-0-470-48953-6

Office 2010 All-in-One For Dummies 978-0-470-49748-7

Office 2011 for Mac For Dummies 978-0-470-87869-9

Word 2010 For Dummies 978-0-470-48772-3

Music

Guitar For Dummies, 2nd Edition 978-0-7645-9904-0

Making Everything Easier!"

Golf

DUMMIES

Clarinet For Dummies 978-0-470-58477-4

iPod & iTunes For Dummies, 9th Edition 978-1-118-13060-5

Pets

Cats For Dummies, 2nd Edition 978-0-7645-5275-5

Dogs All-in One For Dummies 978-0470-52978-2

Saltwater Aquariums For Dummies 978-0-470-06805-2

Religion & Inspiration

The Bible For Dummies 978-0-7645-5296-0

Catholicism For Dummies, 2nd Edition 978-1-118-07778-8

Spirituality For Dummies, 2nd Edition 978-0-470-19142-2

Self-Help & Relationships

Happiness For Dummies 978-0-470-28171-0

Overcoming Anxiety For Dummies, 2nd Edition 978-0-470-57441-6

Crosswords For Seniors For Dummies 978-0-470-49157-7

iPad 2 For Seniors For Dummies, 3rd Edition 978-1-118-17678-8

Laptops & Tablets For Seniors For Dummies, 2nd Edition 978-1-118-09596-6

Smartphones & Tablets

BlackBerry For Dummies, 5th Edition 978-1-118-10035-6

Droid X2 For Dummies 978-1-118-14864-8

HTC ThunderBolt For Dummies 978-1-118-07601-9

MOTOROLA XOOM For Dummies 978-1-118-08835-7

Sports

Basketball For Dummies, 3rd Edition 978-1-118-07374-2

Football For Dummies, 2nd Edition 978-1-118-01261-1

Golf For Dummies, 4th Edition 978-0-470-88279-5

Test Prep

ACT For Dummies, 5th Edition 978-1-118-01259-8

ASVAB For Dummies, 3rd Edition 978-0-470-63760-9

The GRE Test For Dummies, 7th Edition 978-0-470-00919-2

Police Officer Exam For Dummies 978-0-470-88724-0

Series 7 Exam For Dummies 978-0-470-09932-2

Web Development

HTML, CSS, & XHTML For Dummies, 7th Editi 978-0-470-91659-9

Drupal For Dummies, 2nd Edition 978-1-118-08348-2

Windows 7

Windows 7 For Dummies 978-0-470-49743-2

Windows 7 For Dummies, Book + DVD Bundle 978-0-470-52398-8

Windows 7 All-in-One For Dummies 978-0-470-48763-1

Available wherever books are sold. For more information or to order direct: U.S. customers visit www.dummies.com or call 1-877-762-U.K. customers visit www.wileyeurope.com or call (0) 1243 843291. Canadian customers visit www.wiley.ca or call 1-800-567-4797